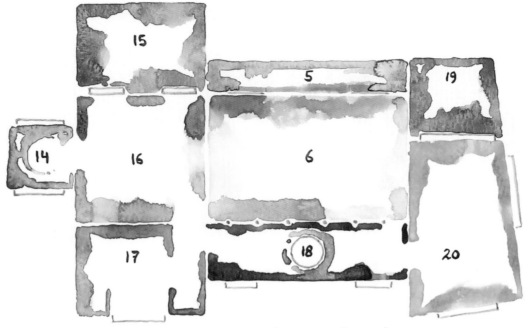

SECOND FLOOR

14. Sleeping Alcove
15. Terrace
16. Winter Bedroom
17. Bathroom
5. Terrace
6. Drawing Room Below
18. Balcony
19. Roof
20. Closet

DAWNRIDGE

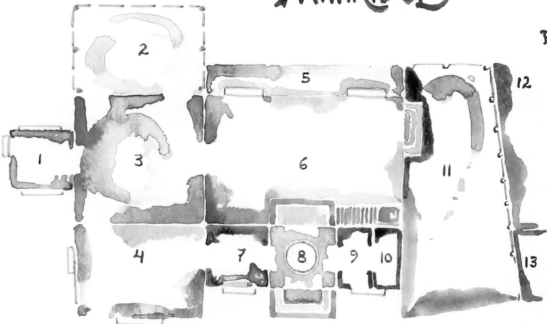

FIRST FLOOR

1. Office
2. Monkey Room
3. Library
4. Kitchen
5. Terrace
6. Drawing Room (Summer Bedroom Below)
7. Bar
8. Entrance Hall
9. Camelot Room
10. Venetian Powder Room
11. Green Room
12. Garden
13. Upper Terrace

TONY DUQUETTE'S
DAWNRIDGE

HUTTON WILKINSON

PHOTOGRAPHS BY TIM STREET-PORTER

FOREWORD BY HAMISH BOWLES

ABRAMS, NEW YORK

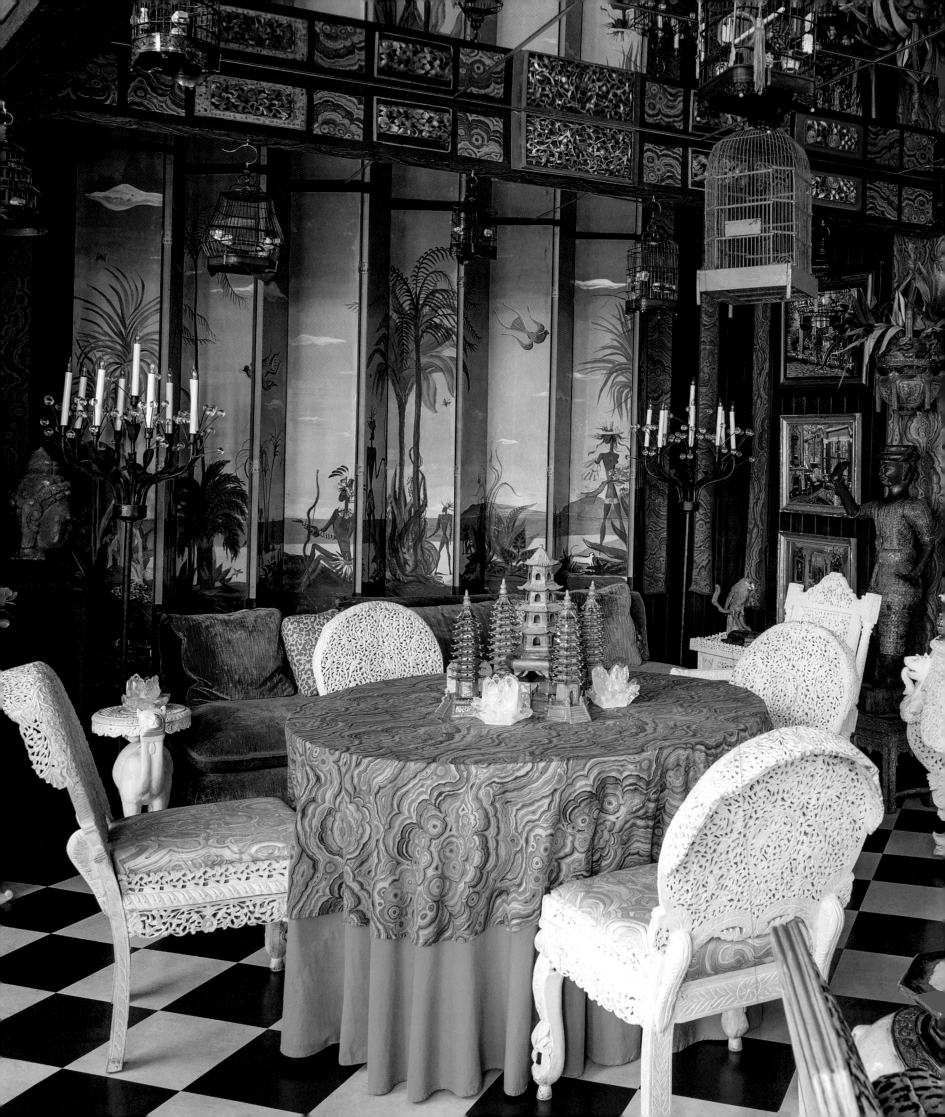

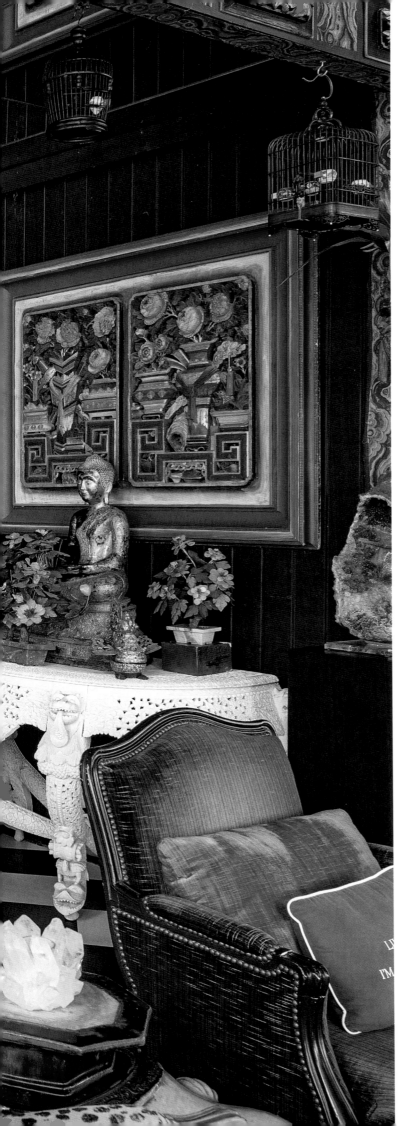

CONTENTS

Foreword

........................

Magic was the highest word of praise that Tony Duquette could bestow upon object, experience, or person. He was a design alchemist who could take base materials—fish bones, snail shells, tree bark—and transform them into objects of wonder and delight. "I want everything to have spontaneity, to move and laugh," he once said, and as a young artist, his exceptional gifts soon saw him taken up by the chic Hollywood decorators Billy Haines and Jimmy Pendleton. Erelong, Duquette was the protégé of the even more celebrated Lady Mendl, whose career as the actress Elsie de Wolfe was distinguished only by the élan with which she wore the latest fashions on stage. She found her true calling, however, as the blue-rinsed doyenne of interior design taste. Mendl encouraged Duquette to create a "moible" for her and the resulting *meuble*—a grand *lacca povera* secretary filled, as *Vogue* noted at the time, with his "jeweled fetishes"—became a centerpiece of After All, Mendl's trendsetting Los Angeles home, and a calling card for his talents.

The great Gilbert Adrian was one of those who came calling. Adrian, as he was known, honed his art as the fashion director of Metro-Goldwyn-Mayer, shaping the on-screen style of Garbo, Crawford, Lombard, Shearer, and Hepburn. In the early 1940s, with America cut off from Paris fashion news during the Occupation, Adrian astutely began to bring his talents to off-screen fashion, selling his designs via the most exclusive department stores across the country—and his own high-style salon—to a legion of deep-pocketed customers who weren't afraid to make an entrance. "Amaze me!" was Adrian's injunction to Duquette, and the young artist obliged with decors for the designer's salon and fashion shows of eclipsing fantasy and charm. Duquette was made for Tinseltown, the land of illusion, and for the director Vincente Minelli he created movie decors as fanciful as the homes that he invented for himself and his wife, the ethereal artist Elizabeth Johnstone.

Duquette was fearless. He built Dawnridge in a cleft in the hills above the rolling, palmy lawns of Beverly Hills and created a universe of his own where Venice met Shangri-La. I can never forget walking into what seemed to be a candlelit anteroom to a palace here. It was elaborately paved in faceted antique mirror, which on closer inspection—and if truth be told, really only when it was pointed out to me—was in fact made from the pressed aluminum foil dishes in which the Chinese take-out orders were delivered, and did not lead to the promised imperial splendors but to a useful tool shed instead. With a wave of Duquette's wand, a collection of industrial lamps, stacked one above the other, was thus miraculously

transformed into a sacred object that might be found dangling from a temple ceiling in Lost Horizons, and served to illuminate the lights of elephant-high obelisks crusted with abalone shells. Next to these wonders, old-fashioned trash cans were mounted one above the other and pierced with gothic openings until they resembled ancient Cairene minarets. Through tricks of scale and trompe l'oeil and false perspectives, a distant pavilion across a broad lake was, in reality, little more than a set-builder's facade artfully set into a shallow ledge in the ravine on the far side of a modest *basin* of water. Inside, Duquette's eye-tricking skills with a paintbrush created convincing simulacrums of malachite and lapis and porphyry, and of jaguar spots and ermine tails and angel wings, when there was nothing but cloth and plaster and wood and canvas and pipe cleaners and a great, roiling ocean of imagination.

Hutton Wilkinson, Duquette's pupil, protégé, and collaborator since the early seventies, and now his spiritual heir, worked with the master for clients including Dodie Rosekrans, for whom they evoked a maharajah's throne room in a prim apartment on Paris's rive gauche, and transformed the *piano nobile* of the storied Palazzo Brandolini on a majestic turn of the Grand Canal in Venice. Here, the Duquette-Wilkinson interventions included a bedroom like a mermaid's grotto with walls of iridescent net layered over Mary Pickford's Chinese wallpaper. The curves and volutes of elaborate, impasto eighteenth-century plasterwork framing the mirrors in the immense reception gallery, meanwhile, proved insufficiently whimsical to Duquette's purpose, and so he and Wilkinson spent laborious hours embellishing it with a thousand tendrils of deep-sea coral—not, as it happens, plucked from the sea but instead carved in Thailand from rattan.

Hutton Wilkinson, the acolyte turned master, who learned the craft at Duquette's side through the decades, has subtly transformed the original structures of Dawnridge into a sort of shrine to the Duquettes and their works that Wilkinson has been gifted or assiduously sought out through the years—sleuthing the auction rooms and *antiquaires* around the country. They now form a unique collection that is a work of art in itself and serves as a moving testament to Tony and Beegle Duquette's febrile and unbridled imaginations, their invention, and their artistry.

To set off these imaginatively presented works, Wilkinson has rationalized Dawnridge, spiriting away its cobwebs and dust and letting in the diamond California light. Original fabrics have been rewoven from fading scraps to replicate their intended splendor, and Wilkinson has re-edited Duquette pieces such as the free-form gilded consoles that writhe like great sea serpents and the pagoda lamps that seem to have been fashioned from Brobdingnagian blocks of pale jade or alabaster, but are, in a Duquette-ish sleight of hand, cast from workaday resin.

Hutton, his wife, Ruth, and their scampering dogs have no need of living in a museum, so he has created a second stage set for themselves, a new house that hovers in the clouds above Dawnridge, and showcases his own dashing brand of Duquetterie, with its leopard underfoot and gold leaf overhead, and lacquered cinnabar in the great heights in-between. Here, ancient icons are mounted on Japanese screens in a riot of old gold, scarlet, and ebony paint and lacquer; Chinese pictures hang against carved Chinese screens glimmering with shards of mother-of-pearl; and a series of Venetian paintings depicting—what else—the Festival of the Redentore, with its gondolas and fireworks and moon-lit splendors, are set against a wall of gold. The alchemy continues.

—HAMISH BOWLES

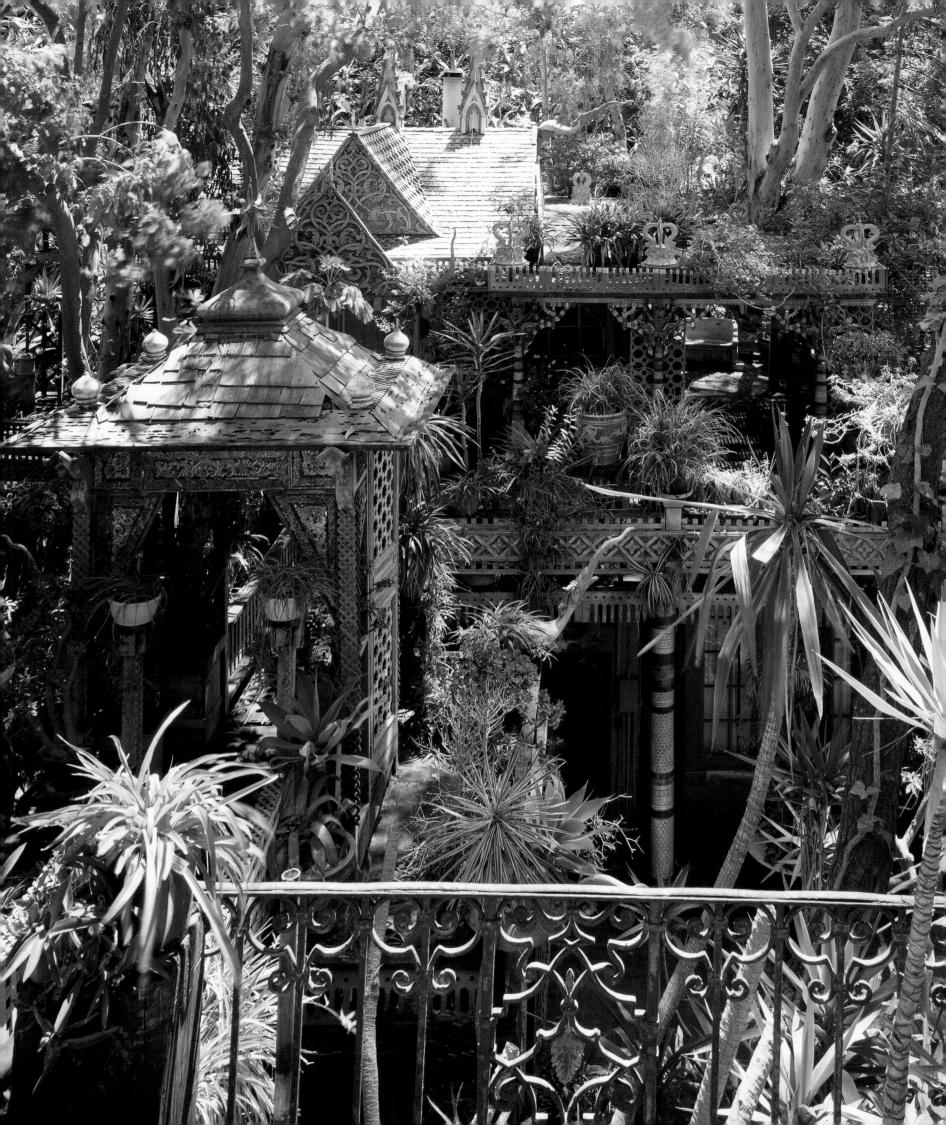

A LIVING HOUSE

......................

AFTER TONY DUQUETTE'S DEATH IN 1999, I took a trip to Hong Kong. One night, my friend Charlie Garnett gave a party for me at the China Club, where I was persuaded by friends to visit a psychic who'd recently set up shop on Hollywood Road. I went to see what all the fuss was about early the next day. Arriving at my destination, I put down my one hundred dollars and went into the room where the fortune-teller waited. "Is your name Anthony?" she asked me immediately.

"My business partner's name was Anthony," I said.

"He's not with us anymore is he?" she asked.

"No, he passed away not too long ago," I replied.

"You're very involved in a house project right now," she said.

"Yes, I am," I answered. That house was Dawnridge, and upon my return to Los Angeles, I would be facing the removal of all its valuable antiques for an auction to settle Tony's estate and the daunting task of redecorating it for an upcoming benefit we were hosting for the Decorative Arts Council of the Los Angeles County Museum of Art. I had my work cut out for me and hoped I hadn't bitten off more than I could chew. "Some people would think that the garden is more important than the house!" the psychic insisted.

"Some people would," I agreed.

"Anthony's in the garden . . . he's very happy and approves of everything you're doing," she told me, and I smiled.

Before he died, I promised Tony that I'd try to save Dawnridge. I said that Cow Hollow, his house in San Francisco, and Sortilegium, his ranch in Malibu, would probably have to be sold, but because Dawnridge was the only property that he'd built from scratch, I would do everything in my power to keep it intact. After the Duquette auction, my wife, Ruth, and I redecorated Dawnridge as a loving tribute to our darling mentors and friends, Tony and his wife, Elizabeth, also known as "Beegle." We like to think that if Tony and Beegle were to come back for a visit they might not recognize the rooms, but they would certainly recognize all of the objects. We deliberately redecorated the house using paintings, sculptures, and furniture that they created, mixing them with antiques, in a style we think they would approve of.

It has been our pleasure to save the life of this fabled house and to continue the tradition of creative hospitality that Dawnridge is known for. As Tony would say, "We do these things for our pleasure, and hopefully, to inspire individuality and creativity in others through the art of living and the living arts." Dawnridge is a living house, constantly changing and evolving. It is the dearest hope of mine and my wife Ruth's—and hope is the thing with feathers that perches in the soul—that Dawnridge will continue to inspire, enchant, and inform for generations to come.

—HUTTON WILKINSON
Dawnridge, 2018

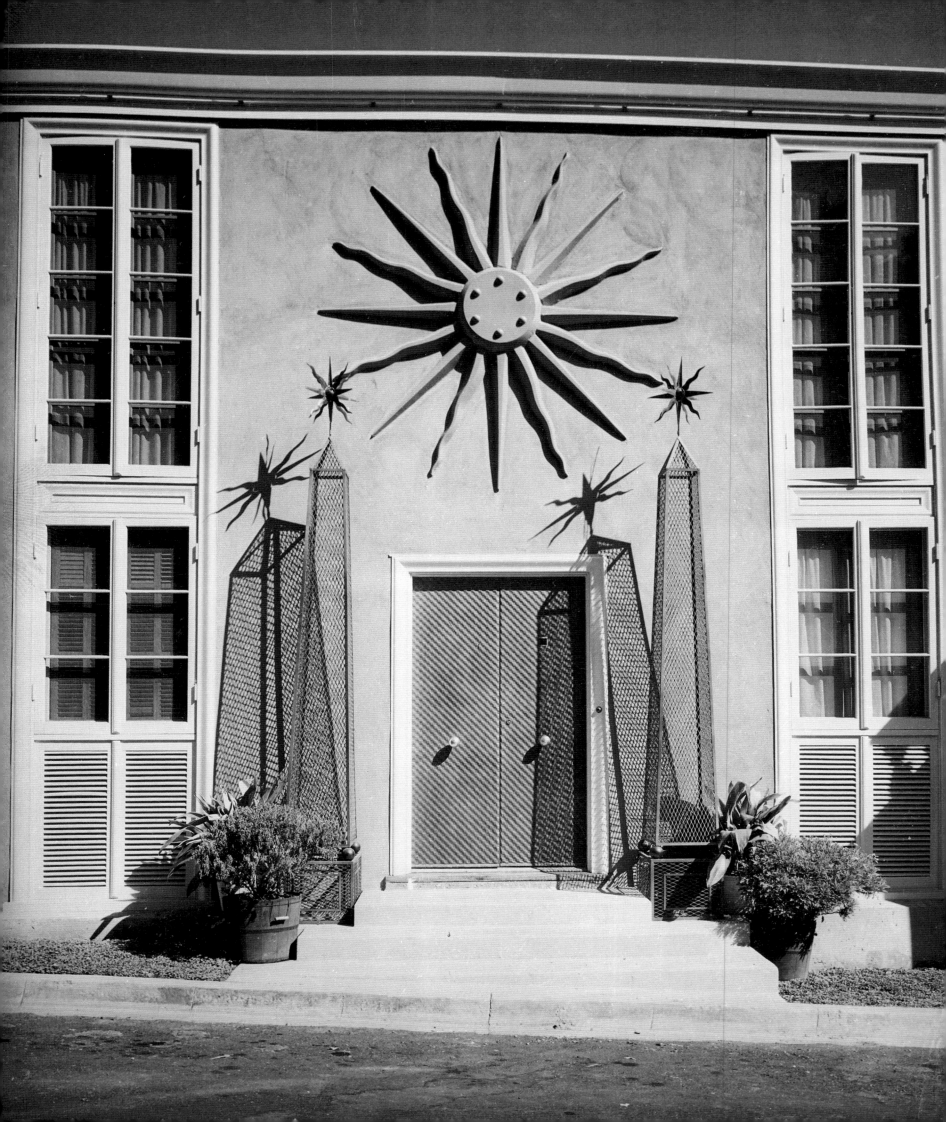

Dawnridge, 1949. The iron obelisks on each side of the front door were moved to the Tony Duquette Studio on Robertson Boulevard where they were covered with abalone shell. The obelisks returned to the gardens at Dawnridge in 1975. **Following spread, from left:** Dawnridge, 1975. Tony covered the façade with lattice and painted it pink with white trim and coral edges; In 2018, I painted the lattice emerald-green and covered it with ivy.

CHAPTER ONE

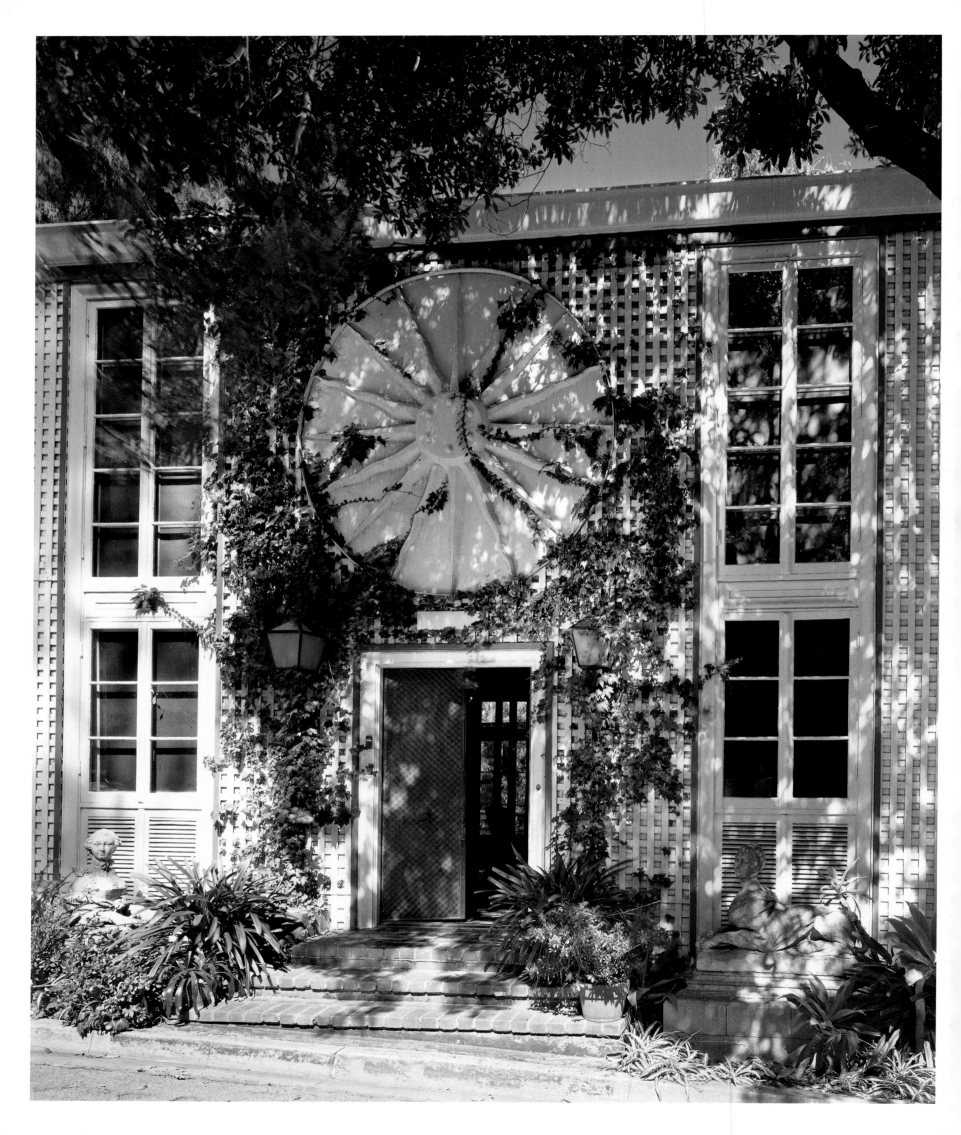

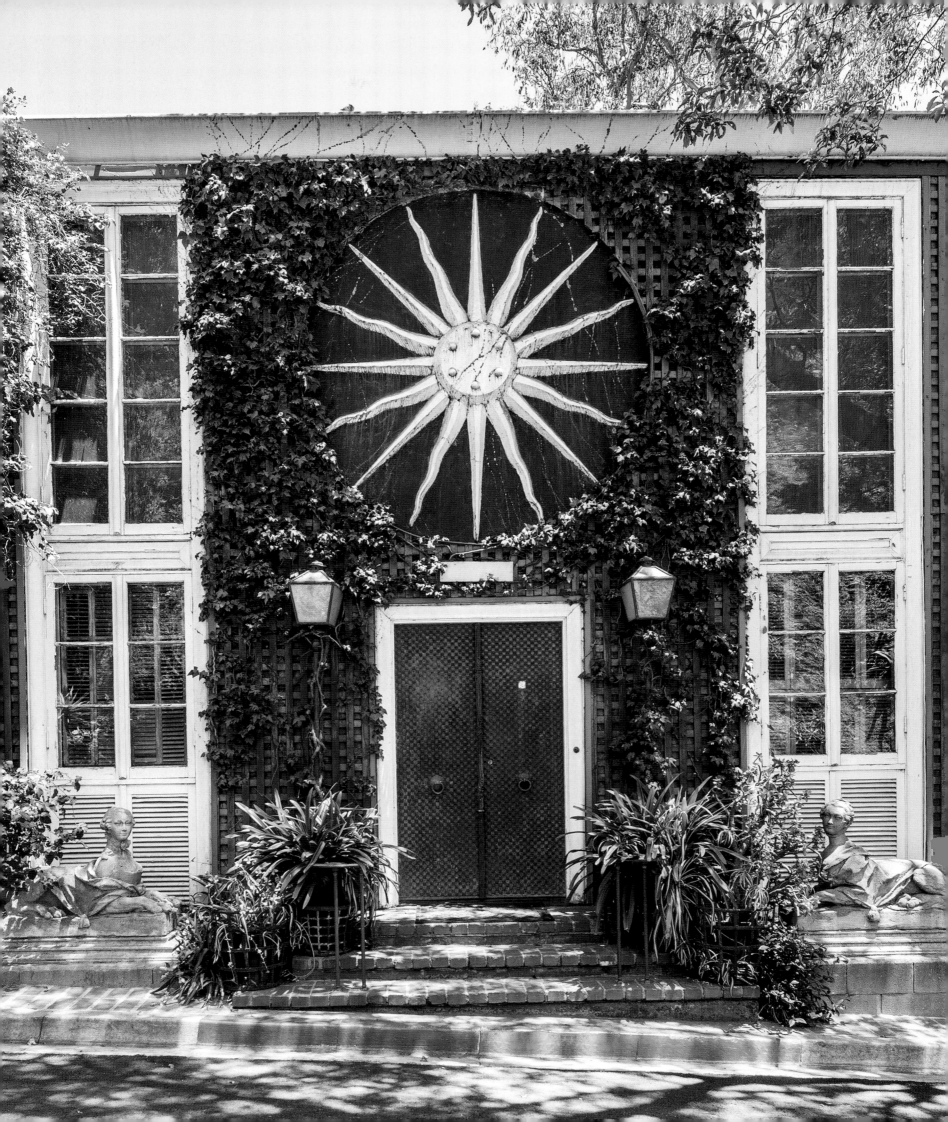

Tony Duquette grew up between Three Rivers, Michigan, and Los Angeles, California. As a child, he would amuse himself by building "estates" in the side yards and empty lots next to his family's homes. These miniature constructions made of twigs and painted cardboard were theatrically lit with birthday-cake candles. After construction was completed, The Witch Boy (as his friend Eudora Welty later called him) would invite his family and friends to an "unveiling," where he would dramatically light all the tiny candles, creating a brief moment of magic. "I would invariably become small, becoming one with my miniature worlds," Tony once told me. "I could play for days within the realms of my imagination and fantasize an entire culture living within the boundaries of my estates. I would spend days creating streets and houses, while imagining the lives that went on there." He never told me if these estates had names.

Later in life Tony would amass ten fully furnished houses, all of which he did name: Fiddler's Ditch, later renamed Dawnridge; Cow Hollow (his pre-1916, San Francisco birdcage Victorian); Beeglesville; Frogmore; Ireland (named for the home's façade, which was salvaged from an eighteenth-century Irish storefront); Doorchester (which was constructed entirely out of old paneled doors); Horntoad; China (a conglomeration of gilded Chinese carvings); Hamster House; and Chat Thai. Through these houses, he brought the magic of his childhood estates to life. To achieve some of these he needed an architect and found one early on, even before he owned land to build upon.

Caspar Johann Ehmcke was born in Munich, Germany, in 1908, making him older than Tony by six years. When Caspar was nineteen, he moved to Stuttgart to study architecture at Stuttgart Technical University. After graduating, Caspar immigrated to the United States, and shortly after arriving in Los Angeles in 1938, got a job at Bullock's department store where he specialized in store planning and design. It was through Bullock's—where Tony worked designing store interiors—that the two future collaborators would meet. As fate would have it, Tony and Caspar rode the streetcar together to and from work each day. It was during this time that Caspar would tell Tony of his Bauhaus-style, modernist training in Germany and his plans to build streamlined houses in Los Angeles. Tony, in turn,

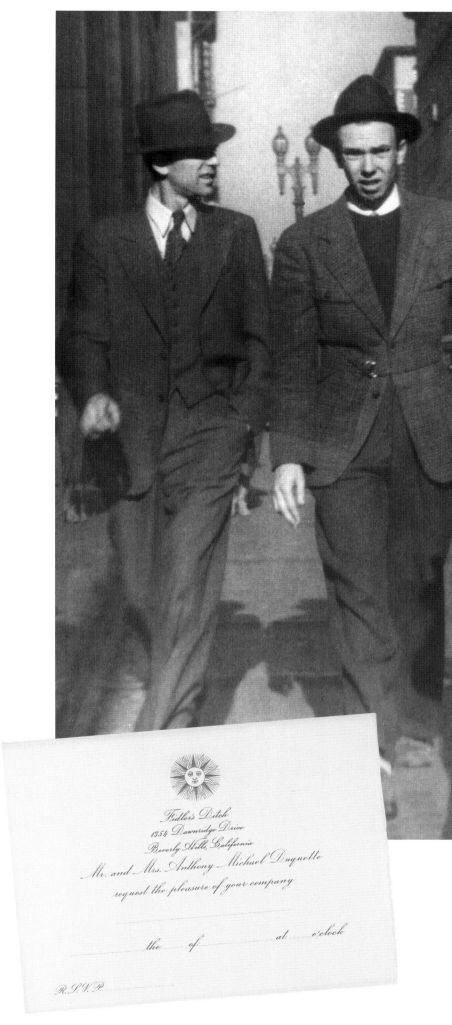

Opposite: Tony at his parents' home in Three Rivers, Michigan, c. 1920. Right, from top: Caspar Ehmcke (left) and Tony walk to work at Bullock's department store in downtown Los Angeles, c. 1938; The engraved invitation newlyweds Tony and Elizabeth would send out for parties at Fiddler's Ditch, c. 1949.

would tell Caspar of his ideal house: a pavilion d'amore, a small Venetian palazzetto, a folly de luxe. What Tony described was the antithesis of anything Caspar had ever dreamed of building. "Someday, you'll build it for me," Tony insisted. It was a dream Caspar hoped Tony would forget.

While Caspar worked away at store planning and design, Tony's job at Bullock's was to change the store interiors four times a year. His directive from the store's owner, P. G. Winnett (my great uncle), was to make the customers forget about Southern California's lack of seasons. "In those days, if women in New York were wearing tweeds and furs, the women in Los Angeles were also wearing tweeds and furs, even if it was one hundred degrees in California," Tony said. "The minute the customers walked through the doors, it was my job to dupe them through the store interiors, temperature, and music into thinking it was summer, winter, spring, or fall!" Tony's remuneration for conjuring up the seasons like a modern-day Merlin was an extravagant paycheck of fifteen dollars per week, on which he fed, clothed, and housed his mother, father, and three siblings.

Tony left his secure job at Bullock's after meeting Elsie de Wolfe, the first lady of American design, in 1940. De Wolfe, also known as Lady Mendl, had fled the Nazi occupation of Paris with her husband, Sir Charles Mendl, and eventually made a new life in Los Angeles after briefly living in New York. A very young eighty-five, she told her friends who begged her to stay that she "was moving to Hollywood to be with the royalty of America . . . the movie stars!" As fate would have it, de Wolfe was introduced to Tony through their mutual friends William "Billy" Haines, James Pendleton, and director Vincente Minnelli, and the rest was history. After claiming Tony as her exclusive discovery—and proclaiming him a genius—she hired him to decorate her new house in Beverly Hills, which she named After All. Taking Tony under her wing, Elsie made it her mission over the next ten years to make him famous worldwide.

Tony met his wife, Elizabeth Johnstone, in 1942. He was in the army, and she was a freelance artist working for Disney. They fell in love and moved in together. Elizabeth was nicknamed Beegle by Tony because she encompassed the industry of the bee and the soaring poetry of the eagle—she was an artist whose talents seamlessly complemented his own. One day in 1949, their

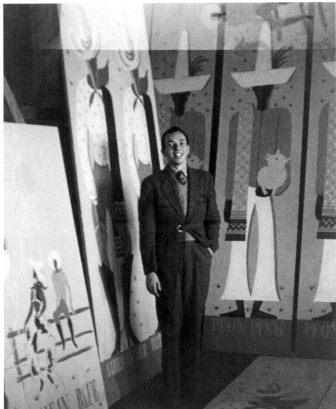

friend Mary Pickford told them, "If you'd just get married, I'll pay for the wedding!" That was all Tony had to hear; a free wedding sealed the deal and the couple was married at Pickfair, Pickford's fabled estate, in Beverly Hills. Pickford was the matron of honor and her second husband, Academy Award–winning actor Charles "Buddy" Rogers, was best man. All of Hollywood was in attendance, including Hedda Hopper, Louella Parsons, Cobina Wright, Gloria Swanson, Agnes Moorehead, Vincente Minnelli, Adrian, and Arthur Freed. Sir Charles and Lady Mendl were also there.

It was with marriage in mind that Tony finally commissioned Caspar to build his dream house, Dawnridge, as a gift for his bride. Caspar had left Bullock's the same year as Tony to complete a housing project for the Metropolitan Life Insurance Company, and would eventually work on the new Jet Propulsion Laboratory, the Navy Test Facility, and an earthquake-proof high-rise for the Sears Roebuck department store. In 1945, he had started his own practice that focused primarily on commercial buildings, including a new recording studio for Decca Records. When a friend of Tony's, photographer Johnny Engstead, announced plans to build a new studio for himself, Tony insisted that the only architect for the job was Caspar Ehmcke. When Tony made an aesthetic proclamation, his friends always heeded his advice.

Before Ehmcke could go to work on Dawnridge, Tony had to purchase the land. Independently, two good friends—one a real estate agent, the other a banker—had approached Tony and said, "When you're ready to build your dream house, call me!" Shortly thereafter, Tony found a canyon lot high above Beverly Hills, just up the road from Pickfair, and told them about the property. All their friends thought Pickford had given the Duquettes the land as a wedding present, but that was not the case. When Tony showed the lot to the real estate agent, she said, "I love you too much to sell you that property. It doesn't have a front yard; it's on a hillside. You're an artist, and you obviously don't know what you're doing. If you buy this property, you're going to lose your

shirt. I refuse to sell you the property." Undeterred, Tony went to the banker, who said, "I love you and Beegle too much to lend you the money to do this project. You're an artist, and you obviously don't know what you're doing. It has no front yard, it's on a hillside, and you're going to lose your shirt. I won't lend you the money; it's too risky." "But for $1,500?" Tony asked. The land was only $1,500 in 1949. A child of the Great Depression, Tony understood value, and despite his friends' warnings, he purchased the property and proceeded to build the house. That's when his parents jumped in. "Don't build the bedroom wing," they told him. "You're going to lose your shirt." And so, unfortunately, he heeded their advice and didn't build the bedroom wing.

Dawnridge was to be Ehmcke's first residential commission, but built to Tony's very Venetian specifications. It was a thirty-by-thirty-foot box that was divided into a large twenty-by-thirty-foot salon that Tony called the Drawing Room and three ten-by-ten-foot boxlike rooms across the front: the entrance hall, its adjoining vestibule with a small powder room, and the kitchen. A staircase in the double-height Drawing Room led up to a ten-by-thirty-foot balcony above the entrance hall and its adjoining rooms that had originally been intended to access the bedroom wing that wasn't built. Instead, it opened onto a small terrace above a one-car garage, an amenity that didn't interest Tony, who soon turned the garage into a dining room. Under the staircase to the balcony was a staircase leading down to two tiny bedrooms and bathrooms built into the slope of the hillside. "It's like an apartment on its own ground," Tony used to say euphemistically about the house.

That was Dawnridge, originally christened Fiddler's Ditch after the ravine that ran through the back of the property. It was an elegant, small house that magazines called "the Grandest House in Beverly Hills," and when Tony's society friends saw it, they all wanted one too, albeit bigger. Ehmcke went on to design dozens of Hollywood Regency–style houses, as well as a handful of Modernist residences, for those friends, but his first residential commission was destined to become his most famous. Tony and Beegle hosted a whirlwind of parties and visitors during their first year in the house, including the famous French collector of houses Paul-Louis Weiller (Tony would later design a house for him in Paris), the Mendls, Mary Pickford, Marion Davies, Arthur Freed, Fred Astaire, and Loretta Young. The guest lists were formidable. Fiddler's Ditch was christened with a Bal de Derrière, or a Bustle Ball, where all the ladies wore gowns with bustles. The Bal de Derrière was followed by numerous dinner parties, replete with divertissements such as the noted Indian dancers Sujata and Asoka, as well as Balinese dancers, balalaika orchestras, and troupes of Chinese acrobats. At the events, the house servants wore eighteenth-century liveries that Tony had purchased from Baroness Catherine d'Erlanger, who moved to Los Angeles during the war from her home, Palladio's historic Villa Malcontenta in Italy.

Wedding Surprises Guests

By Princess Conchita Sepulveda Pignatelli

WHAT WAS PLANNED as a cocktail party, by Mary Pickford and Buddy Rogers for the popular Elizabeth Johnstone and Tony Duquette, instead turned out to be a wedding reception for the couple.

Their wedding ceremony had taken place at 4 o'clock in the magnificent drawing room of Pickfair. Here, the Rev. John Wells had officiated at the rites with only family and two or three intimate friends present.

Elizabeth Johnstone

Afterwards, about a hundred friends of Elizabeth and Tony joined in drinking a toast to the happy couple.

The drawing room was superbly done, all in white. The window formed an altar as sunlight filtered onto tall stalks of white flowers with fern and shining candelabra.

* * *

"BEEGLE," as Elizabeth is affectionately known, likes a medieval painting come to life. She was given away by Tony's father, Frank Duquette, in the absence of her brother, Ronald Johnstone.

She was arrayed in an exquisite floor-length rosepoint lace, over shaded faille. She wore a spray of white orchids and stalks of wheat.

Her veil was also of lace, of finger-tip length. Her headpiece was a crown of orchids with wheat, gilded to match...

LADY MENDL

Pickfair has been the enchanting scene of several weddings, including that of Lord and Lady Mountbatten some years ago, but none can surpass the beauty of Elizabeth Johnstone and Tony Duquette's marriage.

When Elizabeth, in her fabulous gown which belonged to Mrs. Hamilton Garland, of rose point lace with an exquisite coronet of jewels and gilded wheat, stood with Tony in front of Pickfair's mullioned picture window, the tableau reminded me of a moyenage tapestry.

Tony is the famous designer and painter and his bride, Elizabeth, is a talented artist, too, and they're planning to combine their careers. In fact, their wedding trip to Europe, where they will stay at Lady Mendl's Versailles chateau, has been postponed until the fall after Tony's New York exhibit.

Although the brilliant wedding was private, with only exquisite Mary Pickford and handsome Buddy Rogers and a few close friends and relatives in attendance, the glamorous reception afterwards drew a host of socialites from here and abroad. Mrs. George Delatour flew down from San Francisco especially for the event, while Dorothy Clark Norman postponed her return flight to New York to attend.

Wedding Comes as Surprise to Pickfair Guests

BY BRANDY BRENT

Just about the neatest "fait accompli" around this town in years was presented to their many friends yesterday afternoon by Elizabeth Johnstone and Anthony Michael Duquette. For when guests arrived at Pickfair for what everybody had innocently supposed to be another cocktail reception in their honor, the popular "Beegle" and "Tony" had already tied the knot! You never saw so many surprised faces on so many distinguished guests in your life.

Long affianced, the talented couple were united at 5 o'clock in a simple ceremony performed by the Rev. John Wells in the flower-decked bay of Pickfair's huge dining room. Acting as matron of honor and best man for their good friends were Mary Pickford and Buddy Rogers.

Attire of Bride

Mrs. Duquette, long regarded as an outstanding beauty, was gowned in heirloom rose point lace over honey faille and wore a small coronet of wheat and pearls. Miss Pickford's costume of lavender faille was set off by a coronet of white orchids that blended admirably with the masses of gladiolus, stock, hyacinth and cyclamen . . . all white . . . that filled the room.

Love is not all that was merged. The gifted Tony is regarded local-

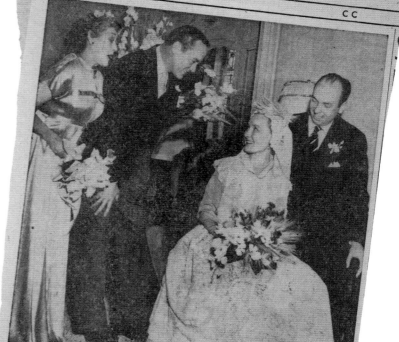

PART 2

VOL. LXVIII

Los A

NUPTIAL PARTY FIGURES—Left to right are Mary Pickford, Buddy Rogers and the newly wedded Mr. and Mrs. Anthony Michael Duquette. Mrs. Duquette, the former Miss Elizabeth Johnstone, and Duquette were married at Pickfair with Miss Pickford as matron of honor and Rogers as best man. The Rev. John Wells officiated.

Times photo

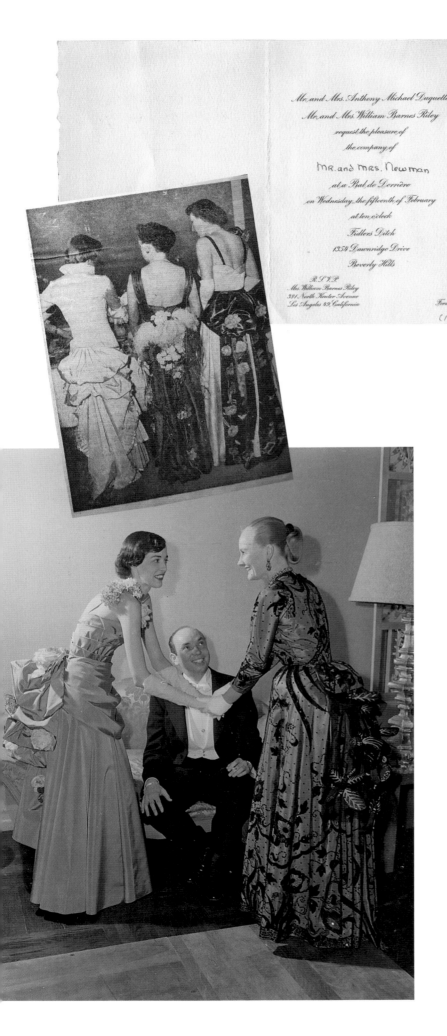

Mr. and Mrs. Anthony Michael Duquette
Mr. and Mrs. William Barnes Riley
request the pleasure of
the company of

MR. and MRS. Newman

at a Bal de Derrière
on Wednesday, the fifteenth of February
at ten o'clock
Fiddlers Ditch
1354 Dawnridge Drive
Beverly Hills

R.S.V.P.
Mrs. William Barnes Riley
381 North Hunter Avenue
Los Angeles 49, California Formal

(1950)

The invitation to, and newspaper clippings regarding, the Bal de Derrière, or Bustle Ball, given by the Duquettes with their friends Mr. and Mrs. William T. Riley, 1950.

The Duquettes only lived at Dawnridge for one year before moving to Paris, where Tony was invited to exhibit his work in an unprecedented one-man exhibition at the Pavillon de Marsan of the Louvre Museum. When they returned from Paris, Tony and Beegle moved into their old studio on Fountain Avenue and, in 1956, they purchased the former Norma Talmadge Film Studio at the corner of Robertson Boulevard and Keith Avenue, an area adjacent to Beverly Hills known as Sherman (now West Hollywood). Their plan was to turn the abandoned and condemned building into their studio, workrooms, and residence. Tony immediately commissioned Caspar to draw up the plans for the new Tony Duquette Studio, where the couple would live and work for the next twenty years before moving back into their beloved Dawnridge.

The Duquettes stayed close friends with Caspar, often recommending him to friends such as Technicolor executive Pat Frawley and his wife, Gerry, and Tony always used him when he needed an architect for a design job—like when working for Doris Duke at Rudolph Valentino's Falcon Lair. In the 1970s, Tony and Elizabeth asked Caspar to design a house at Sortilegium, their Malibu ranch. The Duquettes were enthralled with an eighteenth-century church they'd seen in Austria that was laid out in a trefoil design, and Caspar drew up plans for an incredible house and built an interesting model, but the Malibu house was never realized.

Between 1950 and 1975, while the Duquettes lived in their grand studio, Dawnridge was home to a series of distinguished tenants, including Marlon Brando, who rented their house while he was filming *Julius Caesar*; Eva Gabor and her husband Dr. John Elbert Williams; and Glynis Johns. Nancy Oakes (Baroness Hoyningen-Huene) also rented the house. The last long-term tenant in the house was the notorious Hollywood agent Sue Mengers, who provided us with plenty of stories to dine out on.

The Smart Set

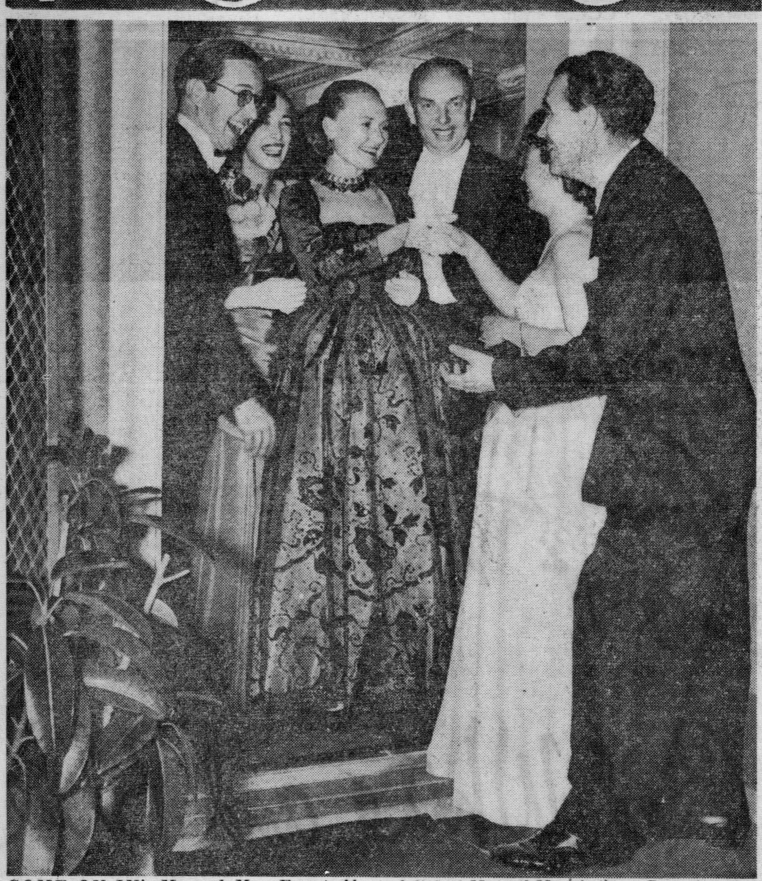

COME ON IN! Mr. and Mrs. Ernest Albrecht Anwing arrived late at the formal party given by Mr. and Mrs. William T. Riley, left, and Mr. and Mrs. Anthony Duquette, center. The event drew several score to Petit Palazzo, Beverly Hills home of the Duquettes.
—Photo by Floyd McCarty, Los Angeles Examiner staff photographer.

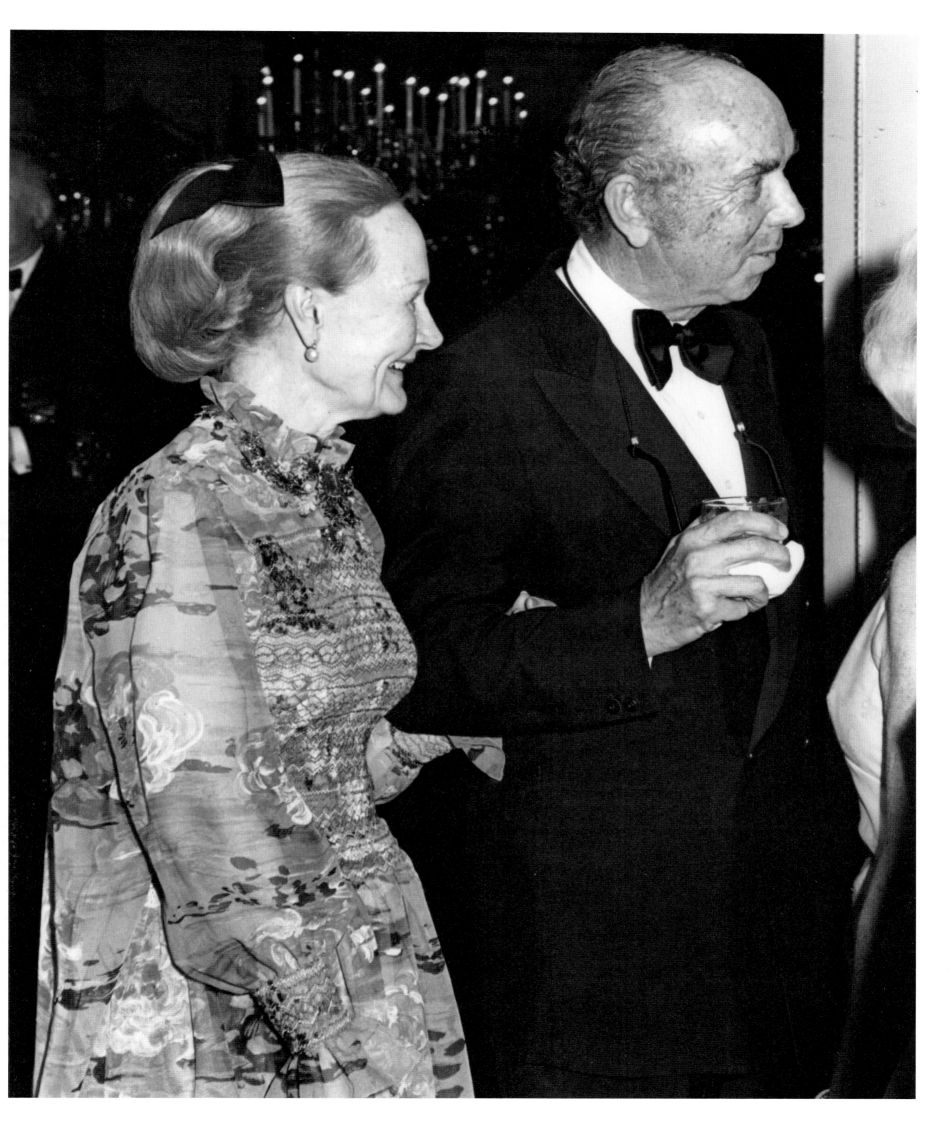

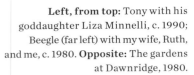

Left, from top: Tony with his goddaughter Liza Minnelli, c. 1990; Beegle (far left) with my wife, Ruth, and me, c. 1980. **Opposite:** The gardens at Dawnridge, 1980.

Stepping into the garden, people were apt to ask, "Where am I?" Tony loved this about the property, and said, "It's only minutes from the Beverly Hills Hotel, but it's impossible to tell that you're not in Japan, Austria, or Southeast Asia!" Tom Ford was so impressed by what he saw that he used the house as a location for a Gucci campaign. Other companies followed suit: Bulgari with Julianne Moore, Abercrombie & Fitch with Bruce Weber, and Gucci, once again, with Tom Hiddleston.

In 1985, Tony and I purchased a massive historic synagogue in San Francisco. It didn't take us long to remodel the vacant, vandalized, and condemned building into the Duquette Pavilion, where we would showcase Tony's work. During the remodeling, Tony and Beegle moved to their house in San Francisco, Cow Hollow, and rented Dawnridge to his client and friend Beverly Coburn, the ex-wife of Academy Award–winner James Coburn, whose house Tony had decorated in the 1970s. While she was in residence, and just a few weeks after the Duquette Pavilion in San Francisco burned to the ground, Dawnridge caught fire again. This was Tony's third fire at all of his properties, and the damage to the house was severe. It was at this time that Tony, Beegle, and I redecorated Dawnridge to the way it would appear in the 1990s.

Elizabeth Duquette died in 1995, four years before Tony. In 1990, Tony and Beegle had given Ruth and me the contents of Dawnridge as a gift and paid the gift tax on it. After Tony's death in 1999, we purchased Dawnridge. Ruth and I felt strongly that we ought to preserve Tony's unique works and residence. In order to settle the estate taxes and satisfy obligations to Tony's heirs, we decided to sell our household goods to get the money to buy the property. To do this, we had Christie's hold the largest house sale in American history. The exhibition was kicked off with a gala for five hundred guests that raised $1 million to benefit the Decorative Arts Council of the Los Angeles County Museum of Art. The sale took place over three days in a hangar at the Santa Monica Airport, where more than two thousand objects were sold.

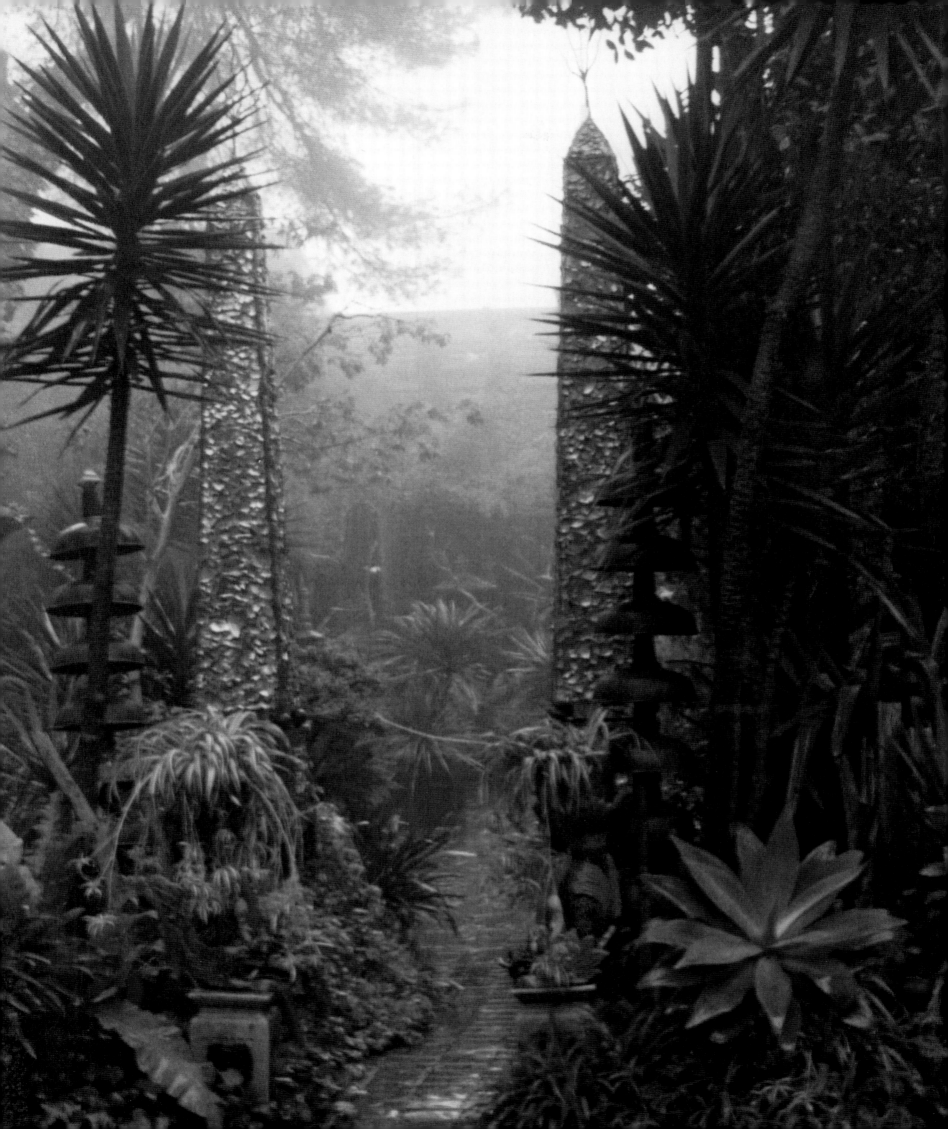

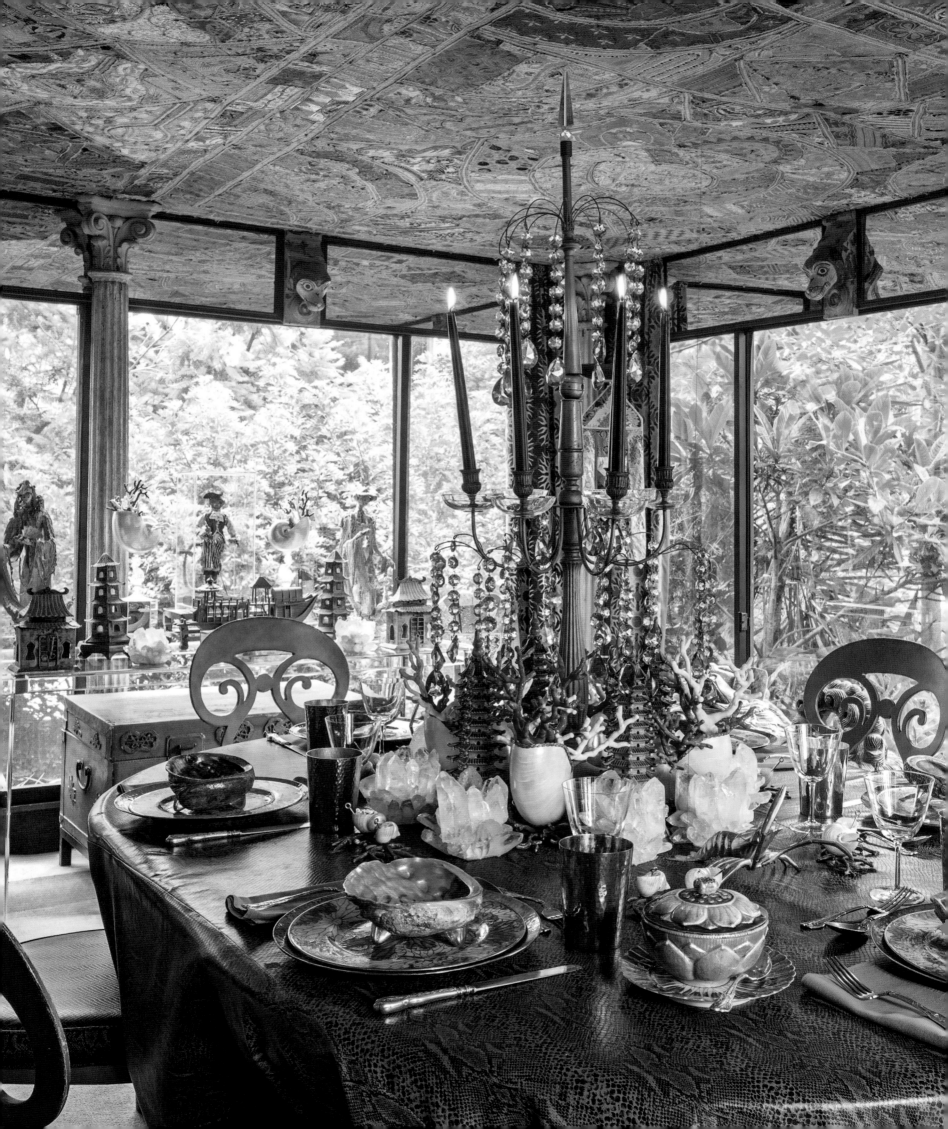

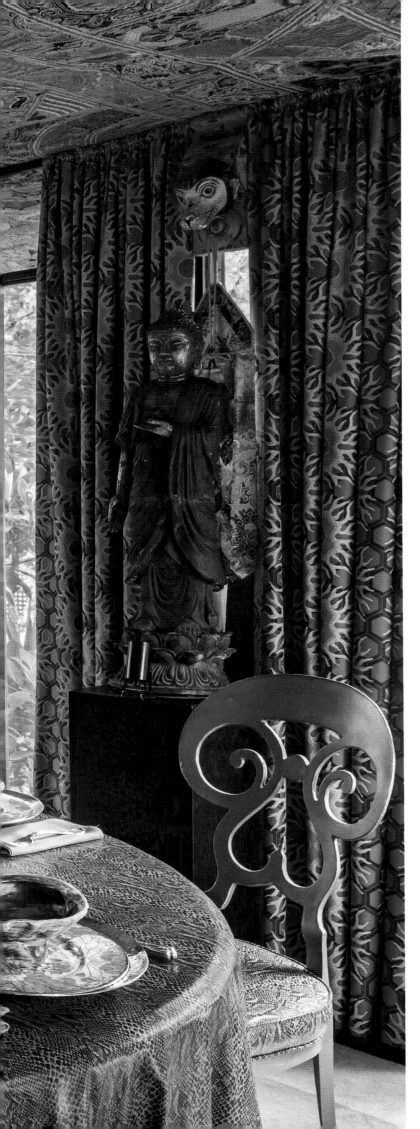

The Monkey Room, 2018. Tony
never had the opportunity to
enjoy the space that overlooked
the gardens, as he had only used
it for storage.

After the sale, I redecorated Dawnridge using objects, furniture, and works of art created by Tony and Beegle, mixed with some of their favorite antiques that I had kept. I once asked Tony, "Why don't you show your own work in your house?" He didn't have an answer, but I imagined he thought that if he surrounded himself with valuable antiques, people would assume he was rich. Of course, he was wealthy, but only because of his investments in real estate. He once told his friend William Matson Roth, who owned Ghirardelli Square in San Francisco, "With all my talent, the only thing that's made me rich is my real estate." Roth said, "That was your talent!" which made Tony laugh. He never tired of telling that story.

Ruth and I used Dawnridge for parties while we continued to live in Hollywood, but after several years, we finally decided to build a house next door. We sold our Tycoon Georgian and moved into Dawnridge while our new home, Casa La Condesa, was under construction. In 2011, when Casa La Condesa was finished, we turned Dawnridge back into a party house and made it the headquarters for our decorating and jewelry business.

The only regret I have is that Tony was never able to enjoy the glassed-in porch that became the Monkey Room. Tony always had a pressing need for storage, and after he created the room, he put embroidered Indian tent panels on the ceiling and filled it with stuff. After he died, it only took me a few hours to clear the room and turn it into a sitting room. At the time, I thought about how much Tony would have liked sitting in that room, with its three walls of glass overlooking the gardens. It was the only room at Dawnridge that was never finished in his lifetime. Today, it's used as a dining room. One night, I asked our friend Terry Stanfill, "Why are the dinners in this room always so successful?" She answered, "It's because the ceiling is so low, and the oval table is conducive to conversation." She opened my eyes. The low ceiling— a mere seven-and-a-half feet high—caused the guests to feel as if they were "tearing from the same beast," as Tony used to say. "It's primordial, with the votive candles lighting the guests' faces from below, like the flames from a campfire." —H.W.

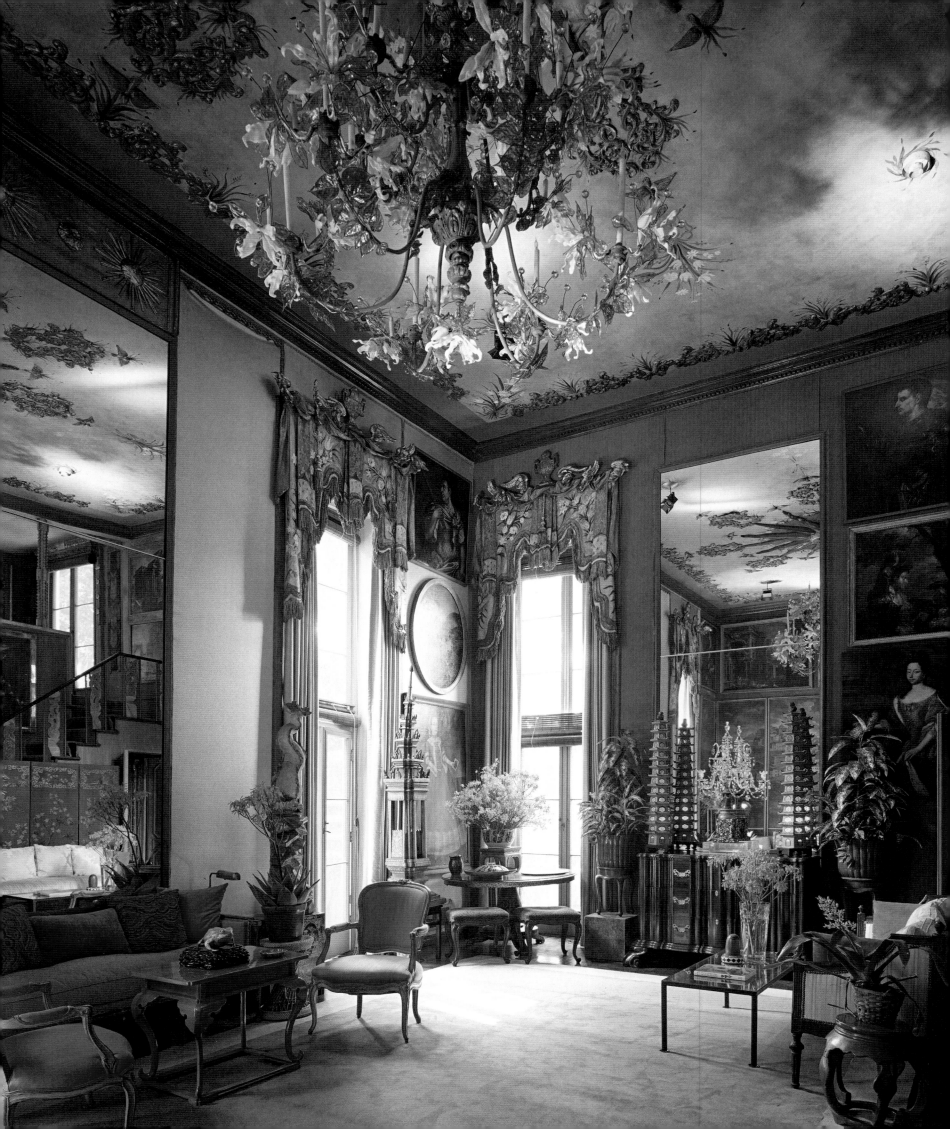

Dawnridge

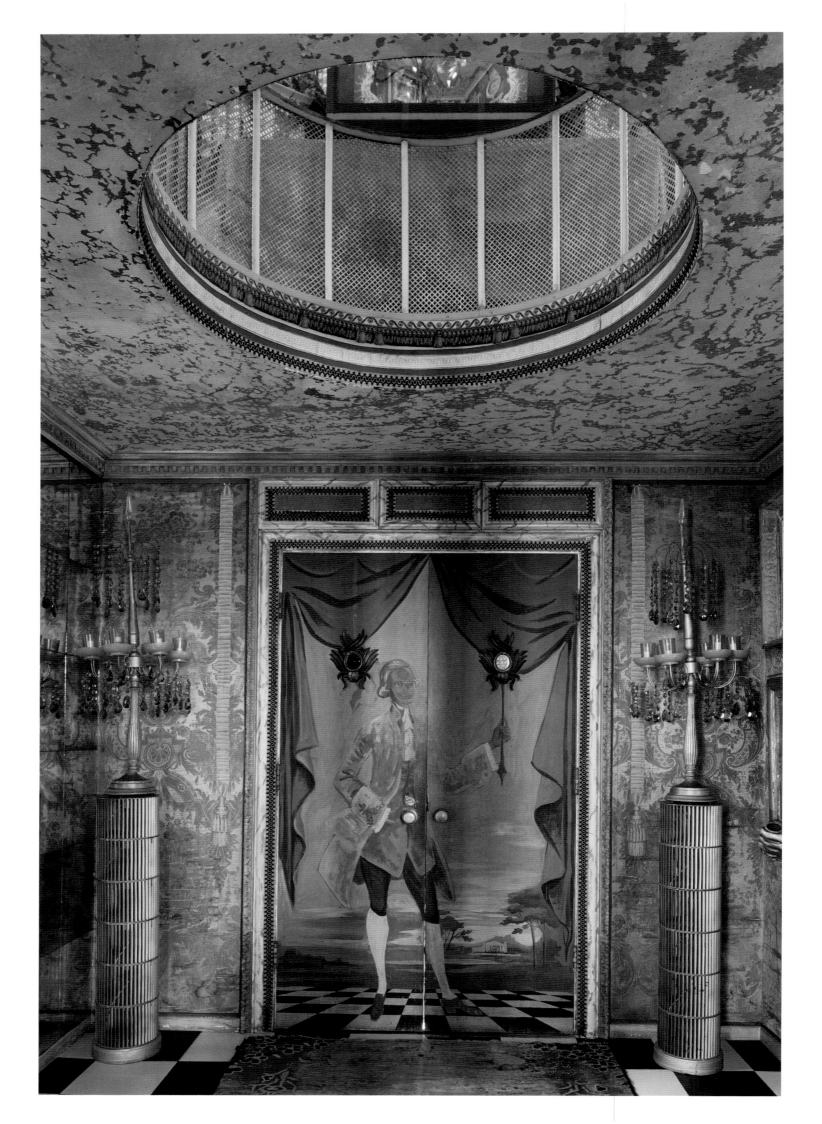

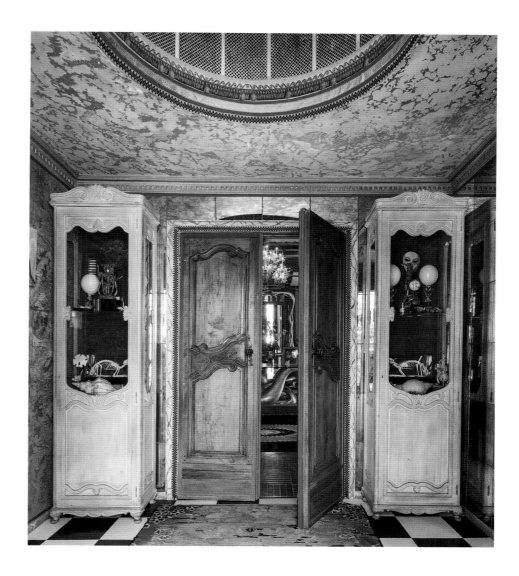

The Entrance Hall

In 1949 Tony and Elizabeth covered two walls in the entrance hall with eighteenth-century citrine-colored damask backed with paper; the other two walls were paneled with squares of antique mirror. Beegle painted the door frames and crown molding with a fantasy faux marble in shades of yellows and blues. They created the doors leading into the Drawing Room from a pair of eighteenth-century French armoire doors, paneling the backs with sheets of clear mirror; antique Venetian bronze hands were used for the front and back door pulls. In the corners, on either side of the front door, there were two eighteenth-century Italian columns holding urn-shaped lamps with shades. Next to one of the lamps was a portrait of an eighteenth-century gentleman framed with seashells; below, a miniature bracket held an antique Spanish colonial retablo surrounded by a silver sunburst. On the opposite wall, on each side of the doors leading into the Drawing Room, a pair of eighteenth-century Italian polychromed figural stands purchased from designer James Pendleton held Tony Duquette coral-encrusted electrified crystal girandoles. The floor was made of black-and-white marbleized linoleum laid out in a checkerboard pattern. The back of the front door was painted by Beegle with the figure of a footman in eighteenth-century livery; the two pocket doors led into a vestibule and powder room on the the left, and a compact kitchen on the right. These doors also featured her artwork—images of ladies in court gowns, one leaving the kitchen with a tray of food and the other seen from the back entering the powder room.

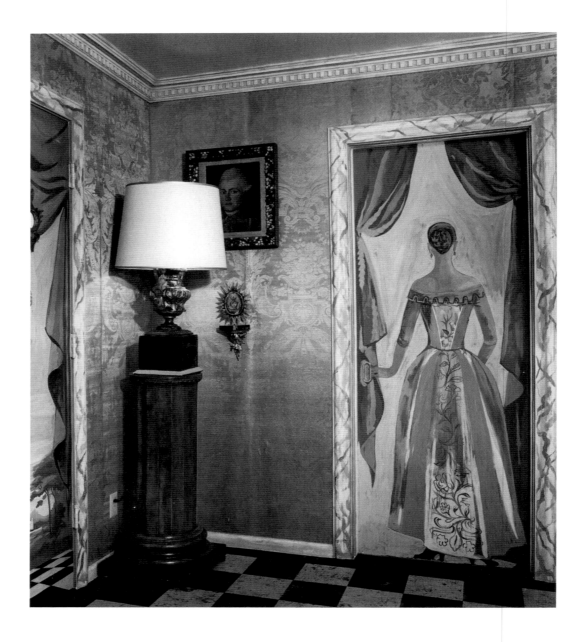

After Tony and Elizabeth moved back into Dawnridge in the 1970s, the only major change to the entrance hall was the addition of blue grosgrain ribbon around the silk damask and the placement of three wooden panels over the doors, which were also enhanced with edges of decorative trim. When the house next door burned down in 1974, the heat in Dawnridge's entrance hall was so intense that it caused the paint on the ceiling to blister and peel. Tony liked this visually . . . so he lacquered over the damage and it remains that way today. Beegle then painted the trompe l'oeil tassels on either side of the front door to disguise water stains caused by the humidity in the room after the fire. During this time, the Duquettes also removed the Italian columns by the door, replacing them with a pair of Roman stools with silk velvet upholstery that had been worn down to the nap.

When my wife and I purchased the house in 1999, we had to rearrange the entrance hall because most of the antiques had gone to Christie's. We replaced Pendleton's stands with French vitrines—which used to stand on either side of the entrance to the ballroom at the Duquette Studio on Robertson Boulevard—and we filled them with objects including Tony's wire-and-plaster figurines; ostrich eggs on Venetian glass stands; the Tony Award for Best Costume Design which he won for the original Broadway production of *Camelot*; cat skeletons, seashells, and corals; and the stuffed toads playing musical instruments that Tony and Beegle had purchased in Tijuana

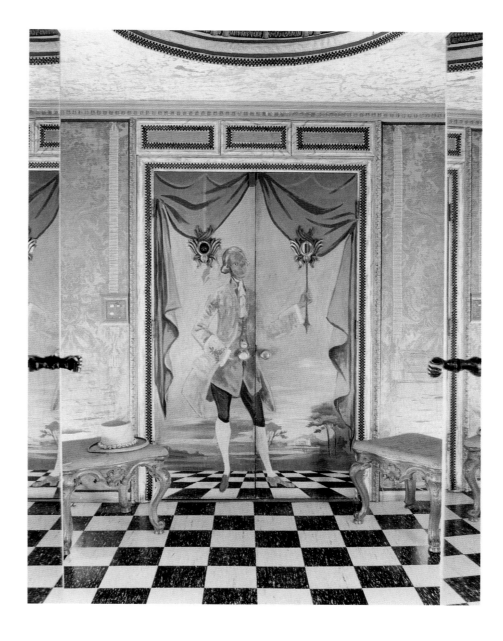

and painted to look like blue-and-white porcelain. Also displayed are the rocks the Duquettes picked up on the Malibu beach when they were beachcombing with their pal, artist Eugene Berman, who later painted faces on them and signed them *E. B. 1944*. Best of all are the two masks Tony constructed around the frames of a pair of antique Chinese fans, which he painted in 1951 for himself and Elizabeth to wear to the Vicomtesse Marie-Laure de Noailles's ball La Lune Sur La Mer in Paris. Sitting on the same shelf are a Ming figure of Buddha in turquoise-glazed ceramic and a gilded bronze toad.

On each side of the front door, I've placed what I call ironic columns—instead of Ionic columns. I made these from discarded air filters, which I stacked together and gilded.

These hold a pair of Tony Duquette electrified crystal girandoles, which were salvaged from Cow Hollow, the Duquette house in San Francisco. The amber cups covering the light bulbs are made from plastic drinking glasses purchased from Pic 'N' Save. Photographer Tim Street-Porter once said, "Tony is the only man I know who can spend $999 in one visit to the 99¢ store!" The carpet is antique Chinese and sits on top of the new, more graphic linoleum floor, which is similar to the material first selected by Tony in 1949. Finally, I removed the sliding pocket doors—painted with Beegle's figures—because they were forever hiding within the walls. They were moved to new locations and are now installed as swing doors.

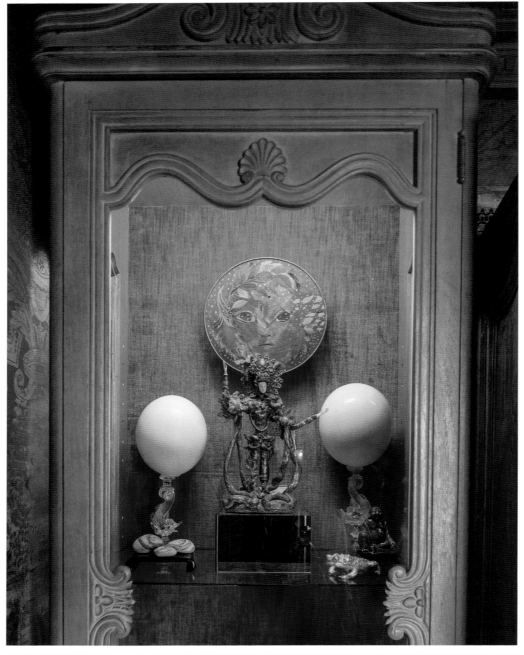

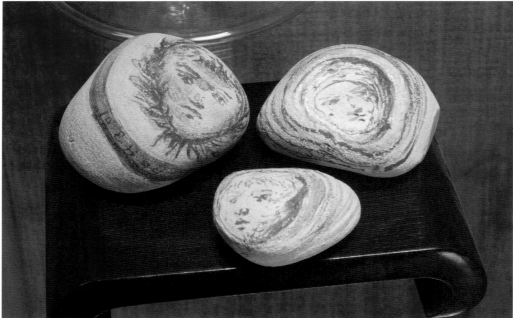

Details of the French display cabinet, 2018. The cabinet holds a number of objects cherished by Tony, including ostrich eggs on Venetian glass stands and a gilded bronze toad (top left), three rocks picked up while beachcombing in Malibu with Eugene Berman (bottom left), and a wire-and-plaster figurine made by Tony to display jewelry (opposite).

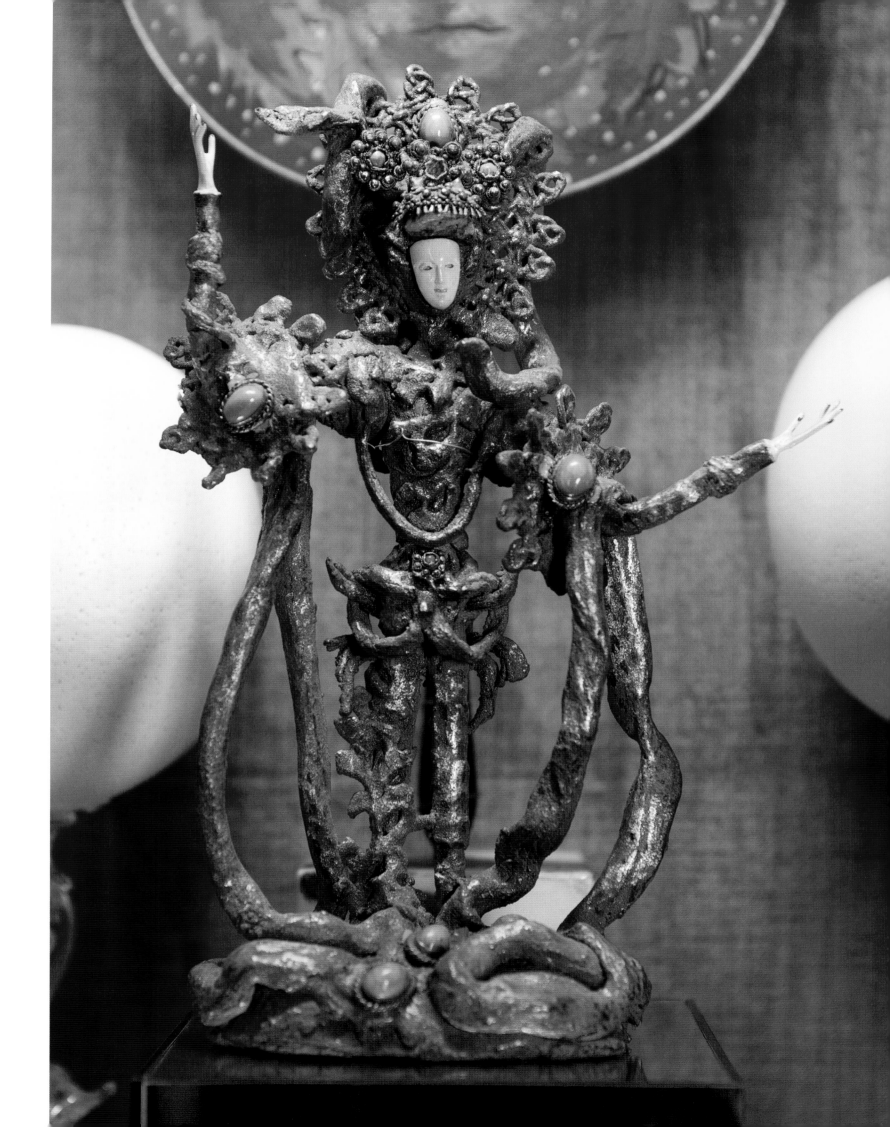

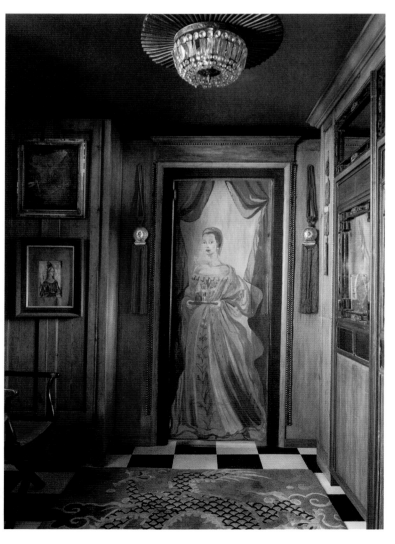

The Bar

In 1949 Tony decorated the vestibule with a nineteenth-century black lacquer papier-mâché table inlaid with mother of pearl, which he purchased from Jimmy Pendleton and later sold to Agnes Moorehead. On top of the table was a bead-encrusted Chinese pagoda designed by Tony as a Christmas decoration. He also created the mirror on the wall by framing an antique remnant of embroidered-and-bead-encrusted satin and then having only a portion of the glass "silvered" to show the textile's elaborately worked borders. Elizabeth painted the pocket door (pushed into the wall) with the figure of a lady entering the room.

The former vestibule is now a bar. I moved the pocket door painted by Beegle and installed it as a swing door leading into the new kitchen. The room is decorated with paintings by Beegle, including one she created for the MGM film *The Sandpiper*, directed by Vincente Minnelli and starring Elizabeth Taylor and Richard Burton. Elizabeth created all the paintings for that film, in which Taylor played an artist living on the beach in Big Sur, California. Against the wall is an eighteenth-century suede-upholstered mahogany director's chair. The carpet is from Nepal and was purchased by Tony and me during our last trip around the world before Tony died in 1999.

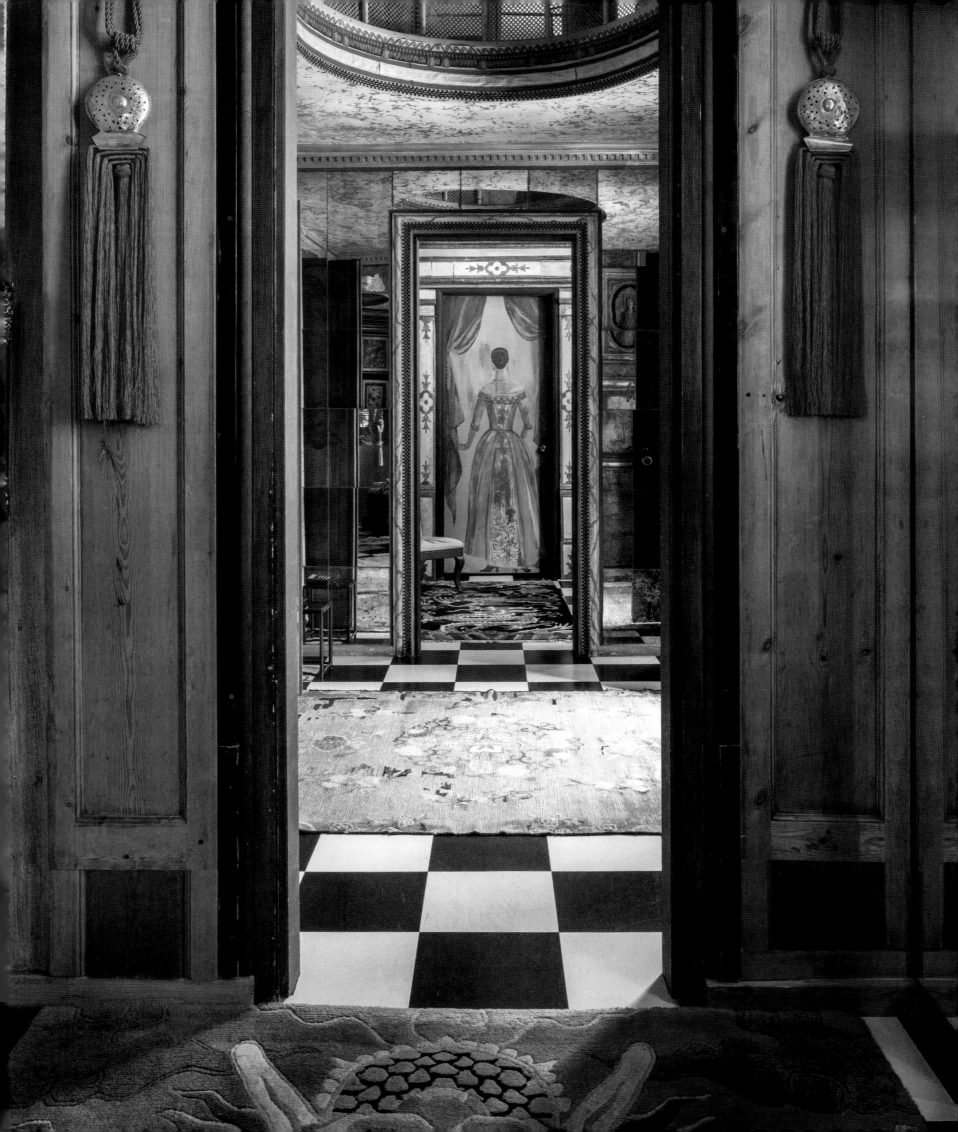

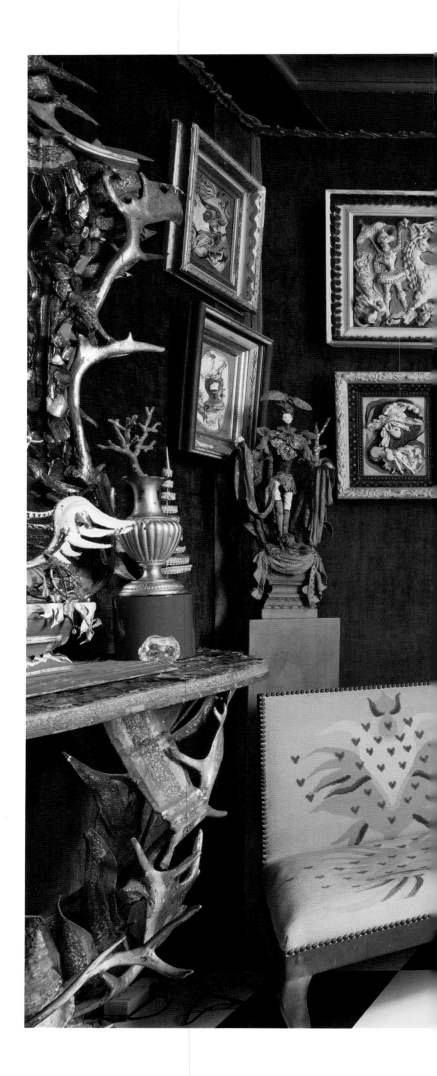

The Camelot Room, 2018. I created the Camelot Room in 2000 and decorated the space with Tony's theatrical designs. The painted door at the end of the room leads into the Venetian Powder Room.

........................

Following spread: The Camelot Room, 2000; The room previously included a Venetian settee (left), which had once been at the historic Larkin House in Monterey, California, and featured an antique Chinese window (right) that Tony had installed in the 1970s and looked into the dining room.

The Camelot Room

The space that is now the Camelot Room was originally the kitchen when the house was built. In 1975, Tony transformed it into a glamorized anteroom, with his 1950s antler-and-abalone console and mirror as a prominent feature. The antlers came from Hearst Castle and were gifted to him by the Hearst family when he and Beegle were guests at La Cuesta Encantada. The console held eighteenth-century Chinese lacquer coral branches from the collection of Elsie de Wolfe, a set maquette created by Tony for MGM's *Lovely to Look At,* and a Spanish colonial statue. Tony also decorated the room with an eighteenth-century black-lacquered and ormolu-mounted French desk, an antique French bracket clock, a Venetian settee, and eighteenth-century Neapolitan crèche figures.

My first go-round on the Camelot Room, which I named for Tony's theatrical designs on display there, was in 2000. I kept the antique Chinese window, which Tony had installed in the 1970s, in place, overlooking the dining room beyond. That window is now mirrored and part of the Venetian powder room. After the Duquette Collections sale at Christie's, I brought in the red-lacquered cabinet to replace the eighteenth-century black-lacquered and ormolu-mounted French desk. On top of the cabinet I placed a collection of geodes surrounding a maquette by Tony he called *Two Deer from Morgan Le Fay's Dominion,* which was created for "The Magic Forest Ballet"

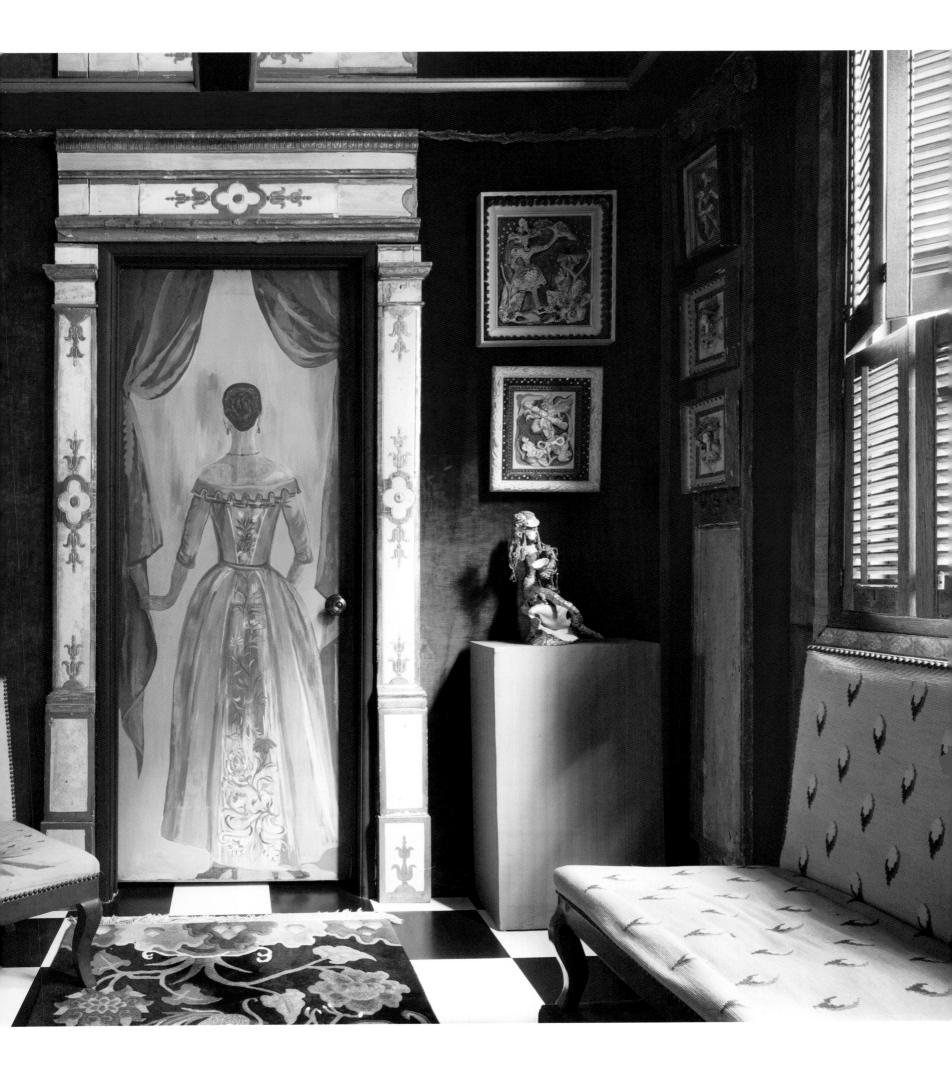

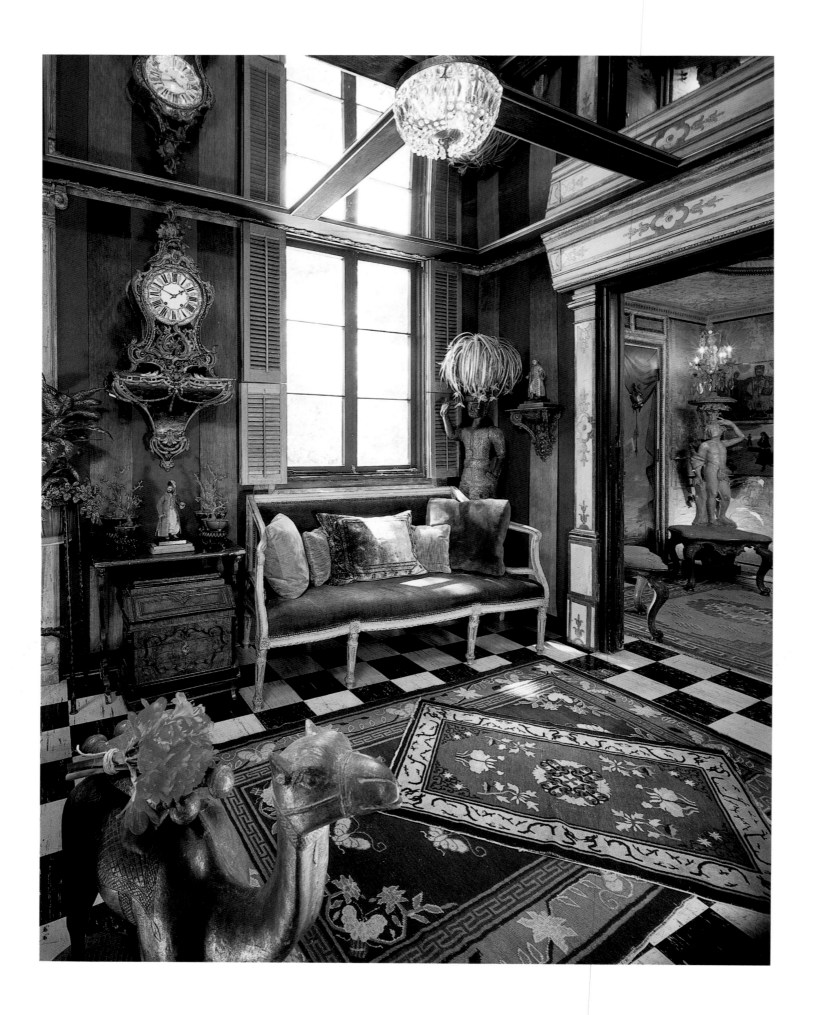

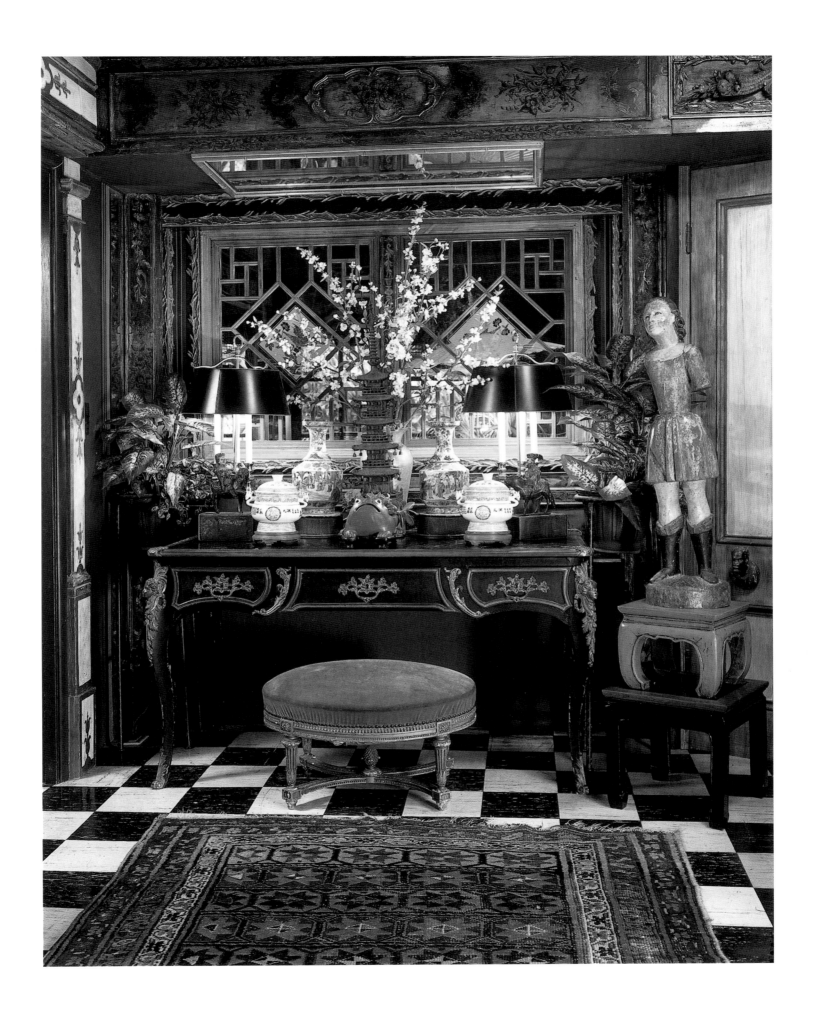

> *"...and people said,
> 'It's the only musical
> where you leave
> whistling the costumes
> and sets.'"*

sequence in the original Broadway production of *Camelot,* starring Richard Burton, Robert Goulet, and Julie Andrews. After begging the show's creators, they obliged and allowed Tony to create *The Magic Forest Ballet,* in which all the animals in Morgan Le Fay's Dominion took on human attributes and danced a little jig. Of course, it was a detour from the show, and people said, "It's the only musical where you leave whistling the costumes and sets."

Because Tony had placed set maquettes for both *Lovely to Look At* and *Camelot* in this room, I decided that it should display more of his theatrical designs, like his Tony Award–winning costume sketches for *Camelot*. To complete this theme, I included some of Tony's earliest bas-reliefs, jeweled statues, and wire-and-plaster figurines, which had attracted

the attention of Billy Haines, James Pendleton, Vincente Minnelli, and Elsie de Wolfe in 1941. I also presented the ermine tail–upholstered Marsan chair that he had created for his one-man exhibition at the Louvre in 1952 on a velvet-covered dais. A similar chair, which Tony made for his one-man exhibition at the Los Angeles County Museum of Art (and which I discovered under a pile of rags at a Santa Barbara garage sale), sits in the corner. Tony called the needlework upholstery he designed for this chair "The Flies of Texas." Tony and I purchased the tiger and dragon carpets in Nepal on our last trip around the world. The door in the Camelot Room, painted by Elizabeth in 1949 as a pocket door, is now installed as a swing door and leads into the new Venetian powder room I created in 2005.

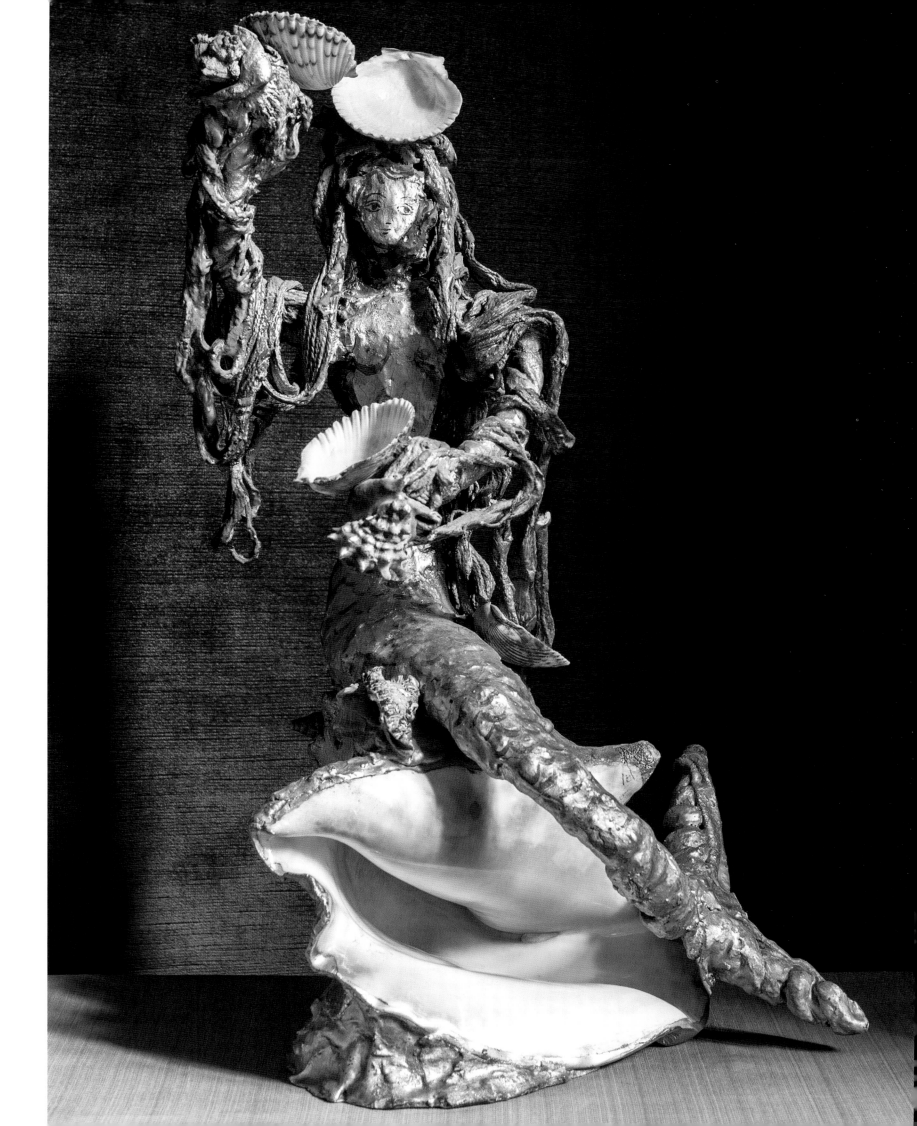

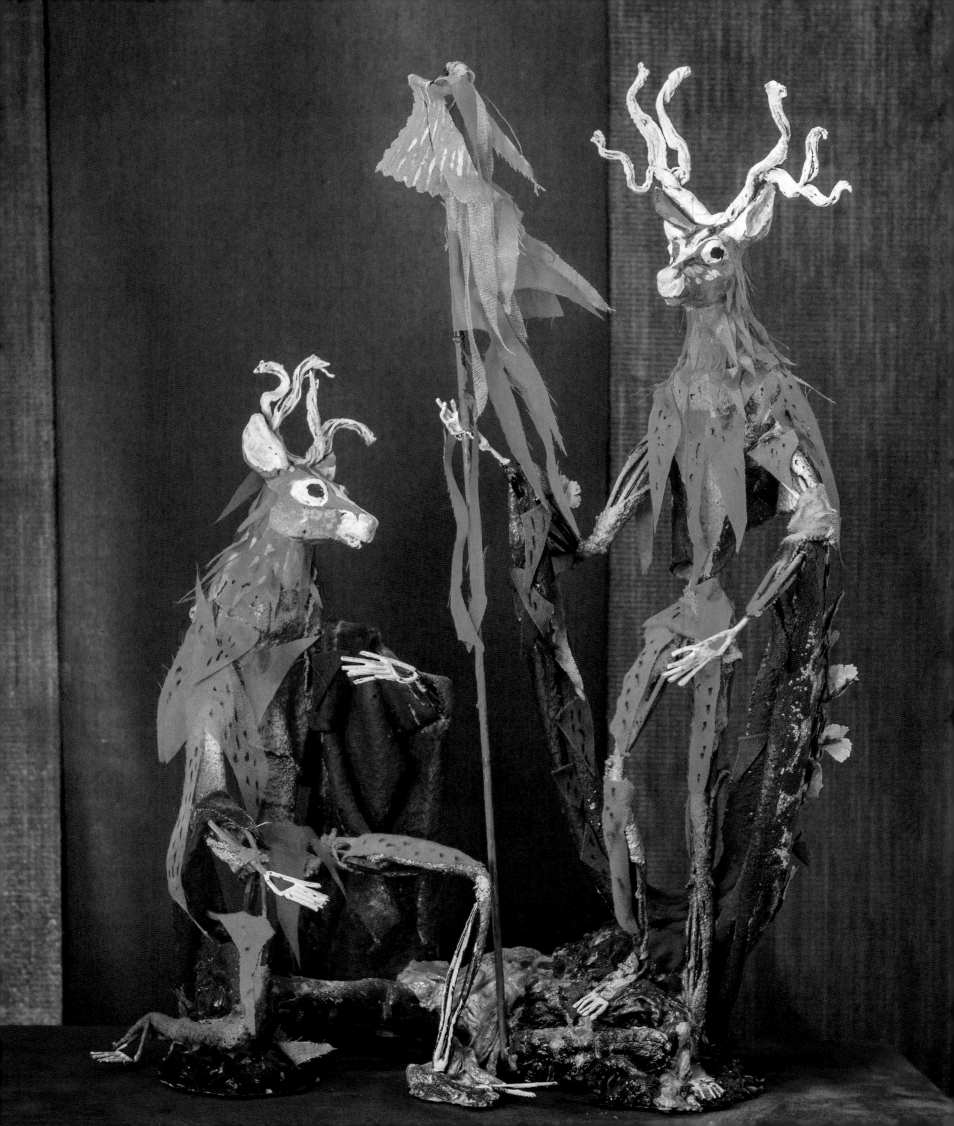

Three-dimensional costume sketch by Tony Duquette, c. 1960. The sketch was created for the original Broadway production of *Camelot*, and sat atop a red lacquered cabinet (right) in 2000.

........................

Following spread: The Camelot Room, 2018. Tony Duquette's original 1950s antler and abalone console and mirror still holds pride of place in the room. It features Venetian glass coral branches set into gilded wooden urns and a maquette created by Tony for the film *Lovely to Look At*.

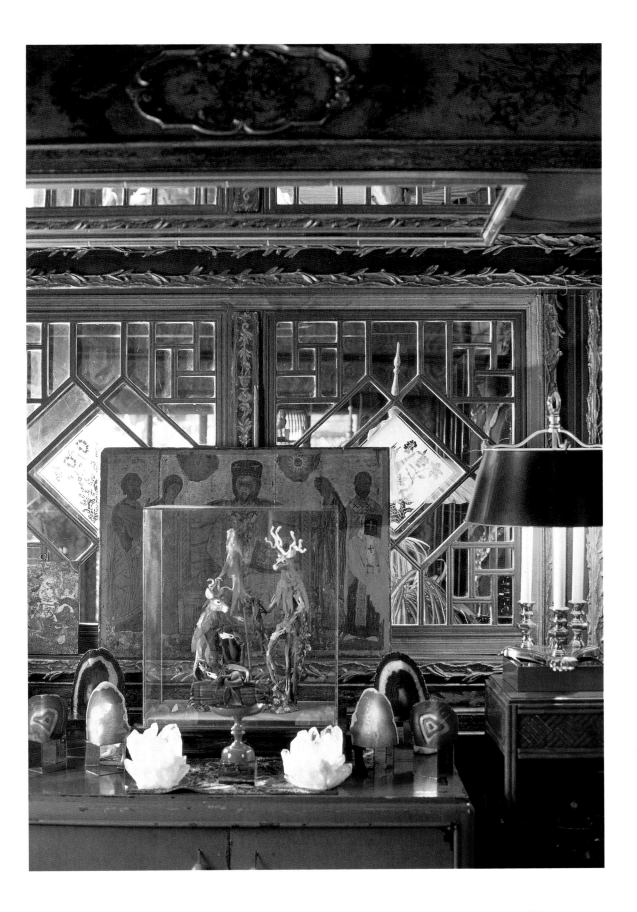

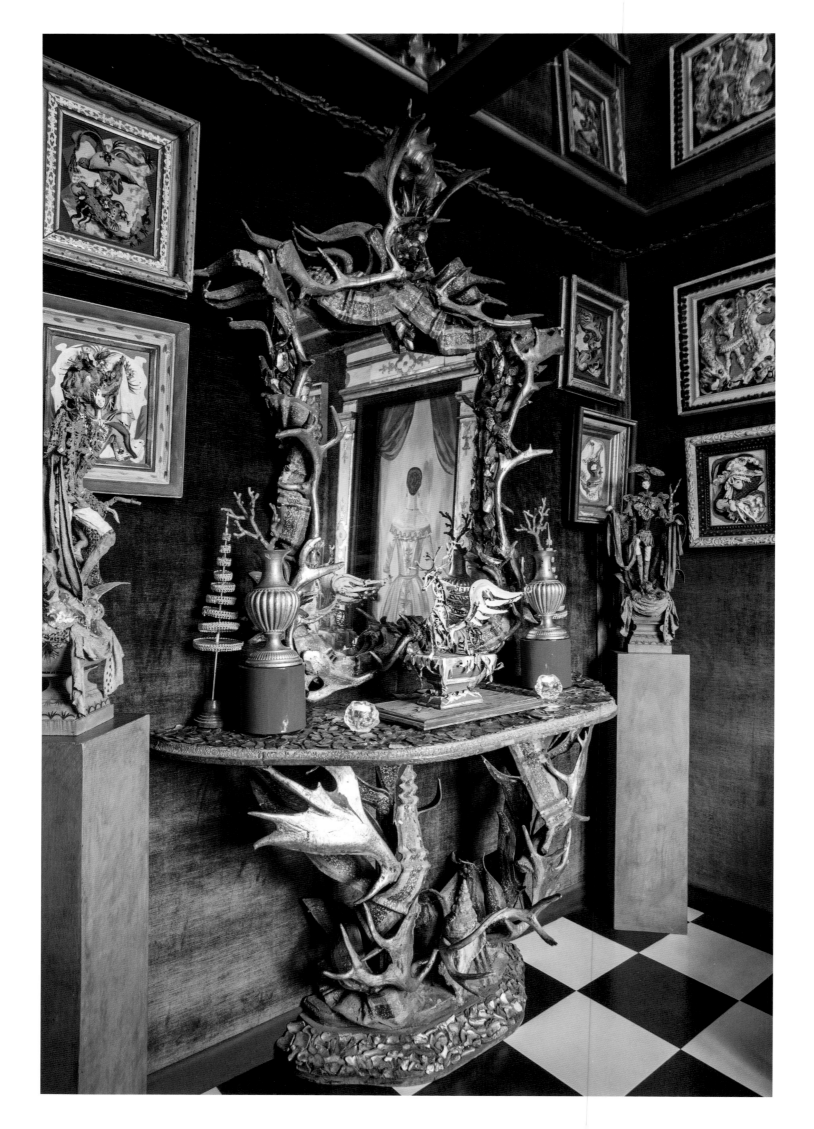

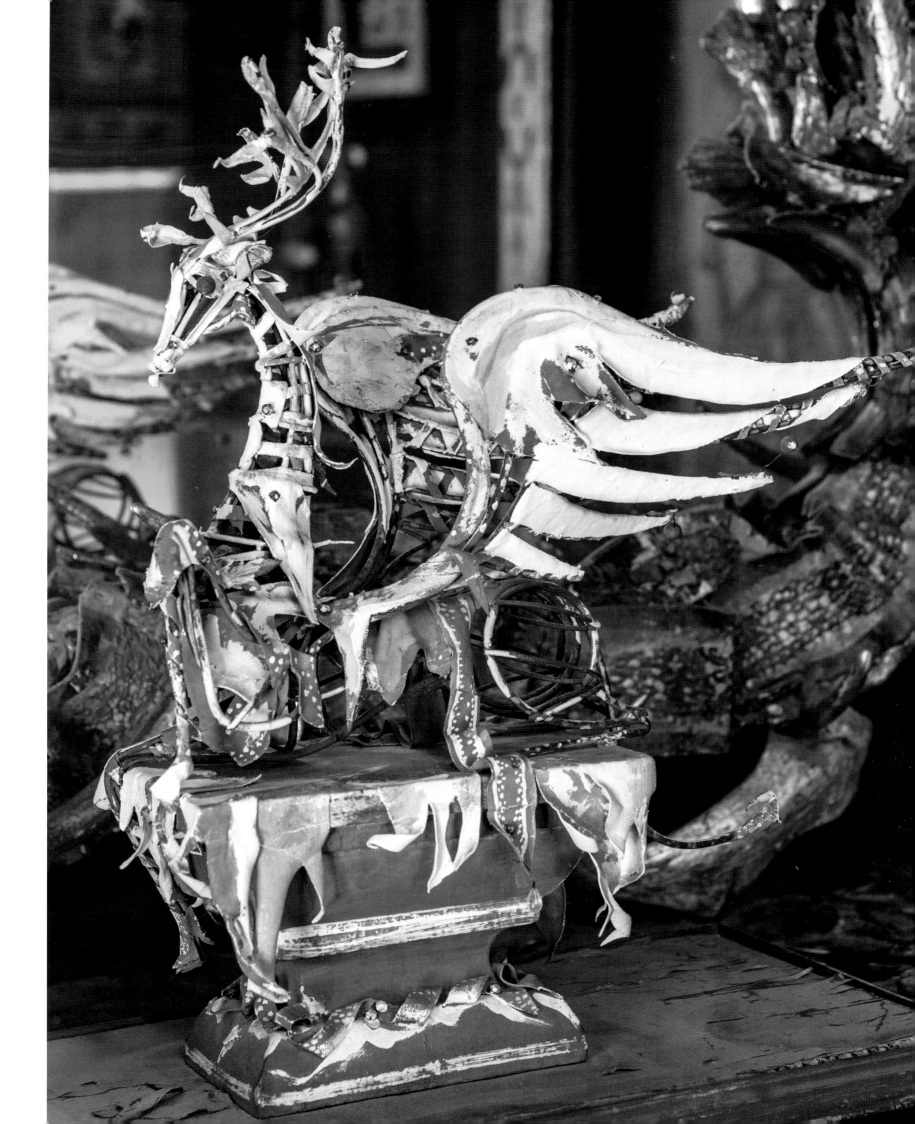

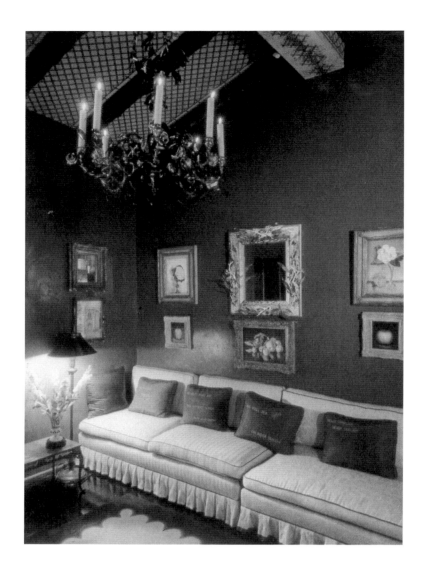

Venetian Powder Room, 2018. I created this space in 2005 and decorated it with many shades of green fabric. The room includes a mirror that was originally in Elsie de Wolfe's Beverly Hills house, which she decorated with a young Tony Duquette in 1941.
Left: The mirror hung in the card room at Elsie's home, "After All," c. 1941.

The Venetian Powder Room

I decorated the Venetian Powder Room using fragments from an eighteenth-century Venetian cabinet; old teal, green, and gold Venetian moldings; and remnants of emerald green silk moiré, velvets, and cottons printed to look like shagreen. Tony created the iconic mirror hanging over the sink for Elsie de Wolfe's house, After All, in Beverly Hills, and I later purchased it from a junk shop in Long Beach. The Venetian paneling is hung with the skull of a crocodile and a shadow box of Tony's exhibition *Our Lady Queen of the Angels* is set into an antique ivory inlaid frame. A framed Elizabethan tapestry has become a luxurious panel on the back of the door, and the walls are hung with a collection of early Tony Duquette watercolors and drawings.

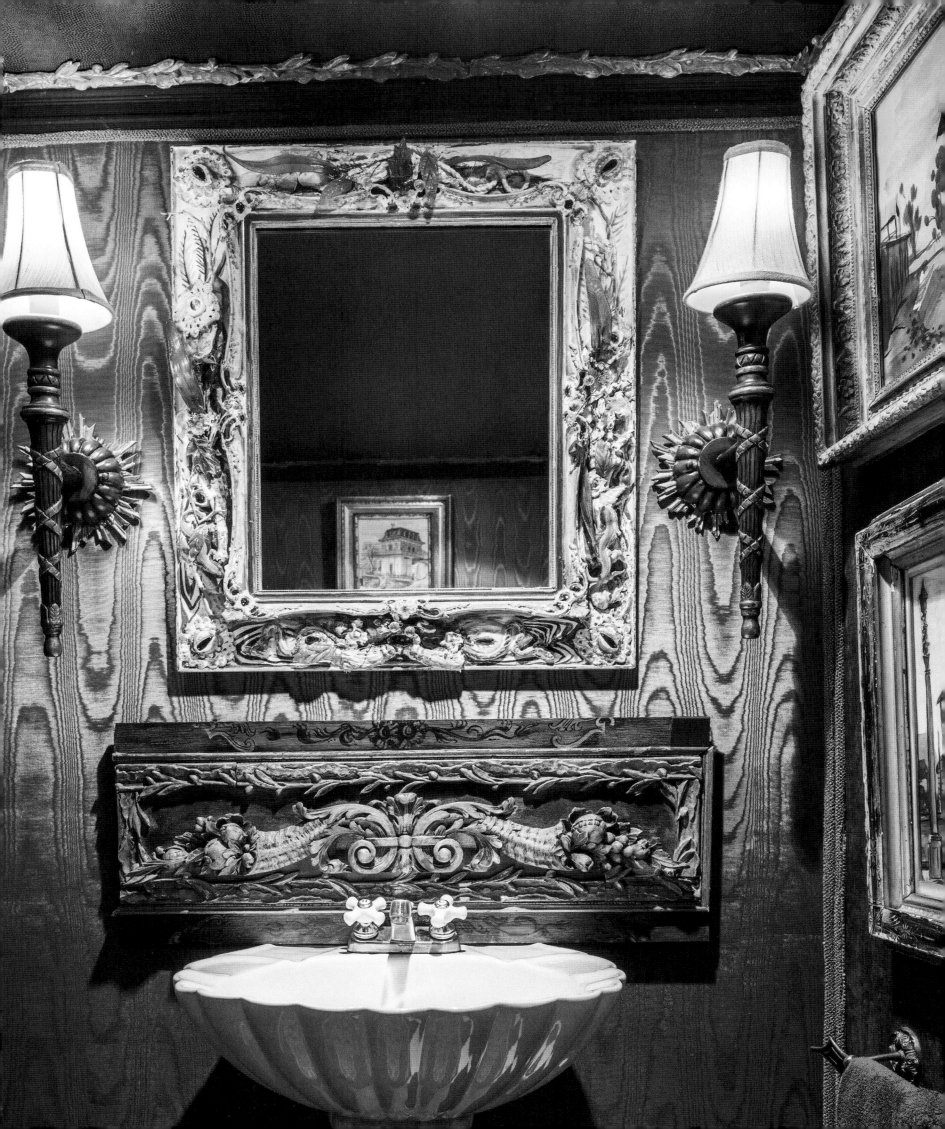

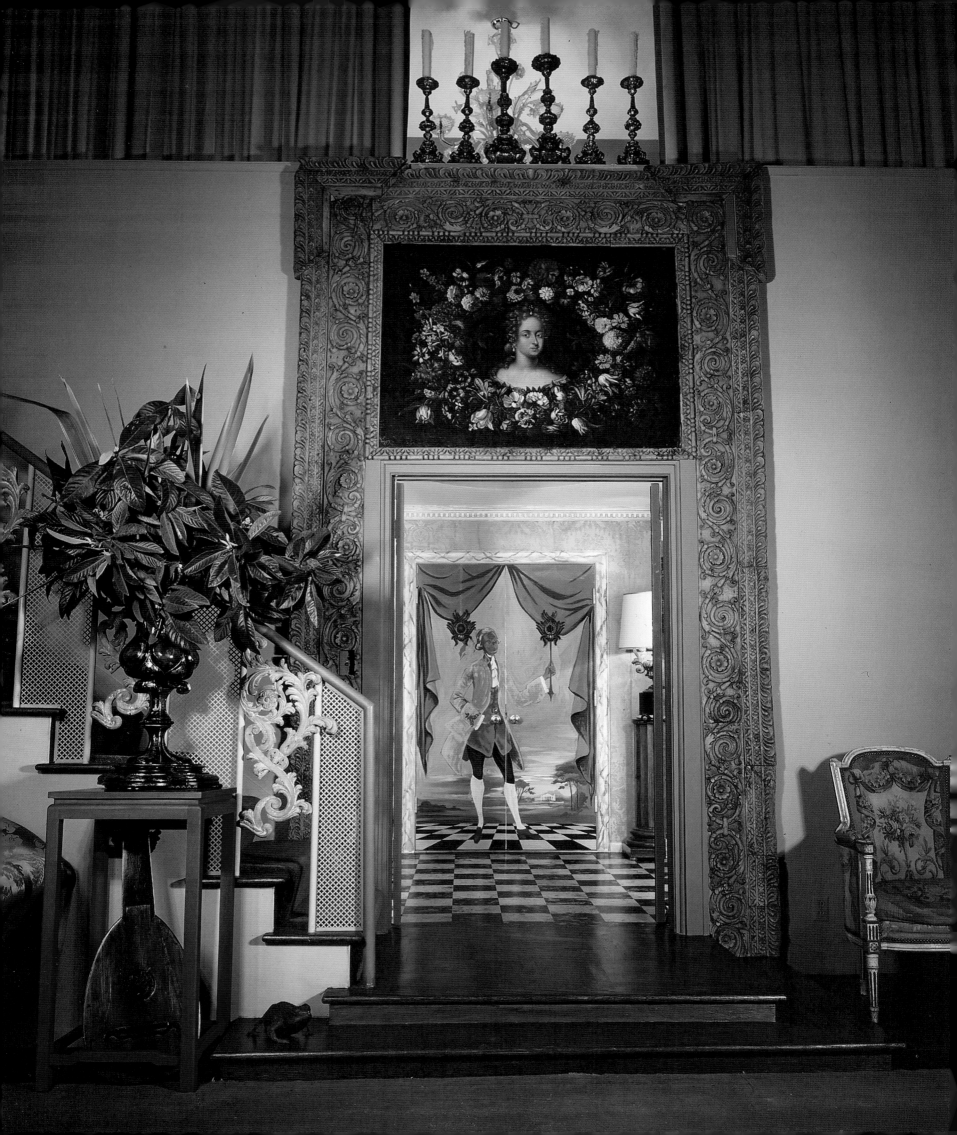

"'We're going to give you a silver tea set for your wedding.' Tony said, 'I don't want a silver tea set; I want the front doors of your house.'"

The Drawing Room

The Drawing Room started out as a very formal room that the Duquettes decorated with antique French furniture, Aubusson carpets, silk damask draperies, and old master paintings, many of which Tony purchased on his first trip to Europe with Elsie de Wolfe in 1947. What made the traditional décor unique was the addition of Tony and Beegle's personal touches, including the painted and molded ceiling decorated with bouquets of flowers, soaring doves, and rococo traceries in silver-gilt, bronze-greens, and jewel tones. Over the next sixty years, the room was transformed as the house changed from a rental property in the 1960s to a personal residence in the 1970s to a place for entertaining in the twenty-first century. When the Duquettes moved back to Dawnridge in 1975 and completely redecorated it for their own pleasure, they brought in things more beautiful than they were valuable. Tony always said, "Beauty, not luxury, is what I value." The original rococo carved decorations on the stair railing were exchanged for carvings from Thailand. The carpets were replaced with jade green, low-pile wool velvet with celadon-green borders.

The carved seventeenth-century Spanish door surround was a wedding present from Adrienne and Cissy Hellis, the daughters of a Greek shipping tycoon. When Tony and Elizabeth were married at Pickfair, they said, "We're going to give you a silver tea set for your wedding." Tony said, "I don't want a silver tea set; I want the front doors of your house." The Hellis sisters not only sent over this magnificent carved doorway, but also sent two pairs of fourteenth-century Spanish doors that Tony installed as the entrance to his studio on Robertson Boulevard in Los Angeles. The old master painting would remain over the door until it was sold at the Christie's Duquette Collections sale; it was then that I replaced it with a sheet of mirror and Tony's one-eighth scale model of his *Primal Sun* sculpture.

The chandelier Tony created using antique elements—simple tubular metal arms and Peking glass mixed with beaded French glass flowers—hung from the center of a giant plaster sunburst that matched the giant sunburst over the front door on the exterior façade. The original chandelier shattered due to the heat of the fire next door, but it was refurbished with new Venetian glass lilies in 1975. Other Duquette touches included the lambrequins over the windows, which Tony created by

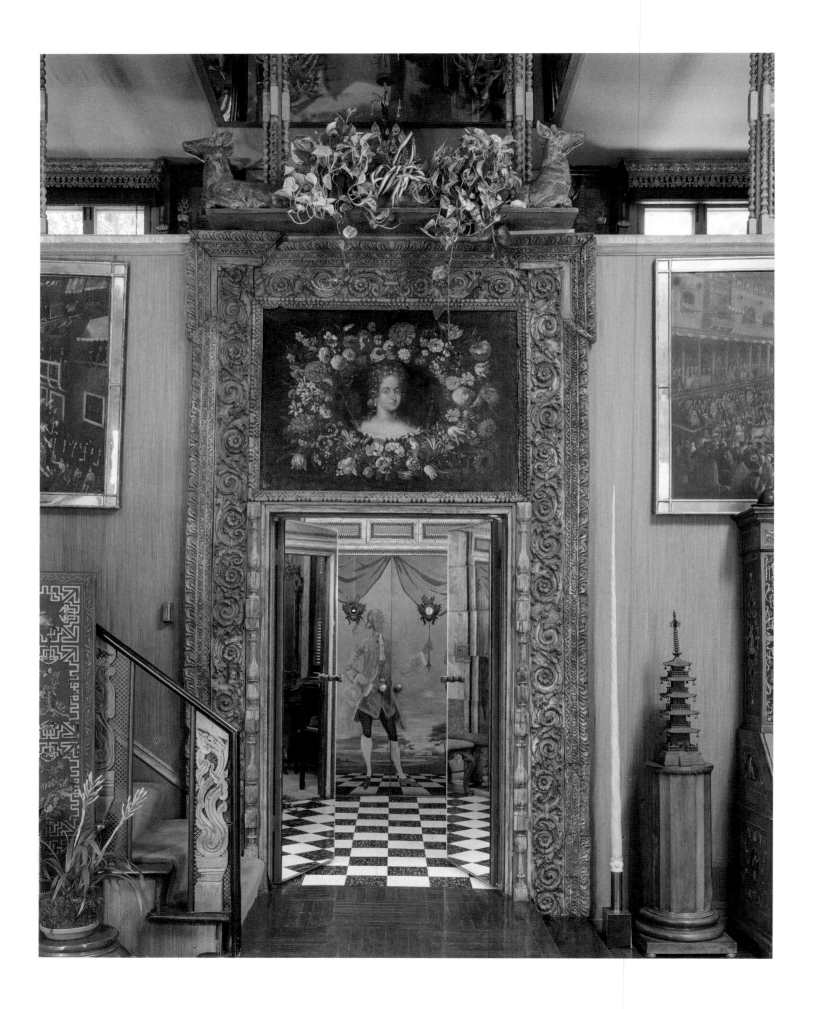

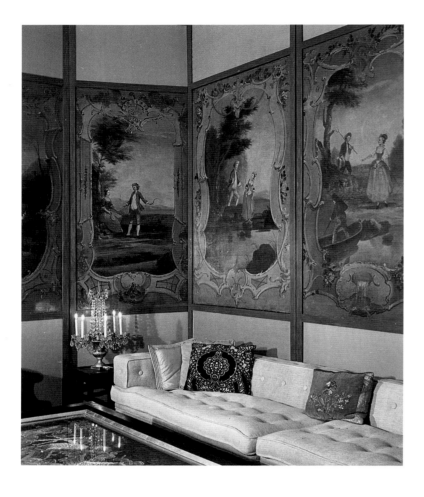

dipping T-shirt jersey into a vat filled with plaster mixed with white glue and then draping the saturated fabric into his desired shape. After the fabric dried, Beegle painted the hardened cloth to resemble tooled leather, and Tony crowned the entire concoction with repoussé silver urns from Spain and eighteenth-century Italian carved wings. With the addition of a few coral branches—and likely a mystical or magical incantation like "abracadabra"—they had lambrequins *de luxe*.

In 1949, the Duquettes installed floor-to-ceiling panels of antique mirror squares, one between the windows and the other at the far end of the room. The mirrored panel between the windows was centered by an antique Boulle bracket and clock inlaid with tortoise shell and etched brass decorations. On each side of the mirrored panel, Tony placed his sunburst torcheres made with eighteenth-century Italian candlesticks, convex mirrors, and gilded Italian sunbursts. The other mirrored panel was anchored with a long, eighteenth-century Louis XVI–style, Venetian-gilded-and-polychromed console table. With these in place, the rest of the

room was ready to furnish. The original colors of the walls were Adrian green, a pale celadon color favored by Tony's friend and client Gilbert Adrian of MGM fame. The eighteen-foot-long, coral-colored, silk damask draperies were discovered at the Paris flea market in 1947 and purchased with Dawnridge in mind. Add to this Duquette's one-of-a-kind plaster-decorated folding screens and the eighteenth-century portraits of Roman emperors hung high up near the crown molding, and the mise-en-scène was set for a party. In front of one of the screens, a long custom sofa, which almost ran the width of the room, was paired with a set of four eighteenth-century Louis XVI bergères upholstered in their original Aubusson tapestry coverings.

The Duquettes redecorated Dawnridge as a rental property in the 1960s, and Tony used eighteenth-century French panels framed as eighteen-foot-tall screens in this room. The sofas were reupholstered in white linen, and the lamps and shades were replaced with crystal girandoles, which Duquette created out of old cast-iron French urns.

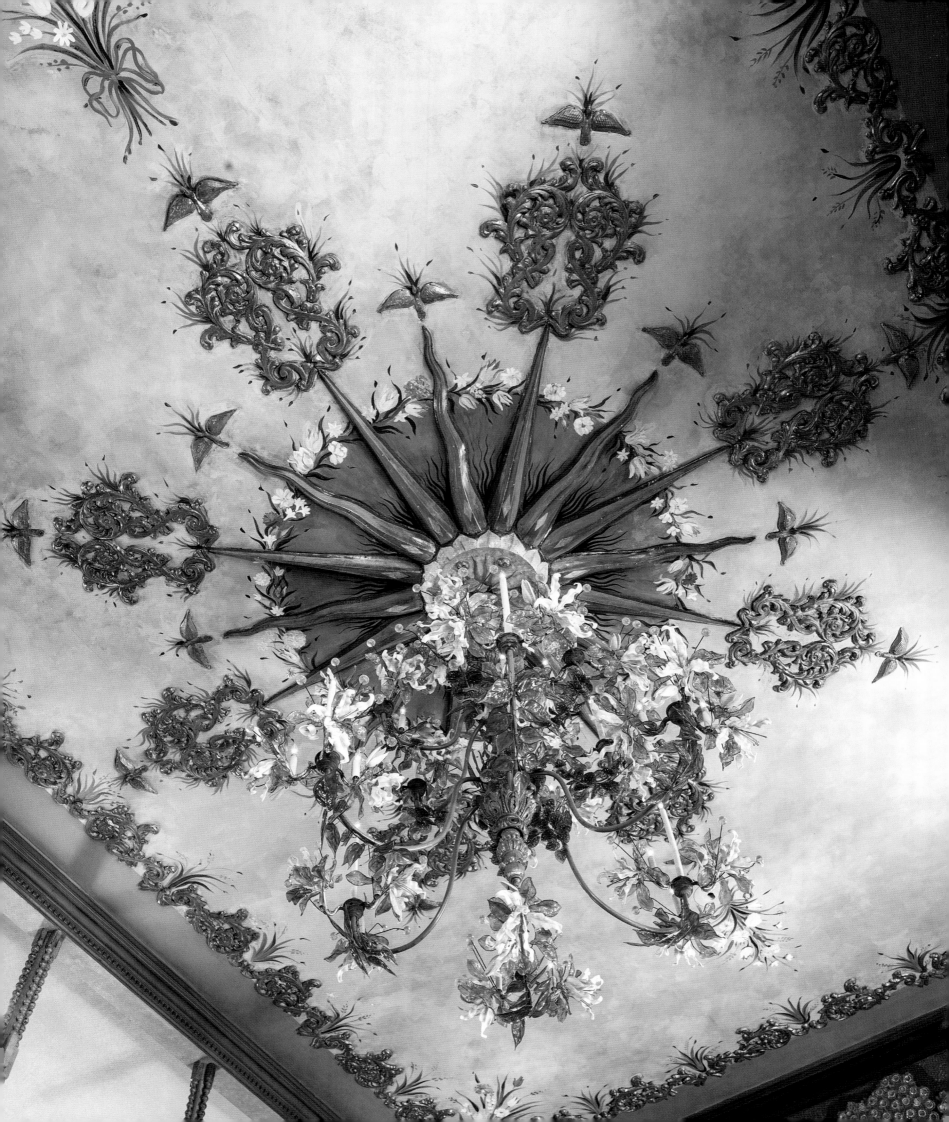

North corner of the Drawing Room, 1949. In the center of the wall is a panel of antique mirror squares with Tony's sunburst torchères on either side. His original mirror and plaster bas-relief screens stand in the corners. **Below:** Tony Duquette sitting in front of his bas-relief screens, 1949.

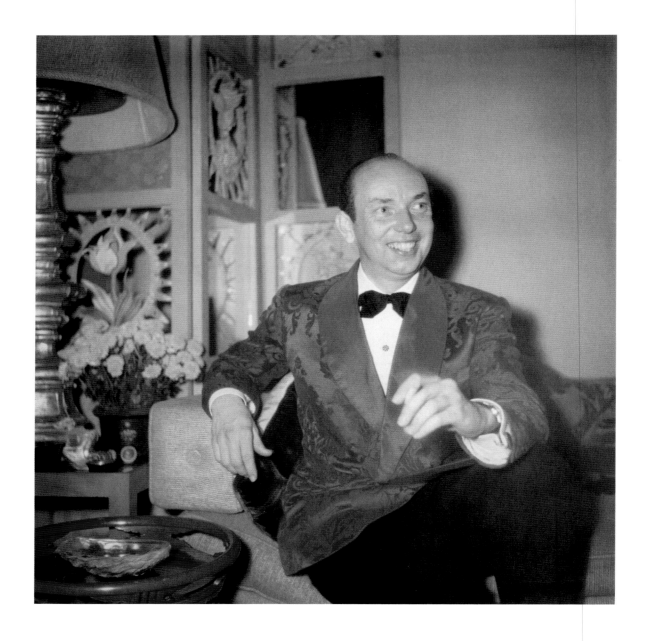

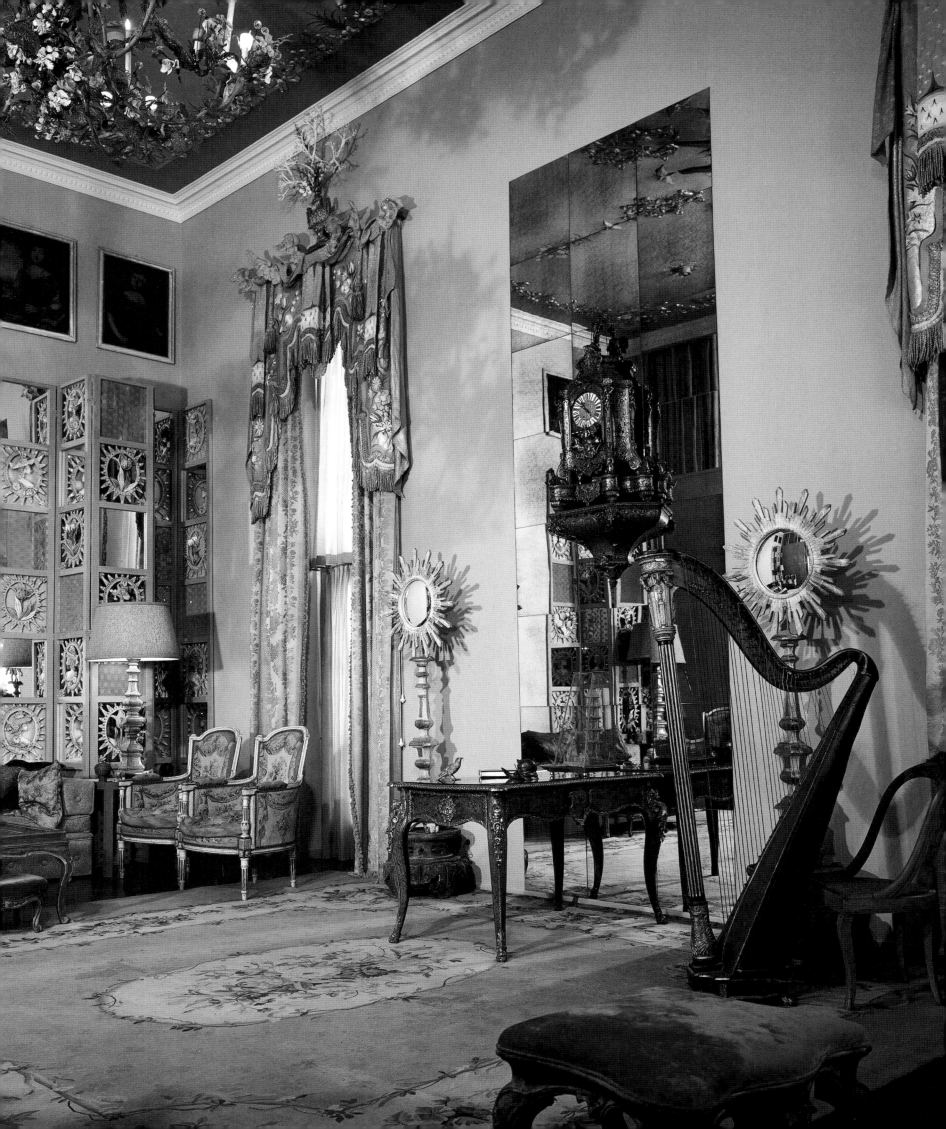

North wall of the Drawing Room, 1975. Tony redecorated the space after moving back into the home and replaced the French panels with an eighteenth-century mural depicting a scene in Porto Mauritius.
Below: View of the north corner of the Drawing Room from the balcony, 1949. Hanging from the ceiling is the original Peking glass flower chandelier with electrified votive lights nestled into the bouquets.

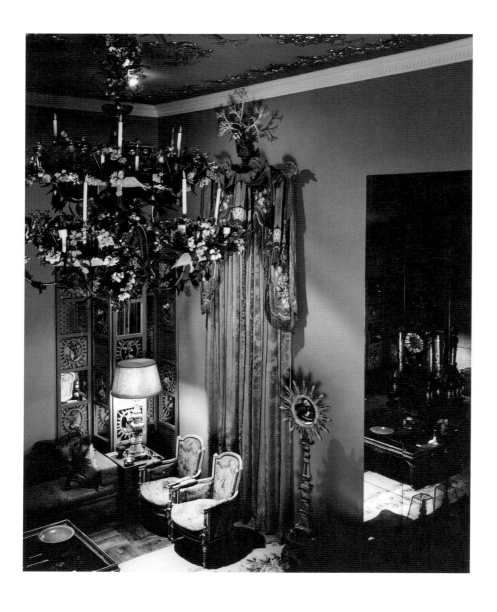

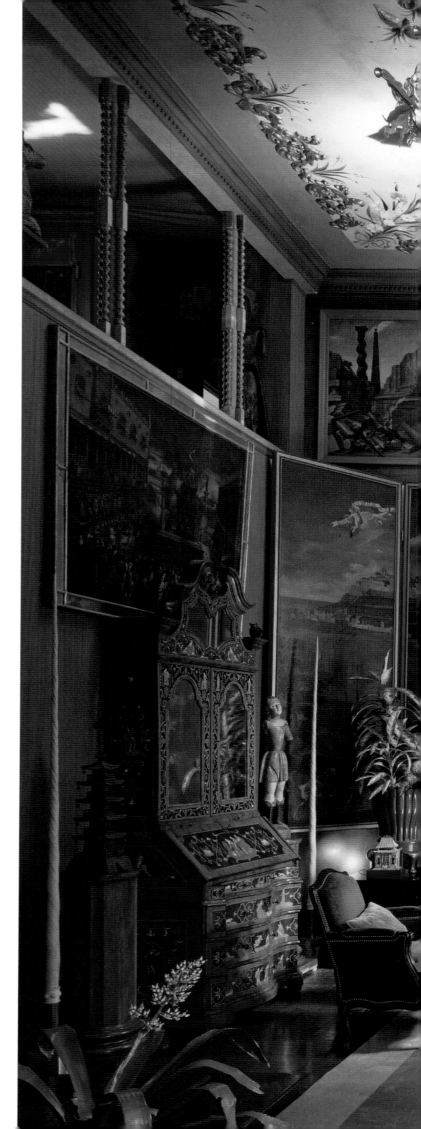

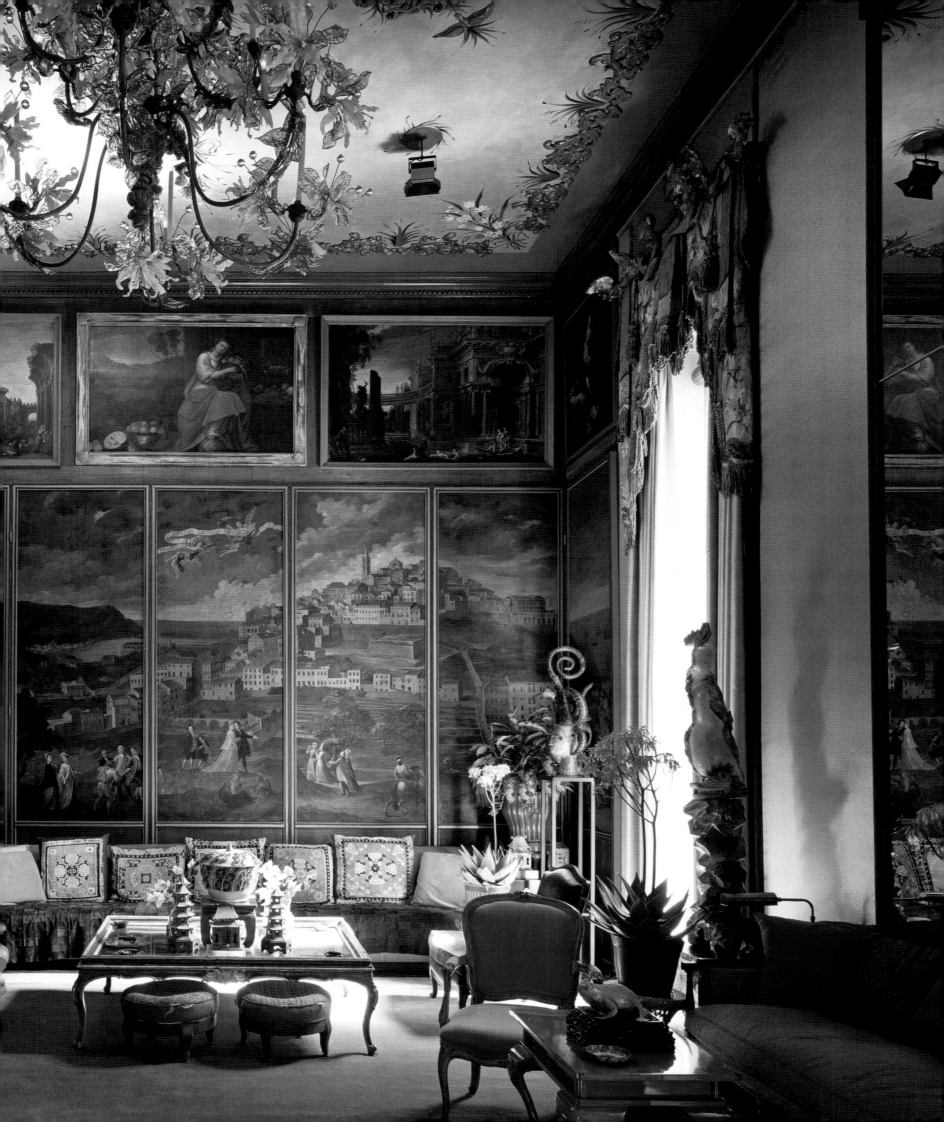

Tony Duquette shell grotto in cast resin, c. 1960. Tony created this as a party decoration for an Undersea Ball.
In front are the eighteenth-century Venetian dolphins from the collection of Misia Sert, which were given to the
Duquettes as a wedding present and later placed in the Drawing Room in the 1980s (opposite).

........................

Following spread: East wall of the Drawing Room, 2018. I later added recreations of the original
sunburst torchères, which had stood in the room in 1949, and replaced the eighteenth-century sofa with Tony's biomorphic
console and mirror presented on an upholstered stand.

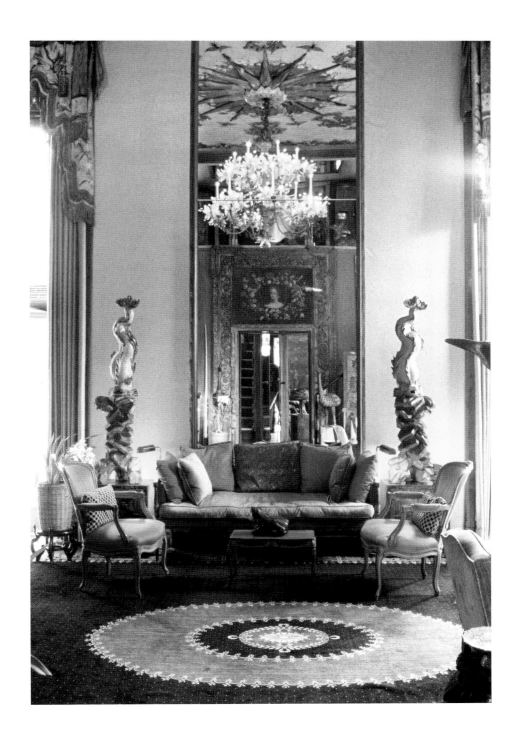

In 1975, as you entered the room, the first thing you saw was the pair of eighteenth-century Venetian dolphins from the collection of Misia Sert flanking a pillow-strewn eighteenth-century Italian settee. The settee, upholstered in apple-green silk, was placed in front of the new fifteen-foot-tall clear mirror panel that had replaced the antique mirror squares installed when the house was built. Later, I would replace the dolphins with the original sunburst torchères that had stood in the room in 1949; Tony's biomorphic console and mirror would stand in place of the settee, positioned on a dais like an object in a museum.

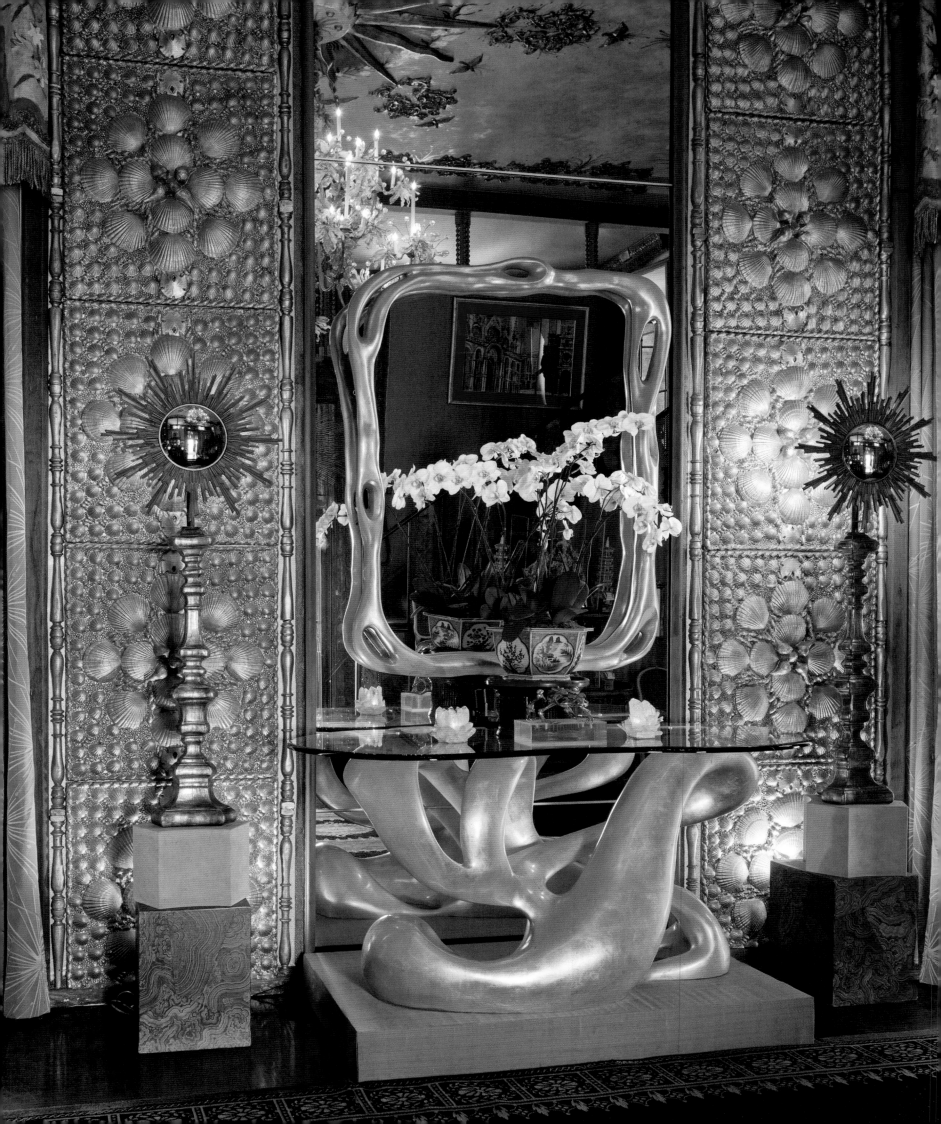

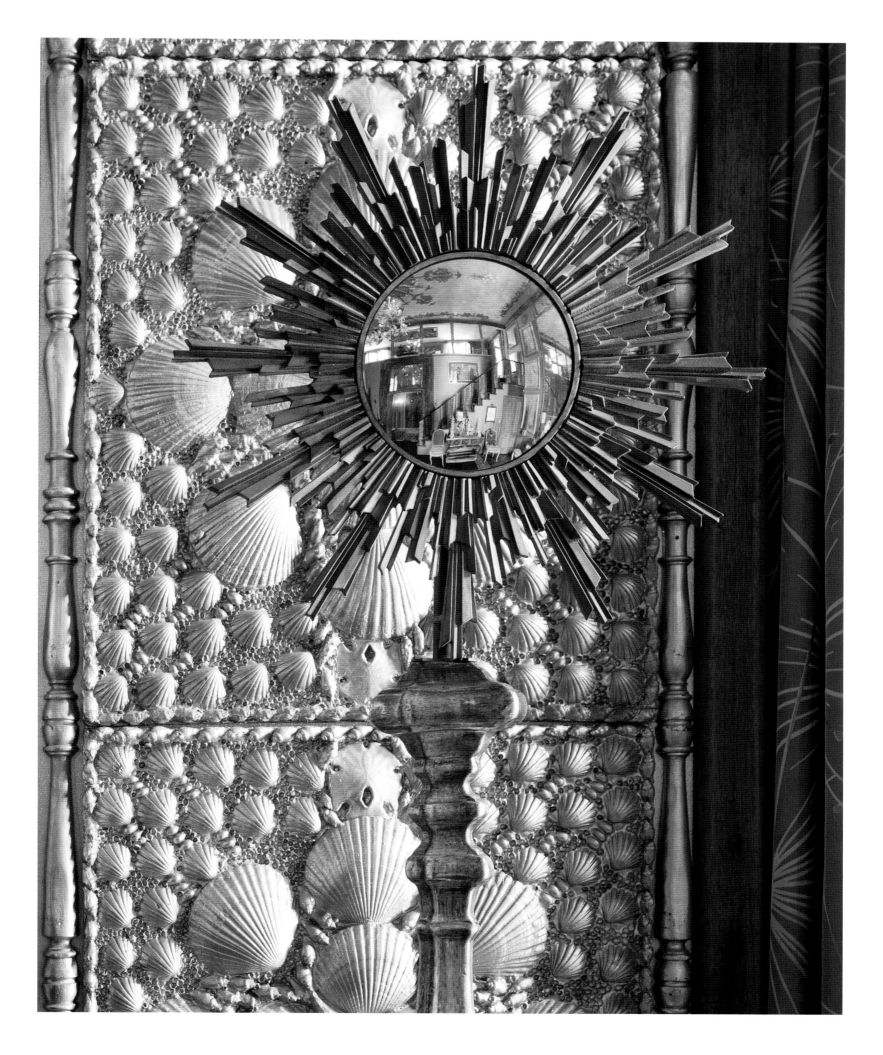

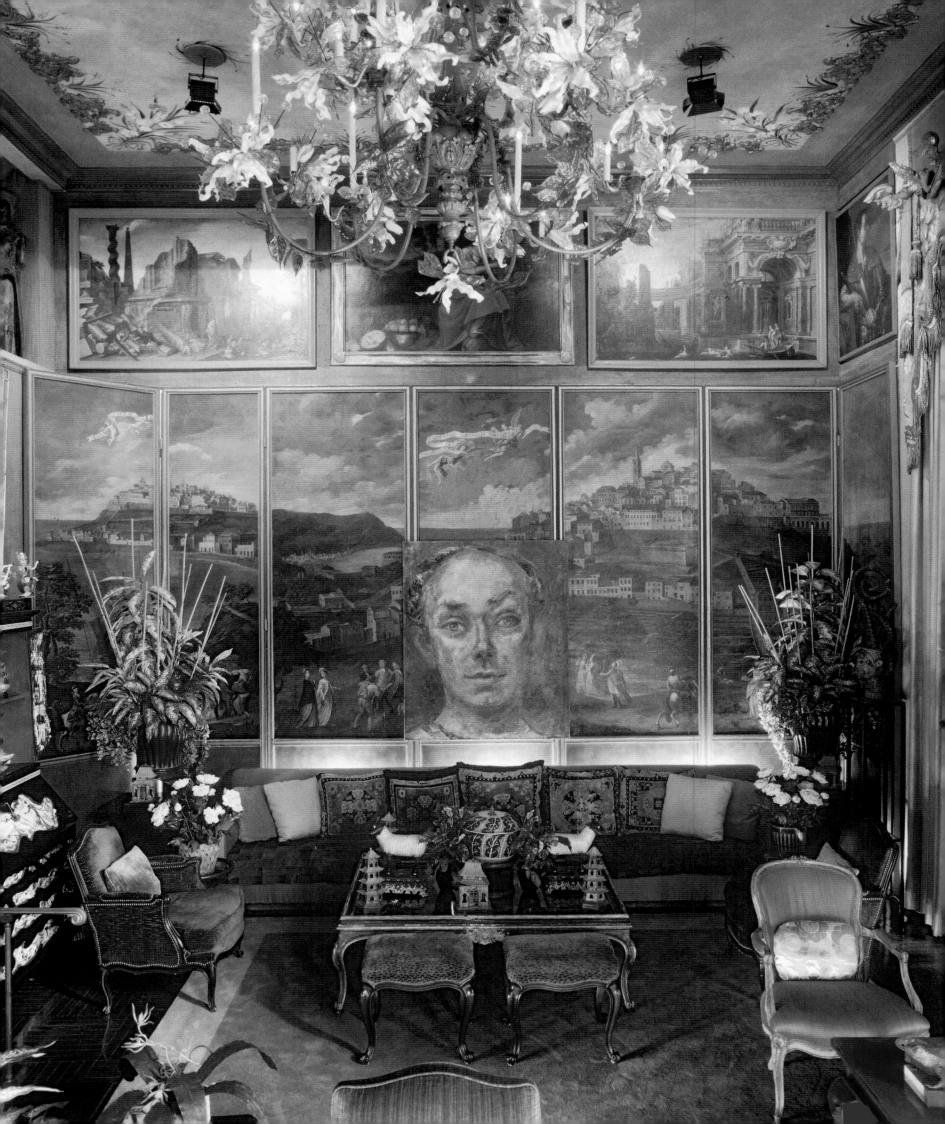

North wall of the Drawing Room, c. 1990. Tony layered his portrait by Marion Pike on top of the eighteenth-century mural.

........................

Following spread: The room originally included a Piedmontese secretary desk (left) flanked by Italian fruitwood pedestals. Tony would eventually sell it to John and Dodie Rosekrans in 1999, replacing it with the desk he made for Elsie de Wolfe (right) in 1941.

........................

Pages 76 – 77, from left: Detail of the Elsie de Wolfe cabinet, 2018; The Tony Duquette for Jim Thompson Duquetterie linen fabric was inspired by the two decorated doors of the cabinet, 2008.

"A sofa should never look like a sofa, but rather should look like a pile of rich stuffs and carpets, piled high on the prow of a pirate's ship."

On the east wall, Tony placed an immense twelve-foot-long banquette sofa designed by his friend Billy Haines, which he purchased from a charity sale and reupholstered in sap-green satin, then covered it with a throw of patchwork forest-green suede. Tony followed his friend Syrie Maugham's advice when she told him: "A sofa should never look like a sofa, but rather should look like a pile of rich stuffs and carpets, piled high on the prow of a pirate's ship." He also replaced the tall screen of eighteenth-century painted French panels that he'd made for the rental house with a magnificent eighteenth-century mural depicting a scene in Porto Mauritius. The mural was purchased from the Baroness Catherine d'Erlanger; Tony later mounted it as a folding screen. In the 1990s, Tony would eventually layer the panels with his portrait, circa 1960s, by Marion Pike. In the corner, Tony placed an African Ekoi mask, which had been on display at LACMA as a loan from the Duquettes; it was later sold by Christie's to Dodie Rosekrans, and I later placed it in her palazzo in Venice.

Two of eight seventeenth-century paintings of Venice by Joseph Heintz the Younger, which Tony and Beegle had purchased from the Baroness d'Erlanger, were prominently placed on the stair wall, and a prized Piedmontese desk inlaid with ivory was positioned beneath one of the paintings. Tony would later change out the desk—having sold it to John and Dodie Rosekrans to use in their Venetian palazzo—in favor of the famous cabinet he made for Elsie de Wolfe in 1949. The decorated doors of the cabinet would even inspire a printed linen fabric: Tony Duquette for Jim Thompson "Duquetterie." Next to the cabinet he placed his own Ghost Snail electrified sculpture, saying, "I'm always trying to get light into a room without using lamps and shades. Look around, you won't see very many lamp shades here." In 1990, the Aubusson chairs were replaced with ebonized Louis XV bergères upholstered in striéd emerald green velvet.

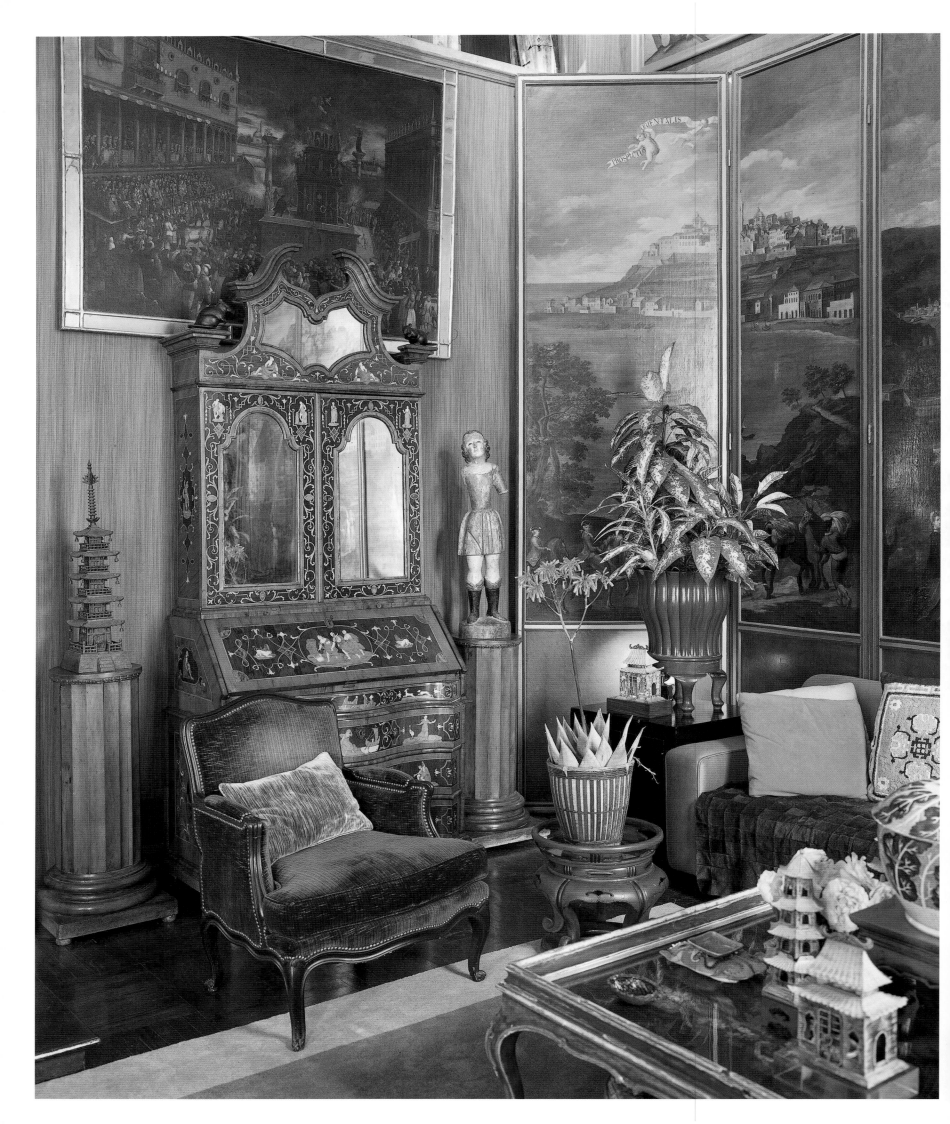

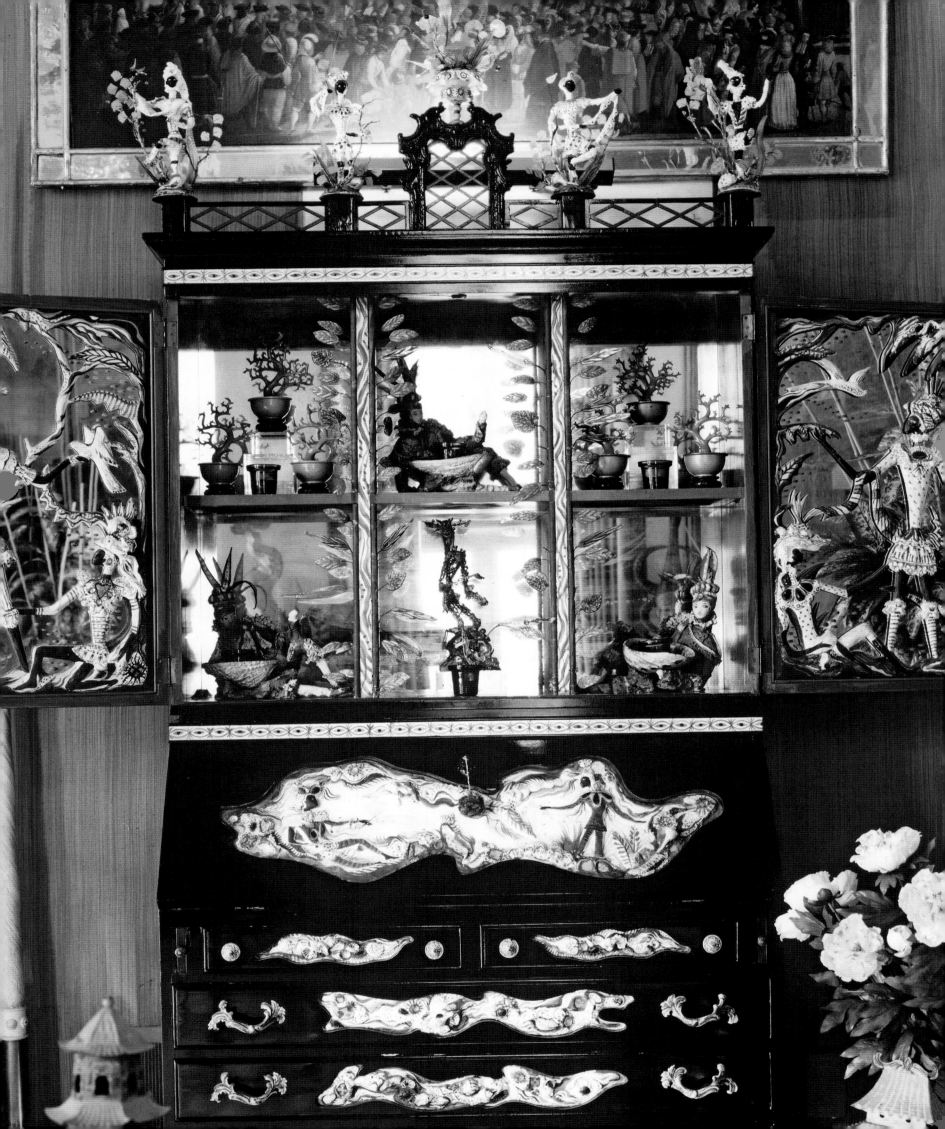

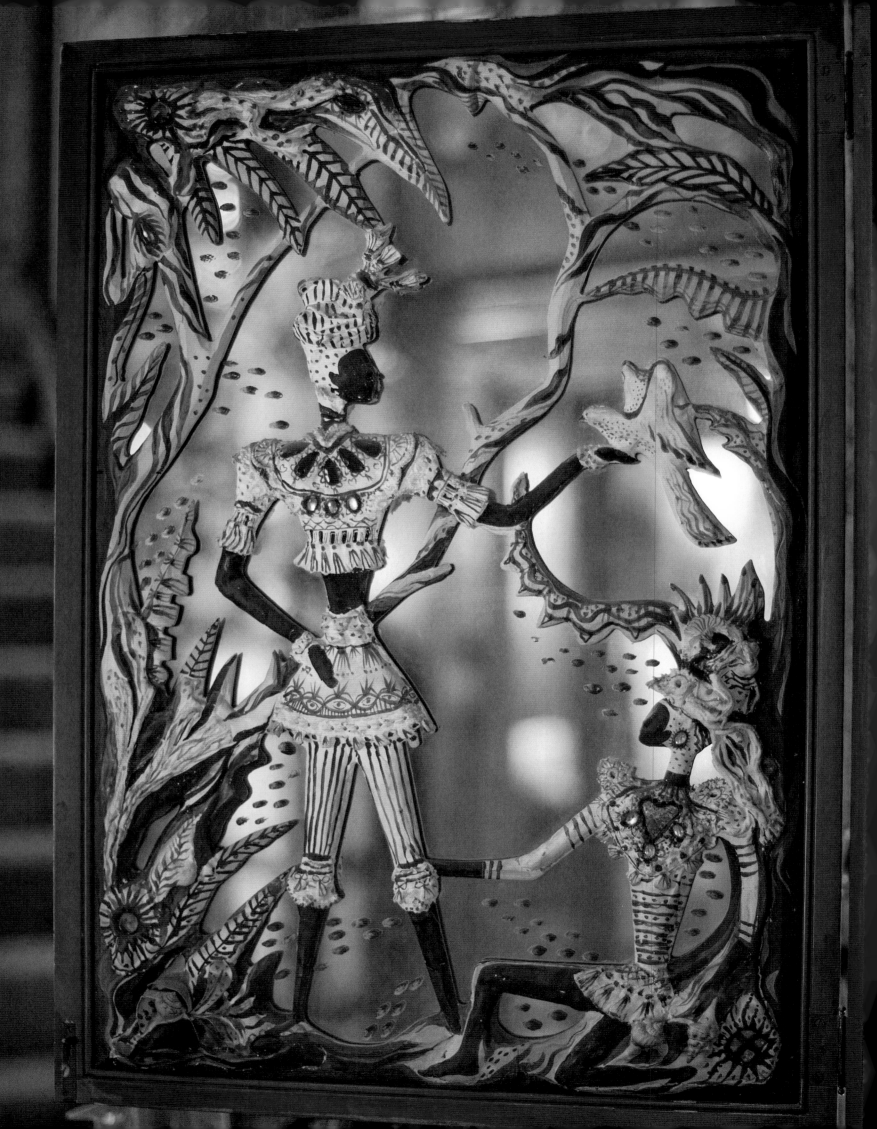

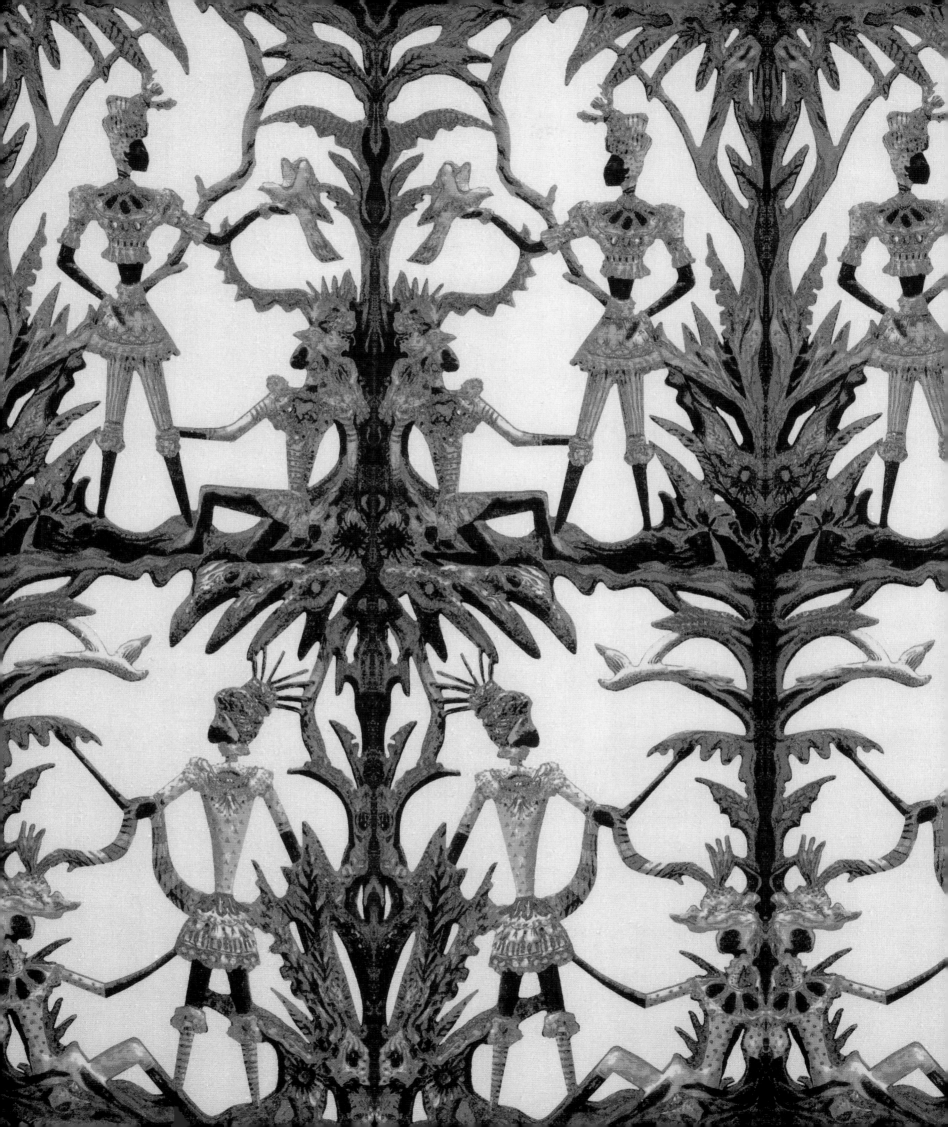

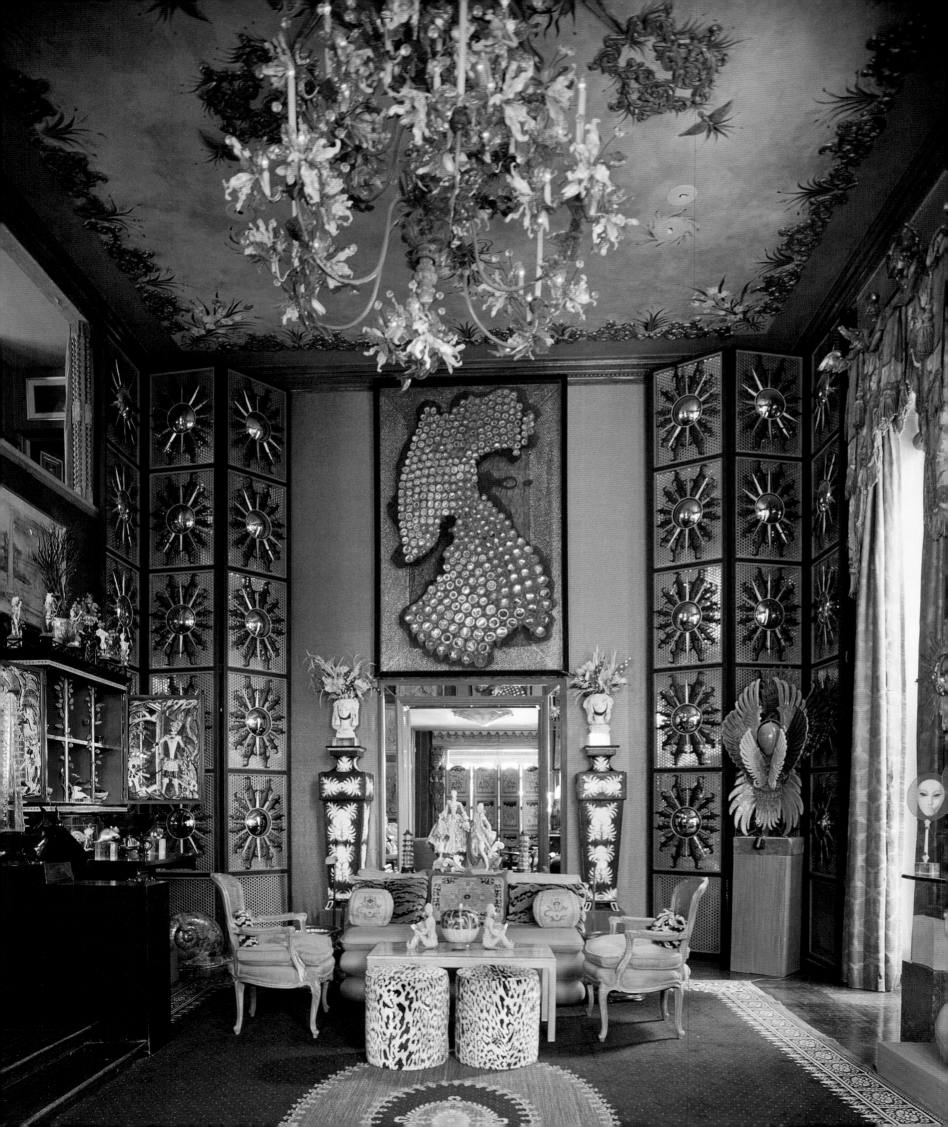

North wall of the Drawing Room, 2001. Following the Christie's sale, a door was cut through the wall connecting the Drawing Room with the library. I created the sunburst screens using metal hubcaps to replace the wall of eighteenth-century Italian paintings and added artwork by Tony above the doorway.

Right: One of the two three-dimensional costume sketches by Tony Duquette for the 1952 San Francisco Opera production of *Der Rosenkavalier*.

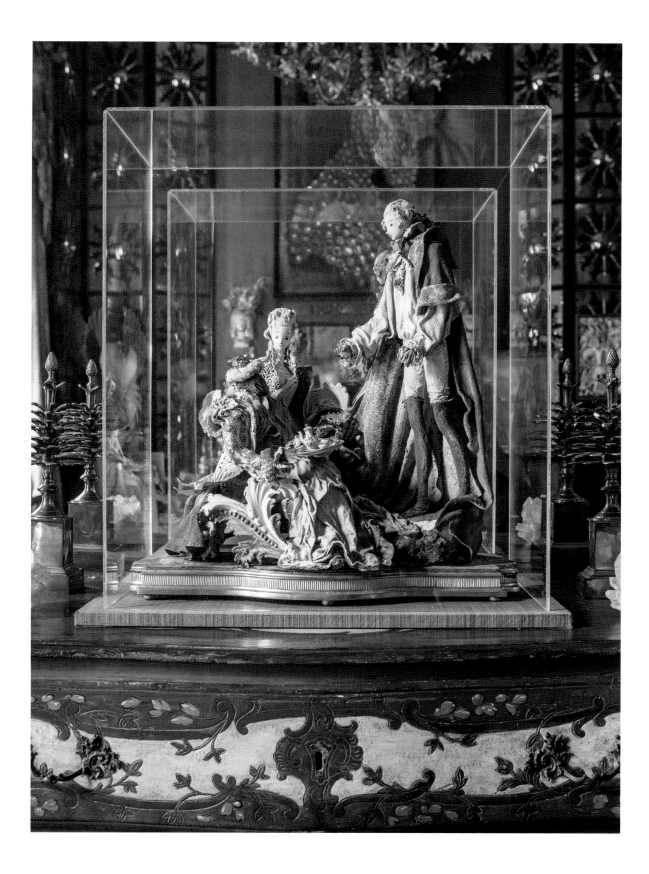

Since the Christie's sale in 2000, I've redecorated the Drawing Room a number of times. The first time, I replaced the seventeenth-century Venetian paintings on the left wall with Tony's watercolors of Venice, which had been exhibited at the Louvre. I also replaced the wall of eighteenth-century Italian paintings with the sunburst screens featuring metal hubcaps. I cut a door through the wall, connecting the Drawing Room with the library beyond, and flanked the new mirrored doorway with the stands and plaster heads Tony created for the Cobina Wright residence in 1952. Tony's multimedia assemblage of window screen, Mylar, and rhinestones—known as *A Fragment of a Priestess' Robe or A Specimen of Rhinestone Disease*—was hung above the door. The walls were reupholstered with an iridescent bronze to gold lamé fabric, which we also used at the Palazzo Brandolini, and the Ottoman banquette, originally designed by Tony for Cow Hollow, their house in San Francisco, was brought into the Drawing Room. Other objects in the room include Tony's *Phoenix Rising From Its Flames* sculpture in the right-hand corner, as well as two of his three-dimensional costume sketches for Der Rosenkavalier, which are displayed in Plexiglas cases around the room.

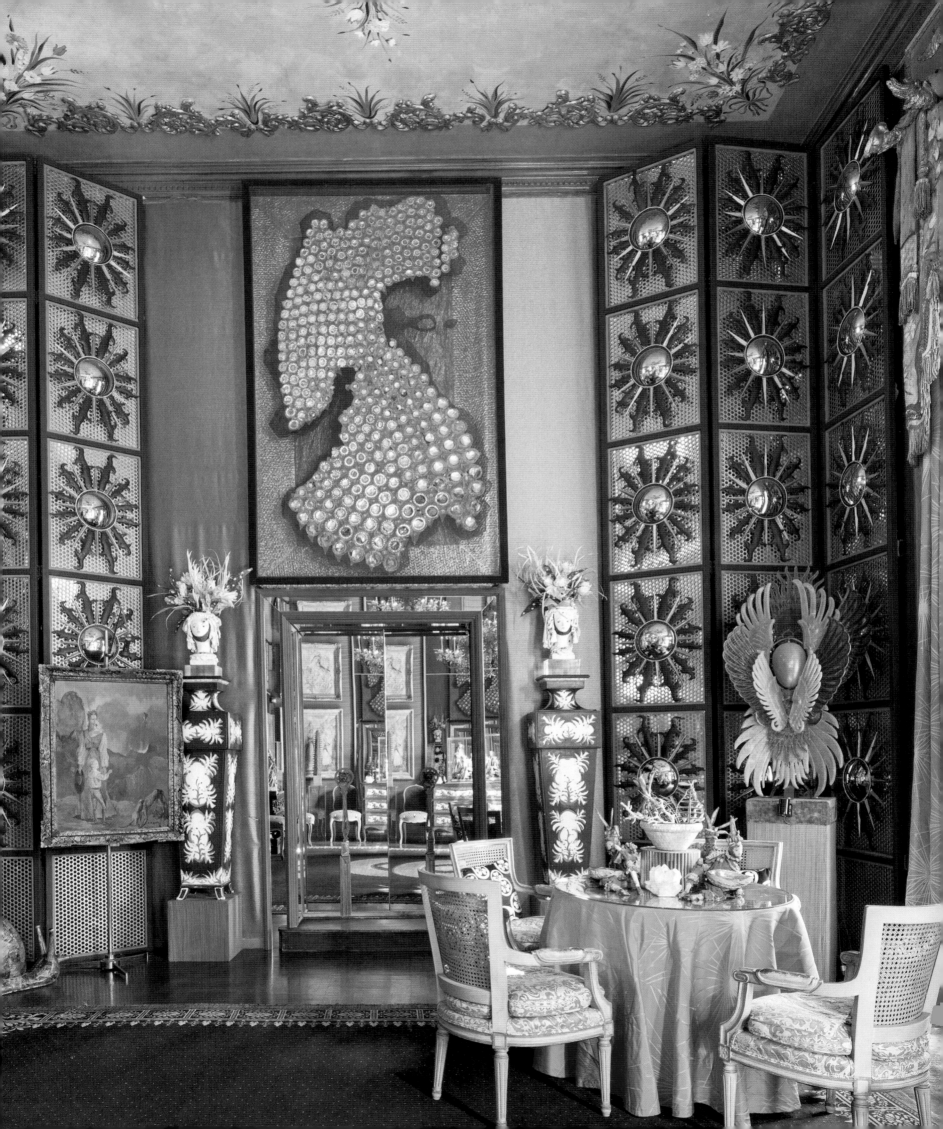

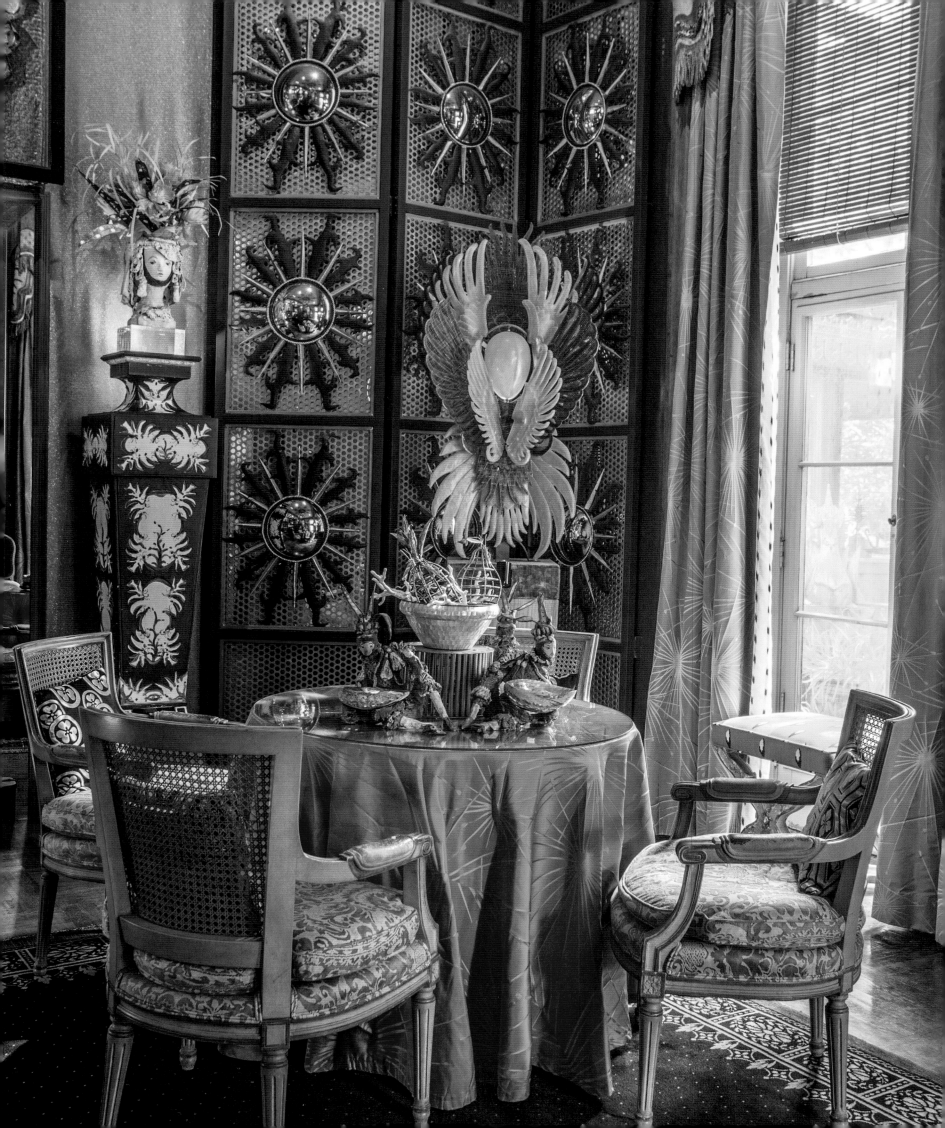

In 2017, I rearranged the room as more of a gallery or reception room than a sitting room. To create this mood, I removed the seating area and added a round table draped in Tony Duquette for Jim Thompson Feu d'Artifices handwoven silk. The four Louis XVI–style chairs surrounding the table are upholstered in old quilted Fortuny, and the table is set with Tony Duquette reclining figurines that are holding abalone shells with votive lights in them. The mother-of-pearl bowl contains Venetian glass coral branches and a display of Duquette's gilded *Modern Fruit* from his exhibition at the Louvre.

The south end of the room has not undergone changes as extensive as the rest of the Drawing Room. In the 1980s, Duquette placed an eighteenth-century French commode with ormolu mounts where the original long Venetian Louis XVI–style console had always held pride of place; he moved the console upstairs to the balcony. After a few years, Tony sold the magnificent French commode and replaced it with…yet another chest of drawers—an eighteenth-century Portuguese piece in the Chippendale taste from the collection of the Duquettes' friend Frances Elkins. On top of this new furniture, Tony placed electrified resin pagodas modeled after a set of nineteenth-century Regency ceramic pagodas he'd found in Ireland when decorating Barretstown Castle for Elizabeth Arden in the 1960s. In the 1980s, Tony also added eighteenth-century paintings to the room, paneling the walls with them from the baseboards to the crown molding. It was at this time that a Chinese red lacquer screen and an Italian settee upholstered in striped white satin also made their appearance in the Drawing Room. Tony and I worked closely on this redecoration and placed a papier-mâché table in the corner, with a Venetian gondola scene painted in the center of its top; we later sold this treasure to Dodie Rosekrans for her dressing room at Palazzo Brandolini in Venice.

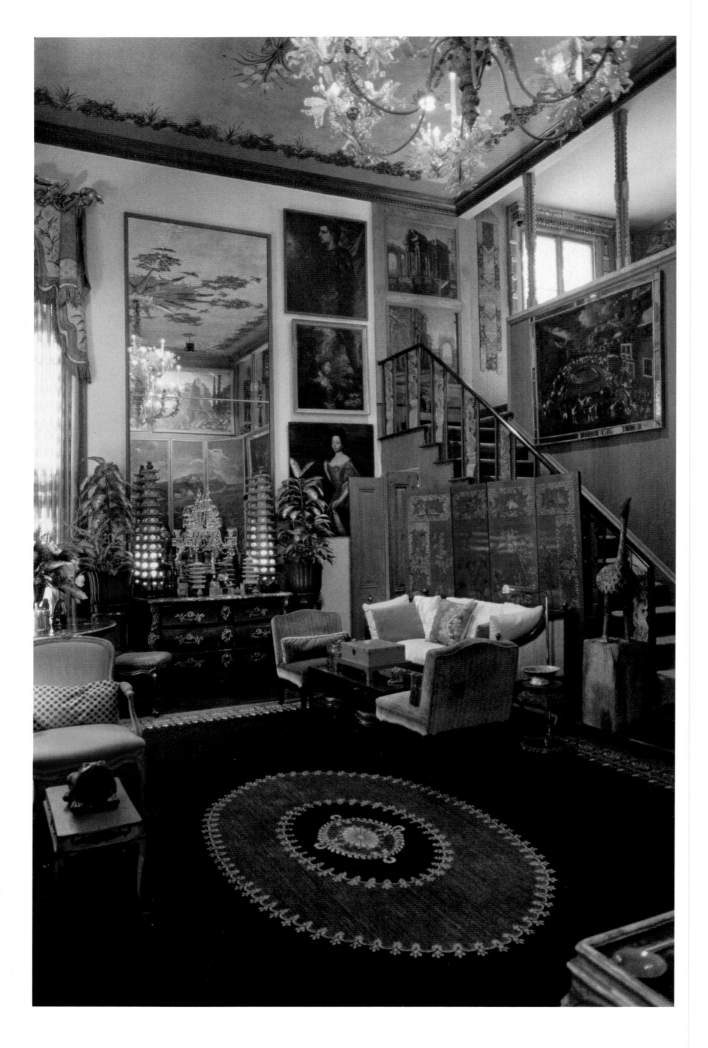

South wall of the Drawing Room, 2018. The seating area (left), c. 1980, was also removed from this side of the room. An antique Venetian chest of drawers now stands in place of its eighteenth-century French counterpart.

........................

Following spread: South corner of the Drawing Room, c. 1980 and 2018. Tony first placed a papier-mâché table (left) in the corner next to an eighteenth-century red-lacquer Thai shrine. The furniture was eventually removed and replaced by me with a Burmese shrine (right).

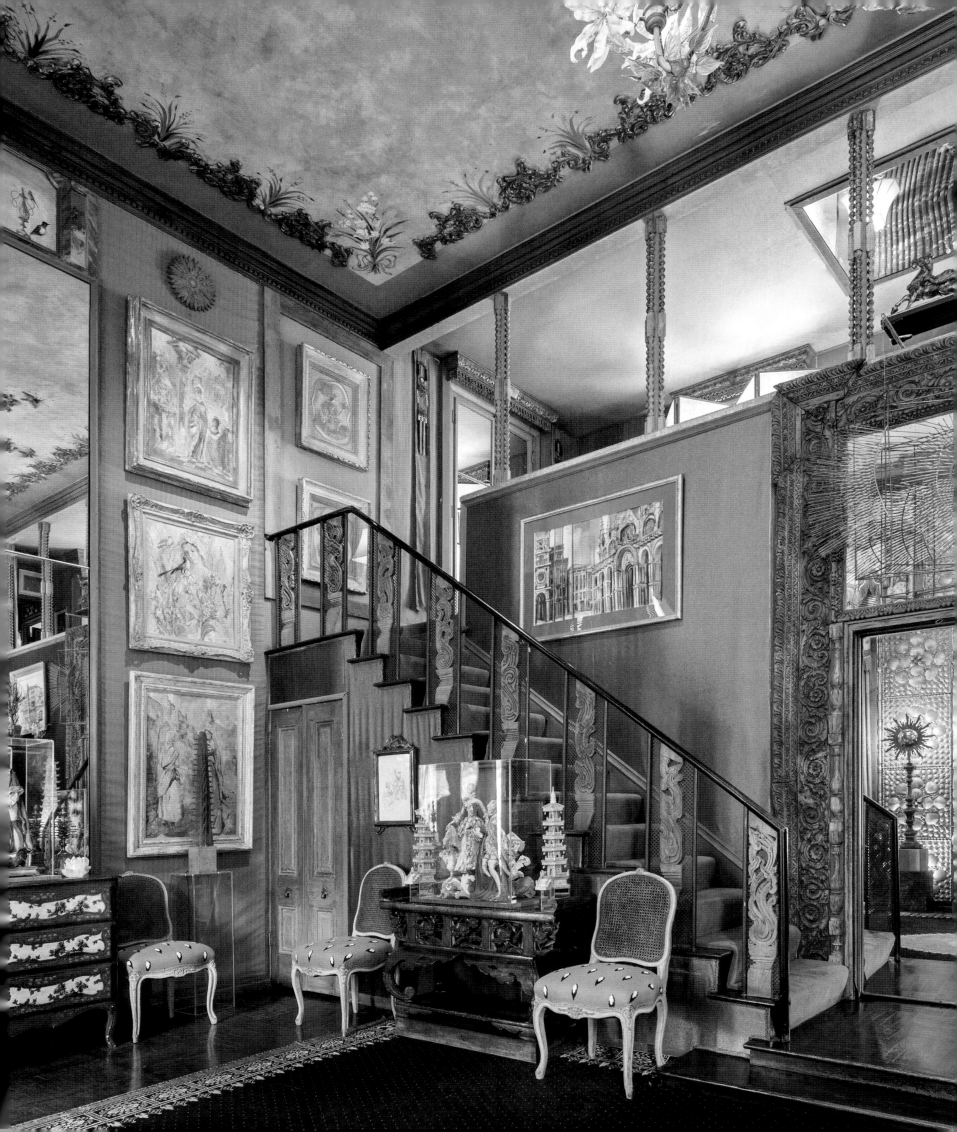

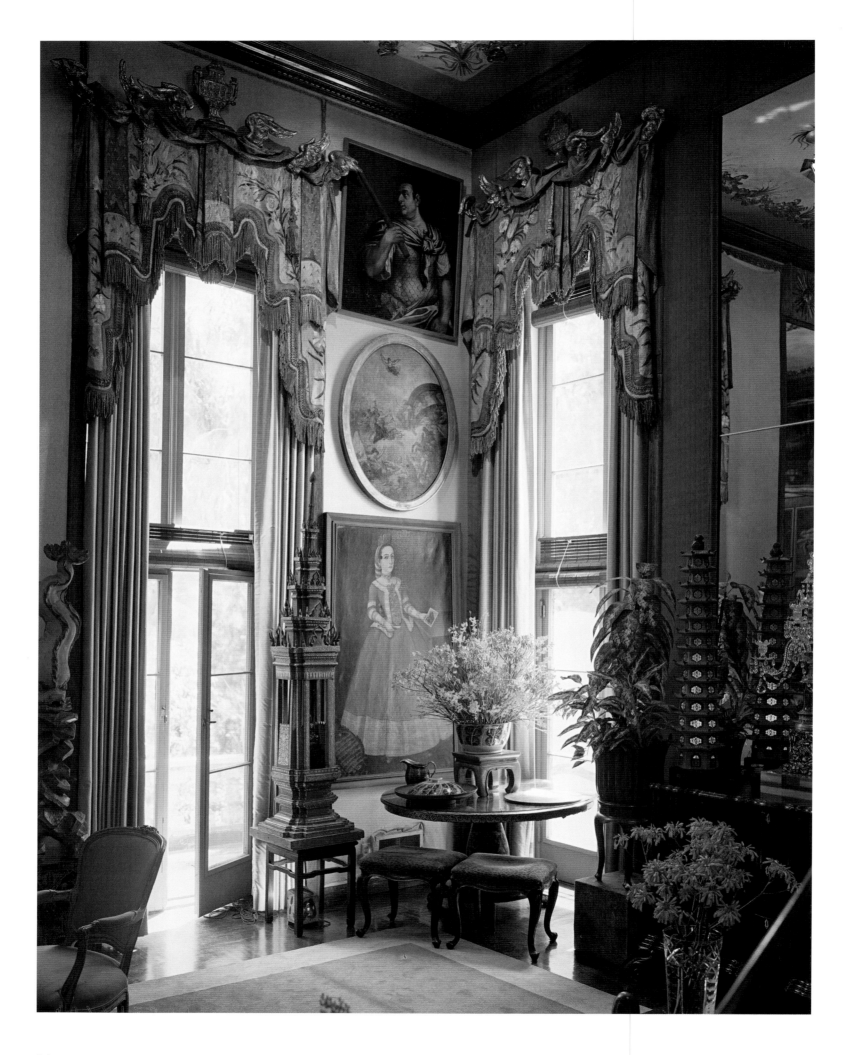

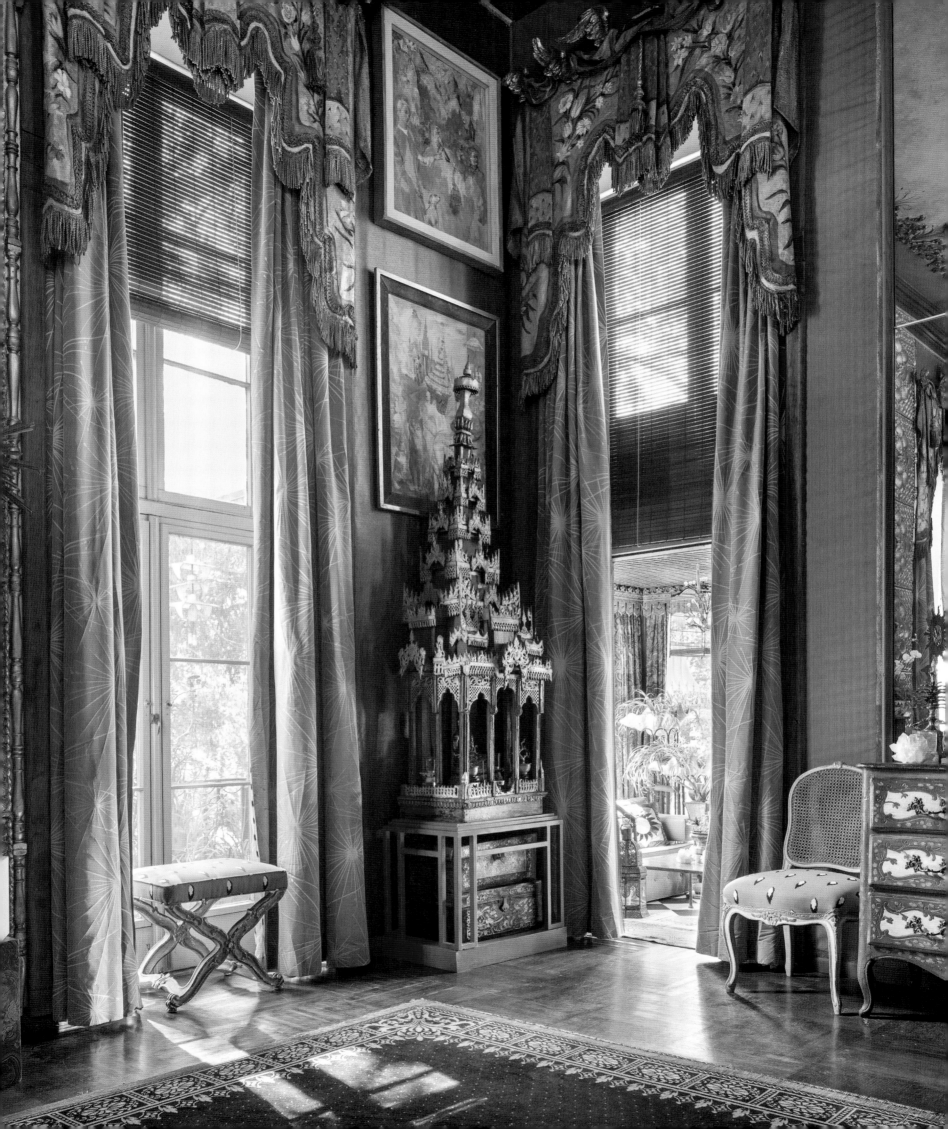

In 2000, I painted the turquoise silk satin curtains with red, gold, and pink spray paint, making an interesting ikat type pattern. When Chad Holman from Jim Thompson saw those painted curtains, he asked me where I got them. I told him I'd painted them during the weekend. When he asked me why, I facetiously told him that I couldn't afford to replace them, and I couldn't afford to clean them, so I painted them. That's when he asked me to make a collection of fabrics for Jim Thompson. Today, the curtains are Tony Duquette for Jim Thompson "Feu d'Artifices" handwoven silk. Recently, I placed the furnishings around the walls to give the space the feeling of a ballroom. An antique Venetian chest of drawers sits under the mirror where the old Portuguese one used to be, and a carved and gilded Japanese table has been placed under the staircase. On top of both pieces, I've placed Tony Duquette's three-dimensional costume sketches for the 1952 San Francisco Opera production of *Der Rosenkavalier*. Around the room, Louis XV chairs, upholstered in Tony Duquette for Jim Thompson "Royal Ermine," have been pushed against the walls, and a Burmese shrine, with its gilded bronze Buddha and eighteenth-century Chinese lacquer coral branches, sits in the corner. Oil paintings by Beegle have now replaced the eighteenth-century artwork on the walls, along with watercolors and bas-reliefs by Tony.

The room has been redecorated and now features antique Chinese picture carpets, Tony Duquette's scale model of the California Sunburst proscenium curtain made for the Dorothy Chandler Pavilion of the Los Angeles Music Center, and his original abalone chandelier that was created for his one-man exhibition at LACMA in 1952.

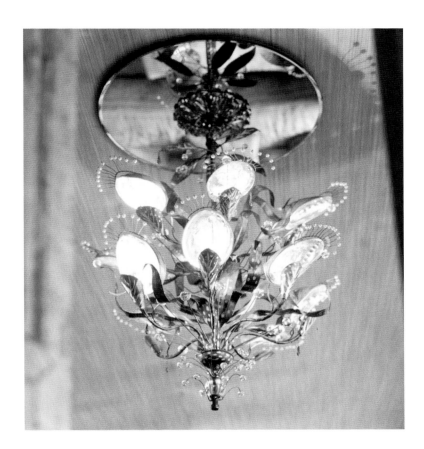

In the 1980s, Tony and I removed the draperies, which could be closed to separate the two areas, and installed the mirror on the ceiling. The red lacquer Buddha to the right of the door is sixteenth-century Burmese.

When redecorating the room, I placed Chinese carpets over the original bronze wool carpeting and installed the abalone chandelier that Tony had created for his one-man exhibition at LACMA in 1952. On the left wall, I hung the scale model for the proscenium curtain at the Los Angeles Music Center's Dorothy Chandler Pavilion; on either side are two Tony Duquette figural lamps originally created for Cobina Wright's home in the 1950s.

Past the bronze head of Buddha, antique Chinese doors disguise a closet where the old wood-burning stove used to sit in 1949, and the doors to the right of the closet lead to the Winter Bedroom, which the Duquettes added to the house in 1975. The walls are paneled with Chinese Coromandel screens, the carpet is Tibetan, and the closet doors are appliquéd with antique trims and hand-painted decorations from Bhutan.

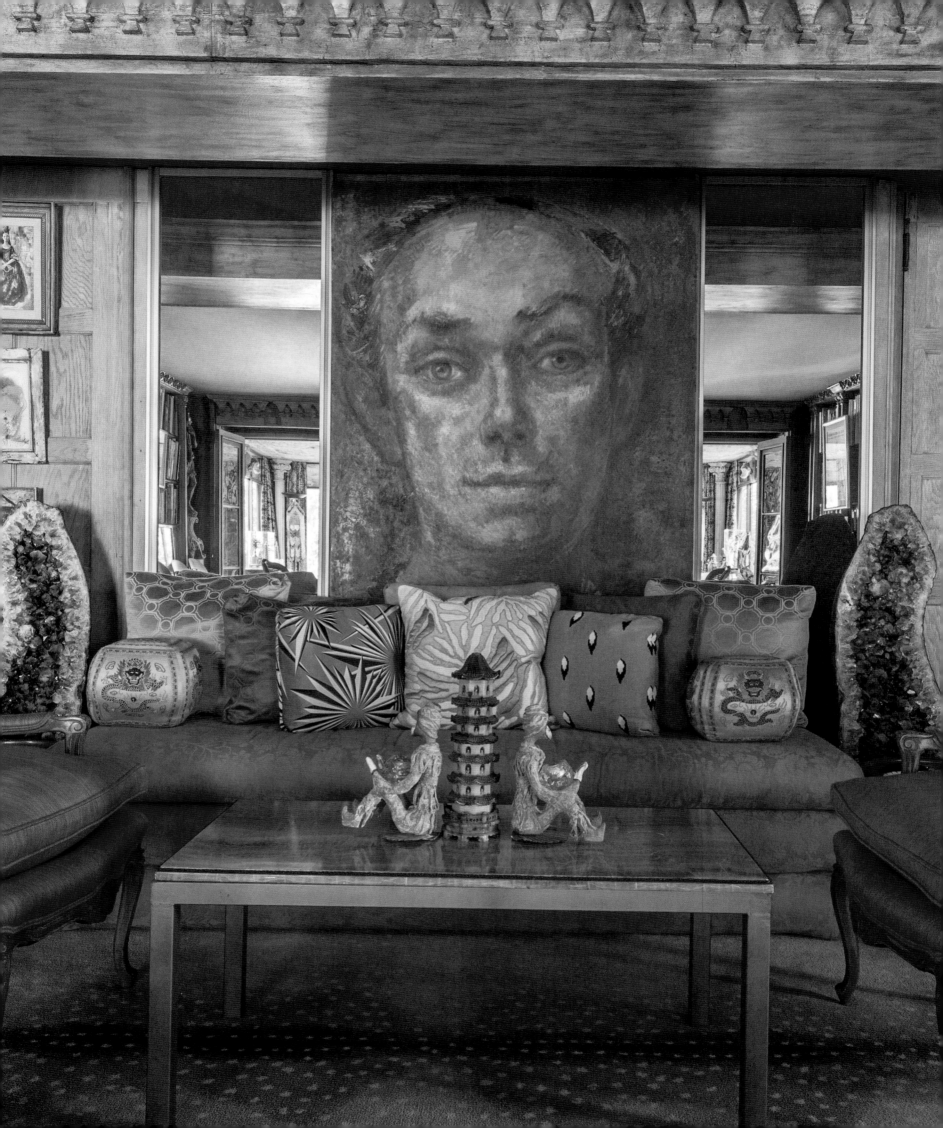

The Library

ne of the first things we did after purchasing Dawnridge was create an enfilade between the Drawing Room and the library. Prior to this, we had to go through the vestibule off the entrance hall and wind our way around to get to the library. It was not exactly the most dramatic or glamorous way to get from point A to point B, so we cut a door between the two rooms. This change was important because it allowed us to convert the library into a dining room on occasion—a necessity as the house

had no formal dining room. Our original plan was to leave the library permanently set up with a dining table covered in books and objects, and use the adjacent Monkey Room as a sitting room that looked out over the gardens. However, after our first dinner party, we realized that the library was too close to the kitchen; there was no butler's pantry between the rooms to muffle the sounds of cooking, clanking dishes, and chattering servants. Because of this, we immediately moved the dining table—an oval, which I learned from experience is the best shape for conversation as it allows everyone at the party to participate—into the Monkey Room and returned the library to a sitting room, which on occasion is converted for dining.

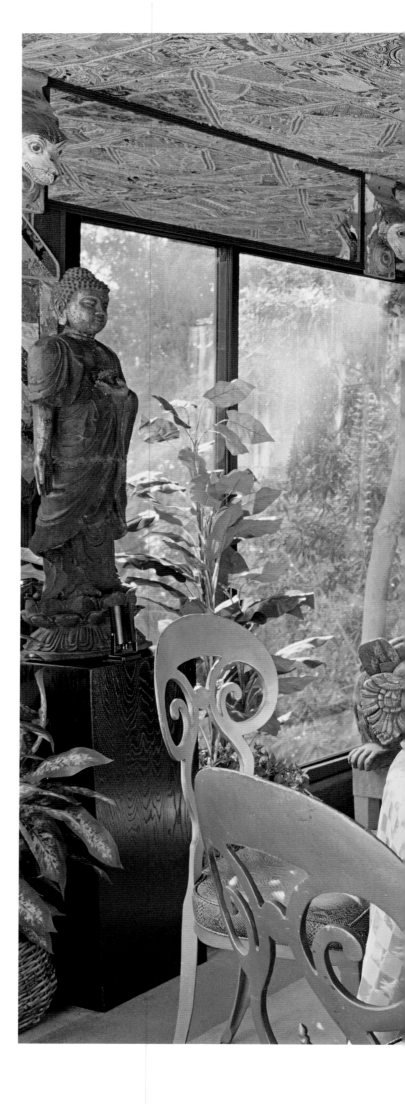

The Monkey Room, 2002.
Here, the table has been set with gold
lamé cloth, vermeil chargers,
cups, bamboo-style cutlery, and
antique Chinese rose medallion
porcelains. Covered Peking enamel
bowls, Venetian glass goblets, and a
centerpiece composed of a
nineteenth-century vermeil palm
tree candelabra surrounded by
ceramic pagodas and eighteenth-
century Chinese lacquer
coral branches complete the look.

The Monkey Room

The Monkey Room was named for the frieze of papier-mâché monkey masks which frame the embroidered and appliquéd ceiling that is upholstered with Indian tent panels. To create the illusion that the ceiling extends to the exterior of the glassed-in porch, Tony placed ninety-nine-cent mirrors from Pic 'N' Save over the windows. The curtains are Tony Duquette for Jim Thompson printed cotton in the Tibetan Sunburst pattern. Opposite the window over-looking the gardens, Tony built bookcases and filled them with a small sampling of his extensive art and fashion library.

The monkey theme is also reflected in figurines that I've placed around the room. On his seventy-fifth birthday, Tony's friend Cynthia Lindsay gave him three dressed monkeys by Oliver Messel. Two of the monkeys were lost when the Duquettes' Malibu ranch burned to the ground, but one survived. I found another monkey by Messel, dressed in a tricorn hat, at the Leo Lerman sale in New York, and added it to the room, along with a pair of figurines made by Tony in the 1940s for the fashion designer Adrian, who used these alongside a perfume or shoe display at his store in Beverly Hills.

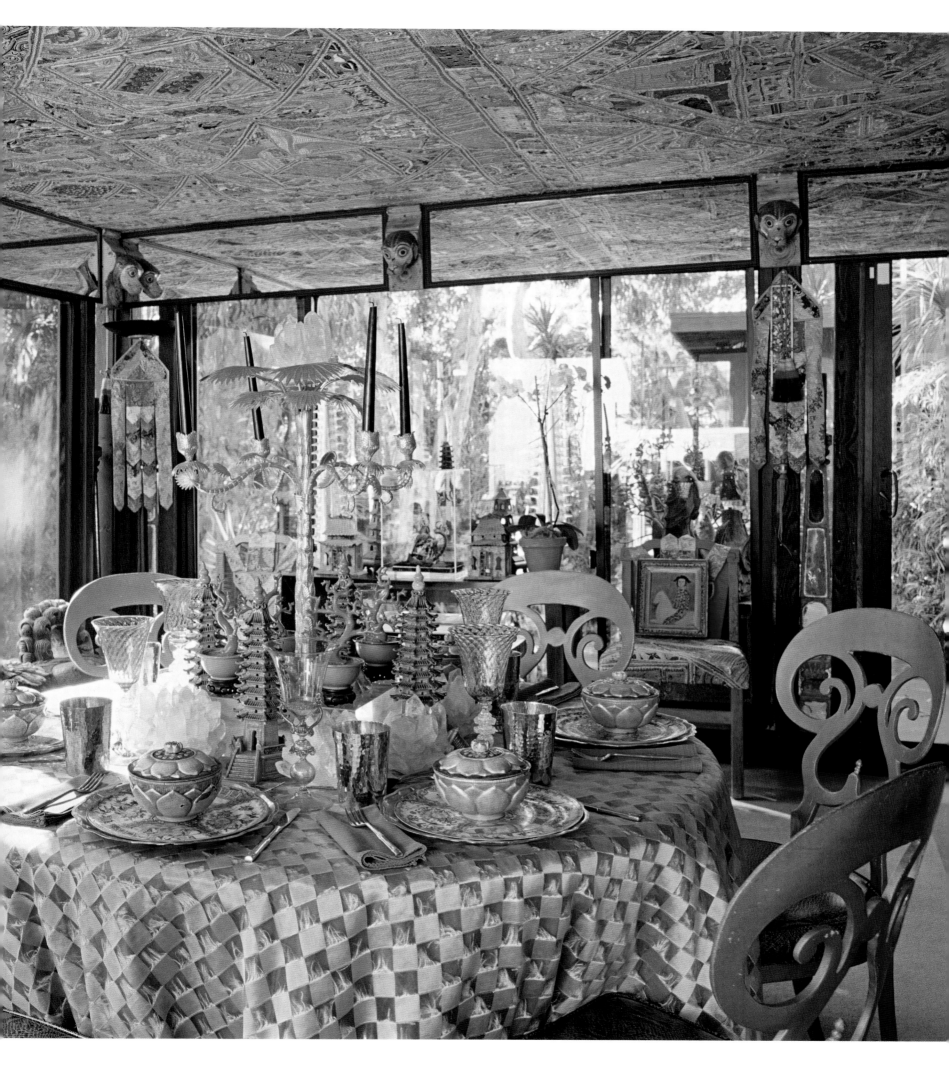

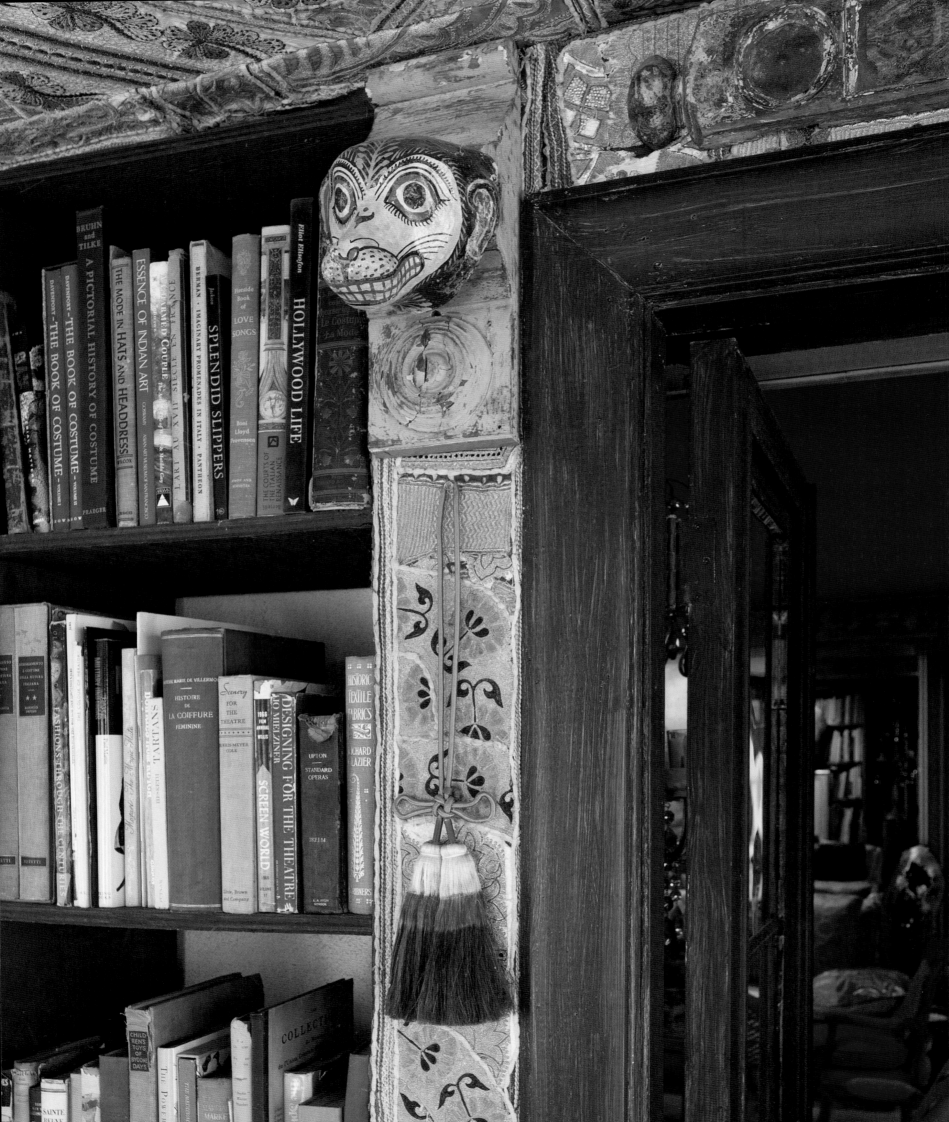

Detail of the built-in bookcases, 2018. The walls, like the ceiling, are upholstered in embroidered and appliquéd Indian tent panels and layered with antique Japanese tassels. **Below:** One of a pair of figurines created by Tony for the designer Adrian, c. 1940. Adrian used these, which Tony sketched out for him first (top), as part of a display at his store in Beverly Hills (bottom).

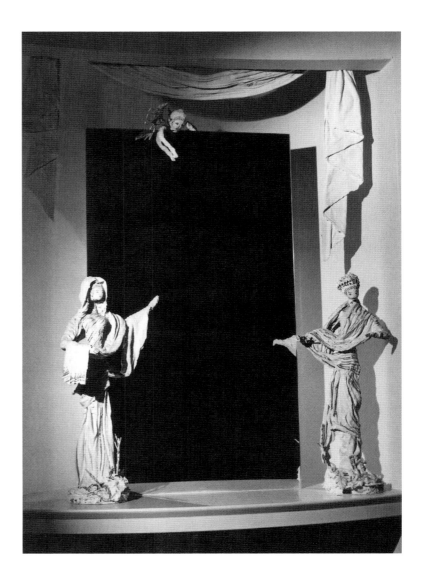

Monkey figurines by Oliver Messel, c. 1950. Tony received three dressed monkeys for his seventy-fifth birthday from his friend Cynthia Lindsay. Only one survived following the fire at the Duquette Ranch in 1993, and is now displayed in the Monkey Room (below). I purchased another Oliver Messel monkey figurine with the tricorn hat from the Leo Lehrman estate to add to the décor (opposite).

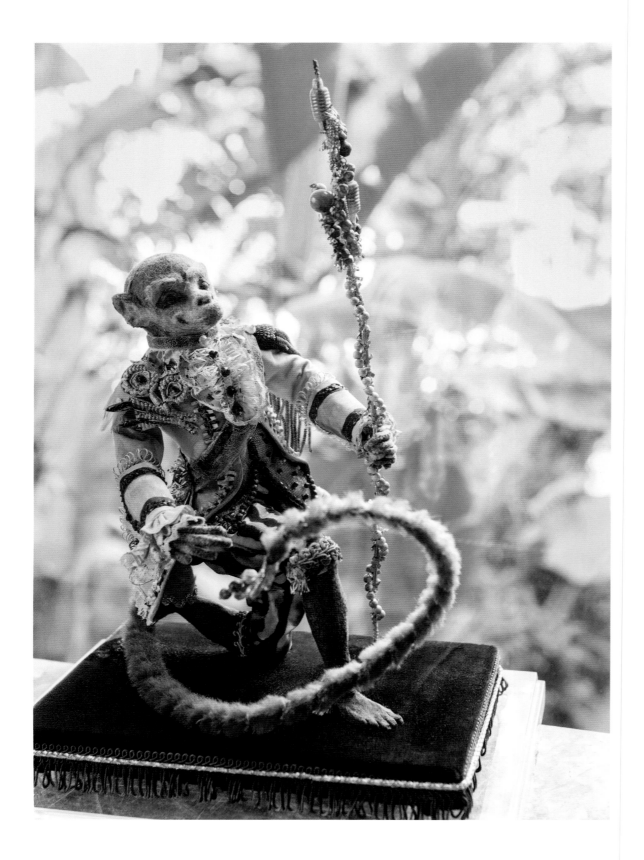

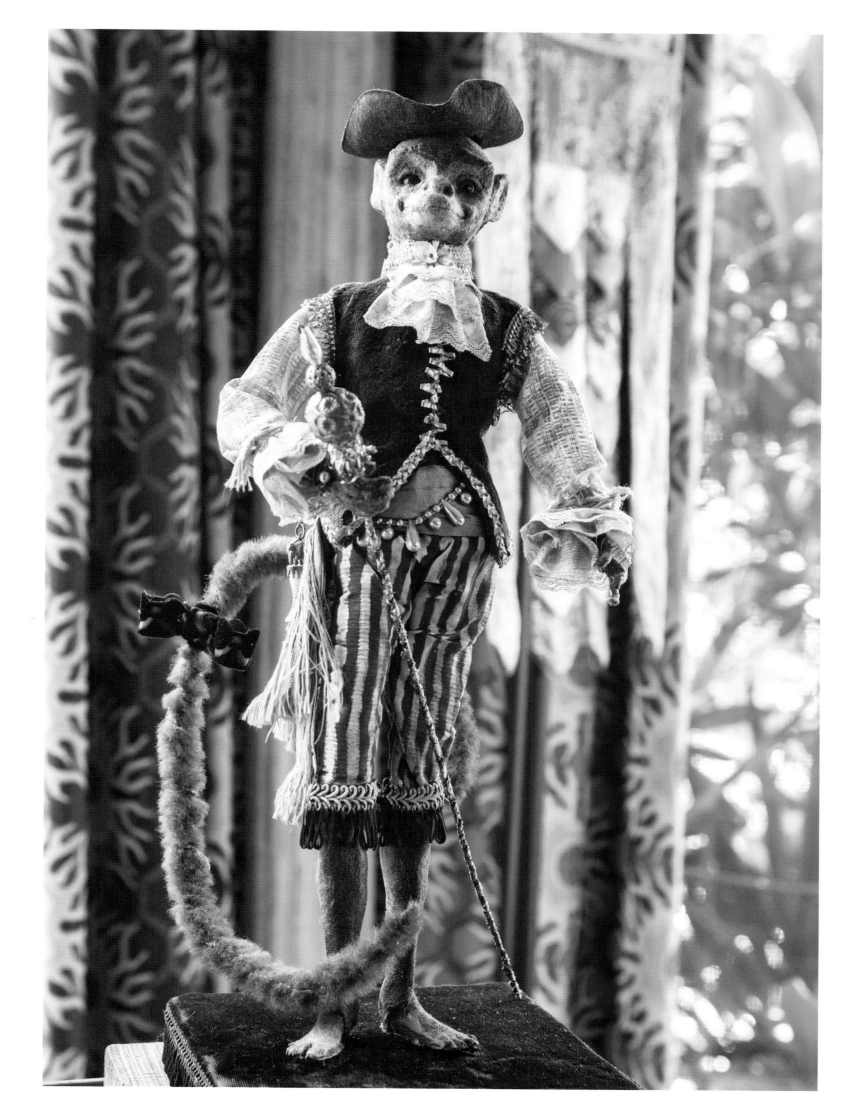

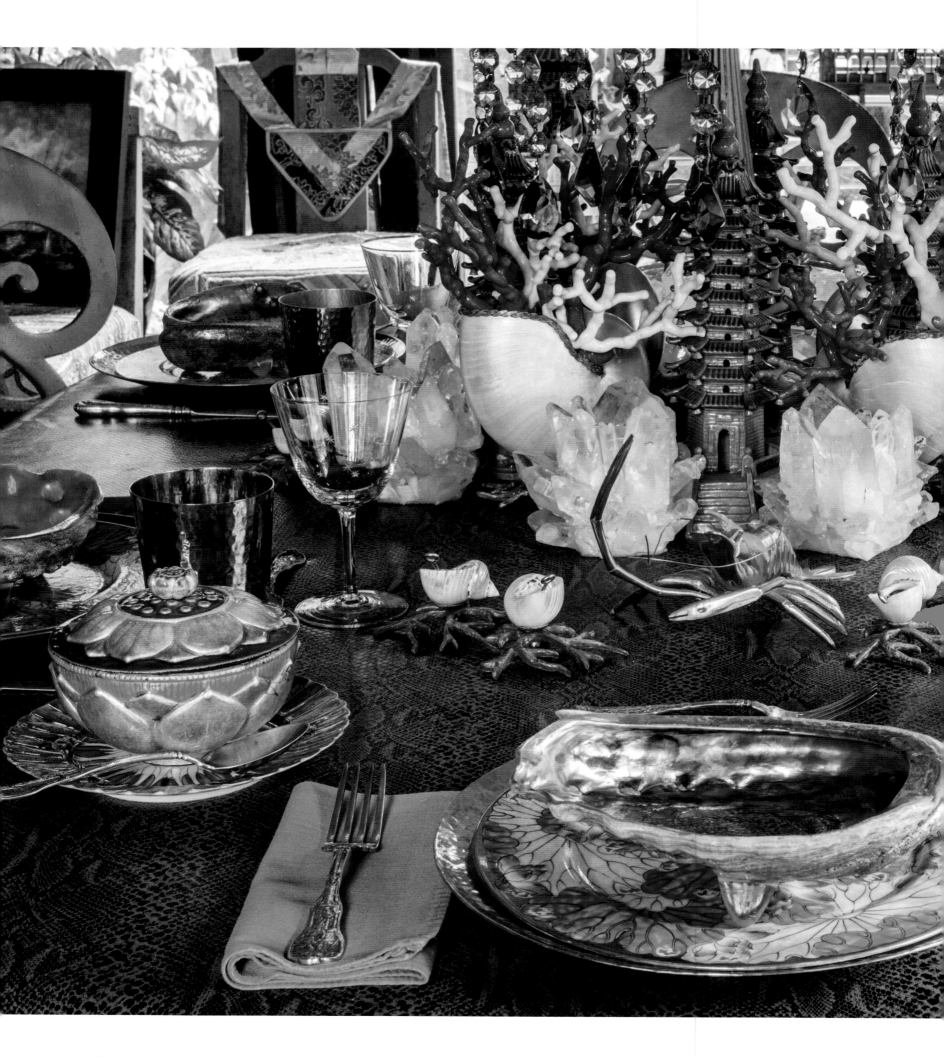

Table setting in the Monkey Room, 2018. Rock crystal votive lights cast a glow on guests' faces, as Tony liked to say, "like the light from a campfire." **Below:** The Monkey Room, 2005. The curtains are made with Tony Duquette for Jim Thompson Tibetan Sunburst fabric.

For our dinner parties, we set the tables with an eclectic mix of antiques and objects made by Tony: vermeil chargers, antique Chinese porcelain in a pink and green lotus pattern on gold, holding abalone soup bowls; antique Baccarat crystal glasses etched with stars; custom-made seashell and coral salt and pepper cellars; and antique silver, Mythologique-patterned cutlery. A Tony Duquette wood-and-crystal girandole holds black candles "so that the flames look like they're floating in midair," as Tony used to say, surrounded by coral-clad nautilus shells sporting Venetian glass coral branches. Vermeil lobsters stand guard at each end of the table, and Tony's signature rock-crystal votives are placed to cast a soft glow onto the guests' faces.

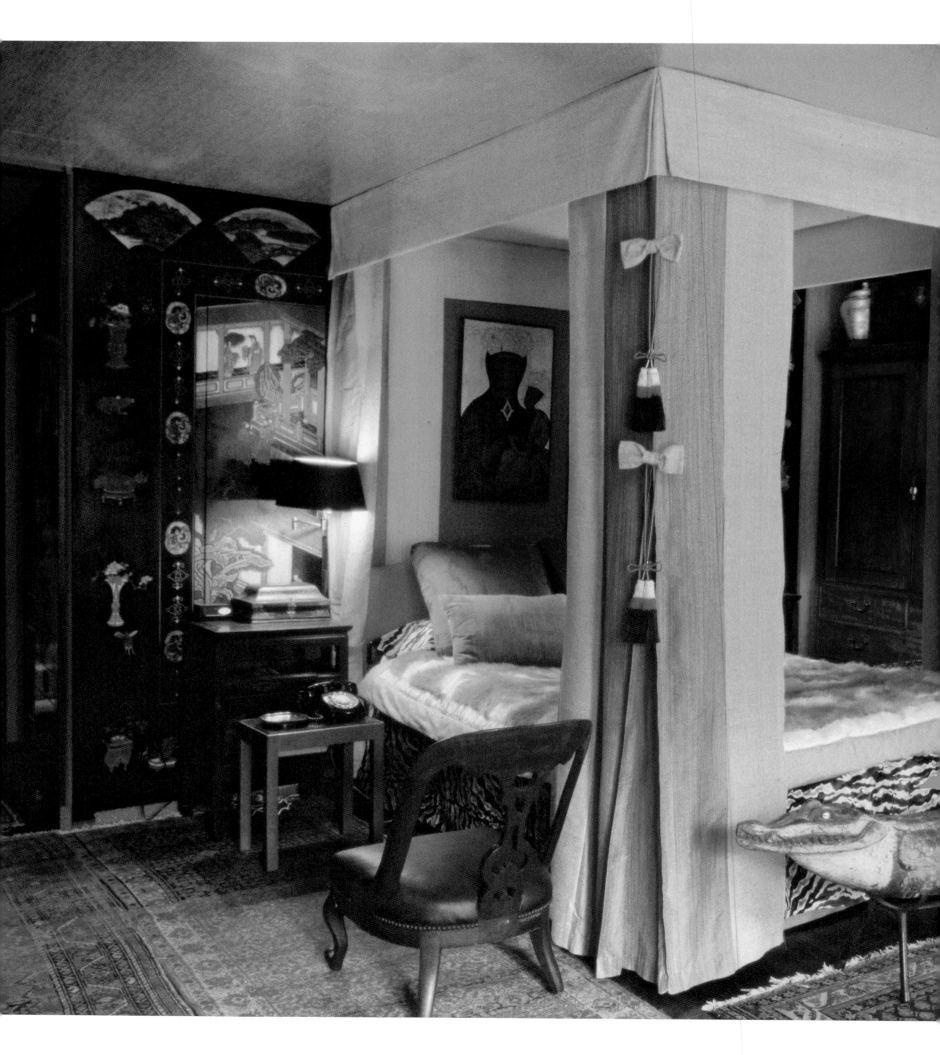

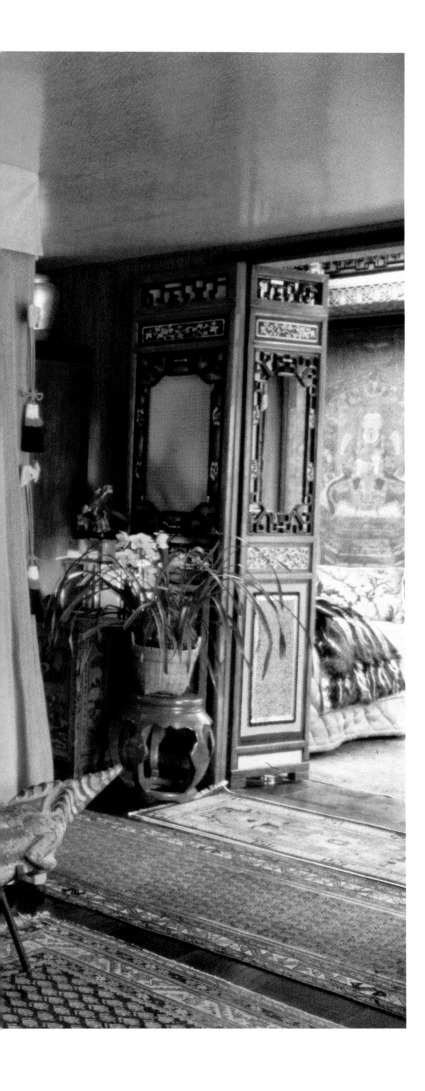

The Winter Bedroom

In 1975 the Duquettes built a new two-car garage and added a master bedroom above it. They called their new chamber the Winter Bedroom, where they moved when the weather turned cold, as opposed to the original downstairs bedroom, which they called the Summer Bedroom. The Winter Bedroom connected with the balcony over the Drawing Room. With my help, Tony decorated the room with antique Georgian furniture and paneled the bed wall using an antique Coromandel screen. The ceiling was covered in gold lamé, and the walls were upholstered in a bronze-colored striéd linen. The bed was hung in coral-colored Thai silk with a pelmet adorned with Tibetan tassels. At the foot of the bed we conveniently placed a carving of an alligator from the South Sea Islands as a place to throw your robe on.

After we purchased Dawnridge, Ruth and I used the Winter Bedroom for guests. We changed the bed hangings, using bolts of coral and saffron yellow Thai silk that were left over from Tony's *Camelot* costumes, and covered most of the walls from floor to ceiling with bookcases. The bed's valance was salvaged from the Duquettes' canopied bed in their San Francisco home, along with the silk tasseled bedspread, hand-painted with birds and flowers. On each side of the bed we placed Spanish colonial *varguenos* and topped them with the fabulous figural lamps Tony made for his exhibition at the Louvre in 1951. Recently, we added even more pieces to the room including a loveseat and a small upholstered armchair designed by the Duquettes' friend, English designer Syrie Maugham.

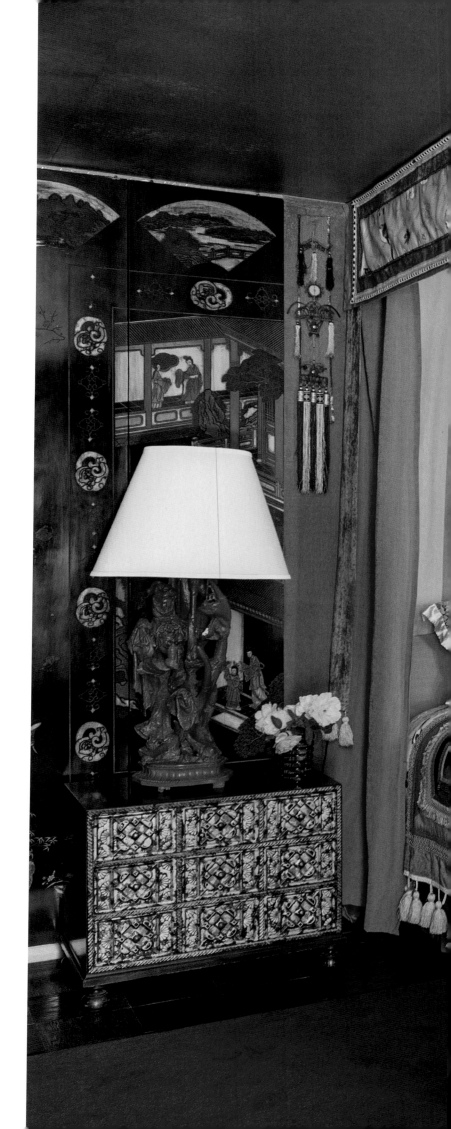

The Winter Bedroom, 2018. The original bed hangings have been replaced with curtains made of coral and saffron colored Thai silk. On either side of the bed are Spanish colonial varguenos with Tony Duquette figural lamps, c. 1951, originally created for his one-man exhibition at the Louvre.

Two pairs of antique Chinese carved teak doors, to which Tony added panels of old Chinese silver damask and frames consisting of several rows of passementerie trim, separate the Winter Bedroom from both the vestibule and sleeping alcove. The Winter Bedroom's sleeping alcove holds an original Syrie Maugham sleigh bed. This bed—a favorite of the Duquettes—was commissioned from Maugham by the actress Ina Claire, who played Grand Duchess Swana in *Ninotchka*. Ina was a great friend of the Duquettes, as well as Ruth's and mine. Over the years, we were able to purchase a lot of fine furniture from Ina, who had collected wonderful pieces not only from Maugham but also from Elsie de Wolfe. Tony hung a Ming Dynasty panel over the sleigh bed and added a nineteenth-century black-and-gold lacquer chair that he purchased on a trip to Chiang Mai, Thailand.

In 2000, the sleeping alcove was completely redesigned after we walled up a window and upholstered the walls with printed raw silk that we found in our warehouse. The bolts and bolts of fabric had been made for Tony by Jim Thompson himself in the 1960s, and were never unpacked. I added a French desk; a Victorian chair; a Chippendale Chinese-mirror from the 1960s featuring an orchestra of carved musicians from Thailand that I affixed myself; and a pair of circa 1940s Tony Duquette figural lamps. The frame around the skylight is made up of Chinese carvings appliquéd with woven passementerie trim, as well as tassels made by Tony using Chinese coins and silk, which he dipped in plaster and painted pink and blue.

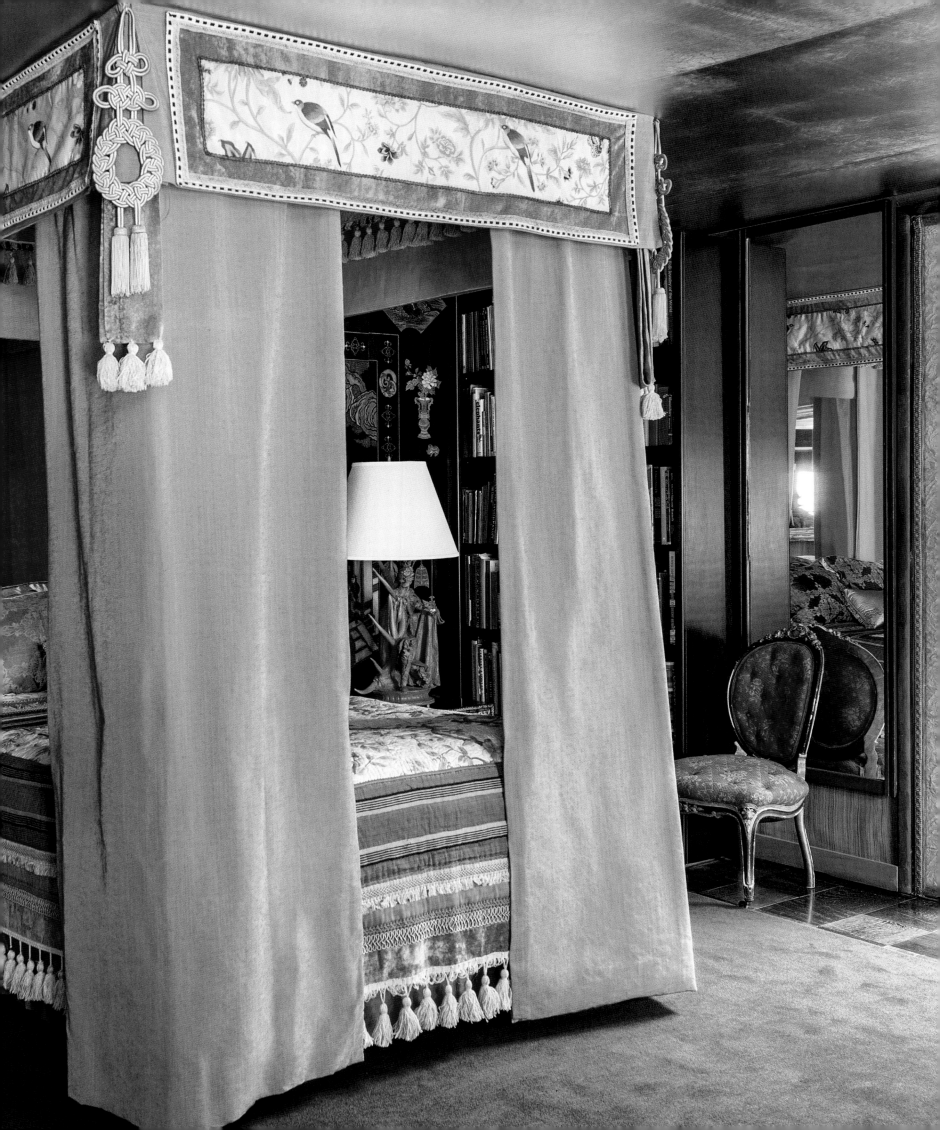

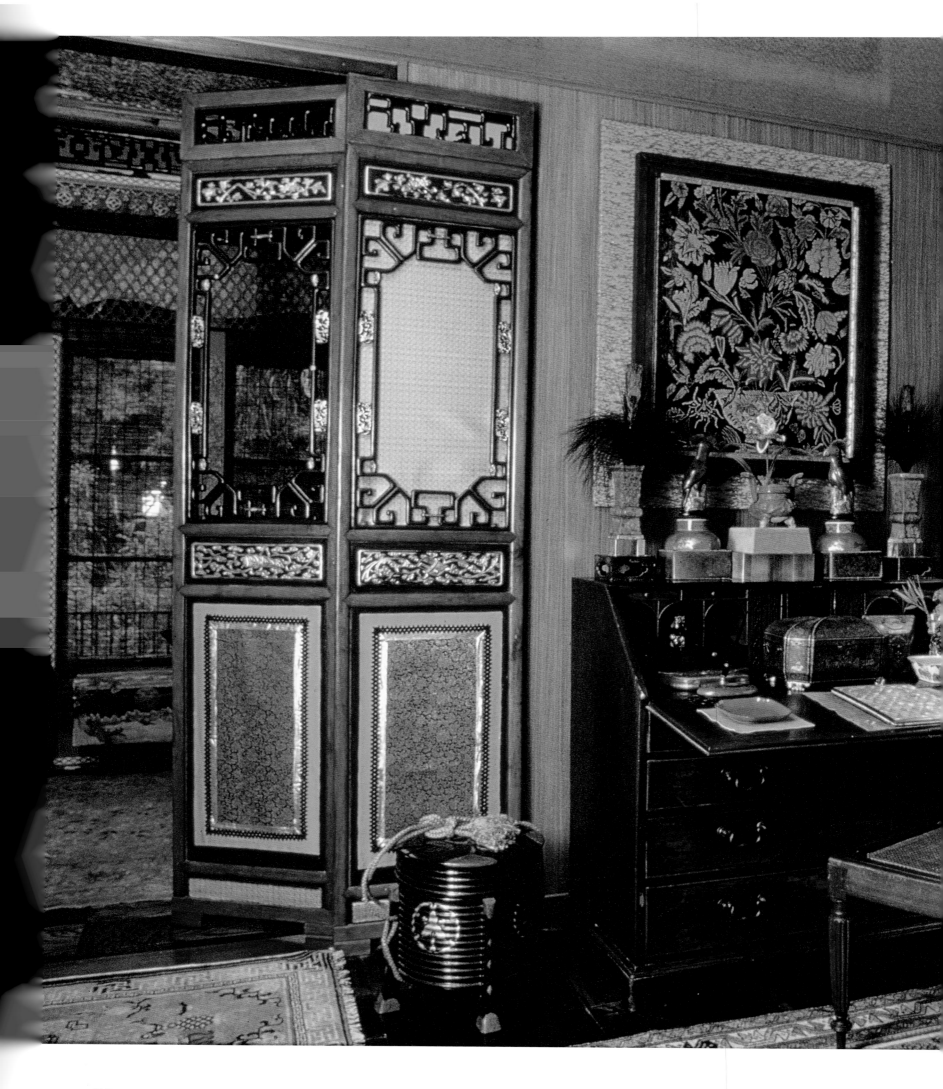

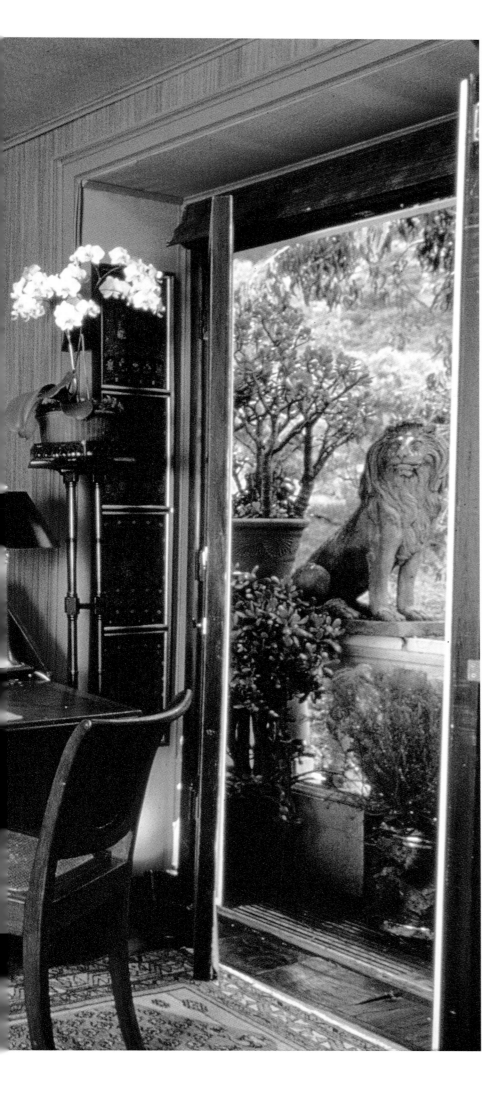

The Winter Bedroom, 1975.
An antique terracotta lion perches
on the balustrade outside the
Winter Bedroom's French doors.
Below: Detail of the antique Chinese
carved teak doors separating the
Winter Bedroom from the sleeping
alcove, 2018.

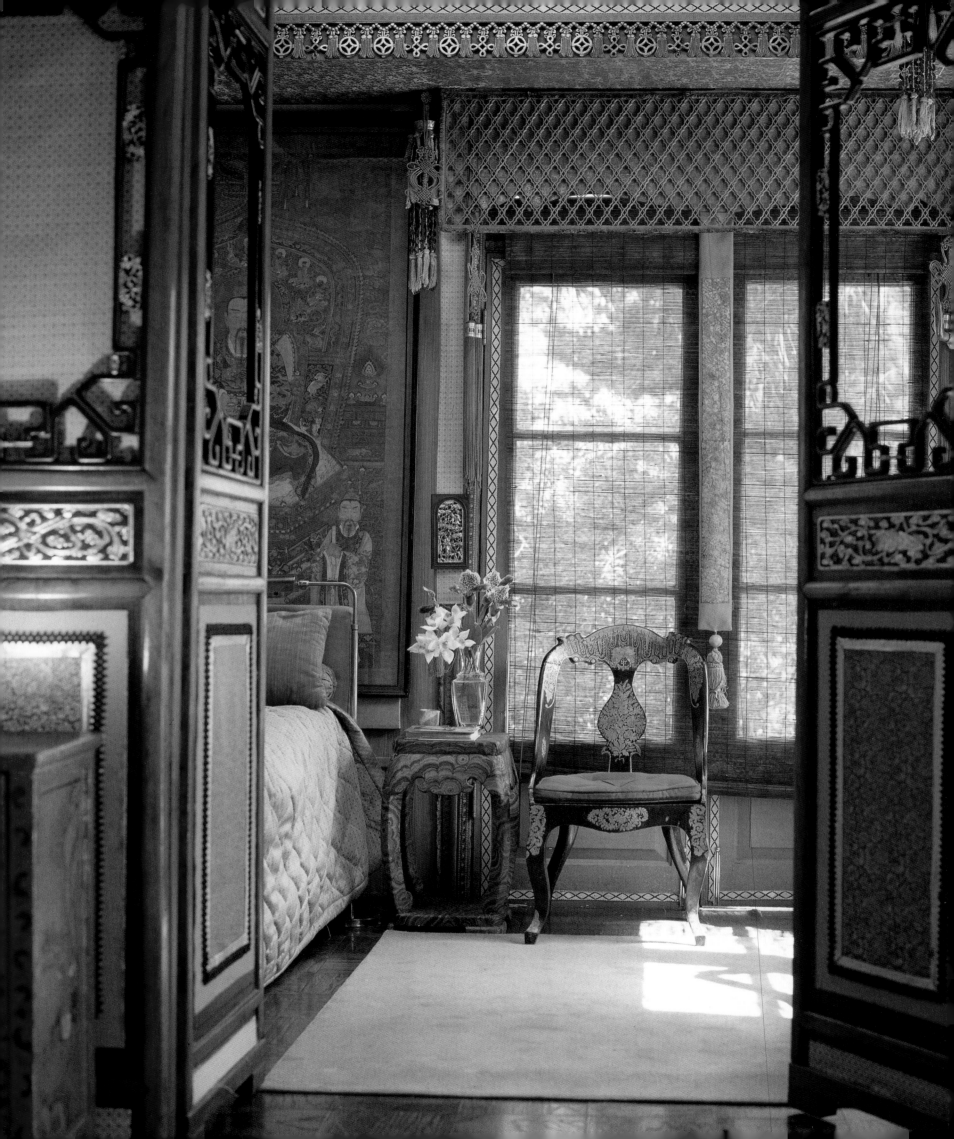

The sleeping alcove, 1975. The Duquettes purchased the nineteenth-century black-and-gold lacquer chair on a trip with Jim Thompson to Chiang Mai, Thailand. A Ming Dynasty panel hangs over the bed. **This page:** The alcove was redecorated with fabric that was printed for Tony by Jim Thompson in the 1960s (top right); Tony Duquette figural lamps, c. 1940, were also added to the room (bottom right); The bathroom is located off the Winter Bedroom, and a malachite-painted commode now stands where the tub once was (below).

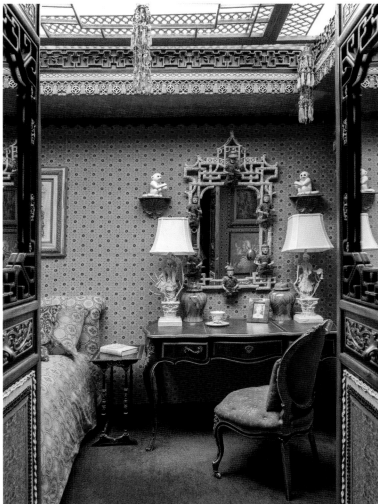

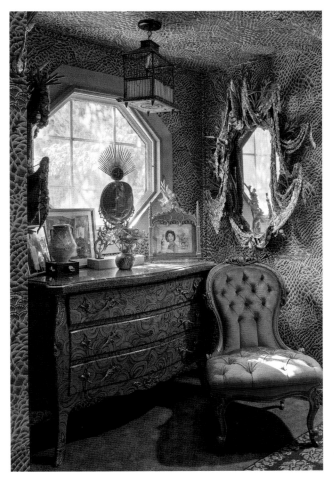

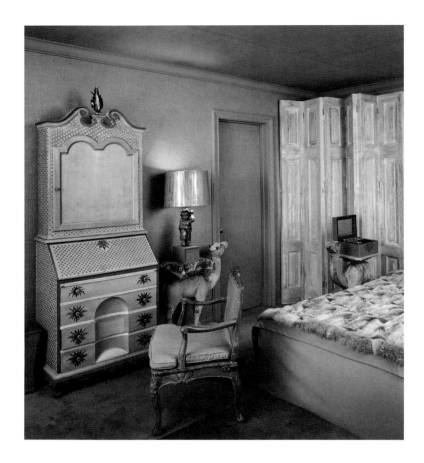

The staircase leading down to the summer and guest bedrooms, c. 1980. Tony paneled the stairway with antique grillworks and mirrors and carpeted the stairs and hall with his signature leopard-print carpet.

........................

Left and following page: The original master bedroom, 1949. The room's walls were upholstered in silver lamé, and folding screens, made from antique paneled doors, were placed in each of the four corners.

........................

Page 117: The Summer Bedroom, 1975. When Tony moved back to Dawnridge, the master bedroom became the Summer Bedroom. The room's original bed coverings featured Chinese embroidery over imperial yellow satin; carvings from China and Thailand helped complete the mise-en-scène.

The Summer Bedroom and Guest Bedroom

Dawnridge originally had only two tiny subterranean bedrooms—situated downstairs just under the Drawing Room—with windows that opened onto a terrace surrounded by an elegant balustrade overlooking the ravine below. The original master bedroom had walls covered in silver lamé with wall-to-wall carpeting on the floor. Tony decorated the room with old pine doors that had been bleached and pickled, and hinged together as folding screens. There were yellow linen draperies on the French windows, a vicuña throw on the bed, and a pair of carved Indian camels as night stands. An elegant secretary desk, which Tony had studded with nail heads and sequins, centered the wall across from the windows, and next to this was an eighteenth-century French chair.

In 1975, after the new Winter Bedroom was completed, the original master bedroom would become the Summer Bedroom.

Because it was built into the hillside on three sides, it was naturally cool in the summer and even colder in the winter. The new space upstairs was a warmer place to sleep in the winter, so the Duquettes moved their quarters with the seasons. In the stairway leading to the bedrooms, Tony paneled the walls with antique grillworks and mirrors and carpeted the stairs with his signature leopard carpet. He even installed an antique nineteenth-century Chinese pagoda as a newel post in this newly Orientalized stair hall. It was at this time that Tony replaced the wall-to-wall carpet in the Summer Bedroom with red lacquer squares topped with a custom Portuguese covered needlework rug in a leopard pattern. He draped the bed in antique Chinese embroideries and upholstered the walls with pink Thai silk. The headboard was covered with Tony's precious tiger skin patterned silk velvet. At the foot of the bed, Tony placed an antique Chinese grape-root table, part of a set he purchased from the Hearst collection, which he layered with leopard skin.

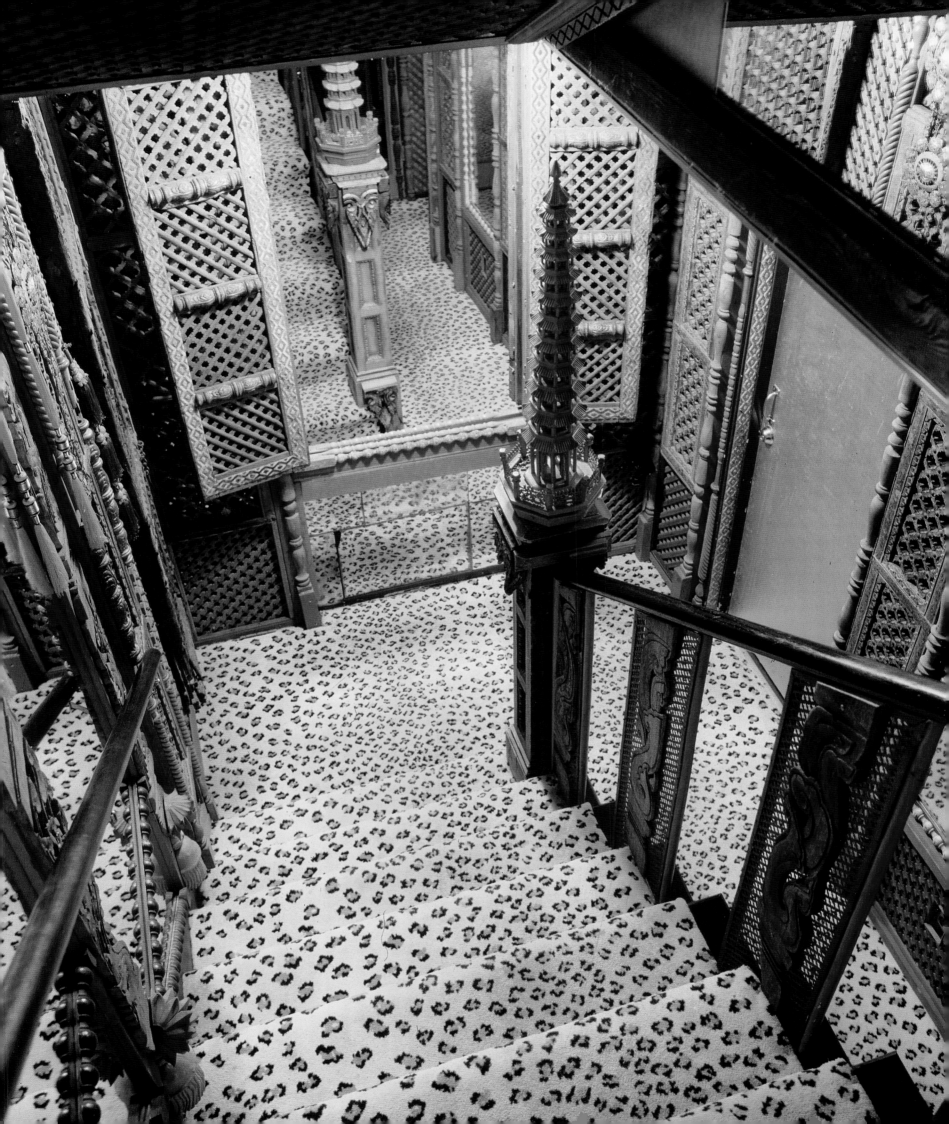

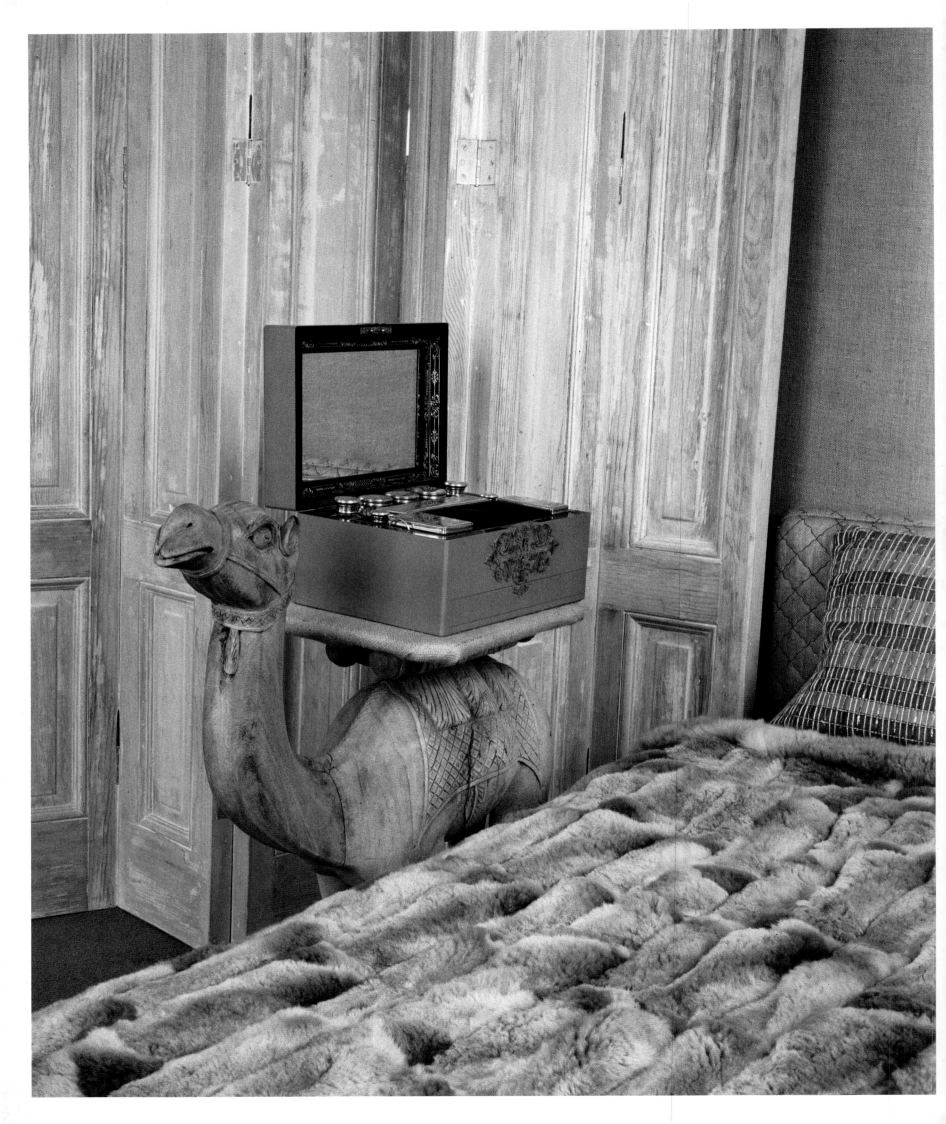

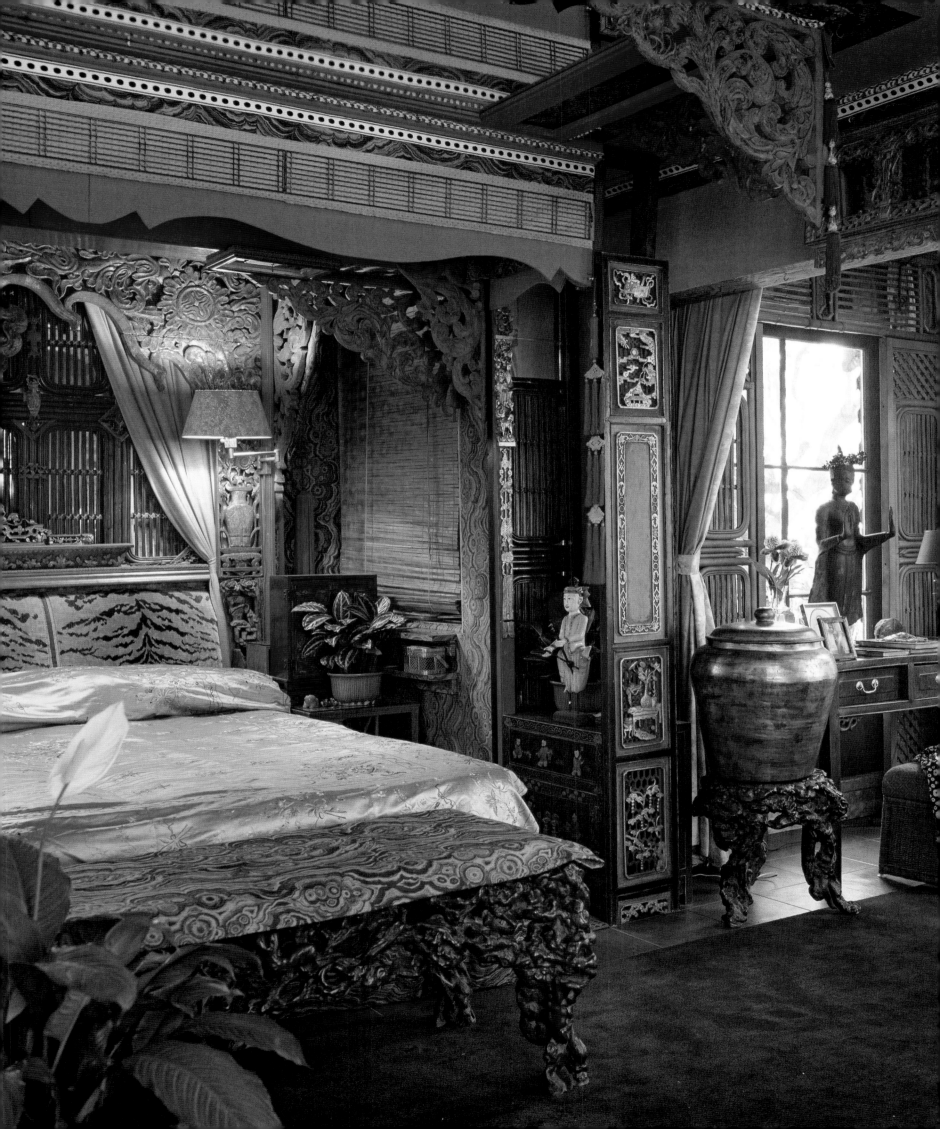

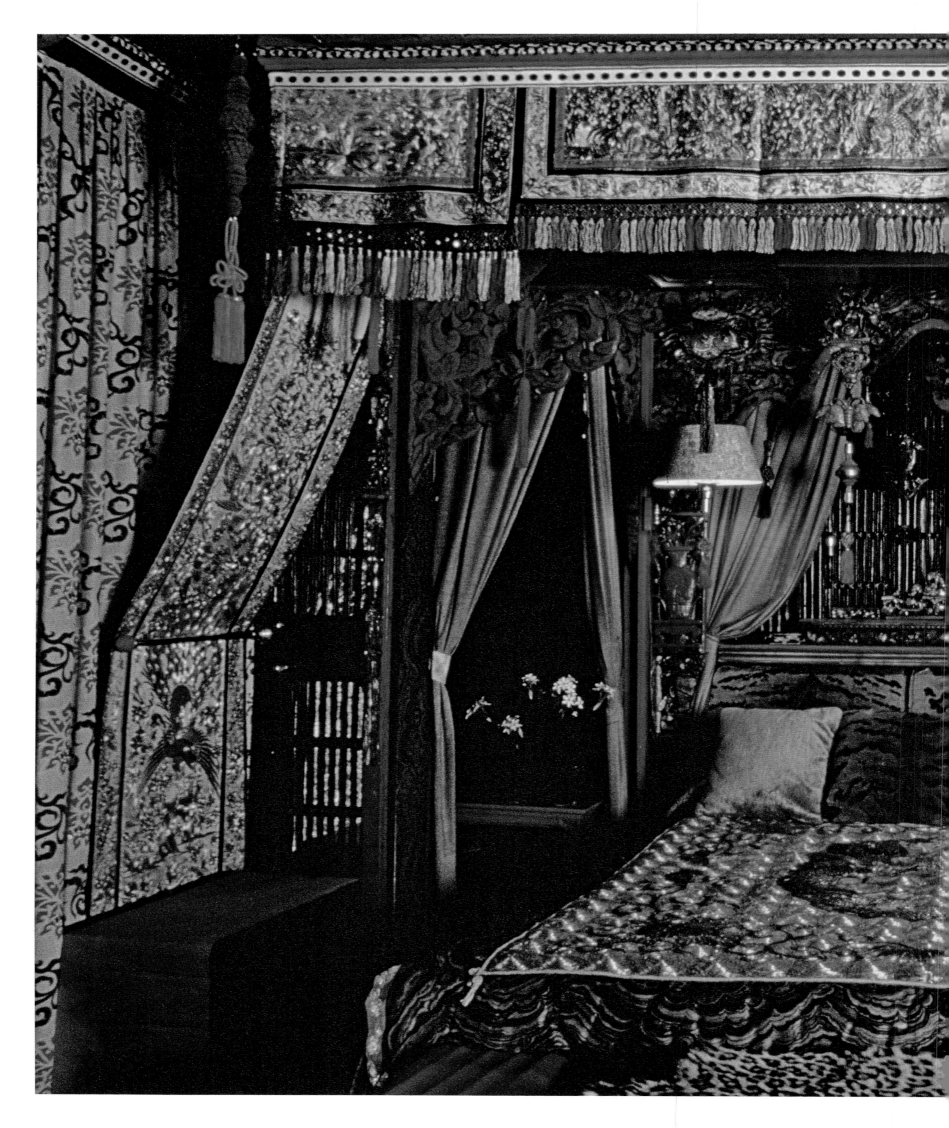

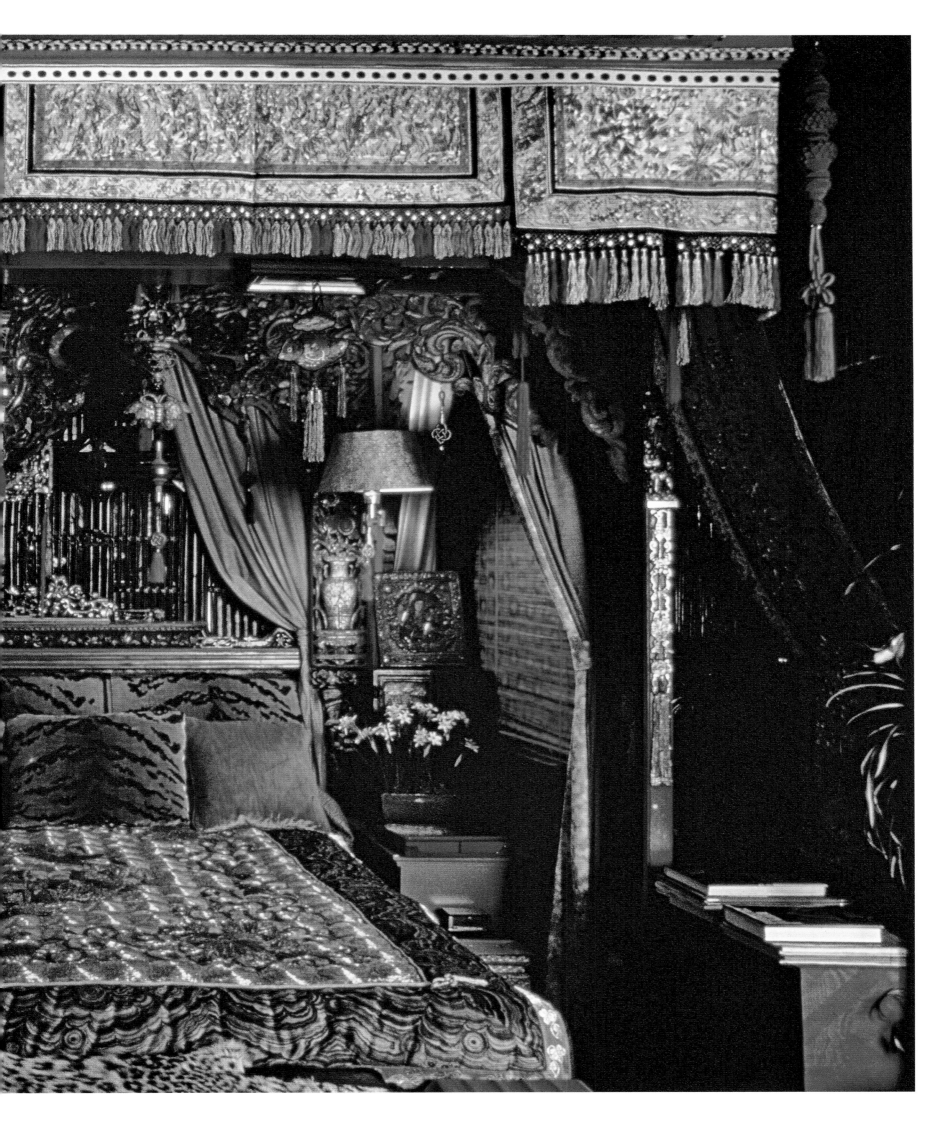

Previous spread: The Summer Bedroom, c. 1980s. Tony redecorated the bed alcove using an antique gold embroidered bedspread and installing silk hangings embroidered with silver threads overlaid with pink gauze.

........................

Opposite: Entrance to the dressing room, 1990. A pair of antique doors, with gilded Thai stands on either side, lead from the Summer Bedroom into Tony's expanded dressing room.
Left: The guest bedroom, 1949 (top) and 1990 (bottom). Tony transformed the guest bedroom into his dressing room in 1975 and decorated it with antique Asian carvings, bronze Buddhas, and red laquer.

The Summer Bedroom was only a fifteen-foot square, but the guest bedroom next door was even smaller—a mere fifteen-by-ten-foot hole in the wall. Tony used to say that the only benefit of this room was that "if you fall down, you can't hurt yourself because you'll definitely fall onto the bed!" He covered the First Empire bed with woven black-and-white Mexican carpets; the walls were covered with hand-painted eighteenth-century Chinese wallpaper. He also hung one of his original chandeliers decorated with Venetian glass flowers from the ceiling and placed two of his floral lamps on the chest of drawers. Tony used the guest bedroom as a dressing room, while Beegle had her own wardrobes and bathroom just off the adjacent master bedroom.

In 1975, Tony turned the guest room into a proper dressing room, creating a direct entrance through the Summer Bedroom next door. A pair of antique doors, covered with malachite-printed cotton, ecclesiastical trim of woven gold thread, and panels of antique Chinese damask now separated the two spaces. On either side of this new doorway, Tony placed gilded Thai stands holding cast-resin pagodas which he lit from within. The door pulls were antique Damascus steel inlaid with silver. Tony decorated the newly enlarged dressing room with antique Asian carvings, bronze Buddhas, and oriental rugs layered over the wall-to-wall leopard carpeting, a look that he and Doris Duke earlier christened as "Chow Fun."

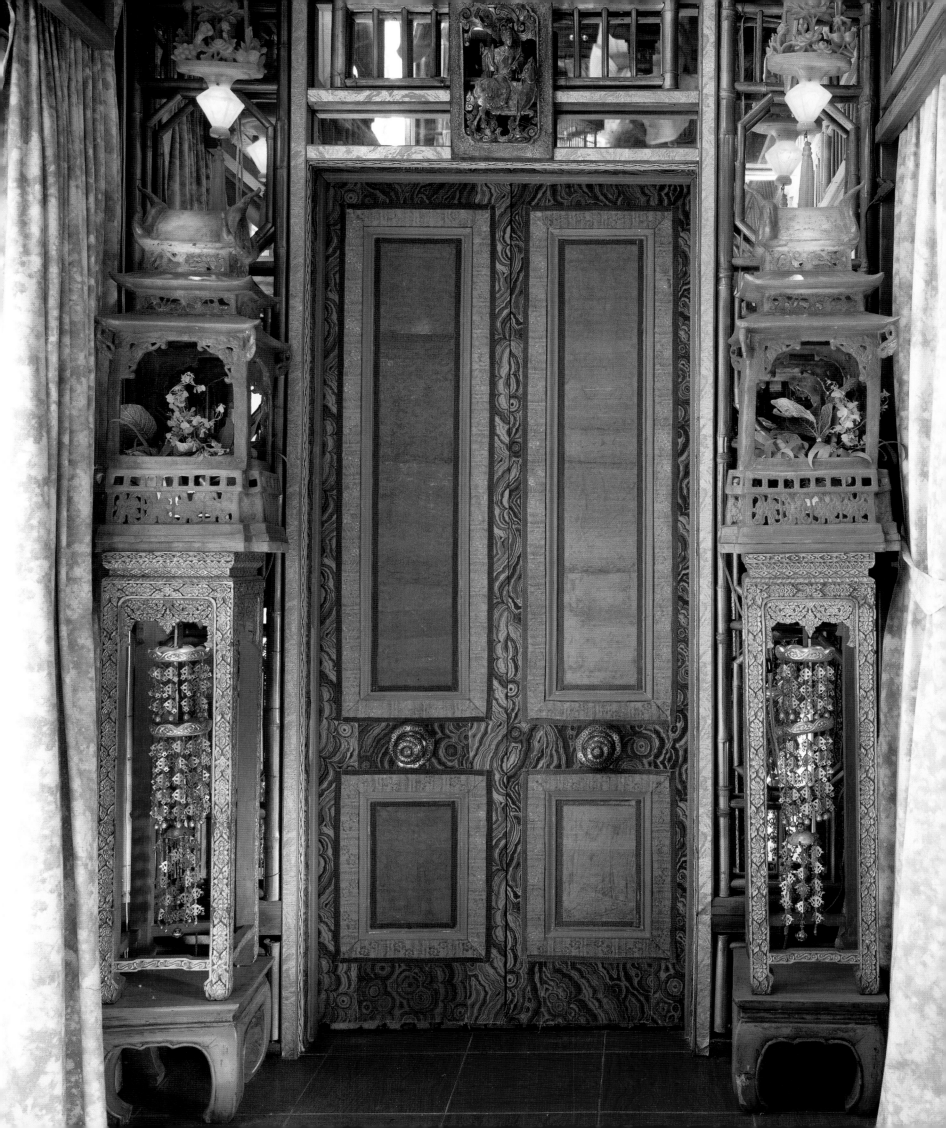

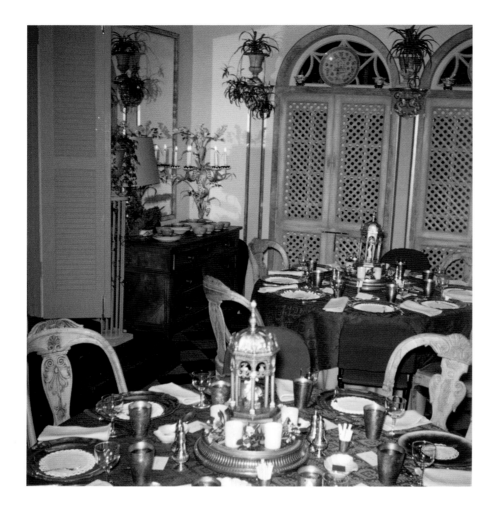

The dining room, c. 1975. After the fire from the house next door burned out the dining room, the arched windows were replaced with large paned windows. A pair of upholstered sofas form a seating area paneled with old Chinese doors and mirrors. **Left:** The dining room, 1949. Originally a one-car garage, the space was instead used for dinners and entertaining. Arched French doors from a wrecking yard were installed to create the feeling of a garden pavilion.

The Green Room

The Green Room started out as a one-car-garage in 1949. Tony immediately turned it into a dining room. In its original incarnation, the garage door—which is still in place—was hidden behind a drapery of old Fortuny printed cotton. In front of this, Tony placed a large oyster-veneered seventeenth-century English cabinet to hold china and linens. Arched French doors—salvaged from a demolition—were installed to take advantage of the room's southern exposure and to give the former garage the feeling of a garden pavilion. Beegle painted the decorative moldings with ermine tails, while Tony placed brackets on the walls to hold antique carved and gilded urns from Italy. Of course, the entire mise-en-scène was lit by one of Tony's original floral chandeliers in Peking glass, which sparkled in the many mirrors strategically placed to enhance the perspective of the magical space.

The room was tiny, but Tony was able, on occasion, to set up three tables of eight, so that twenty-four guests could be seated for dinner. As I've already mentioned, Tony liked to say, "People enjoy being crowded together at dinner parties. Sitting elbow to elbow, cheek by jowl, revives a primordial memory deep within them of sitting around a campfire and tearing from the same beast." At Dawnridge, before 1990, tables were always round and draped to the floor with ever-changing cloths. Tony and Beegle had a beautiful set of early nineteenth-century Venetian gondola chairs that he'd stripped and bleached. If additional seating was needed they'd add in gilded ballroom chairs.

After the fire in 1974, the arched French doors were replaced with large paned windows. Tony also added a pair of upholstered sofas to form a seating area at the end of the room, which was newly paneled with vintage Chinese doors and a mirror. In the 1990s, the dining chairs were bamboo finished in black lacquer and upholstered with Indonesian ikat–covered cushions.

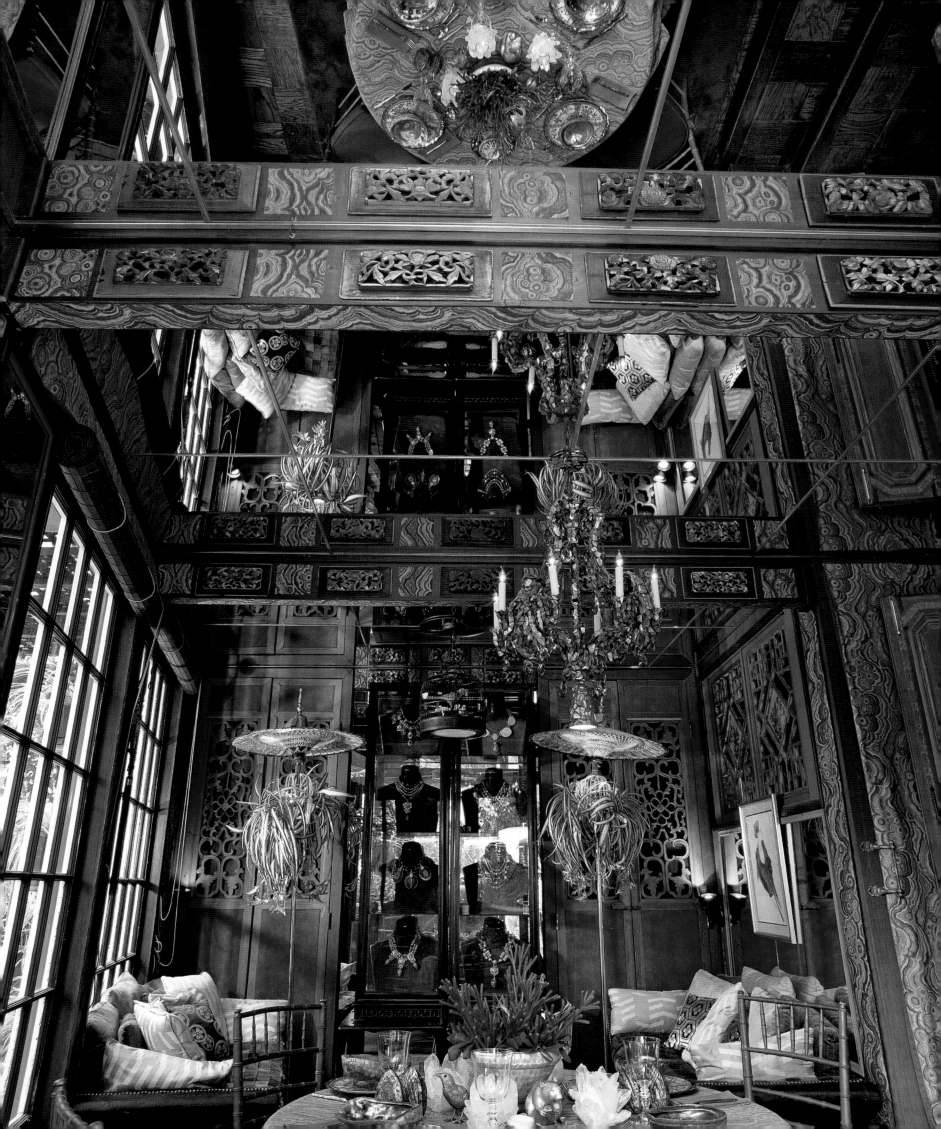

The dining room, c. 1990. The table is set with rock crystal votives holding an eighteenth-century gilded nef in the form of a Spanish galleon.

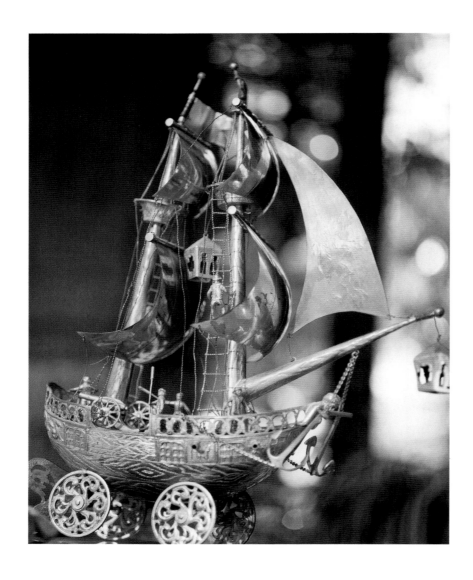

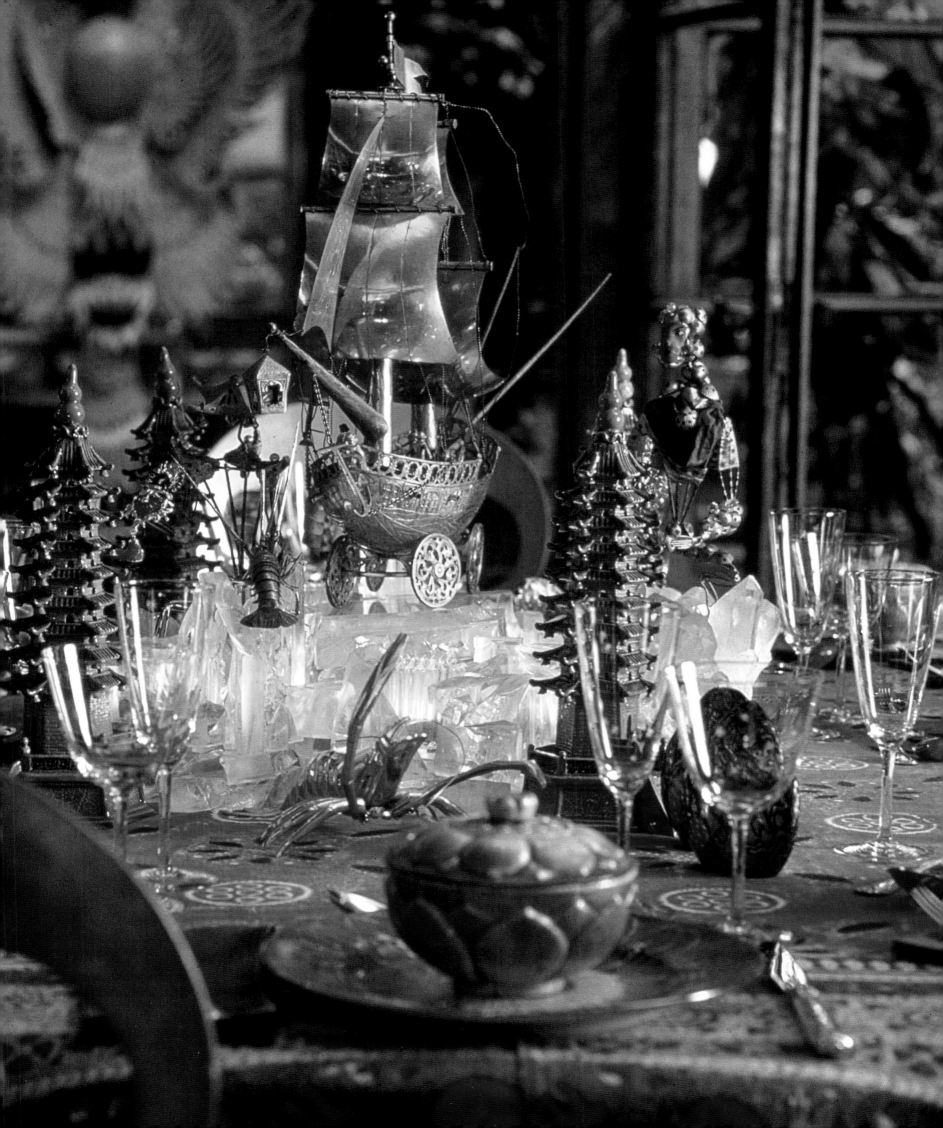

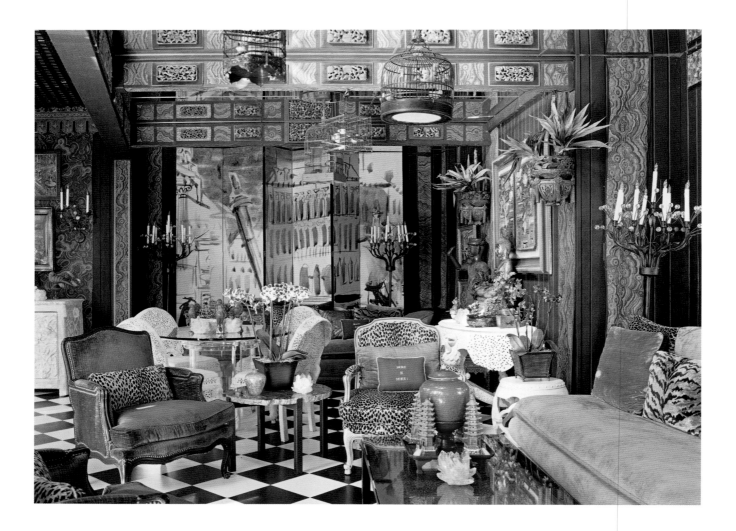

The Green Room, 2005. I transformed the old dining room into the Green Room, and made the folding screen (below) at the back of the room by blowing up an eight-by-eleven-inch pen-and-ink drawing of Venice created by Tony in 1947 on his first visit to Europe with Elsie de Wolfe.

At their dinners, the centerpieces were rarely floral—instead, they were made of large rock crystals paired with pearls on wires, coral branches in lacquered bowls, or Chinese figures, all surrounded by votive candles that "lit your face up . . . like the light from a campfire." Tony would constantly repeat this, and then remind me, "We don't eat by candlelight because it's romantic, but because it takes us back to the cave where we used to sit around an open fire and tell stories." Eighteenth-century papier-mâché temples of love; figurines he designed himself made of dipped plaster and rhinestones; seashells, taxidermy, and precious antique objects all appealed to his sense of theater whenever setting a table for a festive occasion. To create a different look each time guests were at dinner, sets of dishes were used on a revolving basis; Tony would pair them with vermeil chargers engraved with his crest, simple painted

tin plates from Haiti, or priceless Chinese porcelain dishes. In the 1950s Tony and Beegle took every piece of silver that they could lay their hands on to Tiffany's to have it gold-plated. He often patted himself on the back, telling me of his prescience at knowing that gold was actually cheap back then. Because of this, they had sets and sets of cutlery to choose from. Crystal and Venetian glass goblets were paired with gold-plated silver cups that were always used for water.

After Ruth and I purchased Dawnridge, we converted the old dining room into the Green Room, named for its dominant color scheme, and today it's most often used as a place to serve cocktails before dinner. Part of the ceiling is still mirrored—just as Tony had designed it—with malachite-patterned fabric-covered beams studded with antique Chinese carvings and panels of abalone. We covered the ceiling on the side of the room

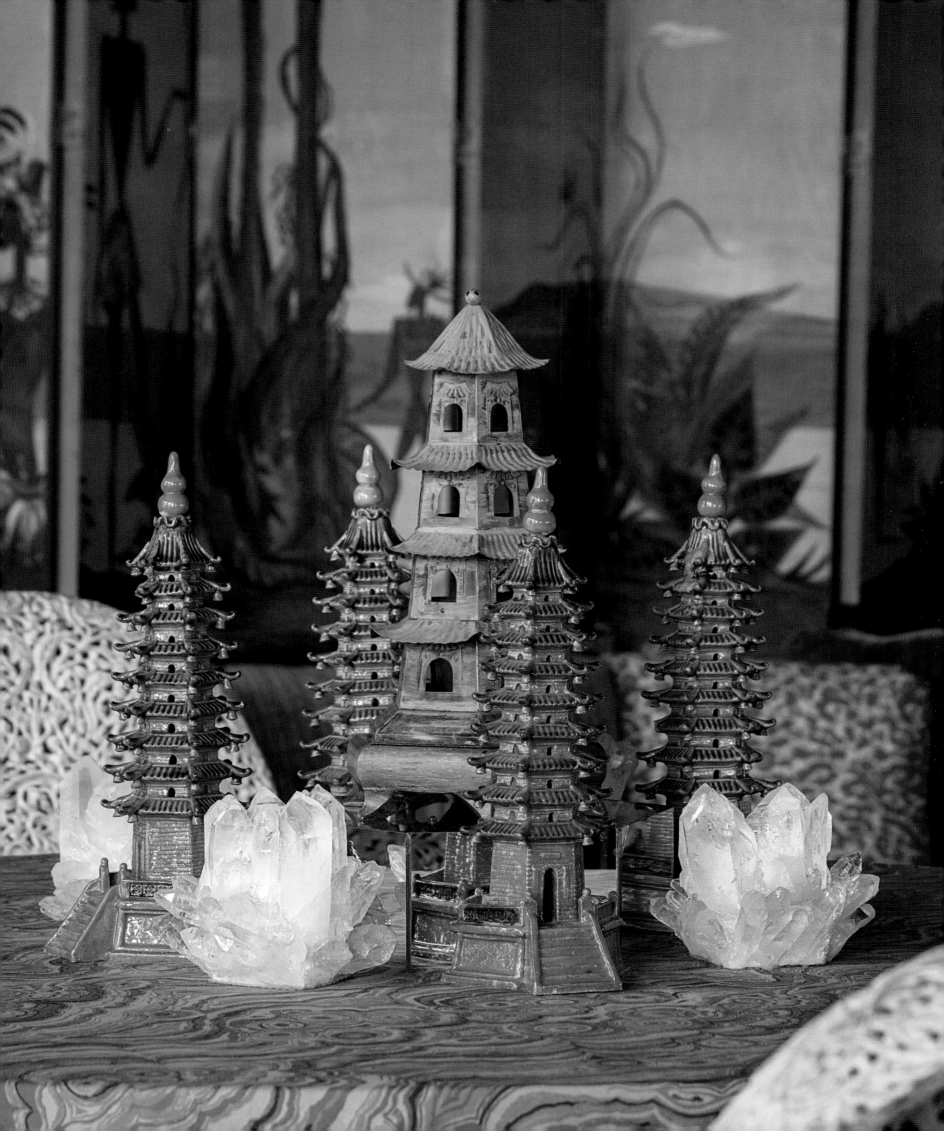

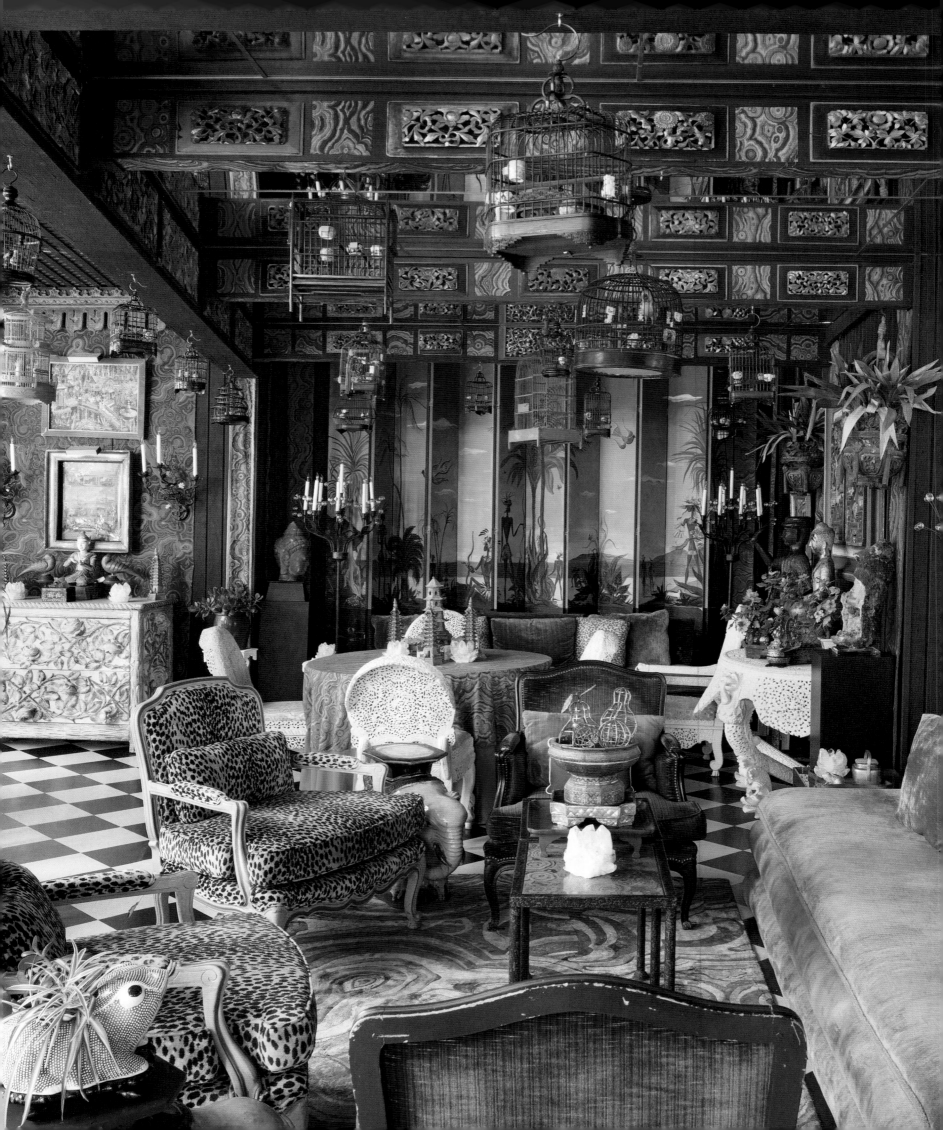

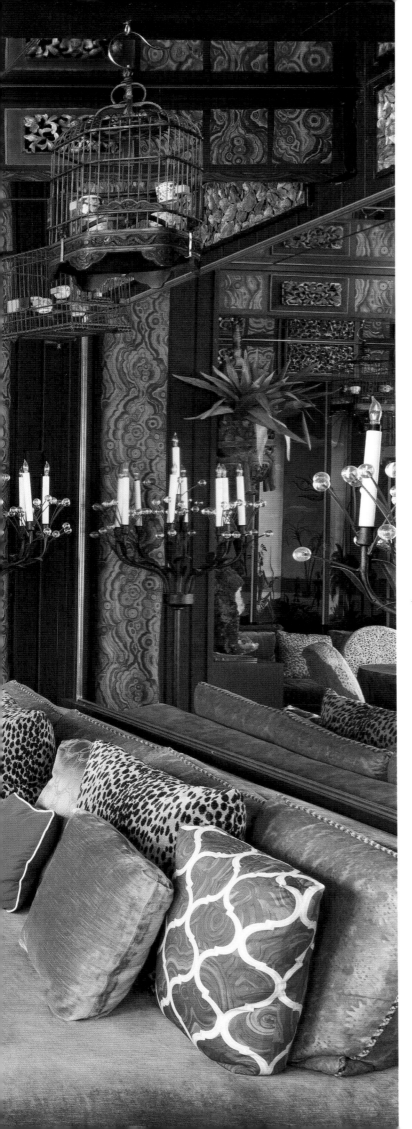

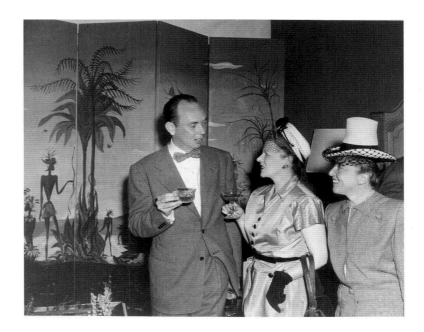

The Green Room, 2018. The room now includes a folding screen created by Tony Duquette for his first one-man exhibition in 1947. **Below:** Duquette standing in front of his screen at his exhibition at the Mitch Leison Gallery, 1947.

closest to the garden with Mylar, and then overlaid it with dark green painted lattice and finished it with an antique French copper valance. We overlaid the dark green board-and-batten walls with strips of Tony Duquette for Jim Thompson malachite-printed cotton and installed a Tony Duquette malachite-patterned silk carpet. At the back of the room, we installed a folding screen that Tony created for his first one-man exhibition in 1947. The screen was later used by Adrian before being sold to Tony's client and best friend Patricia Hastings Graham. It recently returned to Dawnridge as a gift from Mrs. Graham as part of her estate. Our recent redecoration of the room included the expansion of Tony's collection of antique birdcages, which are now hanging all over the ceiling. The new Green Room curtains are Tony Duquette for Jim Thompson Gemstone printed cotton in lapis lazuli blue. A black-and-white-checkered floor has also been installed on the diagonal, and the addition of three conversation groups of furniture and a table for dining completes the look.

The centerpiece on the skirted table features Tony's *Modern Fruit*, which he created for his one-man exhibition at the Louvre in 1951. The skeletal fruit in gilded brass has been placed in a mother-of-pearl bowl surrounded by Ming parrots, rock-crystal votives, and abalone shell salt and pepper shakers. I painted the carved Indian blackwood furniture white, and placed antique Asian artifacts on the side tables.

The Green Room, 2018. In the corner, Tony's rose chest has a number of objects on display, including a carved Indonesian figure sitting on top of a Chinese imperial yellow porcelain stand, a nineteenth-century lacquer box holding a Lalique Buddha, and carved Indian parrots perched on red-lacquer stands from Thailand.
Right: A Tony Duquette *Insect Man* sculpture poses in front of the lapis luzuli Tony Duquette Gemstone curtains by Jim Thompson.

In one corner of the Green Room, near the door leading out to the terrace, I added the Rose Chest, which was Adrian's favorite piece of furniture and used by Cecil Beaton in Mrs. Higgins' house in the film *My Fair Lady*. Hanging directly above the Rose Chest—and around the room—are the late Julian La Trobe's paintings of Dawnridge and a pair of eighteenth-century floral French sconces. The tablescape on top of the chest includes a carved Indonesian figure sitting on top of a Chinese imperial yellow porcelain stand; a nineteenth-century lacquer box holding a Lalique Buddha; and a pair of carved Indian parrots perched on red lacquer stands from Thailand.

I placed an antique French desk painted in a malachite pattern by Scarlett Abbott in front of the window. The desk—flanked by a pair of Chippendale Chinese étagères holding blue and white porcelains—has a tablescape which includes a stuffed cockatoo wearing a miniature Thai crown, a pair of wire-and-plaster lizards made by Tony for his client Cobina Wright,

Tony's *Insect Man* sculpture, a small painting by Elizabeth Duquette, and a 1940s Duquette Ashtray Man holding a votive candle. Two coral-painted birdcages and an antique Chinese lantern have been electrified to bring light into the space. The two Venetian stools on each side of the desk are upholstered in Tony Duquette for Jim Thompson Royal Ermine.

Another corner of the Green Room, near the entrance to the Drawing Room, includes a sofa designed by Tony for Doris Duke's Falcon Lair and Louis XV chairs upholstered in Tony Duquette for Jim Thompson Gemstone fabric in lapis lazuli blue. Chinese glass cabinets on each side of the door display *Talismans of Power*. Opposite the cabinets are a Thai spirit house and Tony's original giant clam shell étagères holding cascading spider plants. The étagères were originally designed for the producer Arthur Freed to display Phalaenopsis orchids in. As a final touch, I created the coral branch, Lucite, and iron chandelier to hang above the newly expanded space.

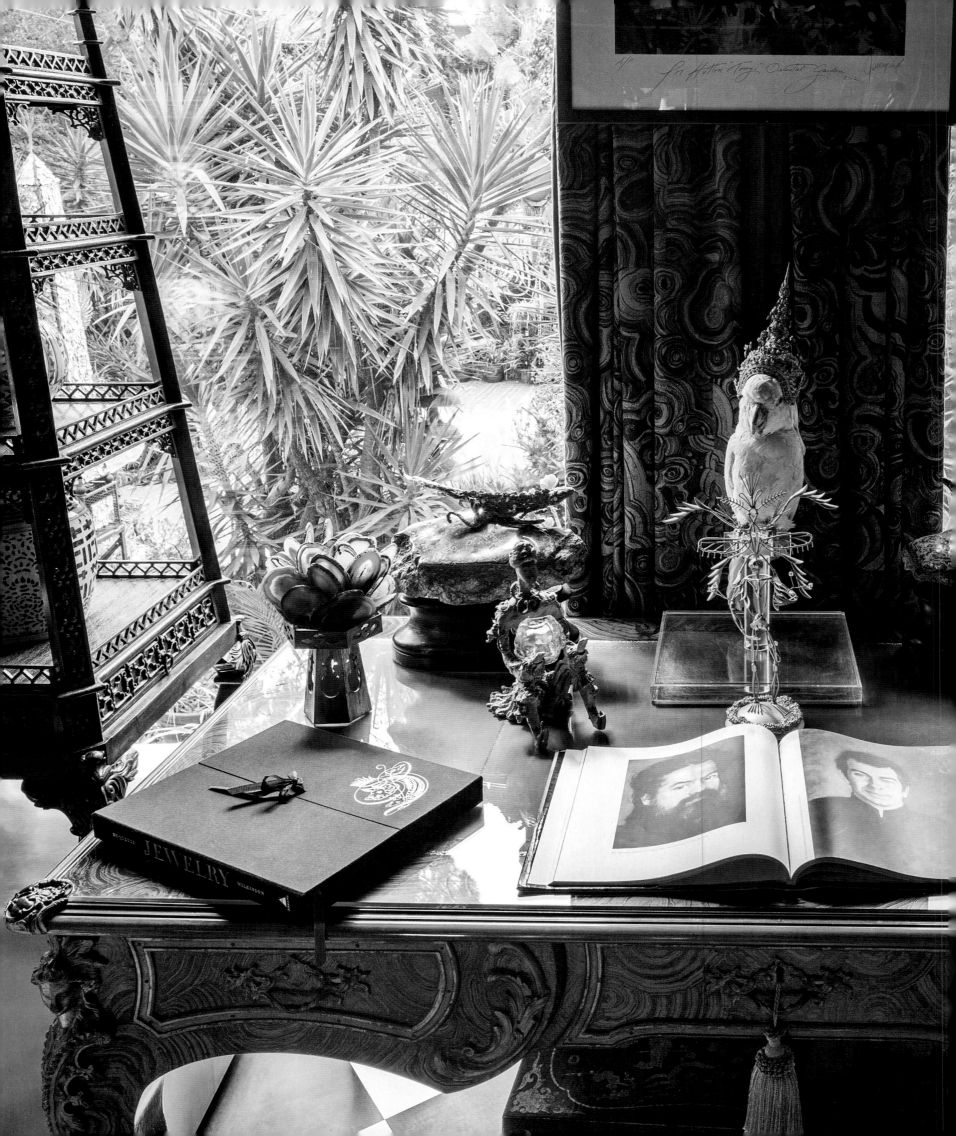

The Green Room, 2018. By the
window is an antique French desk
with ormolu mounts that was
painted for Tony Duquette by Scarlett
Abbott in a malachite pattern. The
desk holds bibelots including a stuffed
cockatoo wearing a miniature Thai
crown in a Lucite case.

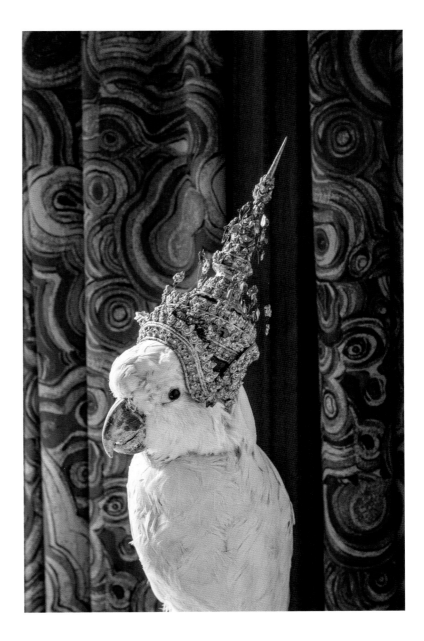

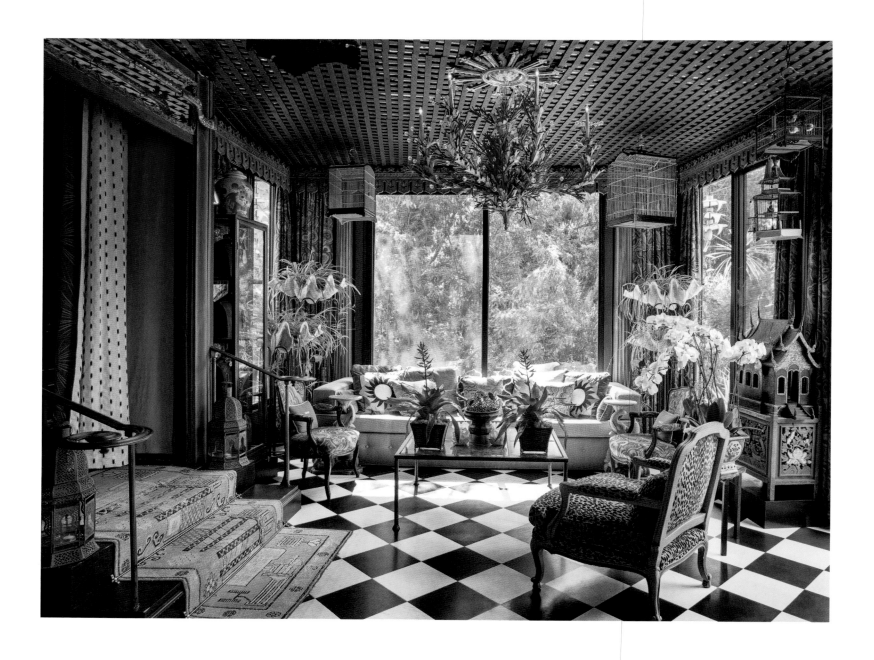

The Green Room, 2018. The sofa was designed by Tony Duquette for Doris Duke's "Falcon Lair" in 1952, paired here with Louis XV chairs. I created the coral branch, Lucite, and iron chandelier for this space in 2005.

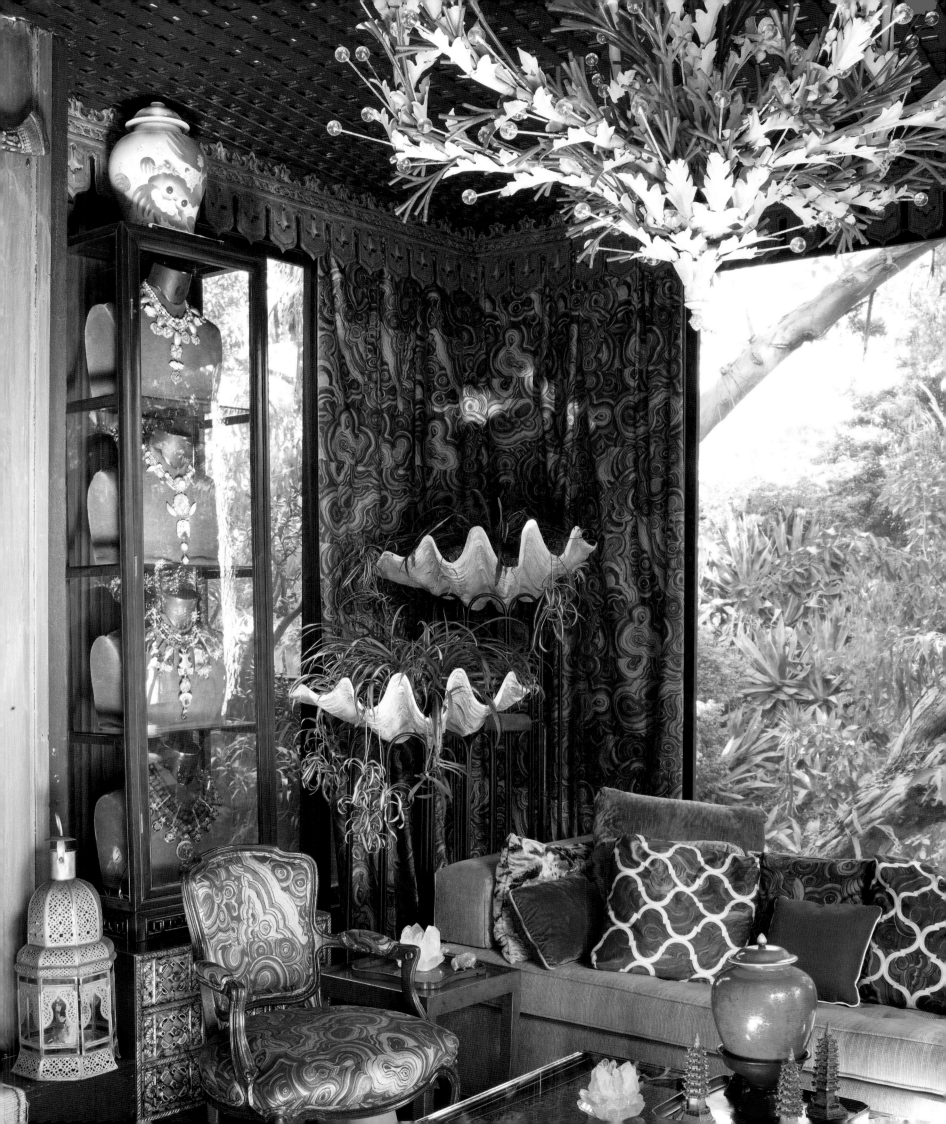

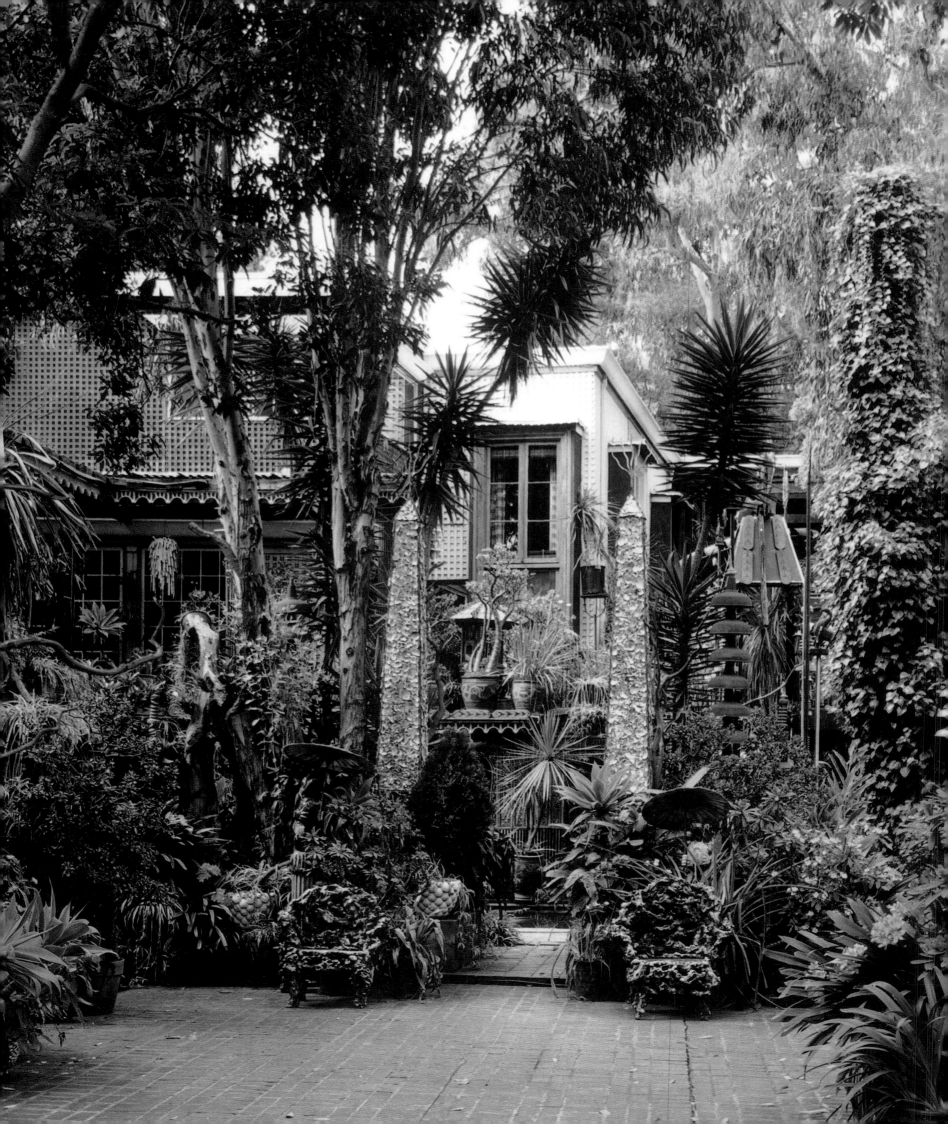

The Gardens

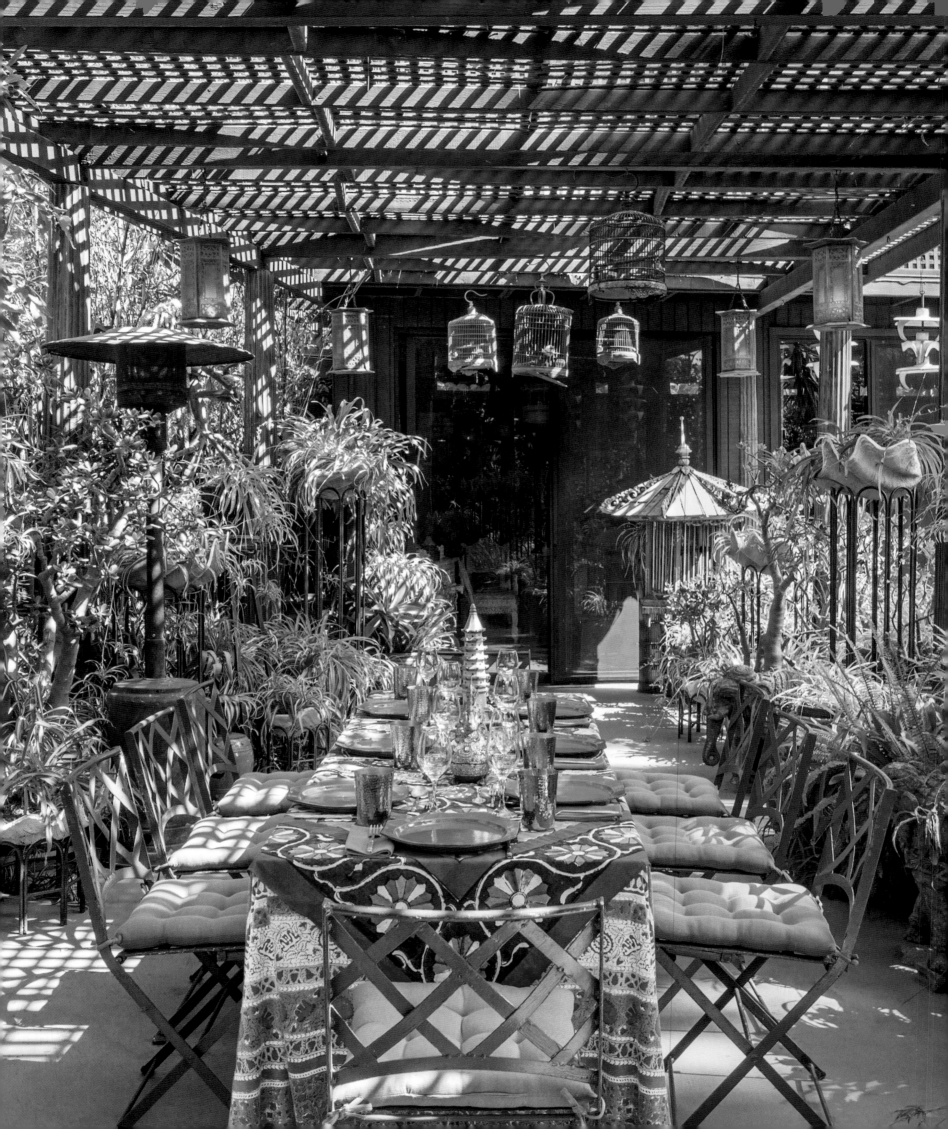

The Upper Terrace, 2018. Lunch alfresco is often served here. Antique copper columns recycled from Los Angeles streetlamps hold up the lattice ceiling, and birdcages, carved Indian elephants, and a collection of antique Chinese ceramic pots complete the decoration.
Below: The original terrace located off the bedrooms at Fiddler's Ditch, 1949.

Upper Terrace

The gardens at Dawnridge are laid out on three levels. The 15-by-40-foot upper terrace is really an extension of the Green Room; here, when the weather is fair, lunches and dinners are served at a long table under the green lattice trellis which is supported by pillars made from recycled copper streetlights and hung with antique birdcages and cast-resin Chinese lanterns that glow at night. Among the plants in diverse vessels—from antique Chinese ceramic pots to mundane black plastic containers, some direct from the nursery, others stenciled by Tony in gold with patterns of lace—that line the terrace are Tony's giant clamshell étagères, antique Thai spirit houses elevated on metal army surplus stands, Indian birdhouses, and a 1930s store-display cabinet that holds a terra-cotta lion.

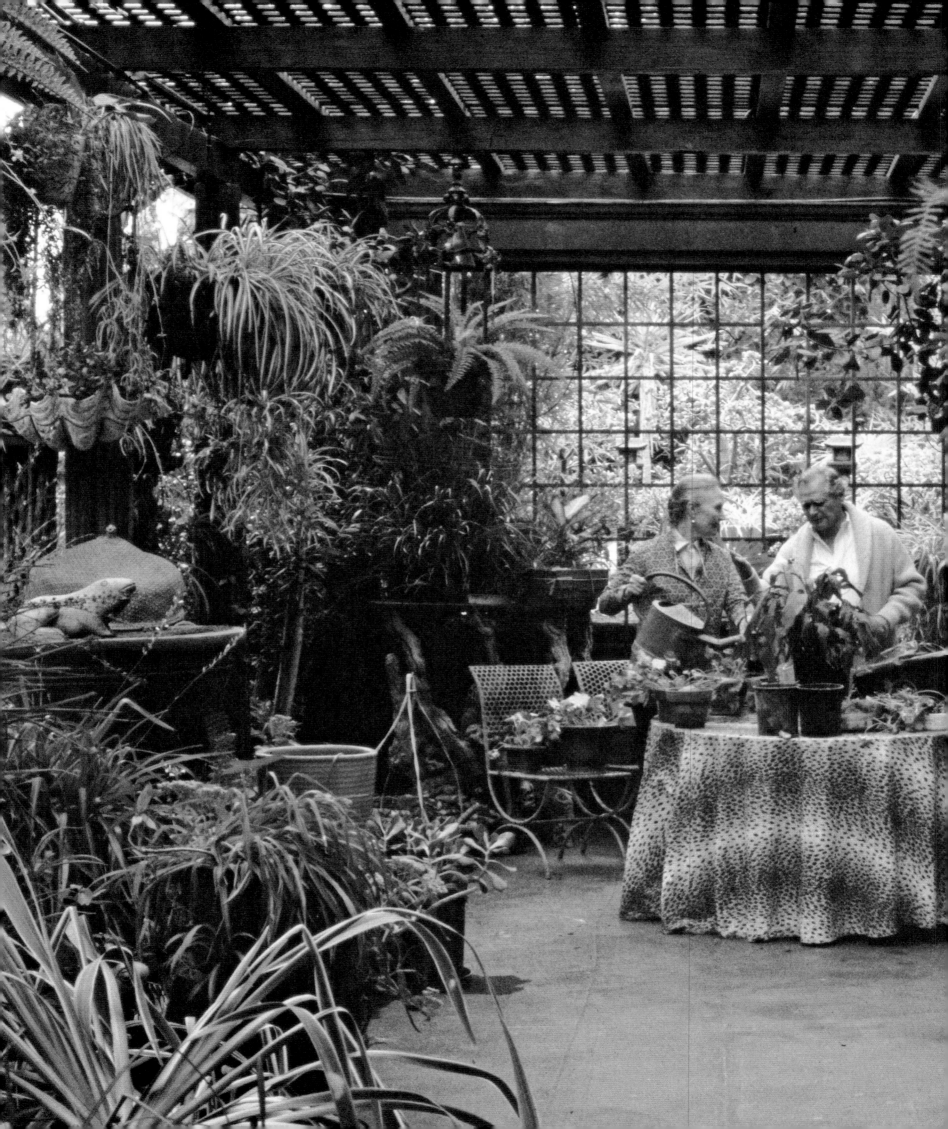

Beegle and her brother
Ronald Johnstone on the
Upper Terrace, 1975.
Ronald Johnstone was a
respected art director
in New York City. As a student
at Chouinard Art Institute
in Los Angeles, he worked for
Tony on special projects
at Bullock's Department Store.
It was Ronnie who introduced
his sister to Tony.

Top: The Upper Terrace, c. 1980.
Bottom and opposite: Staircase leading
down from the upper terrace to the
middle terrace. In the 1980s, the staircase
was flanked by two carved wooden deer
from Thailand. These have since been
replaced with two objects: a wire, resin,
and glass pagoda made for Adrian in the
1940s and a giant iron and resin obelisk
made by Tony for the Los Angeles Opera
Guild production of *The Magic Flute*.

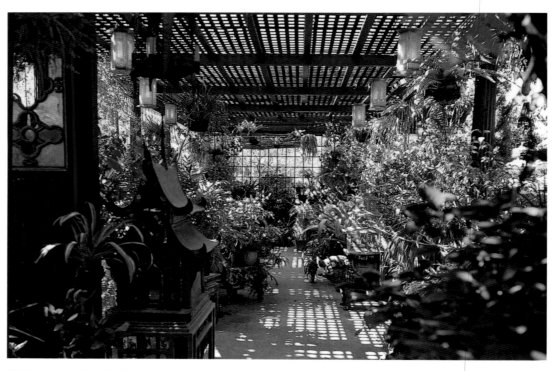

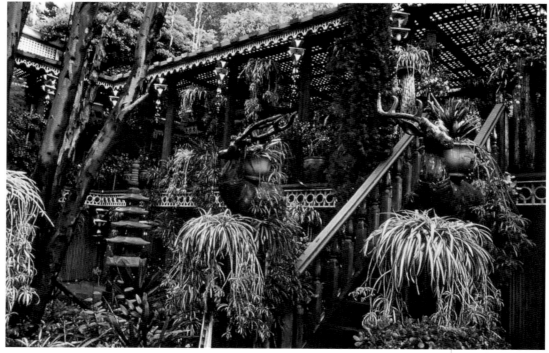

The Middle Terrace, 2018. The garden is dotted with intricate sculptures and carved statues. One of them—a giant carved wooden elephant from India (opposite)—was too large to fit inside the warehouse, so it ended up in the garden.

........................

Following spread, from left: Tony Duquette's 28-foot-tall sculpture, *Phoenix Rising From Its Flames*, 1995; Entrance to the swimming pool, 1995. The iron obelisks, which originally stood at the entrance to Dawnridge in 1949, were placed in the garden next to eighteenth-century Chinese grape-root grotto chairs from the Hearst Collection.

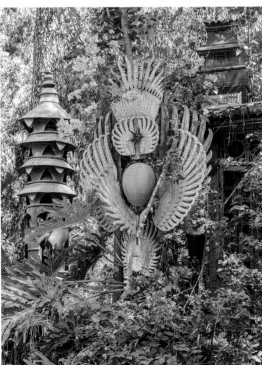

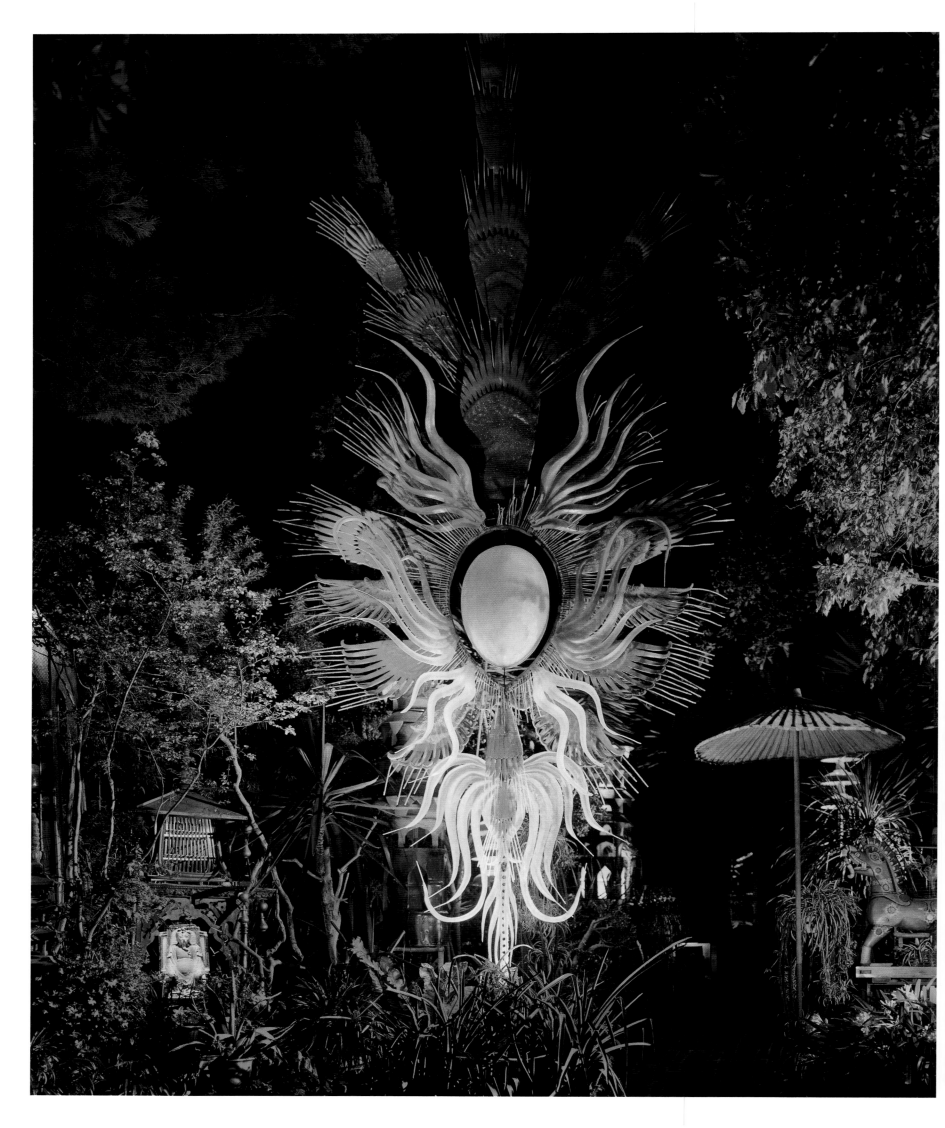

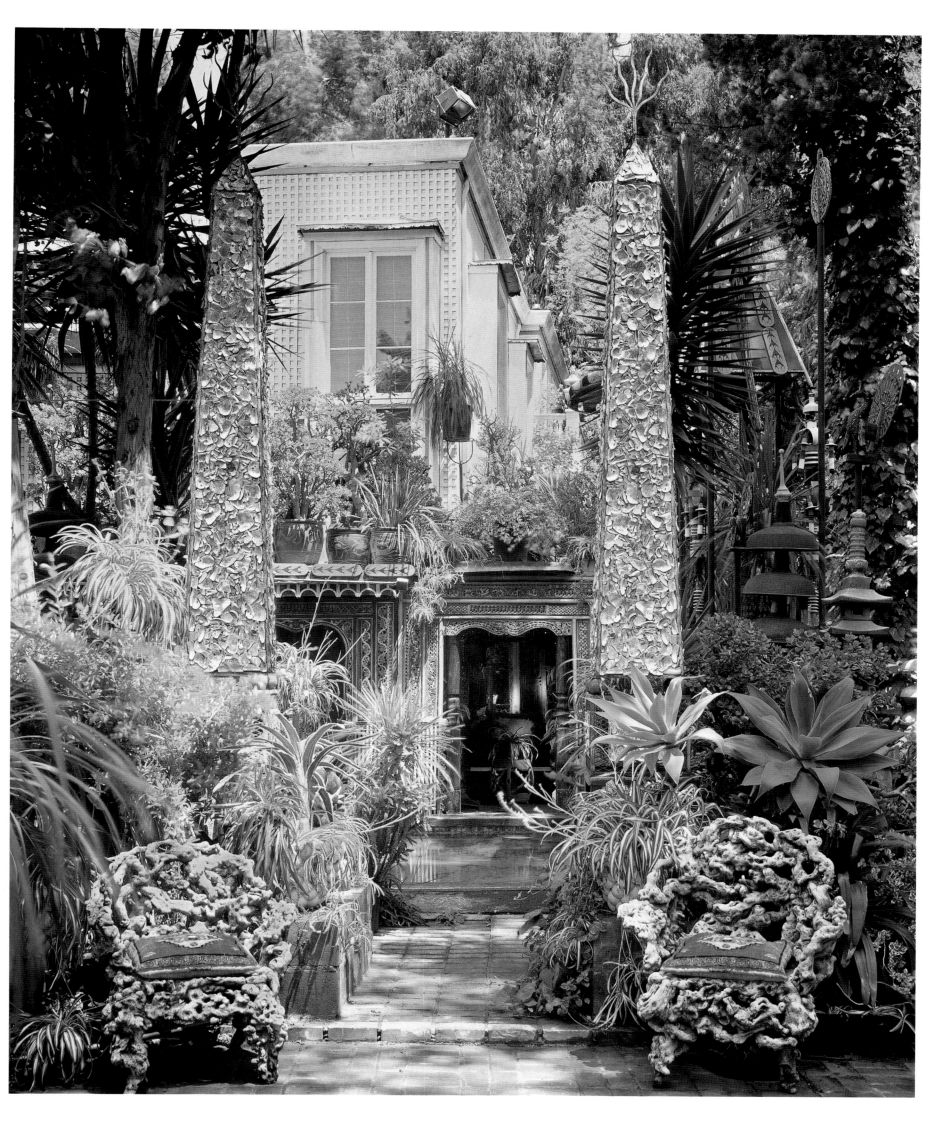

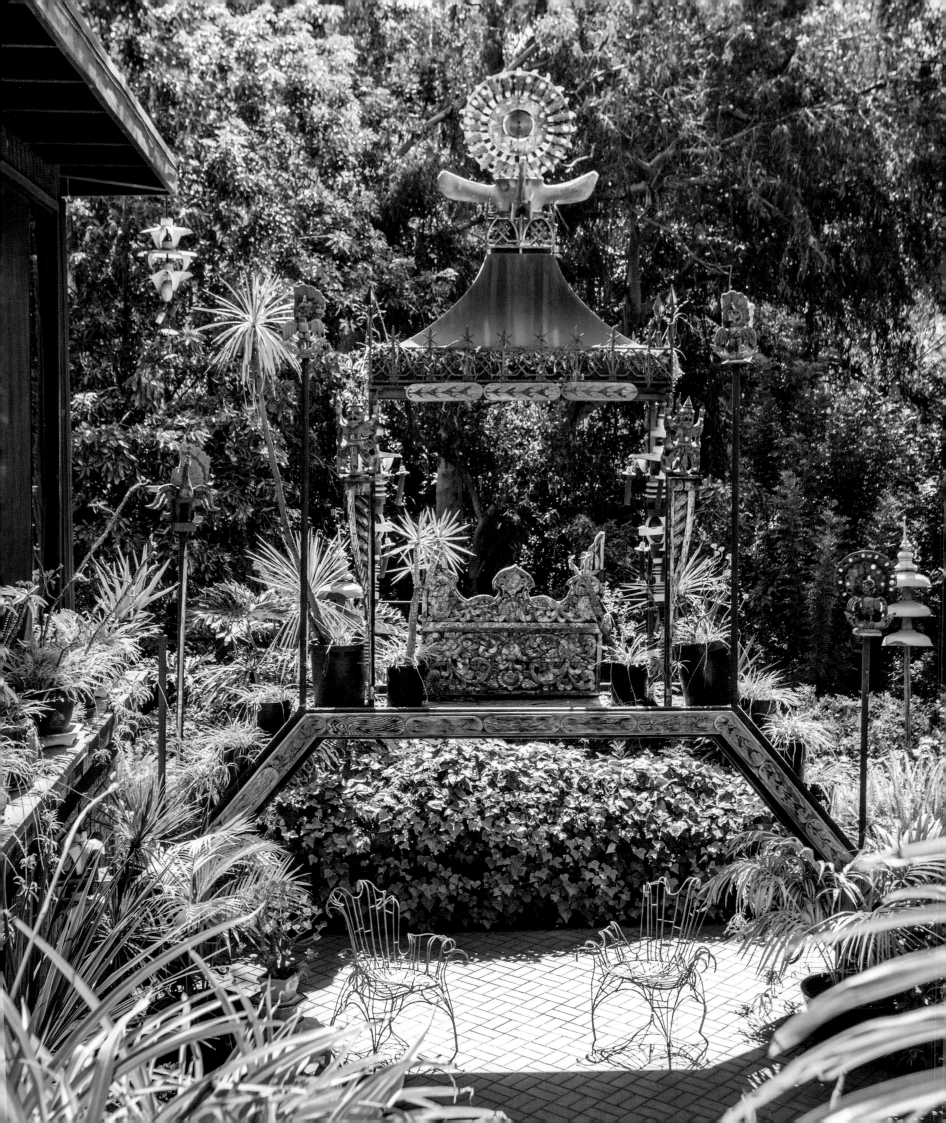

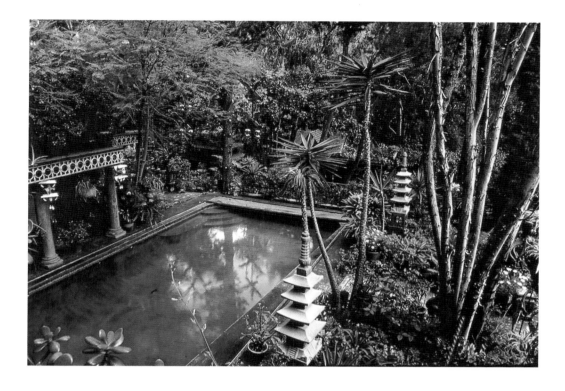

In the 1970s Tony and Beegle put a swimming pool at one end of the middle terrace. The entrance to the pool was flanked by iron obelisks that had originally stood sentry on each side of the front door of the house in 1949. Tony later covered the obelisks with abalone shells and moved them to the ballroom on Robertson Boulevard before bringing them back to Dawnridge. At the far end of the swimming pool, he placed a small bridge—purchased at an army-navy sale—that held a shrine made of Thai carvings topped with a conglomeration of a sunburst, a cast resin whale vertebrae, and caution reflectors normally used on freeways. All of this and more went into the creation of this unique architectural feature. After I purchased the home in 2000, I removed the pool, replacing it with a dance floor, but left the obelisks and the bridge. Tony surrounded the swimming pool, now the dance floor, with arches made from Indonesian carvings. Before the Duquette Collections sale at Christie's, a pair of eighteenth-century Chinese grape-root grotto chairs from the Hearst Collection sat on each side of the entrance to the swimming pool.

The garden is studded with Tony's original pagoda-shaped lamps, which he created with electrical fixtures—purchased from an army-navy surplus store—stacked one on top of the other. Used oil drums, which Tony had pierced with designs and intricately painted, serve as towers dramatically lit from within, and decorative tassels made from discarded electrical fixtures and painted gun shells hang from beams and cornices everywhere you look. The contents of a defunct skateboard factory—a fortuitous find—provided Tony with an enormous supply of orange-painted skateboard platforms stenciled with black flames. He used these painted elements to create friezes and cornices on many of the garden structures at Dawnridge. With Balinese umbrellas and eighteenth-century Chinese grotto furniture added to the mix, the style is indescribable!

The Middle Terrace, 1995.
The pavilion (below) serves as
an archway onto a platform
that hangs over the raven below.
The garden path (right) leads
to Casa La Condesa.

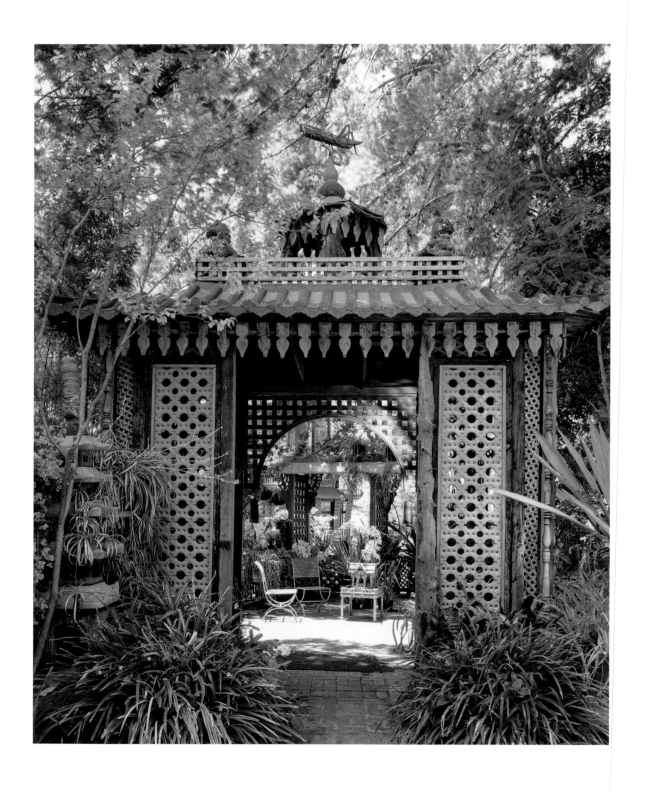

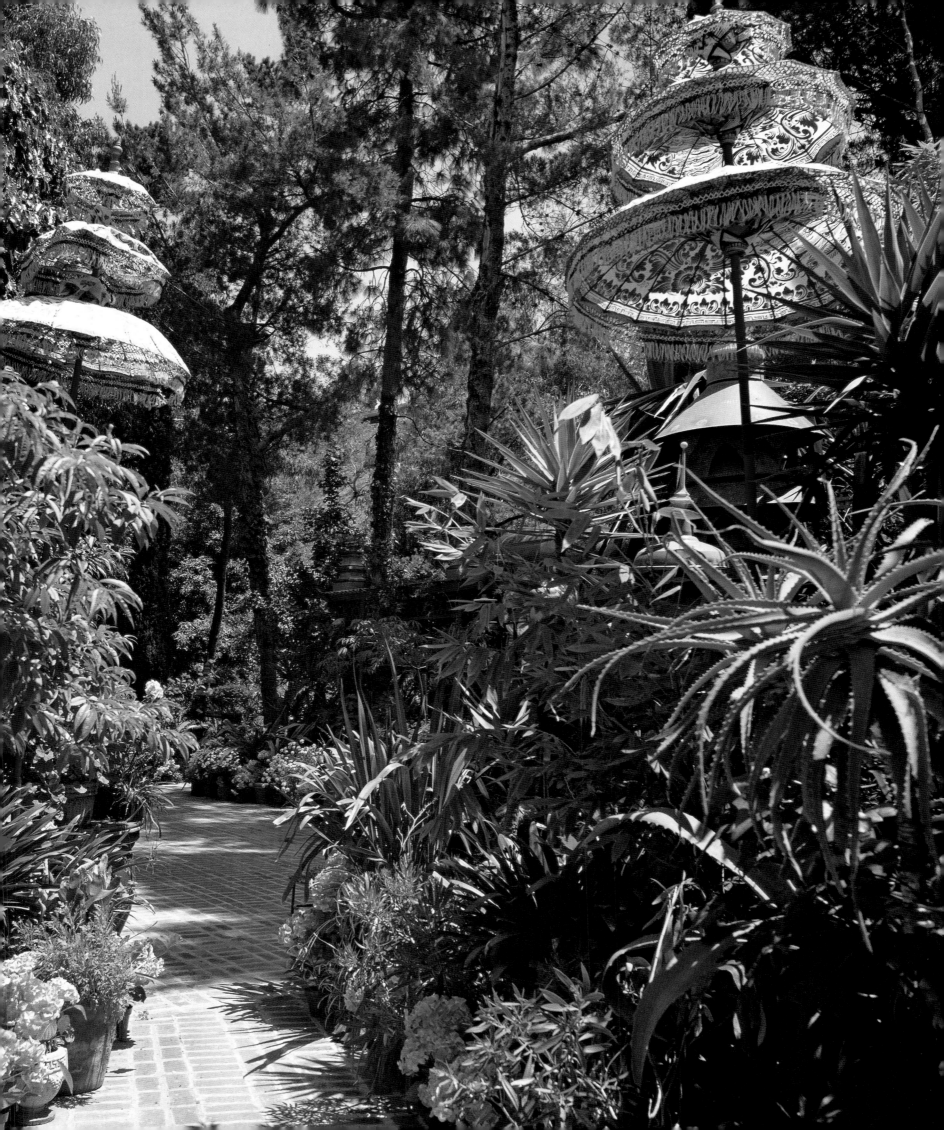

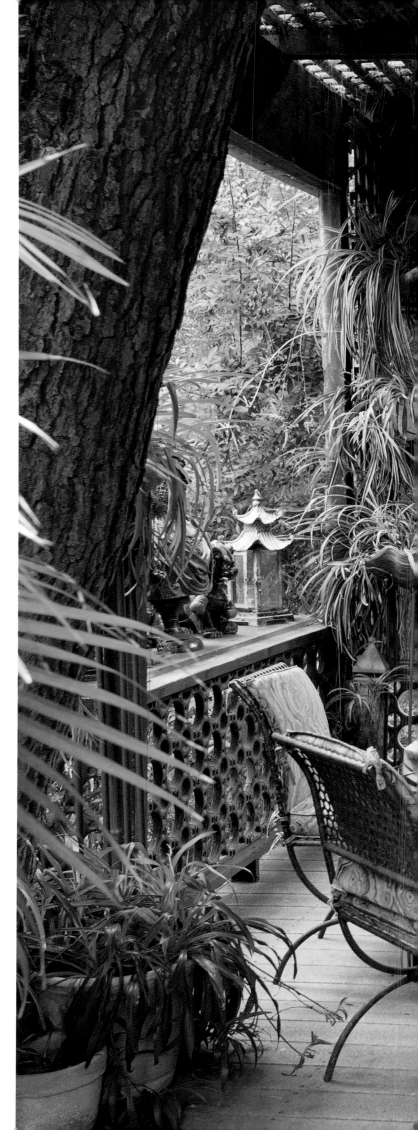

The Tree House, 2018. This space is used for lunch and dinner all summer long. The grape-root and glass table is draped in Tony Duquette for Jim Thompson Golden Sunburst fabric, and is surrounded by chairs designed by Tony and upholstered in malachite-printed cotton.

The Tree House

The pavilion at the far end of the middle terrace from the pool is called the Tree House, as it is situated between two pine trees. I've had to rebuild it twice, using the same architectural elements originally chosen by Tony. The only items that constantly change in this space are the chandelier, the tablecloths, and the chairs; otherwise, the Tree House remains the same cool, shaded refuge conceived by Tony and Beegle for dining alfresco.

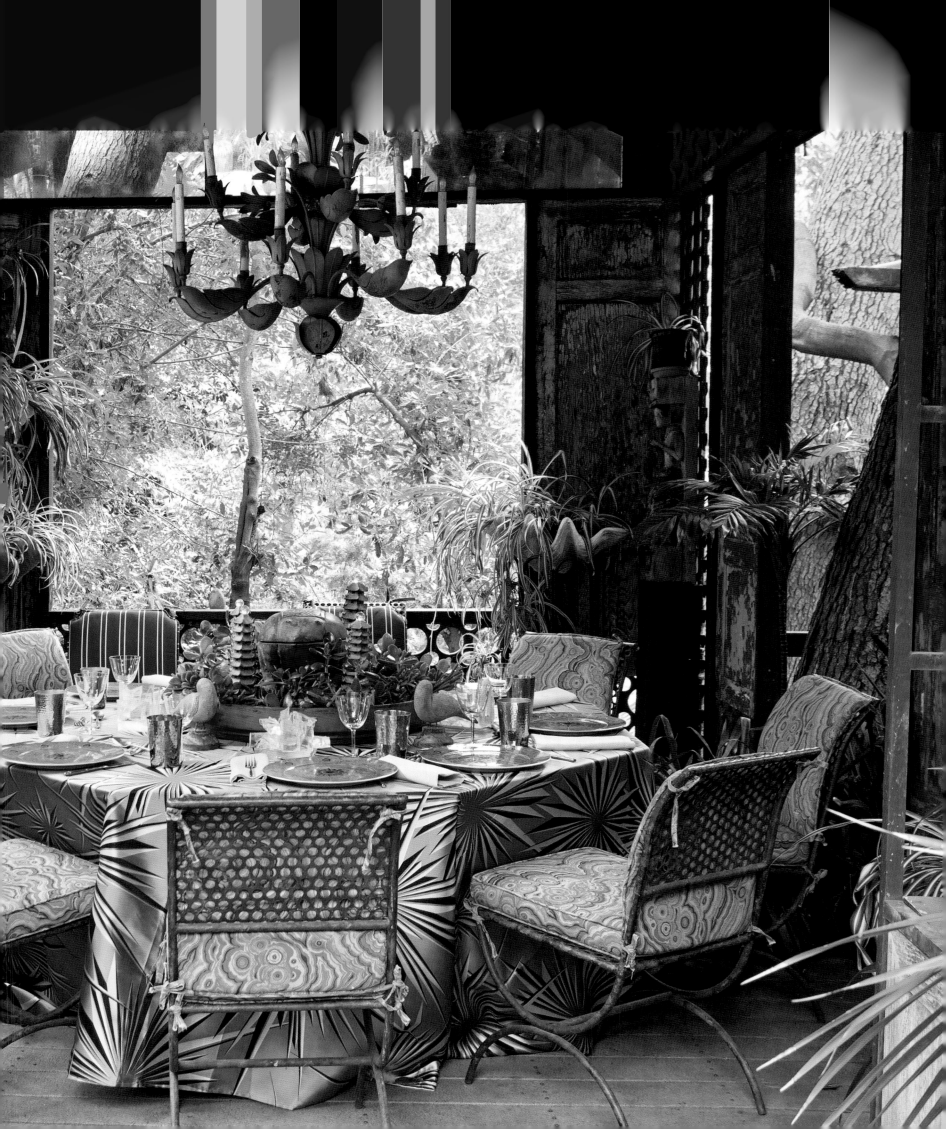

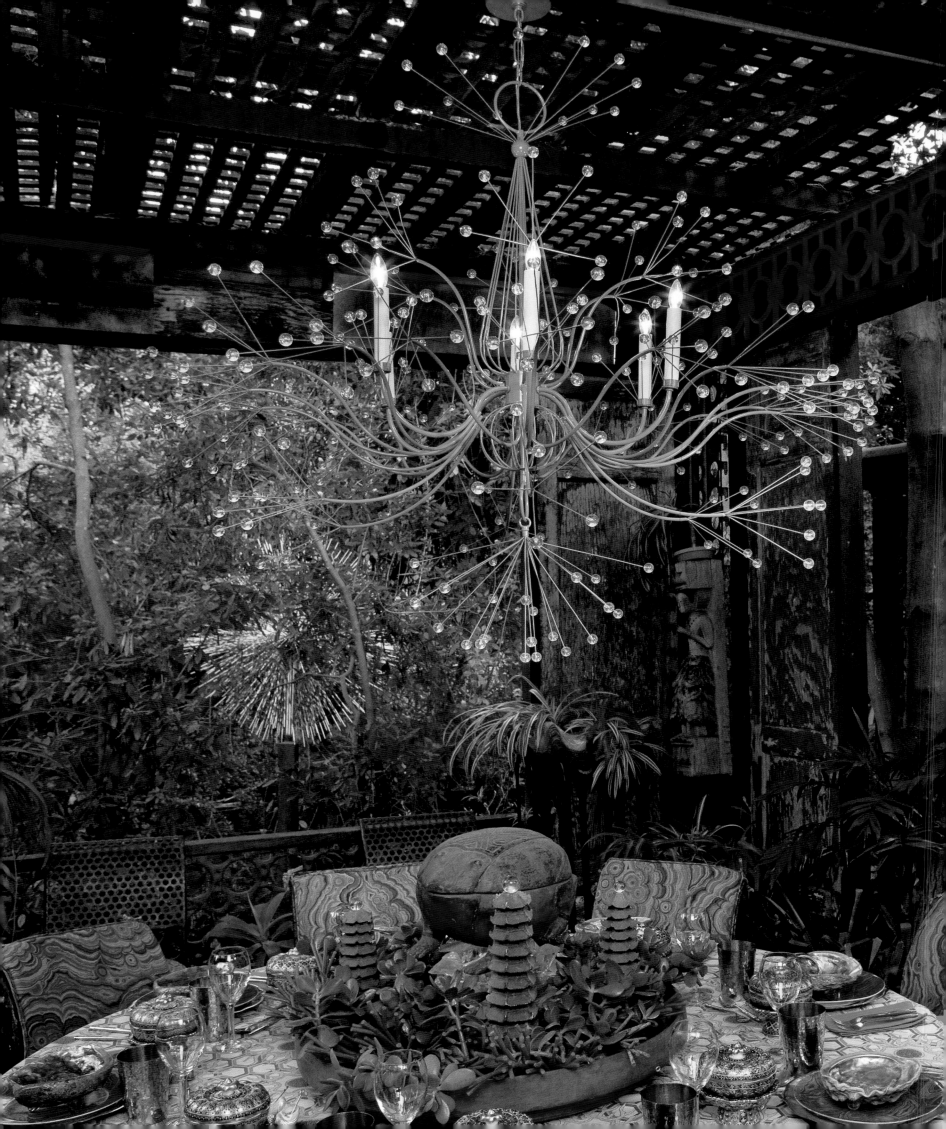

The Tree House, 2005. I installed Tony's Splashing Water chandelier and sconce for Remains Lighting. The table is set with Thai covered dishes and abalone shells on antique Chinese porcelains. **Below:** The Tree House, c. 1980s. Tony originally installed a pagoda chandelier, but would later move it to his Malibu ranch where it was destroyed during the fire in 1993.

........................

Following spread, from left: Outside of the Tree House, c. 1980; Bromeliads, pagodas, and Tony Duquette Phoenix sculptures decorate the garden on the middle terrace, 2018.

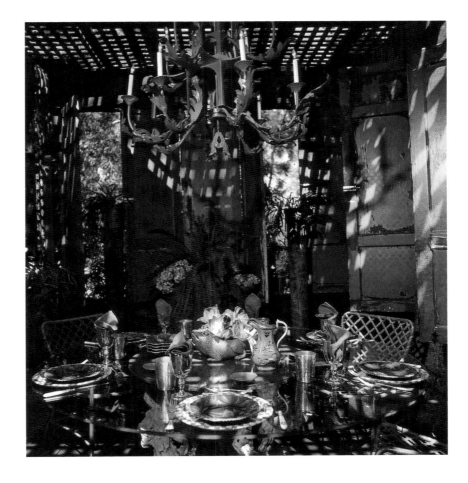

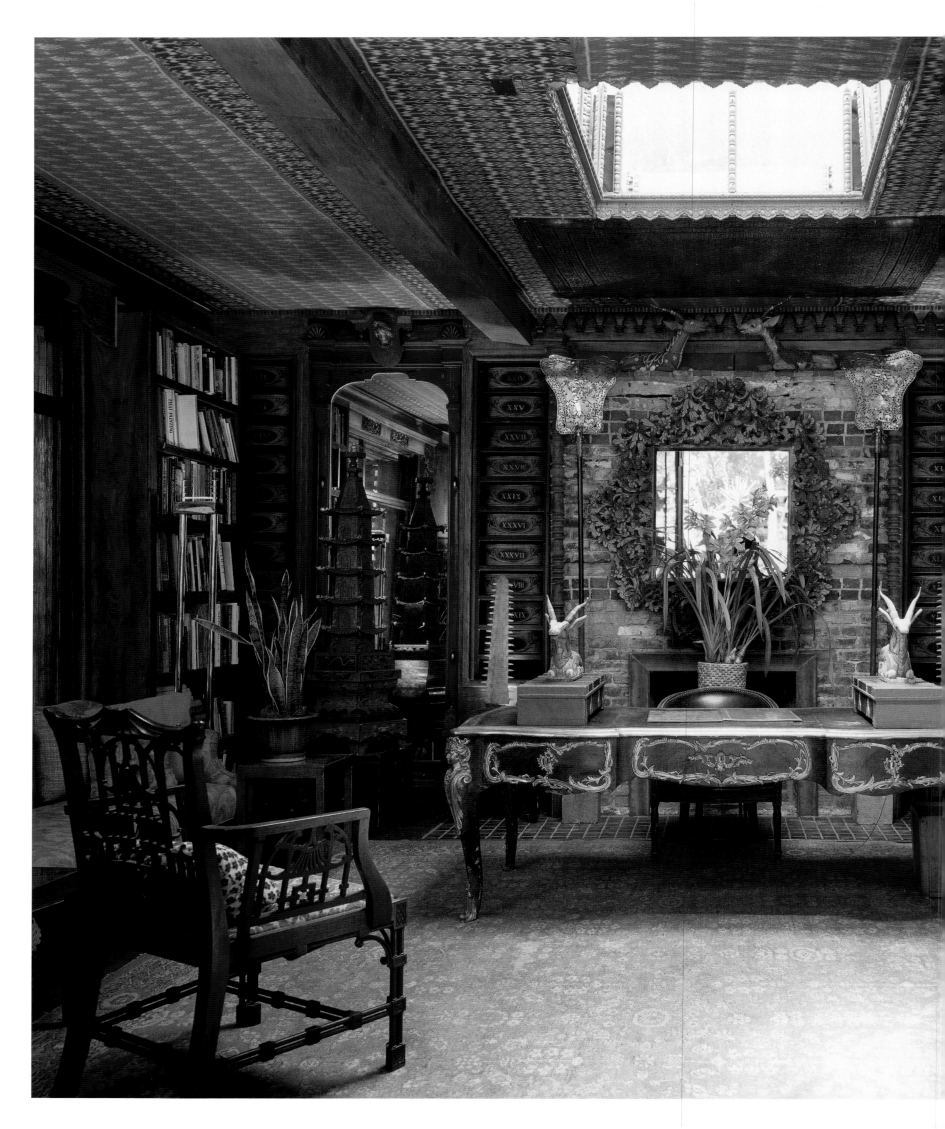

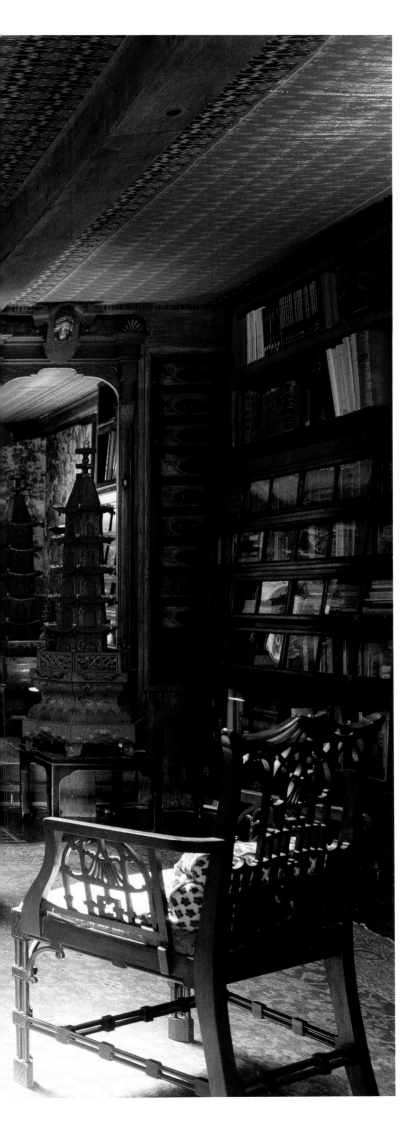

The Garden Room, c. 1980. Although Tony never used the room as his office, he filled it with his favorite possessions, including his French desk, eighteenth-century apothecary boxes, Chippendale Chinese chairs, and oversize red-lacquer pagodas.

The Garden Room

The Garden Room, across the terrace from the Tree House, was built by Tony as an office, but it was merely an excuse for him to decorate a room with some of his favorite things, such as his Louis XV black-lacquered and ormolu-mounted French desk, his collection of eighteenth-century apothecary boxes, a pair of antique Chippendale Chinese chairs, and an oversized pair of red lacquer pagodas. He never used this room—not even once. It was built around the brick fireplace of New Dawnridge, the only part of the destroyed house left standing after the fire. In 1995, he redecorated his garden office adding a pair of his original Phoenix sculptures and a pair of modern Snow Flake screens that he constructed using plastic fast-food baskets, the kind that hamburgers are often served in. Tony had his collection of antique beaded Chinese tassels petrified in resin, and placed a few of them in the office and lit them from behind. I've always thought the Garden Room was haunted by the ghost of the corpse found in the ruins after the fire at New Dawnridge, but if there is a ghost, she is benevolent, as the room is a calm and restful space and a beautifully cool place to relax on a hot summer day. Also, in the event of an overflow party crowd, the newly christened garden room gives us an additional area to set up dining tables.

Looking into the Garden Room from the middle terrace, c. 1980. The entrance is flanked with antique Thai roof ends, Balinese parasols, Chinese pots, and a bronze Garuda bird.

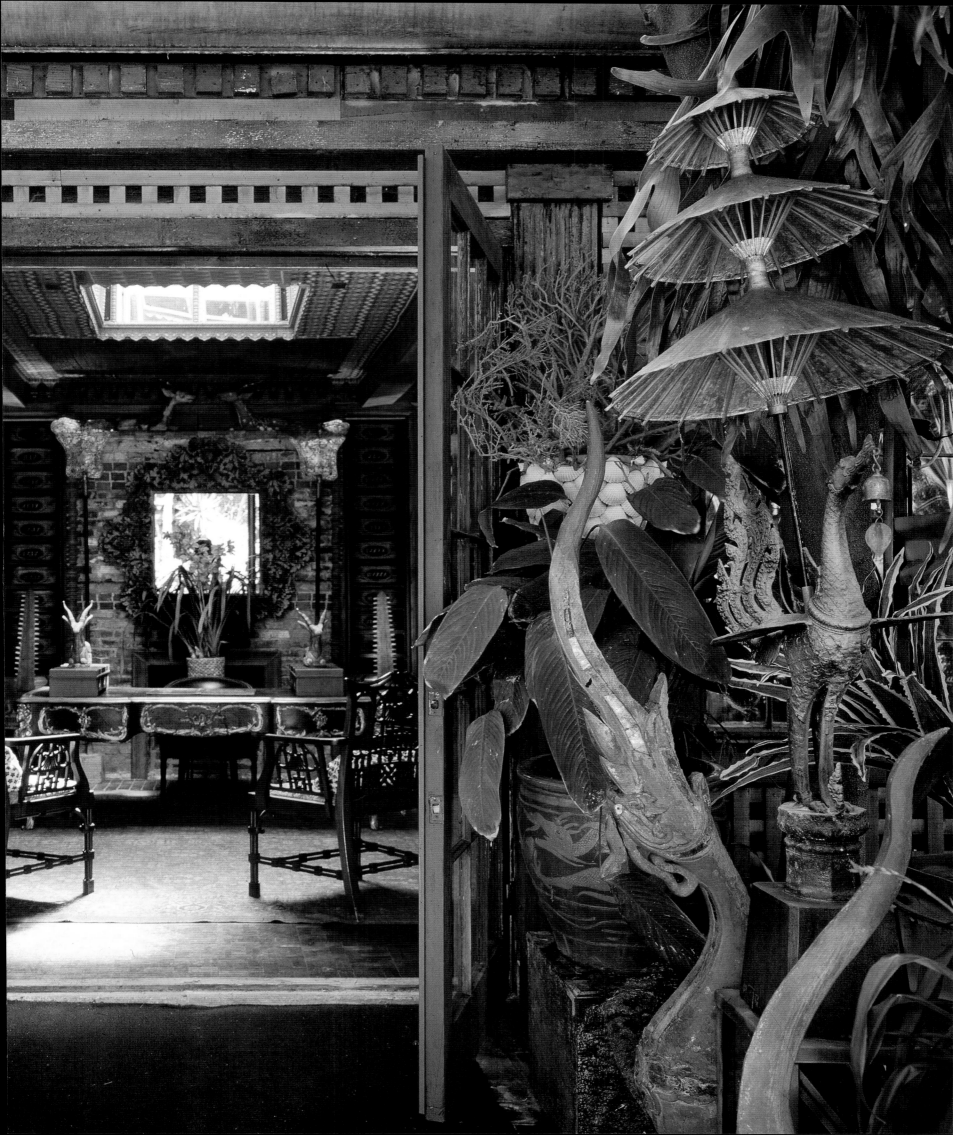

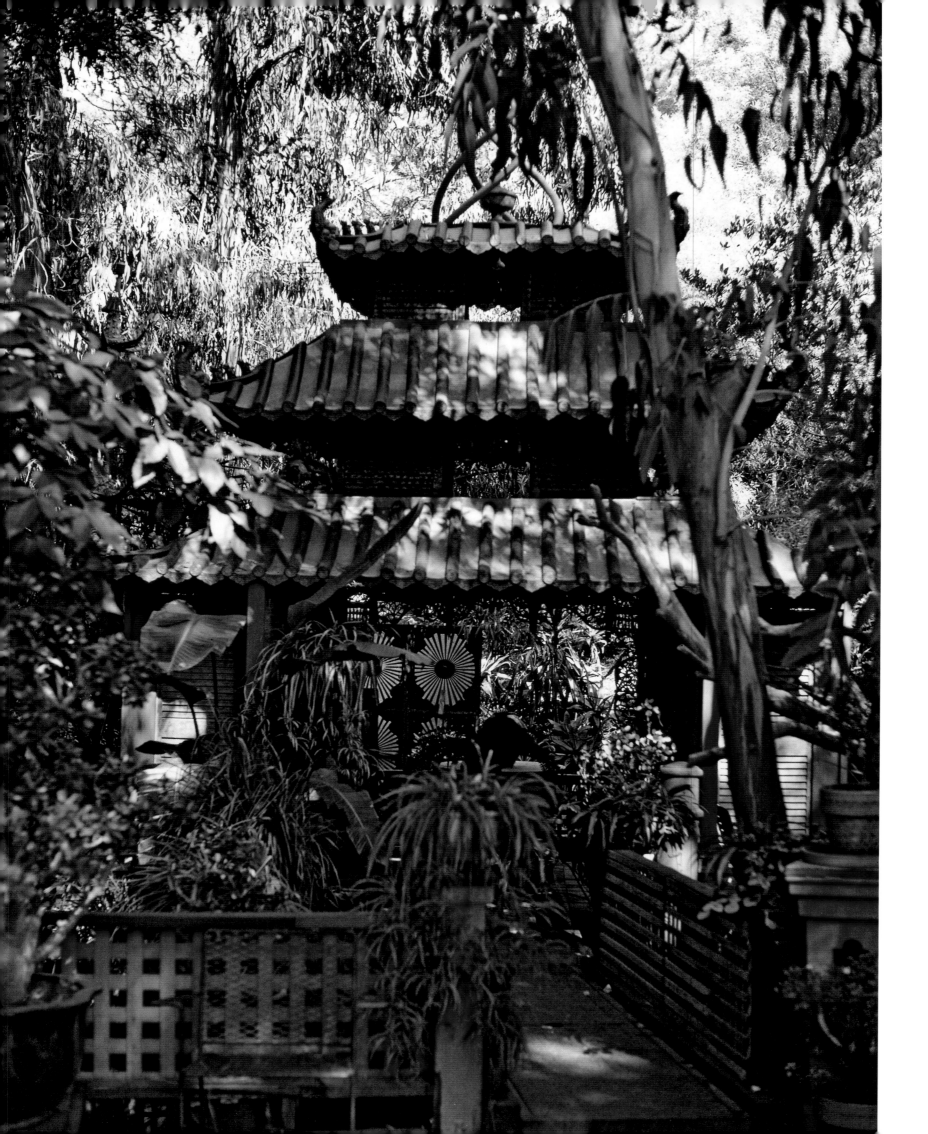

Chat Thai, c. 1980, with its Thai roof ends, Gothic spires, and gables made of plastic materials used in the late 1970s to separate computer wires under office building floors, was used as a guest house down in the ravine at Dawnridge. **Opposite:** The three-tiered pagoda was used for outdoor dining by the Duquettes and their friends. **Middle right:** Tony on the roof terrace at Chat-Thai, c. 1980. **Bottom right:** The white *Winter Sun* and red *Summer Sun* sculptures by Tony Duquette are situated in the ravine between the Chat Thai and Beeglesville.

Chat-Thai

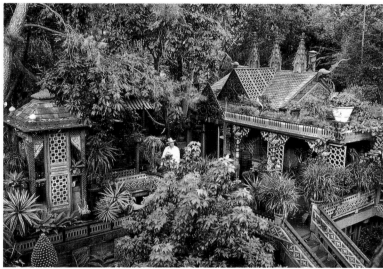

Chat-Thai is the whimsical name of the Thai-style guest house that Tony built on the garden's lower level, in the ravine. Because it was a Thai house, to which Tony added Gothic spires and other architectural fragments—and because our dear friend Patty Graham, who had also lived in France and whom we called "the cat lady," lived there—the house was christened Chat-Thai instead of *chateau*. The name was our double entendre for *Thai cat* in French. The two-story house, with one large high-ceilinged room upstairs and an eat-in kitchen, bedroom, and bath downstairs, was linked to the middle terrace by a causeway known as the Bridge of Sighs. There was also a long ramp, called the Freeway, that descended from the house's second-floor balcony into the ravine. Every night, Patty would smooth out the sand beneath her bedroom window, and in the morning, she'd check for paw prints to see what critters came to visit in the night. In those days, there were many deer, rabbits, chipmunks, and raccoons living in the ravine, but with all of the construction in the neighborhood over the past twenty-five years, that is no longer the case. A few months after Ruth and I purchased Dawnridge in 2000, there were eight days of rain and a little puff of wind. The storm caused one tree to fall down, hitting another tree, and then another . . . like dominoes, until eight large trees fell and smashed Chat-Thai into firewood. The house was completely destroyed, but I was able to save the old red lacquer Thai roof ends to use on future constructions.

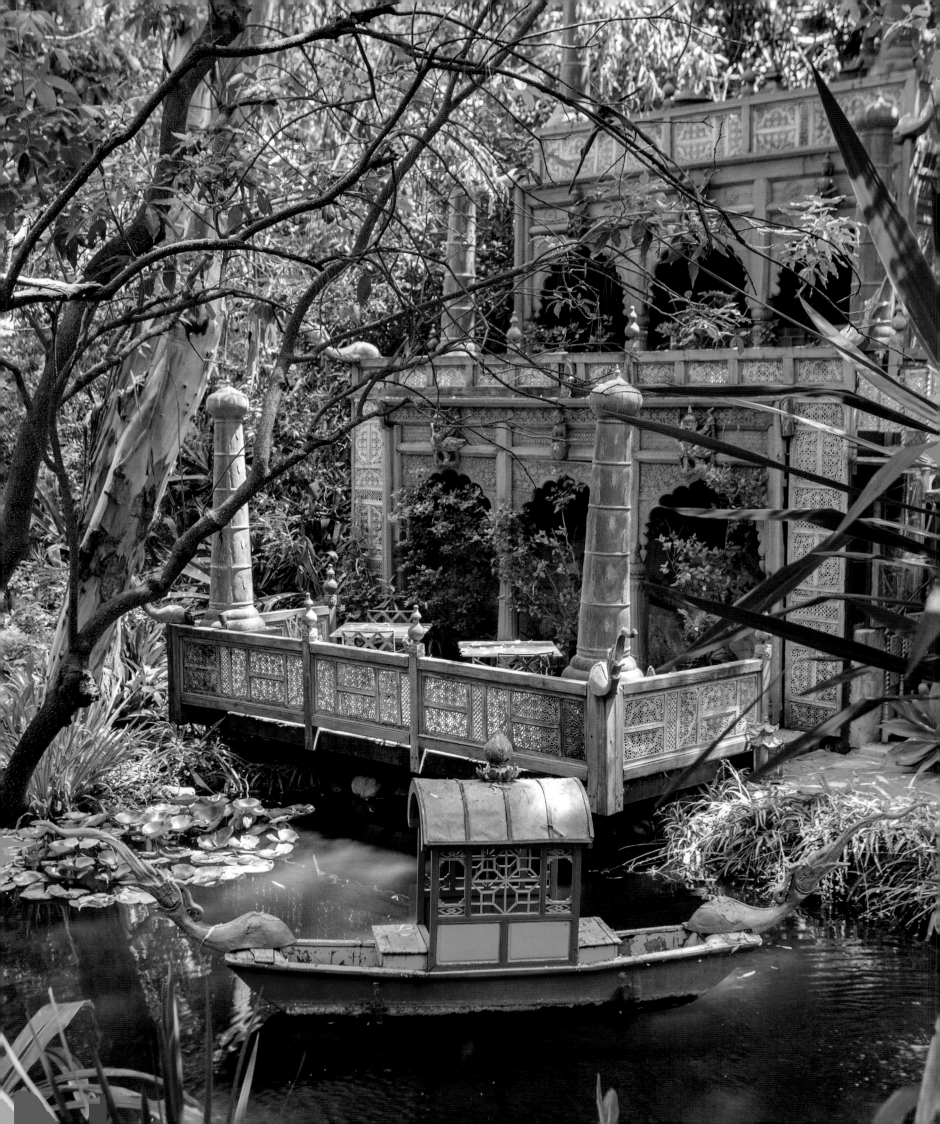

The destruction of Chat-Thai gave me the opportunity to create a lake at Dawnridge—something I had wanted to do since I first saw the property in 1972. One day, shortly after the lake was completed, while driving down Melrose Avenue, I saw the most amazing boat in a shop window. I slammed on the brakes, parked, and went inside, telling the proprietor, "I'll take that boat." After I purchased it I asked, "What is it?" He told me, "It's a Vietnamese wedding boat." I brought it home, painted it red and green, placed a carved lotus flower on its roof as a finial, and added two of the old Thai roof ends from the recently destroyed Chat-Thai, front and back, and launched it on the water. The boat immediately flipped over, and I realized it had not been built for the water; and probably came from the buffet table of the Siam Hilton. Its un-seaworthiness caused me to mount my diminutive yacht in a metal saddle, fixing it in place like the ornament it always was.

The folly on the shore of the lake, which I call the Temple, is nothing more than a stage set—four feet deep—with a wide deck for musicians and dancers to perform upon at parties. Chat-Thai was gone, and a viewpoint was needed. In my warehouse were three coral-colored arches that I'd purchased in India. I realized that they were carved on both sides, so I split them down the middle, making six arches, enough for the upstairs and downstairs of the temple. I also had eight copper spires for minarets, and purchased from India, I culled my collection of carved Indian screens and copper finials to create the balustrade. I decorated the iron spiral staircase with the leftover tops of the screens.

The entrance hall, c. 1980.
The hall contained a pillowed
and tasseled sitting area,
complete with a carved antique
Chinese opium bed covered in
silk brocades and embroideries.
Left: The sitting room, c. 2000.
Tony stacked the eighteenth-
century carved Chinese mirrors
to create an elongated
panel between the bookcases.

Beeglesville

Beegle's painting studio, which we called Beeglesville, was also in the ravine. This was where Beegle painted the ethereal paintings—oil on canvas and acrylic on board—that delighted her friends and collectors. Beeglesville is a Chinese-style house with pagoda roofs salvaged from a Buddhist temple Tony liberated from the old Warner Ranch, where *Robin Hood* and other epic Hollywood films were shot. The exterior was painted in jewel tones of jade green and coral, but it was the interior that was most distinctive. On the ground floor, there was an entrance hall with a ceiling decorated with panels made from gold plastic catering trays and mirrors. The hall also held an intricately carved antique Chinese opium bed, decked out with silk brocades and embroideries, along with Chinese lanterns for good measure. The floors throughout the house were layered with antique oriental carpets on top of a jade-green, wall-to-wall, flat-weave rug. A long Louis XV bench covered in leopard skin acts as a step up to the cozy pillowed and tasseled sitting area. This large room was outfitted with bookcases and Chinese giltwood mirrors carved with representations of Portuguese sailors, and furnished with sofas upholstered in Imperial yellow damask. The décor combined blue-and-white porcelain, taxidermy birds of paradise under glass, and eighteenth-century Vizagapatam ivory objects. An elegant antique French wrought-iron railing led visitors upstairs to the large painting studio, which was stacked to the ceiling with Beegle's canvases in various stages of completion. Here, sturdy English Regency tables, Victorian cane-work chairs, and brass-shaded bouillotte lamps set the mood. The bedroom, which was never used for sleeping, held a fourteenth-century Italian canopied bed from the collection of the Baroness d'Erlanger, which sat in the middle of piles of books that blocked admission to all but the most intrepid.

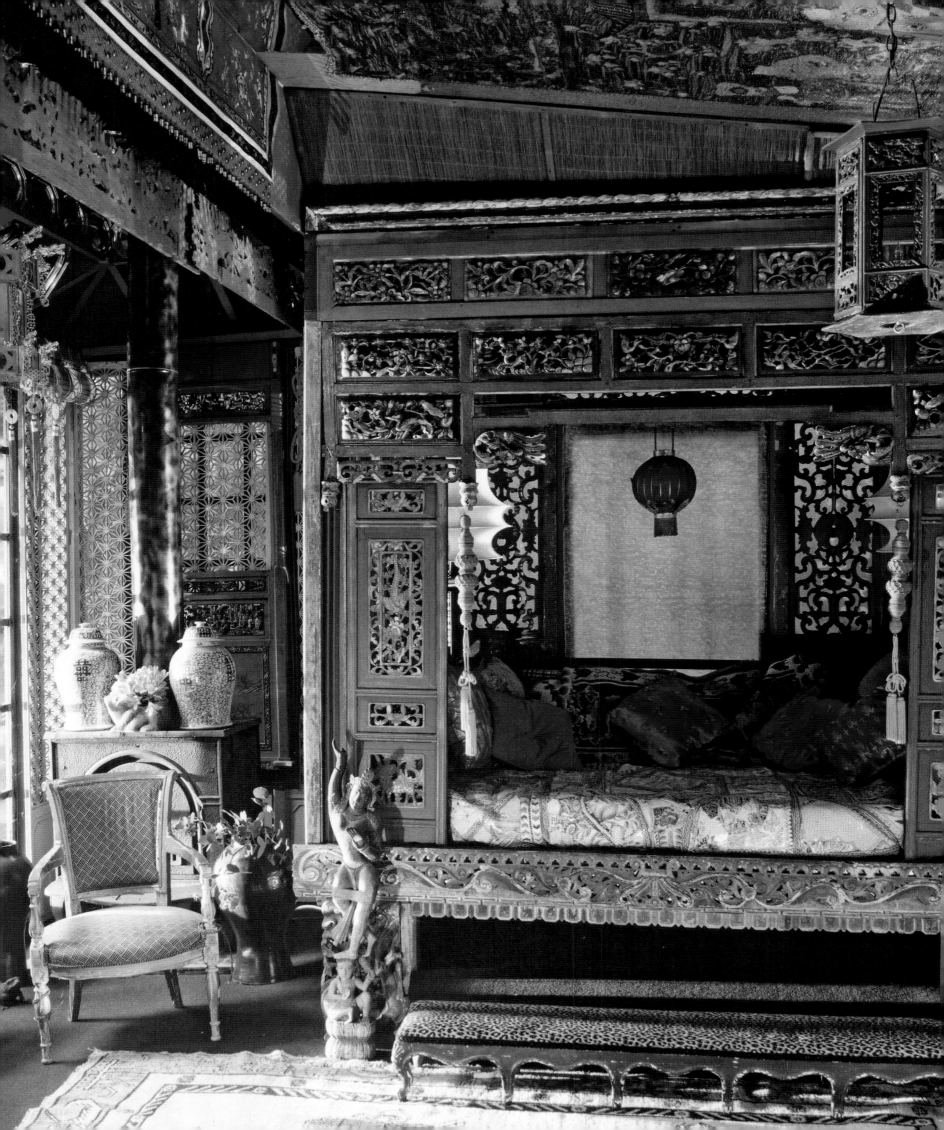

The sitting room, c. 1980. Tony set a taxidermized bird of paradise in a glass case, his poor man's version of the diamond, sapphire, ruby, and emerald creation he had seen in the house of his friend the Maharani of Cooch Behar. Tony's abalone chandelier, which now hangs from the balcony's ceiling at Dawnridge, was originally created for his one-man exhibition at LACMA where it was purchased by his client Mary Gross, and later repurchased by Tony to decorate Beeglesville.

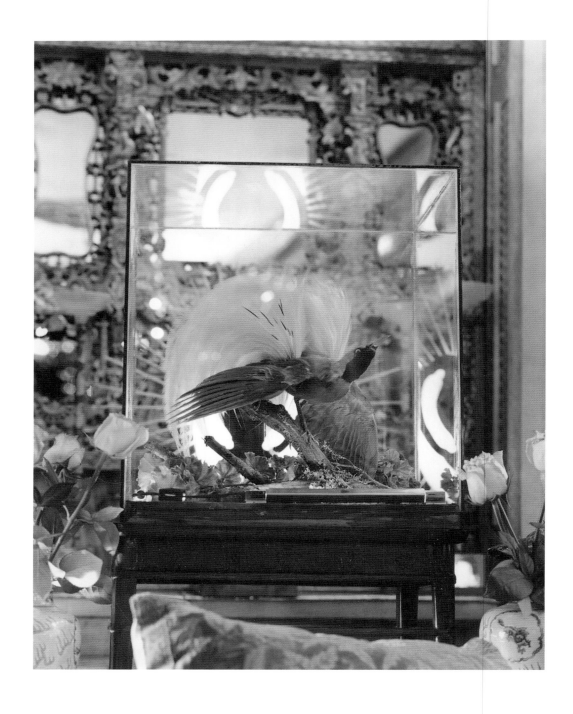

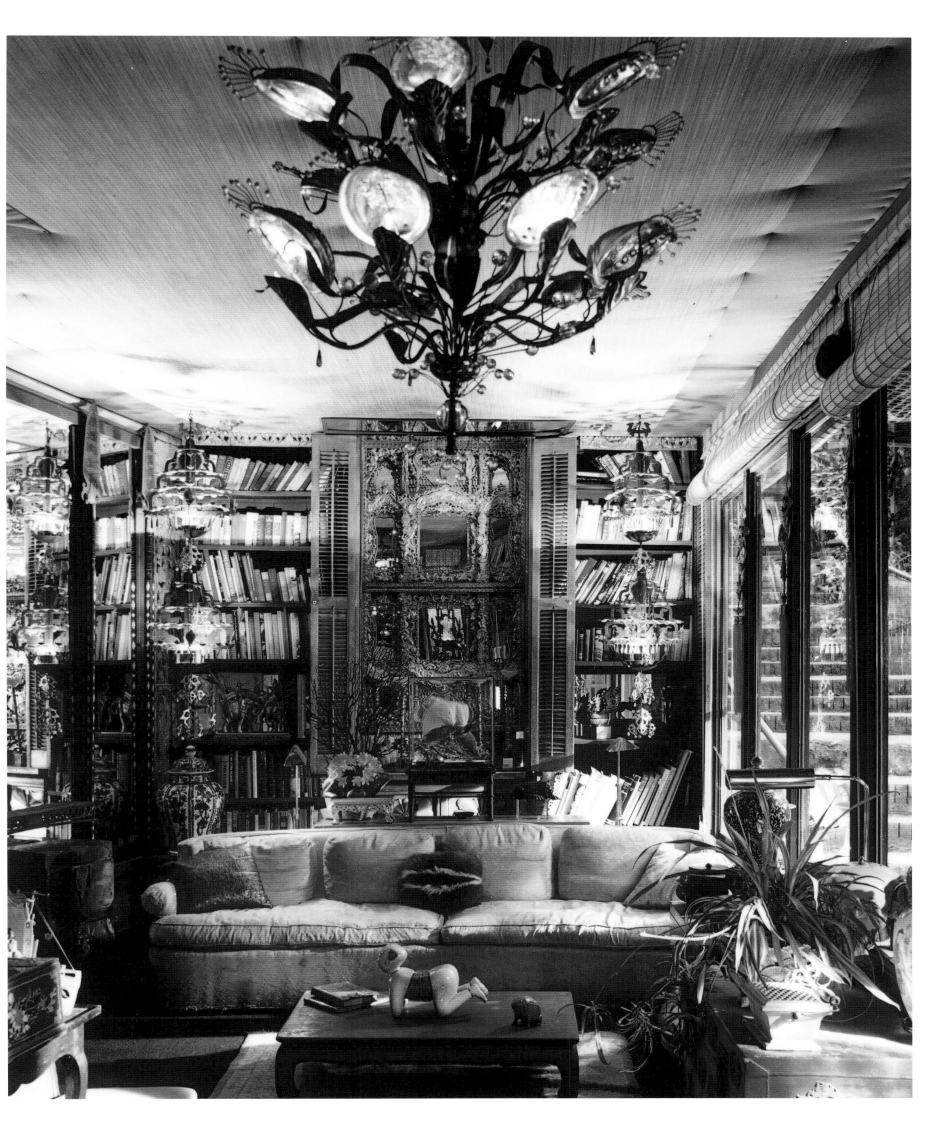

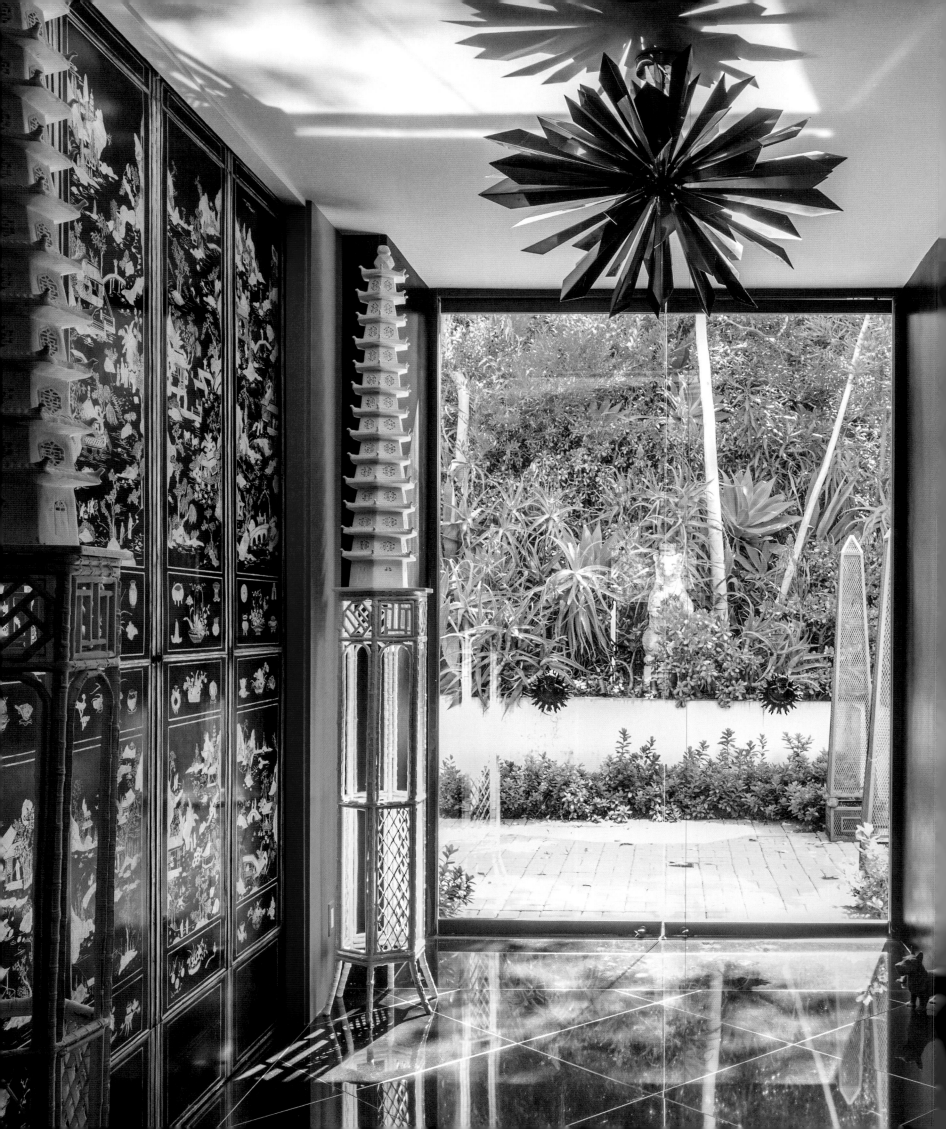

The
Casas

CASA LA CONDESA

In 2011, Ruth and I moved into the house that we designed and built on an empty lot next door to Dawnridge. Unlike the other lots on the street, where the land had been graded to make room for tennis courts and swimming pools, ours, just like Tony and Elizabeth's before us, was not much more than Fiddler's Ditch. Our dream was to have a house with southern exposure, at least one high-ceilinged room, three bedrooms, and three bathrooms. We struggled with the lot; we considered building two pavilions connected by a bridge over the ravine and other ideas that ultimately didn't excite us. Finally, after many unacceptable go-rounds, we discussed our plight with our friends Kacey and Peter McCoy over dinner. Peter, who's considered the best builder in Los Angeles, came up with a simple solution: "Go downstairs to the drawing room. Use the ravine to its best advantage." With those words of wisdom, the entire project instantly fell into place. I drew exactly what I wanted and handed my scale drawings to Sid Drasnin, a noted Los Angeles architect who'd been a young draftsman in my grandfather's architectural office. Sid was then in his eighties, but he ran with my ideas and drew my plans so that they could actually be built. What emerged was Casa La Condesa, named for Ruth, the Spanish Countess of Alastaya.

The house has a formal entrance—accessed through eighteenth-century Spanish gates—that's suitable for gala parties. As guests climb a short flight of red-carpeted steps into the garden, they're able to see festivities happening within. To the left is a treillage pavilion, which on occasion holds an orchestra, and to the right, the red carpet leads across a causeway to a door that opens onto the interior stairs. The doorway is framed by palm trees that Don Loper designed for the lobby of the Beverly Hills Hotel. We purchased these iconic 1940s architectural elements when the hotel was redecorated by its new owner, the Sultan of Brunei.

Our daily entrance, which is used constantly and requires no fanfare other than the ringing of a bell, is reached from the street through a gated courtyard and opens into the entrance hall. The front doors are tall sheets of glass studded with eighteenth-century Venetian bronze blackamoor door pulls; I even added my own bronze sunburst escutcheons, specially made to enhance them.

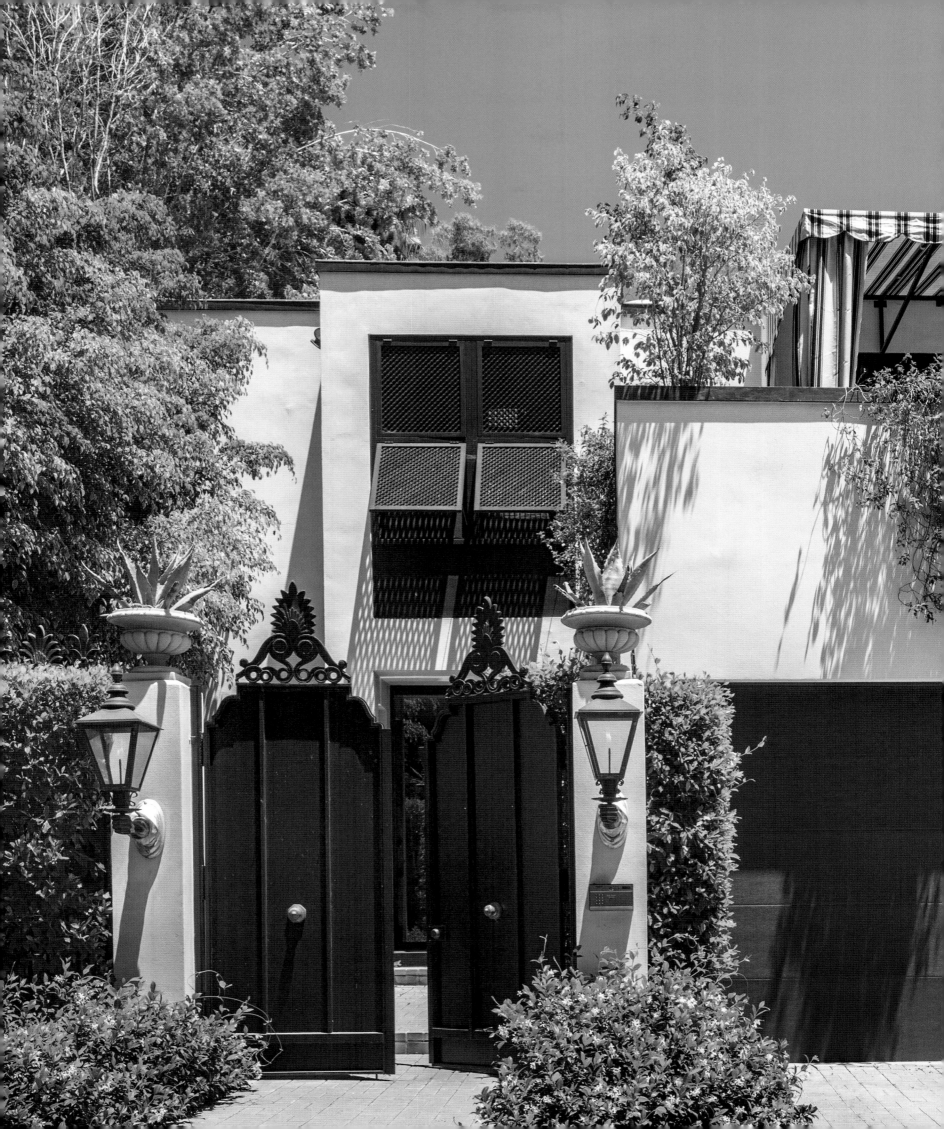

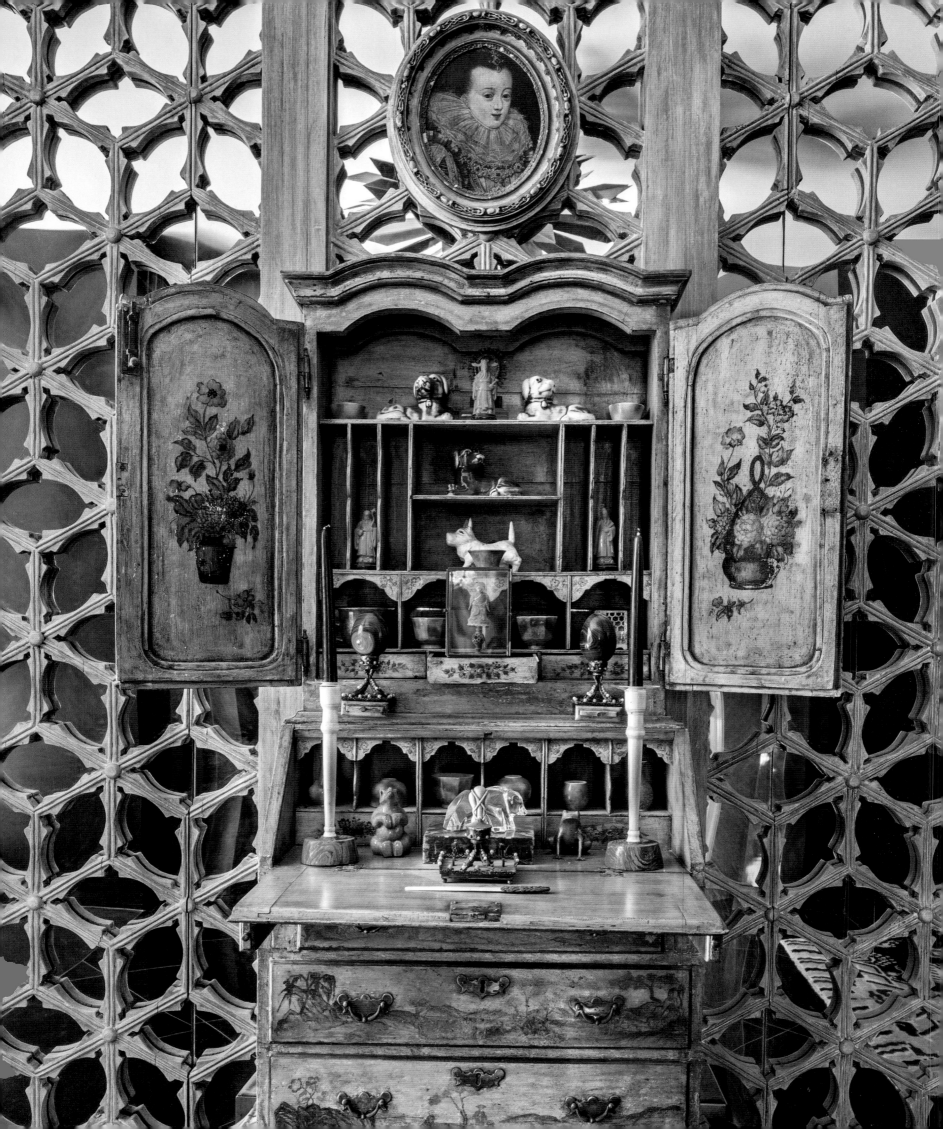

The entrance hall, 2018. The walls are paneled with carved teakwood screens in a traditional Chinese snowflake pattern and lined with mirror. An eighteenth-century miniature Lacca Povera Venetian desk is featured prominently in the hall. **Right:** Powder room, 2018. The powder room is located behind one of the teakwood and mirror jib doors in the hall, and paneled with slabs of Brazilian amethyst. Tony's abalone-and-amethyst-encrusted chandelier, c. 1960s, hangs from above.

The Entrance Hall

For years, Tony and I had discussed making a room in black, coral, and gold, but we never did. One day, I suddenly realized that I had done just that—subconsciously—and I smiled. The floors are polished black granite, and the color scheme throughout the house is predominantly black, coral, and gold.

The walls of the entrance hall are paneled with carved teakwood grills, which act as jib doors. Behind one of these secret doors is a powder room paneled with slabs of Brazilian amethyst. Here hand-tinted nineteenth-century prints of the Brighton Pavilion are displayed, as well as another view of Brighton embroidered in black silk on white satin; there is also a panel of cut velvet Chinese tribute silk on the back of the door. The jewel, however, is Tony's abalone-and-amethyst-encrusted chandelier, circa 1950, which hangs from a silver-gilt sunburst on the ceiling. The other jib door leads to an elevator hall and coat closet.

Across from these hidden doors is the entrance to the dining room. I don't like looking into a dining room the minute you walk through the front door, but sometimes it can't be avoided. In the case of Casa La Condesa, I solved the problem with a pair of sliding grillwork doors that disappear into the wall. I then backed the grills with a two-way mirror so that people entering the house can't look into the dining room and see the table *en fete*…but whoever is inside the room can look out. The entrance hall features a Tony Duquette for Remains Lighting California Sunburst chandelier; also a miniature eighteenth-century Venetian Lacca Povera desk, placed on a dais; a pair of Chinese vases on lighted stands; and a little skeletal Italian saint who warns people to watch their step to avoid tripping up into the stair hall. Opposite the entrance to the library is an antique chinoiserie lacquered screen mounted as pocket doors, which open to reveal our home office. On either side are white Tony Duquette pagoda lamps presented on tall octagonal bamboo stands.

From the hallway, guests can look over the balcony to the drawing room to see who's there and what they're wearing before going down to the party and making an entrance.
Left: One of a pair of antique Chippendale Chinese mirrors hangs over one of the two ebonized Victorian console tables on either side of the stair wall.

The Stair Hall

The stair hall—with its twenty-foot-high window looking out over Dawnridge's gardens, the infinity-edged swimming pool, and the lake with its enchanting Vietnamese boat below—is adjacent to the entrance hall. From here, if you are arriving at a party, you can look down into the Drawing Room and see the guests and what they're wearing before descending the staircase and making an entrance. It's also from this vantage point that you can look across the drawing room and see into the library on the left and the dining room on the right. Otherwise, if you choose, you may look over the stair railing down to the dolphin table or up to the cascading chandeliers that hang one after another, repeating five times for three stories. At each end of the hallway is a console table, which I created by cutting an ebonized Victorian center table in half, mounted on a black lacquered stand. The antique gilded Chippendale Chinese mirrors hanging above were painted white by a previous owner; the Chinese cache pots in a celery pattern are part of our extensive collection of export porcelain.

178

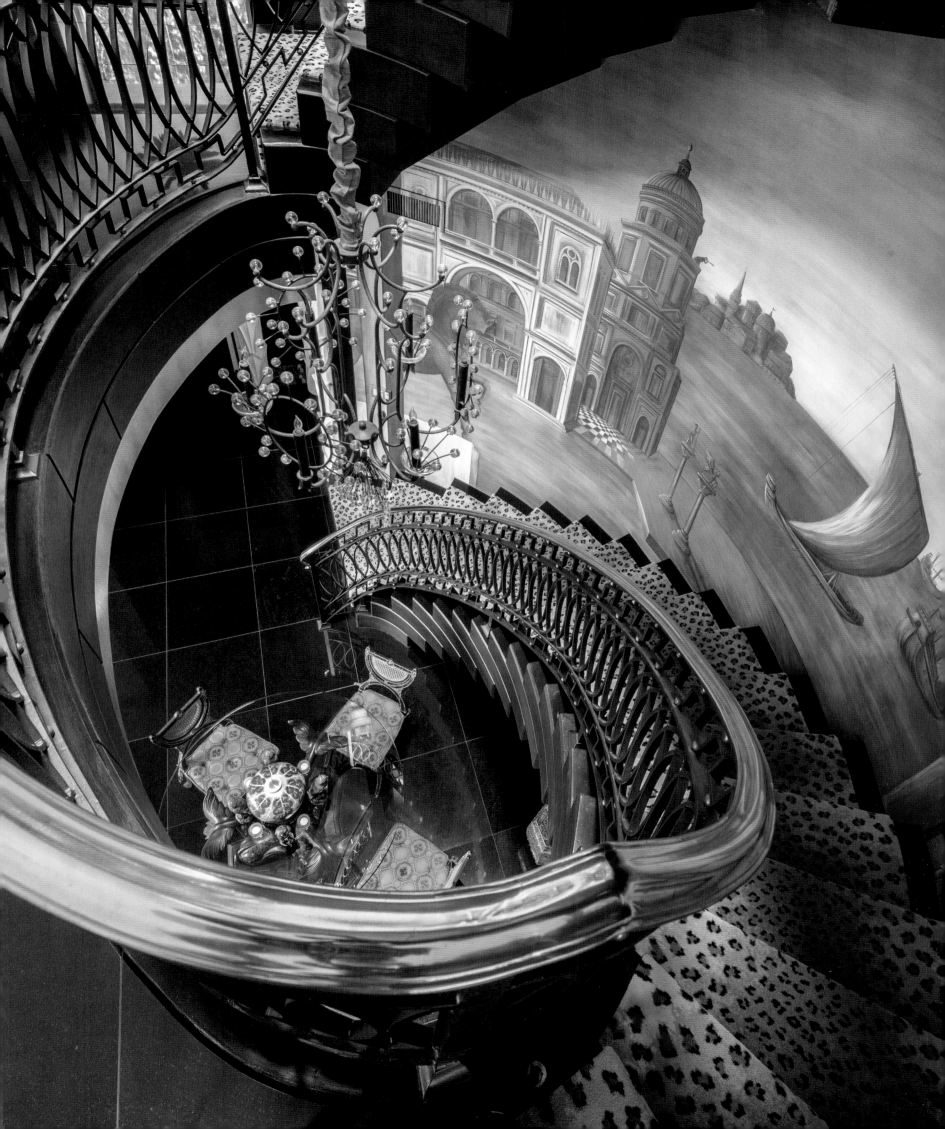

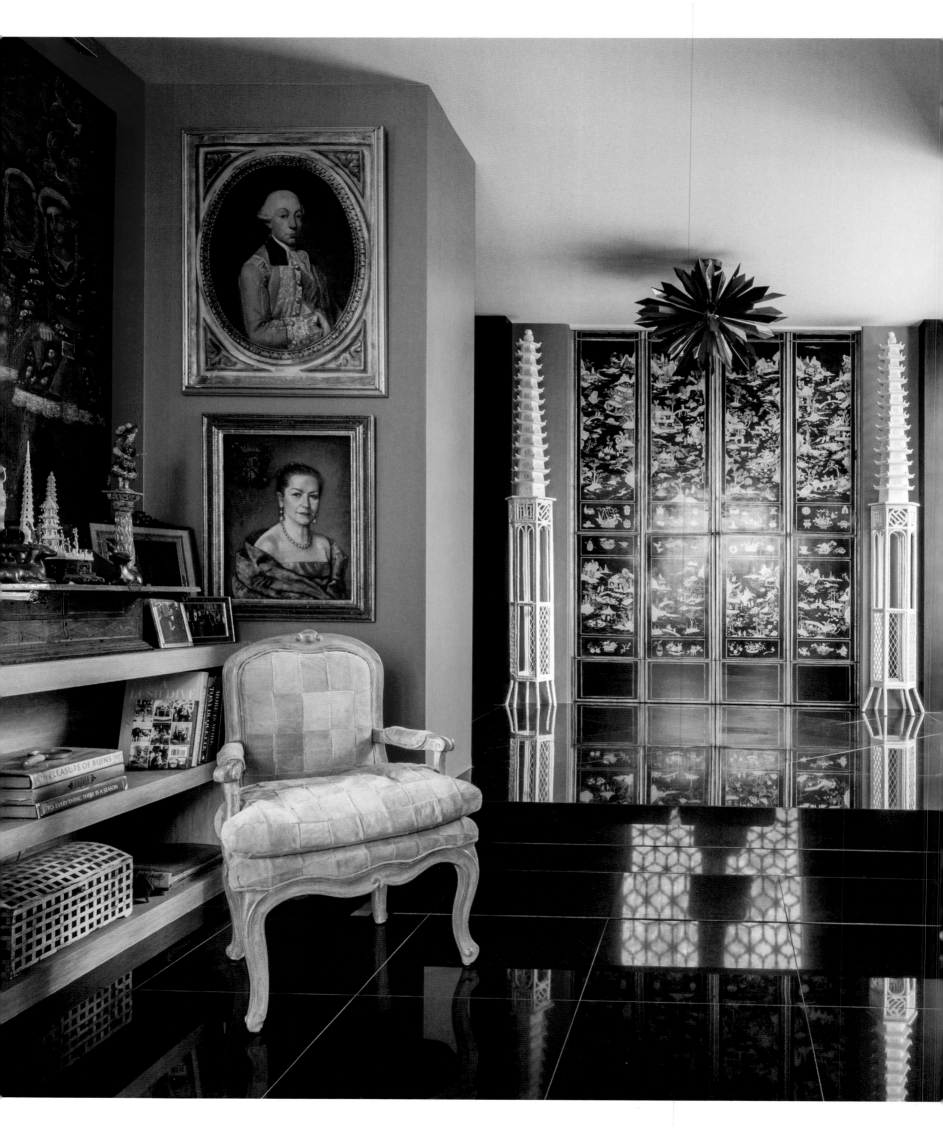

I have hung the library with ancestral portraits and family heirlooms from the Spanish Counts of Alastaya. Our portraits hanging on each side of the stairs are by Juan Fernando Bastos. These were commissioned after His Majesty, King Juan Carlos of Spain, recognized me as the hereditary Count of Alastaya, a noble title passed down through my mother's family since 1760.

.......................

Following spread: View from the library over the drawing room and into the dining room beyond. The sofa, positioned between the two bookcases, was designed by Tony Duquette for Doris Duke in the 1950s and is paired with eighteenth-century Venetian chairs and a cocktail table made of petrified wood with a gilded articulated Japanese lobster atop a petrified tortoise shell as decoration. Hanging above both bookcases are more ancestral portraits and heirlooms.

The Library

The library looks directly across the drawing room to the dining room, and the ceiling spans all three rooms—without any crown molding breaking up the space—giving it the feeling that it's a one-room house. The walls of the library were painted coral, and the ceiling, like the rest of the street-level rooms, a soft amethyst. We had originally planned to fill the room with books, but I later changed my mind and displayed a collection of Spanish colonial paintings inherited from my family. My Spanish ancestor, Don Gonzalo Nieto Principe, came to the New World in 1635 as the perpetual governor of Potosí, a town in the Andes Mountains of Bolivia. At the time, Potosí was the richest city on Earth, thanks to its silver mines, and larger than Paris or London. My South American family didn't move away until 1928, when my mother and her brothers came to Los Angeles. All of my South American treasures came from the various haciendas—a total of ten—that my family owned in Bolivia and Peru.

We added a sofa that was designed in the 1950s for Doris Duke and eighteenth-century Venetian chairs in patchwork suede. The cocktail table is made of petrified wood slices and topped with a petrified tortoise surmounted by an articulated vermeil lobster

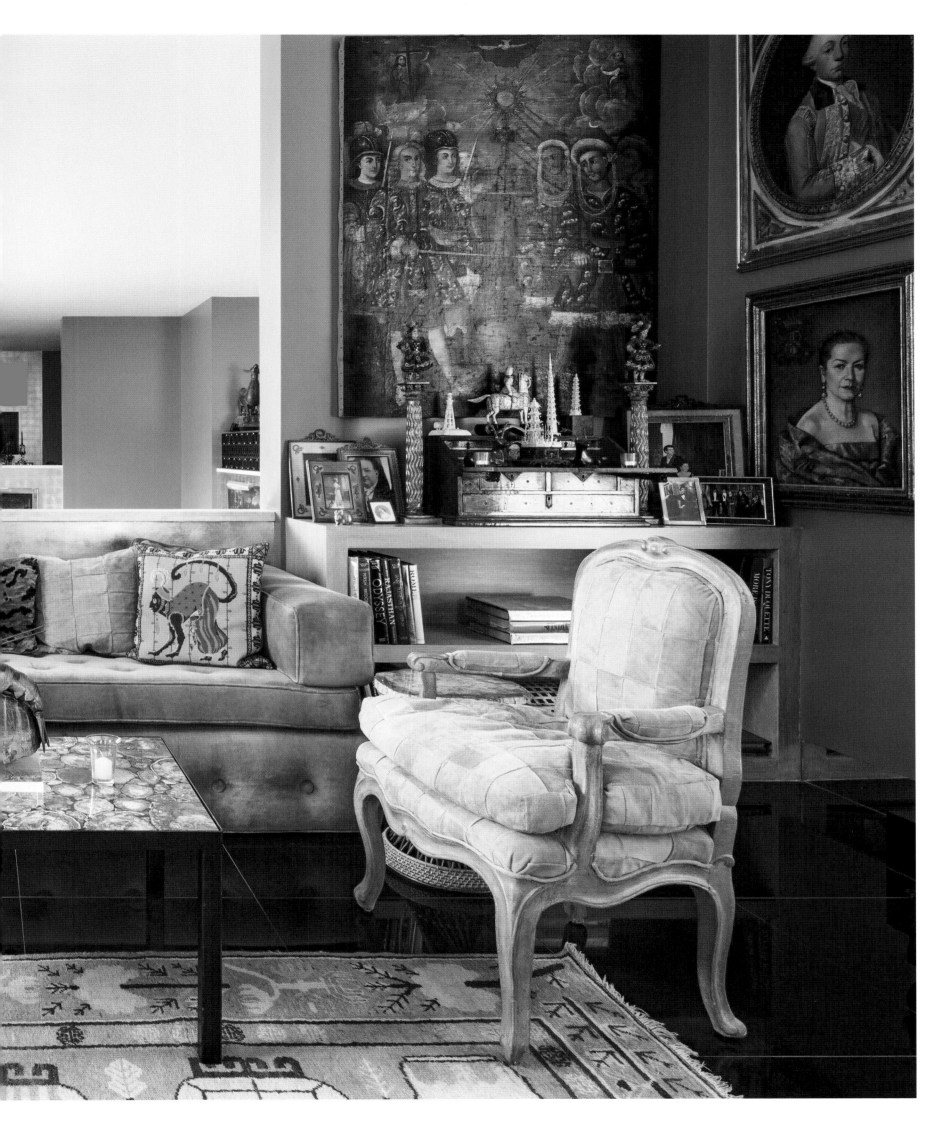

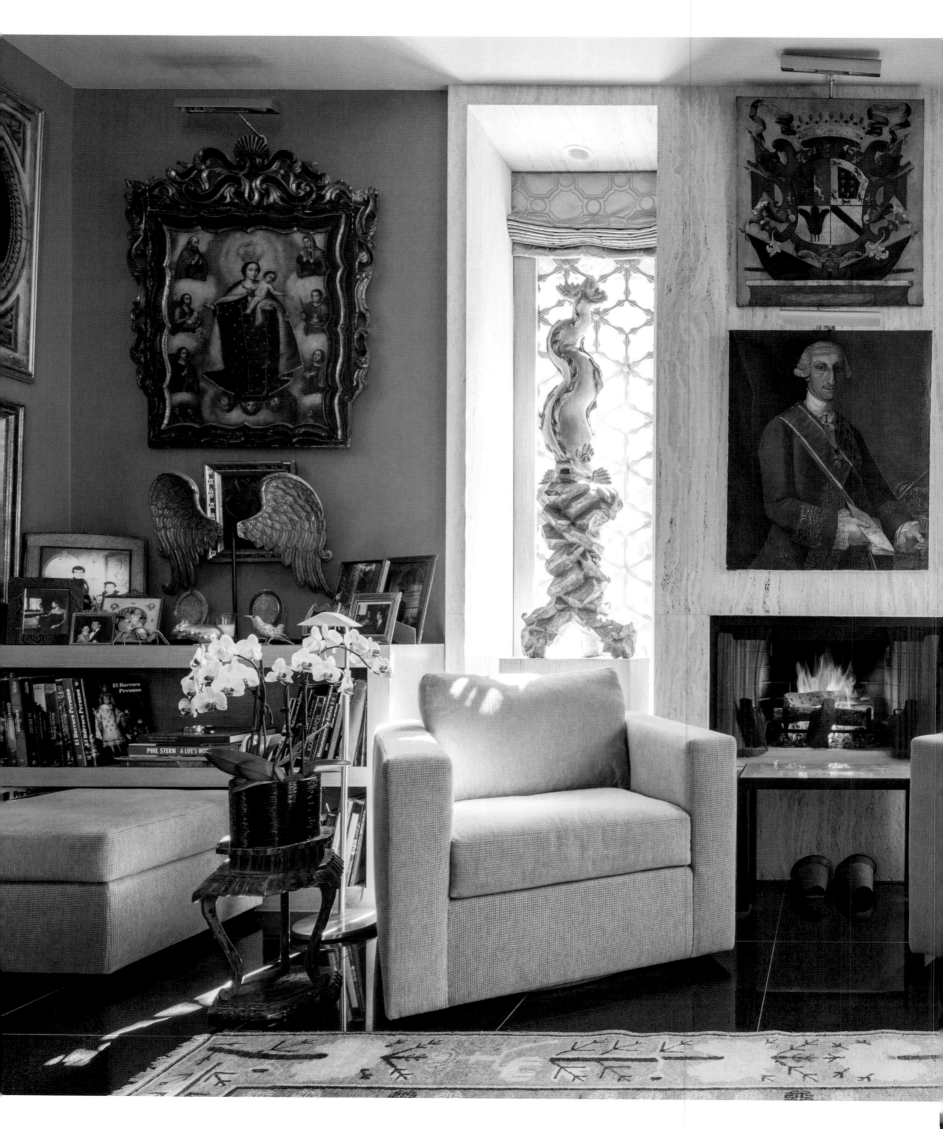

The library, 2018. Framing the fireplace alcove are two eighteenth-century Venetian dolphins from the collection of Misia Sert, and hanging directly above the hearth is my family coat of arms, as well as a portrait of King Carlos III of Spain.

on a Lucite stand. The carpet is an antique Chinese picture rug; the curtains are made with Tony Duquette for Jim Thompson Asia Major woven silk. In the left corner, the bookcase holds an eighteenth-century Spanish colonial statue of St. Joseph dressed in a silver repousse costume. The painting hanging above depicts my ancestor, the second Conde de Alastaya, and his wife praying like crazy that they won't go to hell. In the opposite corner, a number of my South American treasures are displayed: Spanish colonial columns holding figures of archangels dressed as conquistadors, a seventeenth-century Venetian traveling desk with a red lacquered chinoiserie painted interior, photographs of my family, antique ivory Chinese pagodas, an antique ivory tower from India, and a twentieth-century Chinese bone horseman.

The fireplace alcove is made of sandblasted travertine and holds two eighteenth-century Venetian dolphins from the collection of Misia Sert. Above the hearth hangs the original eighteenth-century rendering of my family's coat of arms, created in Spain in 1769 for the Counts of Alastaya. Below that is an accompanying portrait of King Carlos III of Spain holding a document in his hand that reads, "To my friend, The Count of Alastaya." In 2008, King Juan Carlos of Spain bestowed the hereditary Spanish titles Conde y Condesa de Alastaya to my wife and myself.

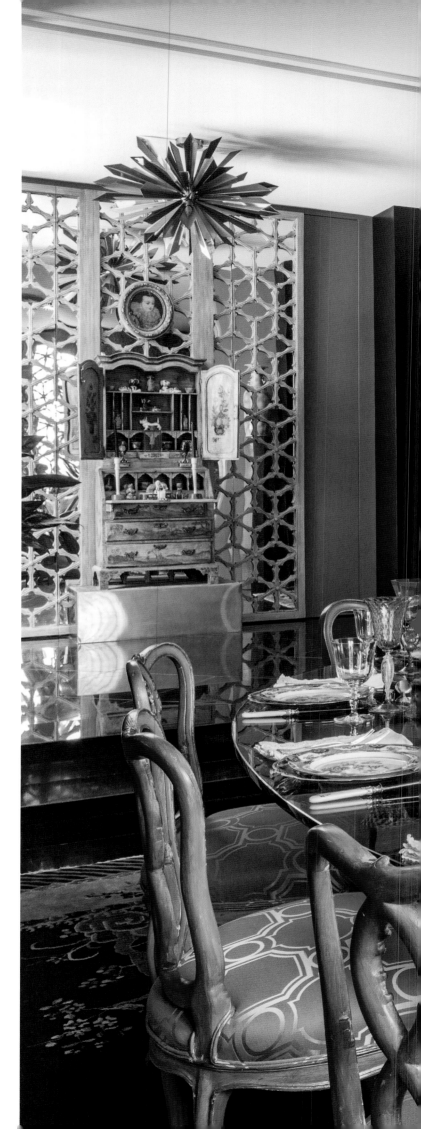

The dining room, 2018. The glass-topped dining table was created by putting two gold palm tree capitals from the Beverly Hills Hotel lobby together to form a pedestal. Surrounding the table are eighteenth-century Venetian coral lacquer dining chairs.

The Dining Room

Also located off the entrance hall is the dining room, which is centered by a large oval glass-topped table, the base of which I created by placing two of the palm tree capitals from the Beverly Hills Hotel together, back-to-back. The chairs are eighteenth-century Venetian in a coral lacquer and gold finish, upholstered with Tony Duquette for Jim Thompson Asia Major in coral silk. The walls are painted in coral, with the indented areas in gold leaf. The late seventeenth-century Venetian paintings hanging in the room are part of a series of eight; the other six are in the Drawing Room. The ceiling fixture is a Tony Duquette for Remains Lighting cast-resin sunburst placed over a recessed light. A monumental twelve-panel, eighteenth-century Coromandel screen was purchased from the venerable Los Angeles antiques dealer Joel Chen, and then split apart into groups of three to be placed in the four corners of the room. A swing door opens into a black lacquer and mirrored butler's pantry, which leads into a large kitchen, paneled in white oak and decorated with blue-and-white Chinese porcelains.

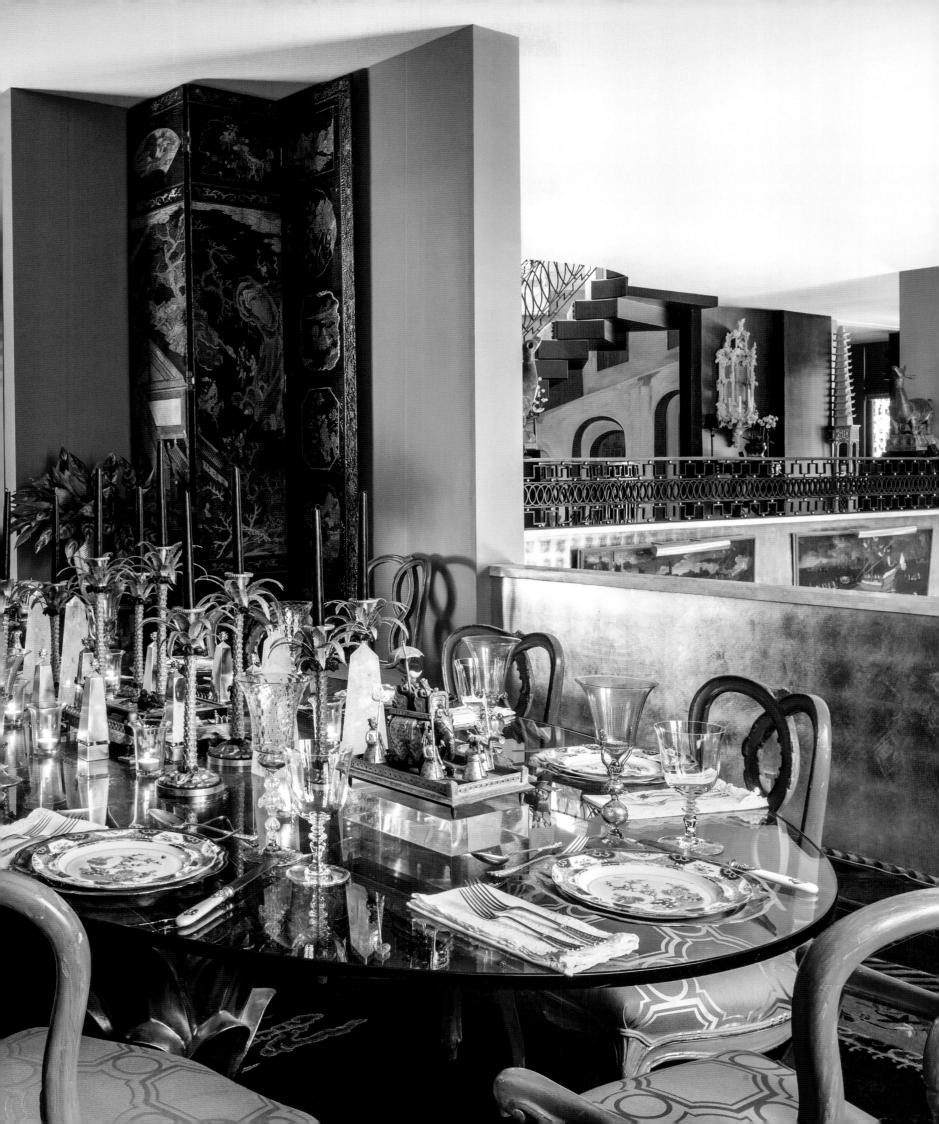

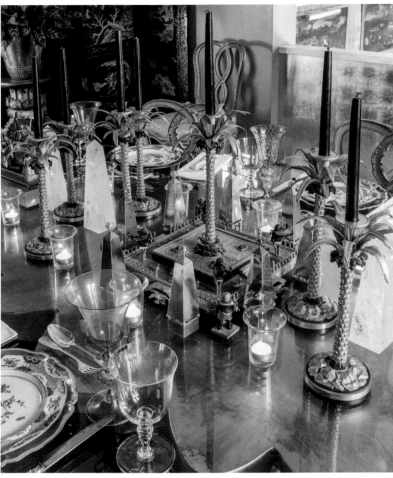

The table is set with vermeil chargers, antique Coalport china, Gorham Mythologique silver flatware, and Baccarat crystal. The centerpiece—depicting Egyptians and a pond studded with lapis lazuli scarabs and a large gilded palm tree in the center—was made along with the other eight candlesticks by the vaunted Venetian jeweler Codognato. I added the rock-crystal obelisks, Tony's original salt and pepper shakers in the form of obelisks, and a group of gold-leafed Indian potentates on elephants to better evoke the exotic mysteries of the East.

The gold-leafed alcove includes two of the eight seventeenth-century paintings of Venice by Heinze. The console table was also made using one of the palm tree capitals originally in the lobby of the Beverly Hills Hotel, and it now holds a collection of antique Chinese lacquered coral branches, a gilded nef on a persimmon lacquer Japanese table, and antique gold rats from Japan. Tony told me that in Japan, if you're rich enough to leave crumbs on the table for rats to eat, then you're considered really rich.

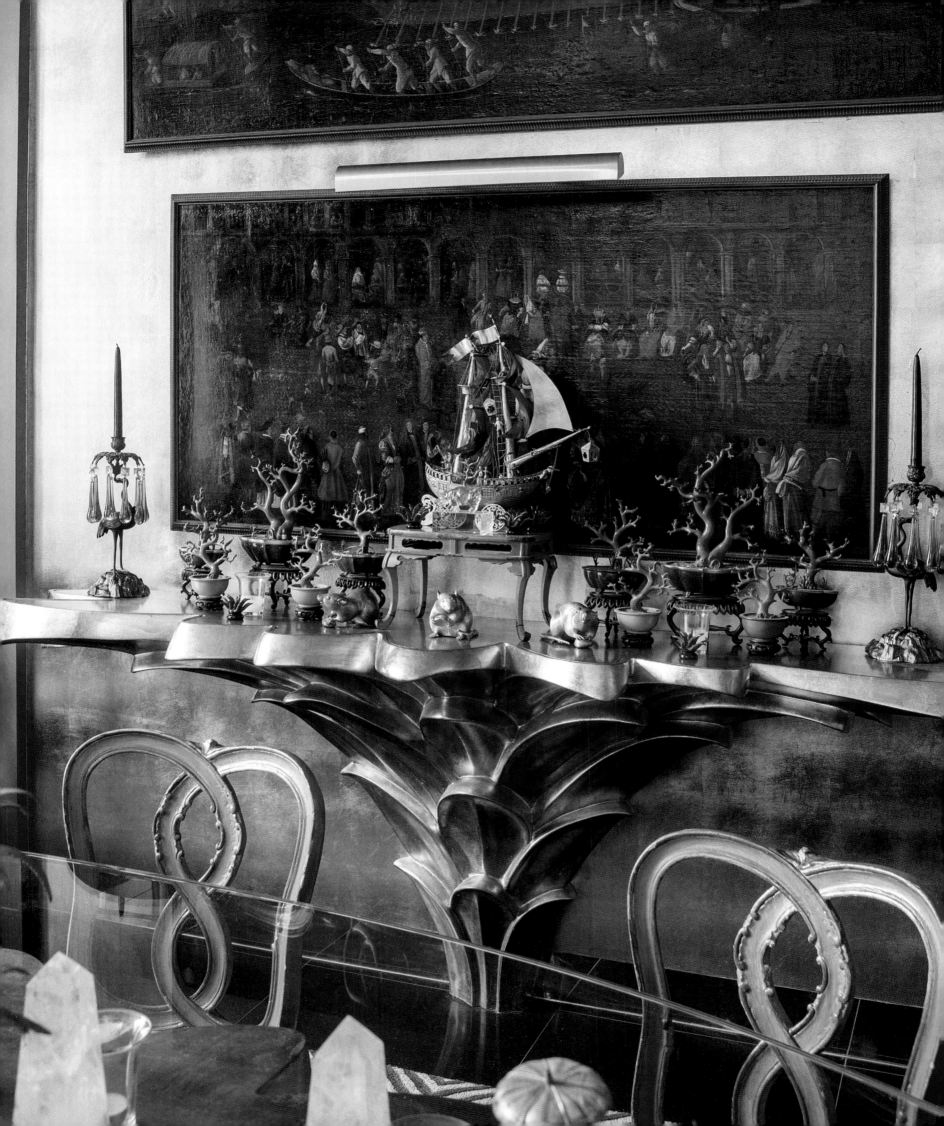

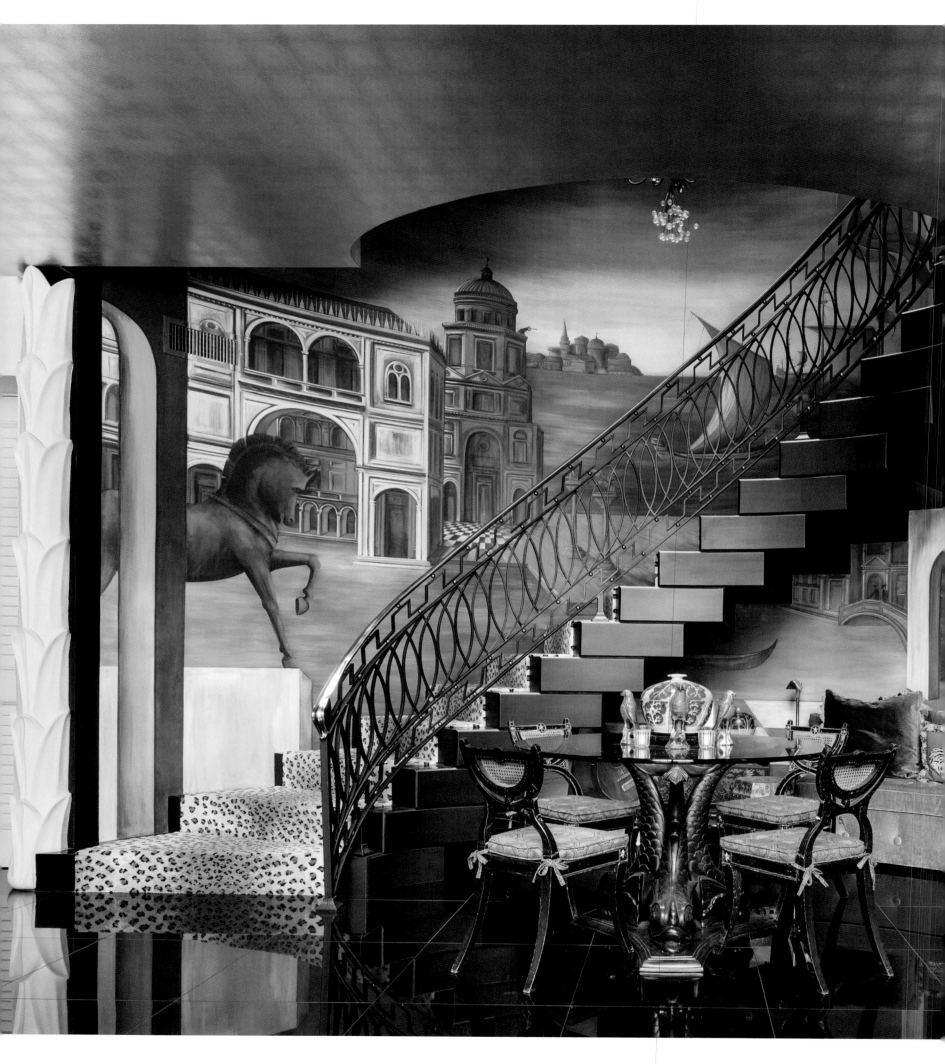

The drawing room, 2018. The stairs leading to the drawing room end on a raised platform with a small table and sitting area for intimate dining. The trunks of the famous Beverly Hills Hotel palm trees act as decorative moldings.

The Drawing Room

Descending the staircase, you pass beneath fantasy murals of Venice painted by Los Angeles artist Scarlett Abbott. I asked Scarlett to make them "a little bit De Chirico," and she did. I told the contractor that the staircase should look "like a sculpture, no matter what it cost," so the entire construction of the stairs was engineered and built as if it were a musical instrument. The railing, which I designed, took four different companies to complete—the iron mongers dropped like flies trying to get it right.

The stairs end on a raised platform with a seating area for intimate dinners and room for a folding bar. There is also a banquette under the stairs, reserved for seduction. A door on the left leads to a powder room, which doubles as a bathroom for the swimming pool. The door on the right leads to a catering kitchen that allows us to serve parties all the way out to the gardens at Dawnridge.

Stepping down into the drawing room, the stairs are flanked by a pair of enormous seven-foot-tall narwhal tusks, a gift from the fashion designer Gustave Tassell. The walls are painted coral, and the indents that hold the Venetian paintings have been gold-leafed. There are two seating arrangements using sofas designed by Tony for Doris Duke, paired with eighteenth-century French fauteuils that have a whitewashed finish and are upholstered in Tony Duquette for Jim Thompson Royal Ermine. The other four antique French armchairs

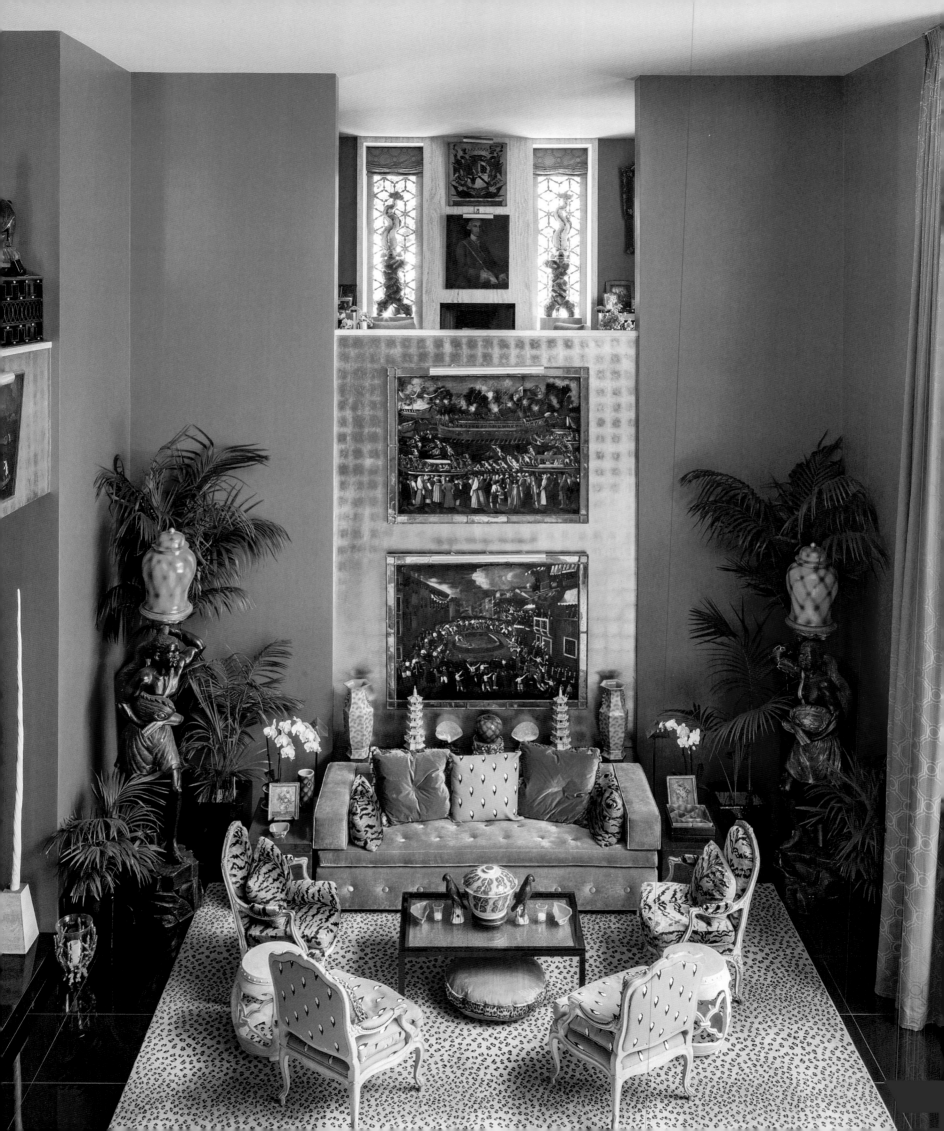

The drawing room, 2018.
The space includes two symmetrical
seating arrangements, with sofas
designed by Tony, circa 1950s, and
eighteenth-century French chairs.
The late seventeenth-century paintings
by Heintz are from the collection
of the Baroness d'Erlanger and hang
on gold-leafed walls.

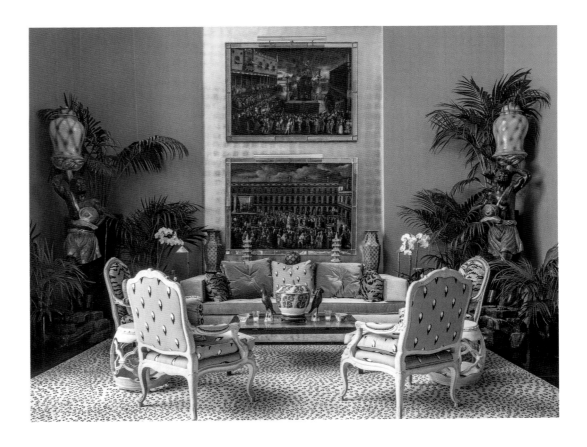

are upholstered in silk velvet, resembling tiger skin, woven in Lyon, France, on looms created for Marie Antoinette. Tony purchased a bolt of this extraordinarily rich fabric on a trip to Lyon with Hubert de Givenchy. Tony always kept the bolt of fabric in a vault for future use. "It's my money in the bank," he said, and it was always too good for him to use. The minute he died, I upholstered everything I could lay my hands on with that fabulous fabric.

The coffee tables, which I created, are inset with eighteenth-century panels of imperial yellow Chinese brocade woven with five-clawed dragons. The four corners of the room are dominated by two pairs of eighteenth-century Venetian blackamoor statues. These seven-and-a-half-foot-tall statues were purchased for my clients John and Dodie Rosekrans. It took four men to move them into their Tiepolo drawing room

at the Palazzo Brandolini on the Grand Canal in Venice. I originally bought only two, but when I took them back to the palazzo, I realized that they were both left-handed. I called the dealer and asked, "Are there any more? These are both left-handed." She checked with the prince at Palazzo Balbi, and he said, "Yes, there were four. I gave two to my sister and kept two for myself." Well, the prince had broken the pair! Fortunately, the dealer was able to get the other two from the sister. After Dodie passed away, I purchased all four from her family and now they are happily ensconced at Casa La Condesa. Truth be told, the room was designed around my collection of Venetian paintings and my dream of eventually getting these blackamoors. I believe in creative visualization; it has worked for me not just where blackamoors are concerned, but in every aspect of my life.

The staircase, 2018. Artist Scarlett Abbott painted the Giorgio de Chirico-esque mural that spans three stories, and includes the family tree of the Counts of Alastaya.

The Staircase

Climbing the elliptical staircase from the Drawing Room, you pass under the two-story family tree of the Counts of Alastaya, which was painted on the wall by Scarlett Abbott to my specifications. The mural traces the lineage of my noble and illustrious ancestors from 1769 to the present. I don't feel any family tree is complete without the addition of monkeys, rodents, lizards, and at least one hornet's nest, so I made sure these were all included in the finished mural. Reaching the top of the stairs, you arrive at a wide landing that doubles as a twelve-foot-tall library in emerald-green lacquer. In the corner is one of my favorite Victorian chairs. Standing at the railing you can look out the window and see a straight-on view of the rose garden and gazebo to the north. There is a large oval skylight that mirrors the shape of the staircase below; hanging from its center, through a silver-gilt sunburst, are five matching chandeliers that cascade down, one after the other, for three stories.

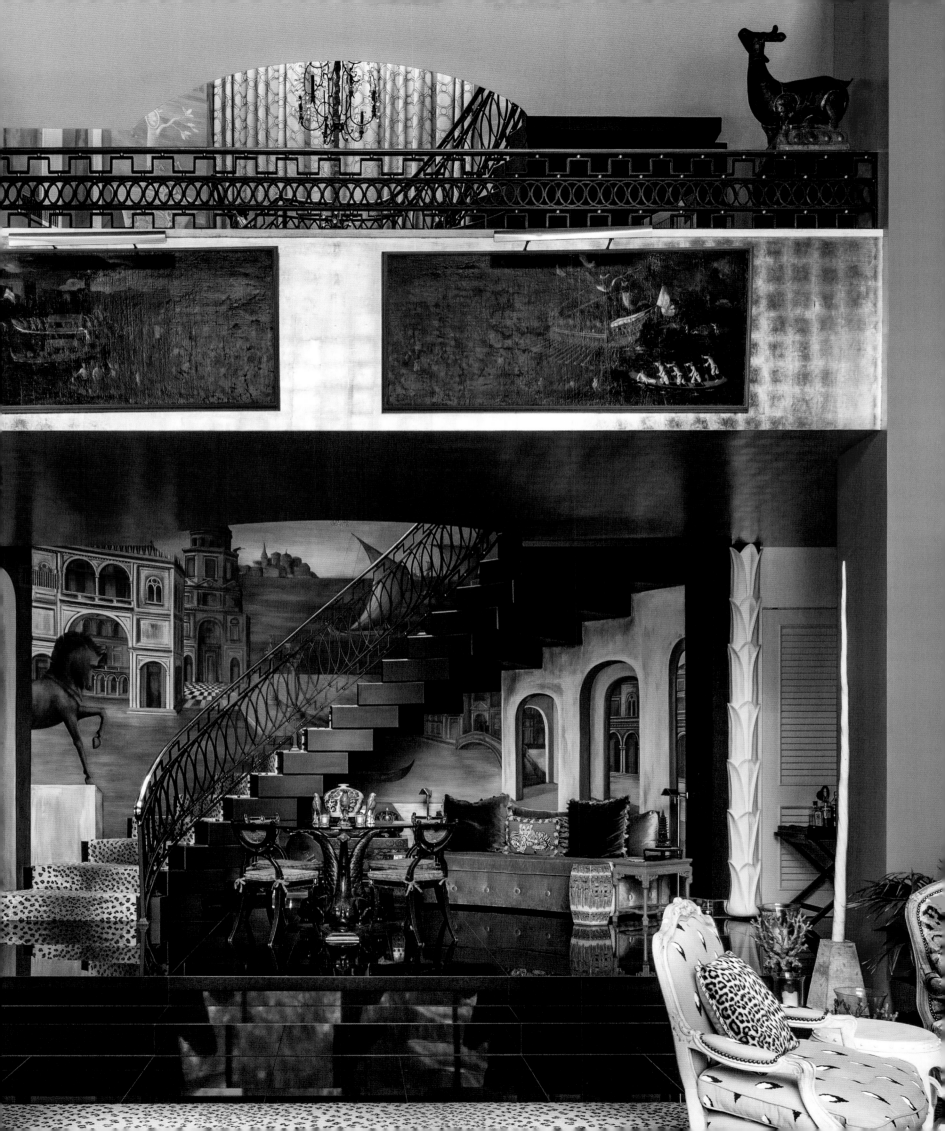

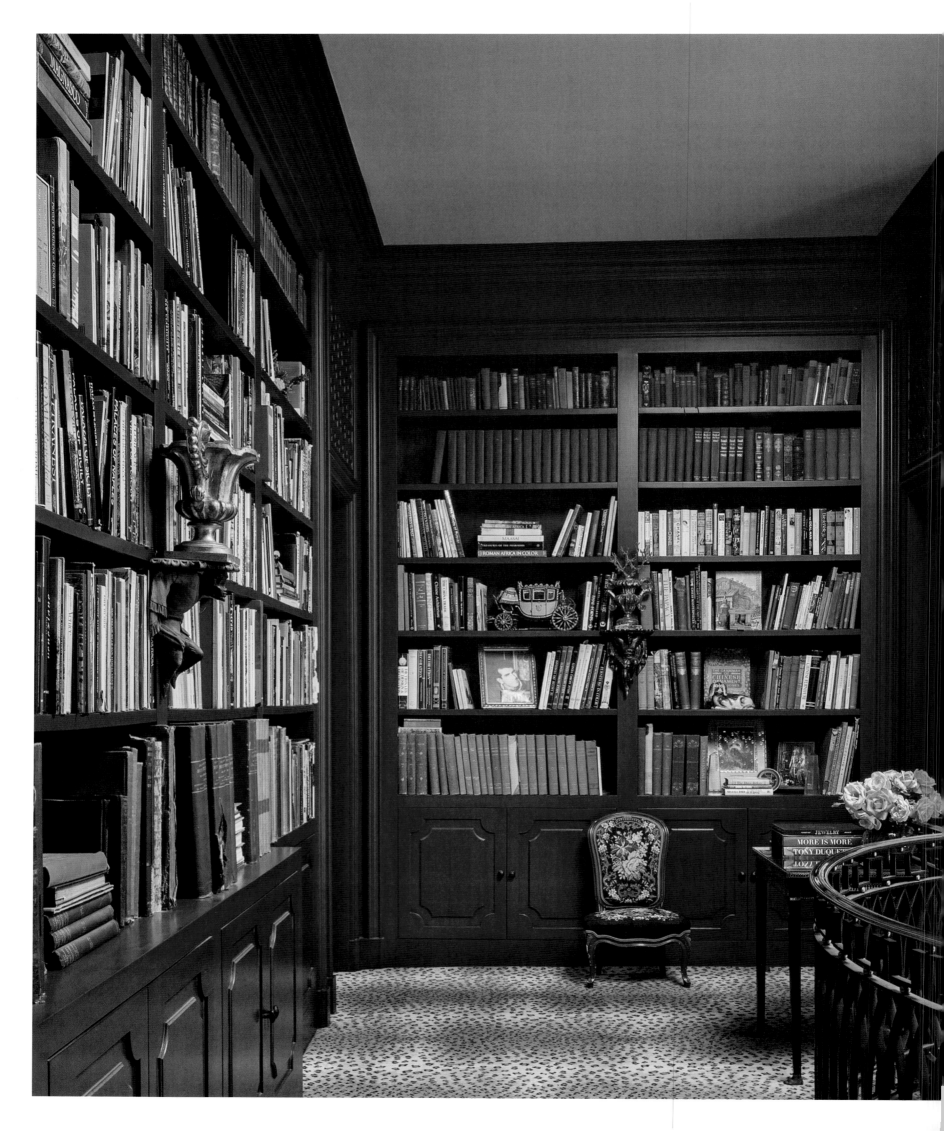

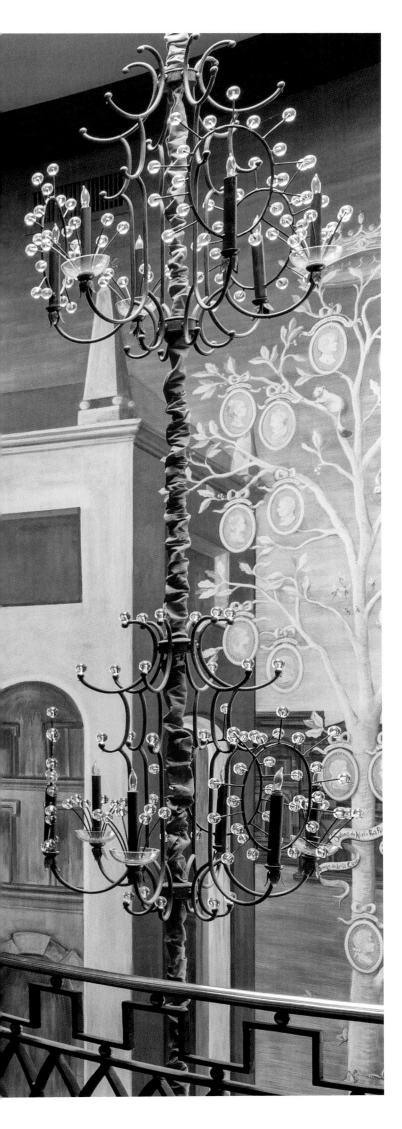

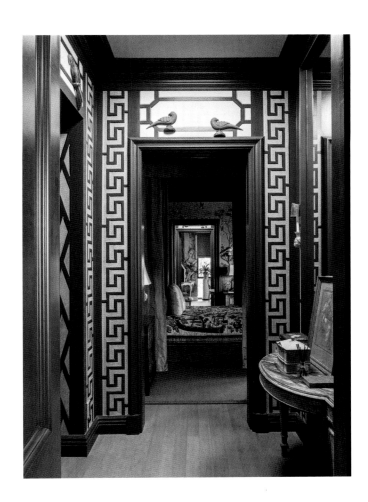

The Vestibules

There are two doors that lead to small vestibules—painted with fretwork by Scarlett Abbott—which open into three bedrooms, with attached bathrooms and dressing rooms. Ruth and I use one bedroom to sleep in, and we each get a bedroom and dressing room to make a mess in. Ruth's sitting room is more organized than mine; hers is always neat and very pretty. Mine is always a mess of magazines, dogs, and scraps of paper. What more can I say?

Sitting room, 2018. My sitting room is paneled with a collection of twenty prints depicting my favorite seventeenth-century Chinese palace Yuanming Yuan.

Hutton's Sitting Room

I chose the bedroom to the right of the vestibule for my sitting room. This is where I can make a mess (which is what I usually do), watch television, and take a nap when necessary. My room is carpeted wall-to-wall in zebra stripes, and the ceiling is gold-leafed. The draperies are natural linen shot with gold Lurex; they cover sliding glass doors that open onto terraces on both sides of the room.

I paneled the room with book-matched mahogany and installed my prized prints of Yuanming Yuan, the pleasure palace designed by Giuseppe de Castiglione for the Chinese emperor Qianlong. Castiglione, an Italian Jesuit priest, told the emperor about Versailles, and the old boy—as emperors are wont to do—decided that he wanted one just like it! During the Second Opium War in 1860, the incredible palace was partly destroyed by the English, French, American, and German armies

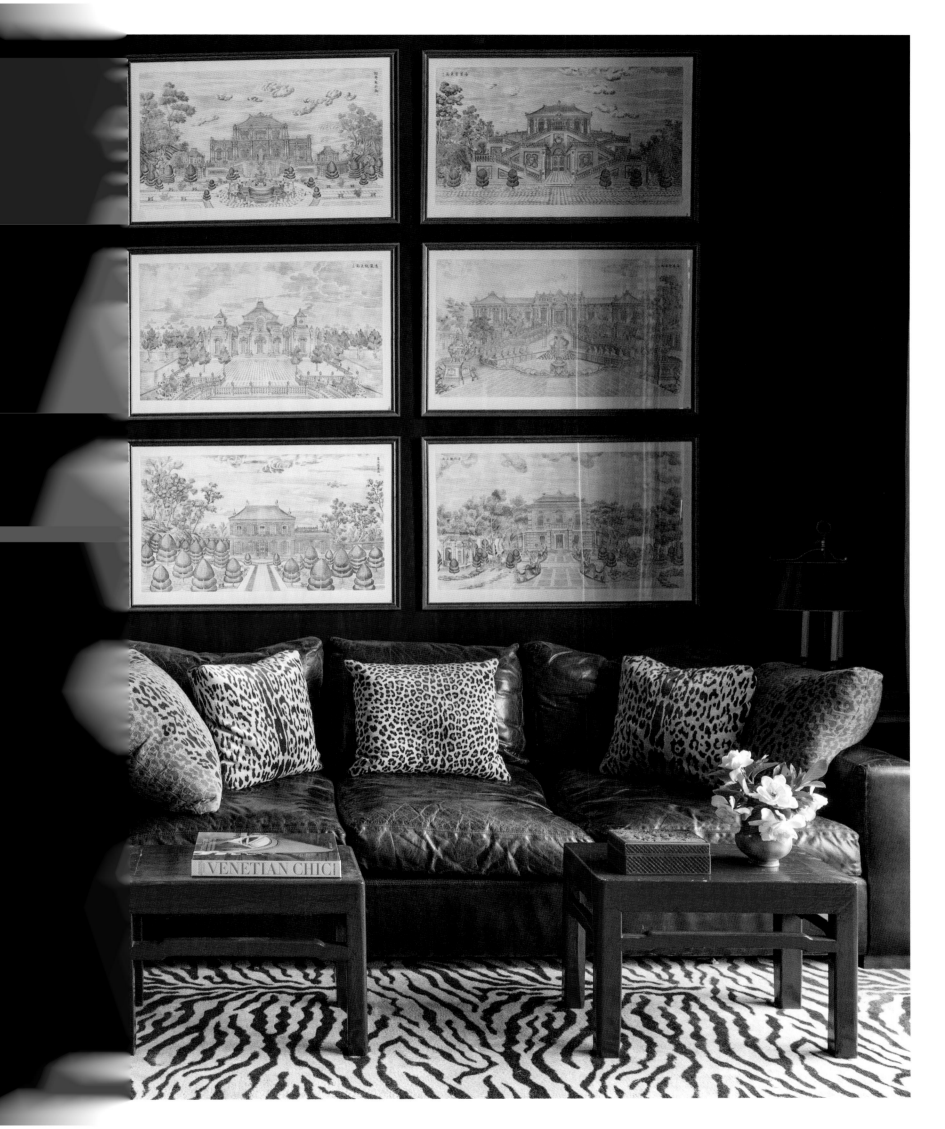

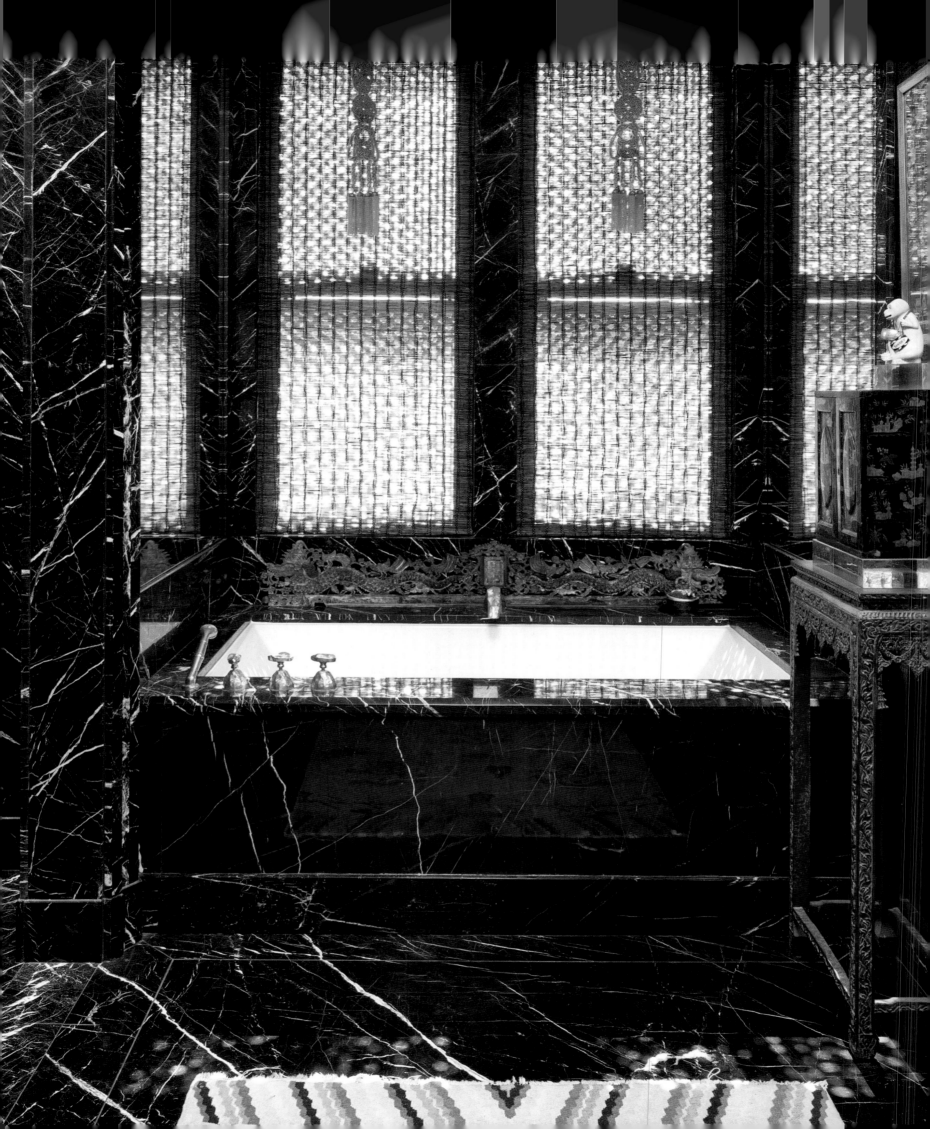

My Art Deco-inspired black
marble bathroom, 2018.
The walls are upholstered in
faux crocodile and hung with
my collection of verre églomisé
Chinese reverse paintings
on glass to mimic Elsie de
Wolfe's own bathroom at Villa
Trianon. The carpet is Chinese
imperial, and the fixtures
are gold nuggets made by P.E.
Guerin, which is something
I wanted since I was eighteen.

"Look, Tony. It's what
we've always been
looking for—that Chinese
palace you're always
telling me about!"

under the command of Lord Elgin. Whatever was left—and it was a lot—was totally obliterated by the Western armies as a punishment for the Boxer Rebellion in 1900. The destruction of this Chinese cultural treasure is considered one of the greatest acts of vandalism of the first half of the twentieth century.

On his first trip to Paris in 1947, Tony visited Misia Sert, and she shared the legend of this half-French, half-Chinese palace—she famously owned bronze heads of a rat and a rabbit that had been pillaged from one of its fountains—which he later told me. Many years later, while walking in the Place des Vosges, we stopped in our tracks, riveted by an art gallery window. "Look, Tony," I hollered with excitement. "It's what we've always been looking for—that Chinese palace you're always telling me about!" We went inside and discovered that it was not an art gallery, but a book publisher called Le Jardin de Flore. When Emperor Qianlong completed his palace, he'd commissioned twenty of the finest engravings on the finest paper and created a folio to send to all the crowned heads of Europe to prove he was not a barbarian. There are only three of the original folios left in the world—one at the Louvre, one at the Metropolitan Museum of Art, and one in a private collection. Le Jardin de Flore published a facsimile in an edition of two hundred at $200 each. That was a very expensive book in the 1970s, but we splurged and purchased two copies—one for me and Ruth, which we immediately framed and hung in our dining room in Hollywood, and one for the Duquettes. Tony never opened his, and after his death, Dodie Rosekrans bought it for $17,000 at the Christie's sale. After Dodie's death, the book sold in her Sotheby's auction for $20,000. I've never visited the ruins of Yuanming Yuan near Peking, the remains of one of the only examples of reverse chinoiserie in the world, but I'm still obsessed with it.

Sitting room, 2018. Ruth's sitting room
includes murals created from enlarged
photographs of Elizabeth Duquette's original
paintings, two eighteenth-century blue
lacquer Venetian chairs from the designer
Adrian, and an eighteenth-century
Louis XVI lit à la polonaise (following page).

Ruth's Sitting Room

R uth's sitting room is much grander than mine. Besides the fact that it has its own fireplace, the room is entirely muraled with images by Elizabeth Duquette. We purchased the two paintings hanging on the mirror over the fireplace at auction, and I decided to have them blown up ten feet tall to create the murals. It was only later that I realized these diminutive paintings were studies for the murals Beegle created for the Twentieth Century Fox film *Goodbye Charlie*. I knew the actual murals well, as I had sold the 15-foot-tall originals to the late Leona Helmsley for her house in Arizona.

My other triumphant adaptation was the fireplace. I needed a 4-foot-wide marble fireplace and couldn't find one for love nor money. Finally, I found a charming trumeau mirror and realized that if I cut off the bottom it would become a perfect Georgian fireplace, so that's what I did. A collection of Meissen porcelain powder boxes decorates the top of the mantel. The eighteenth-century Louis XVI *lit à la Polonaise* was the first piece of furniture Ruth ever purchased; it was from the collection of actress Ina Claire, who purchased it from Elsie de Wolfe. Ina told us that she had based her character Grand Duchess Swana in the movie *Ninotchka* on her pal Elsie de Wolfe. There are lots of pretty things in this room, not least of which are the pair of eighteenth-century Venetian blue lacquer armchairs from the collection of Adrian, the three tiny eighteenth-century children's chairs, and the water drop chandelier, circa 1960, by Tony. This is the place where Ruth hangs out with our two West Highland White Terriers, Piper Dundee and Kippy of the Cavendish.

Ruth's bathroom is a symphony of green Persian marble reflected in three mirrored walls. Scarlett Abbott painted the crown moldings and the back of the door to match this marble, and she also decorated the cabinets on each side of the bathtub

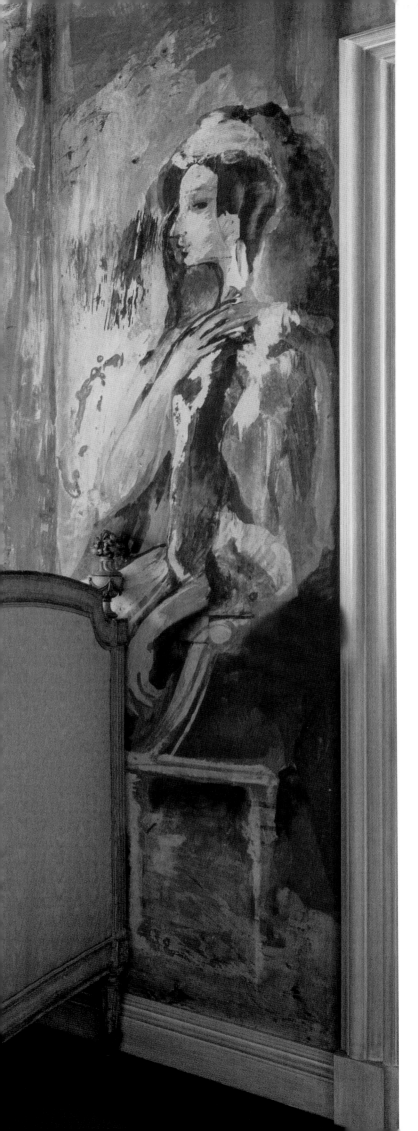

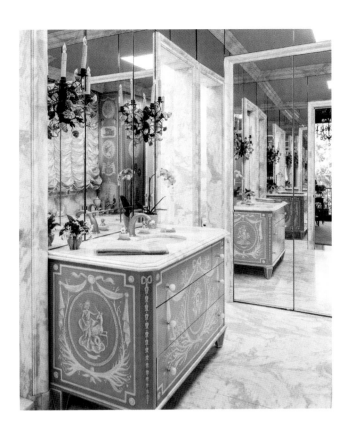

Ruth's Persian green marble bathroom
(below) is mirrored on three sides,
and features painted cabinets and
murals by Scarlett Abbott.

with elaborate scenes. Across the top of the doors and sides, she depicted the four seasons as separate bouquets of flowers, and under these she painted four continents: America, Asia, Europe, and Africa. America is represented by a painting of our former Georgian house in Hollywood; Asia by the Taj Mahal; Europe by our beloved St. Mark's Square; and Africa by the Temple of the Winds, which we visited in Tunisia. These designs are subordinate to the main thrust: portraits of our four puppies, two on each cabinet. Jip, our first, is no longer with us; his brother Argyle, our second, is also deceased; and Piper Dundee and his sister Kippy of the Cavendish. Between the portraits are their coats of arms, featuring dog bones and Scottish plaid. The inside panels are painted with the Cavendish coat of arms—heralding *Bonefide*—and the Dundee coat of arms with the inscription *Barke Dieum*. Completing the iconographic program, also painted by Scarlett, are vignettes of many of Ruth's favorite things, including Venetian glass vases, an eighteenth-century beaded pomandore, her bottle of Poiret Nuit de Chine perfume, and a carved malachite bear. Scarlett also decorated the vanity with Ruth's cipher and representations of Neptune and Venus in decorative oval plaques.

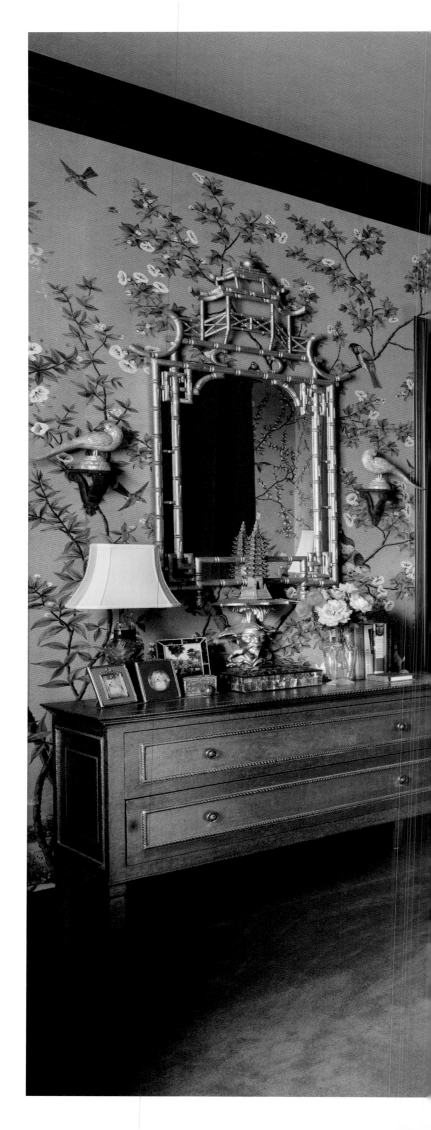

The Master Bedroom

The master bedroom sits between our dressing rooms and sports hand-painted wallpaper that was created for us in India to resemble the Gardens of Shalimar, replete with exotic birds and flowers. The two Louis XVI–style chests were also made for us in India and are covered with repoussé metal that has been gold- and silver-plated. The two chinoiserie mirrors are from the 1960s, and the antique *lac burgauté* mother of pearl inlaid cabinets on both sides of the bed are Korean and were purchased from the Doris Duke estate sale. The bedspread is composed of antique Chinese embroideries that have been cut out and reapplied on quilted satin. The armchairs are by Billy Baldwin in their original emerald-green velvet. The bronze doorknobs in the form of hands were purchased on our first trip to Venice in 1977; we stored them until we finally had just the right house to use them.

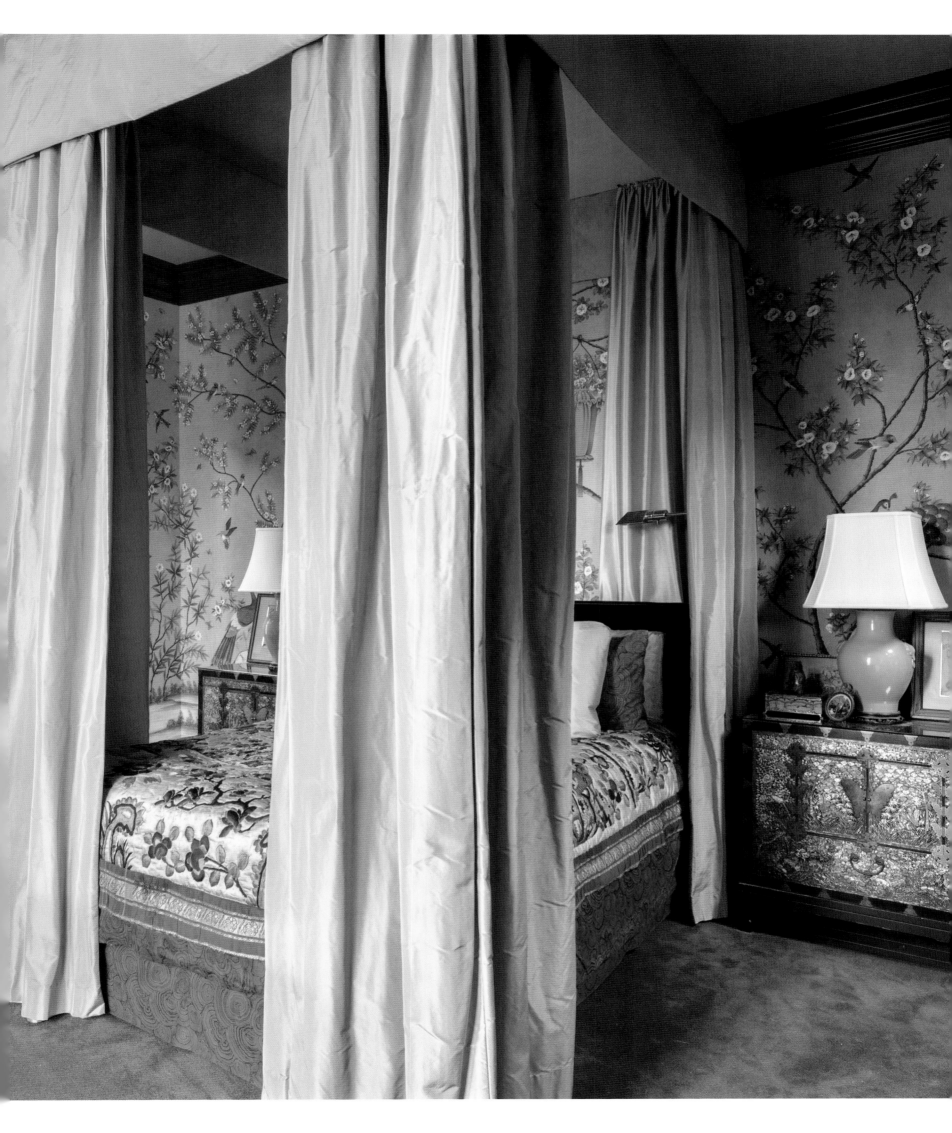

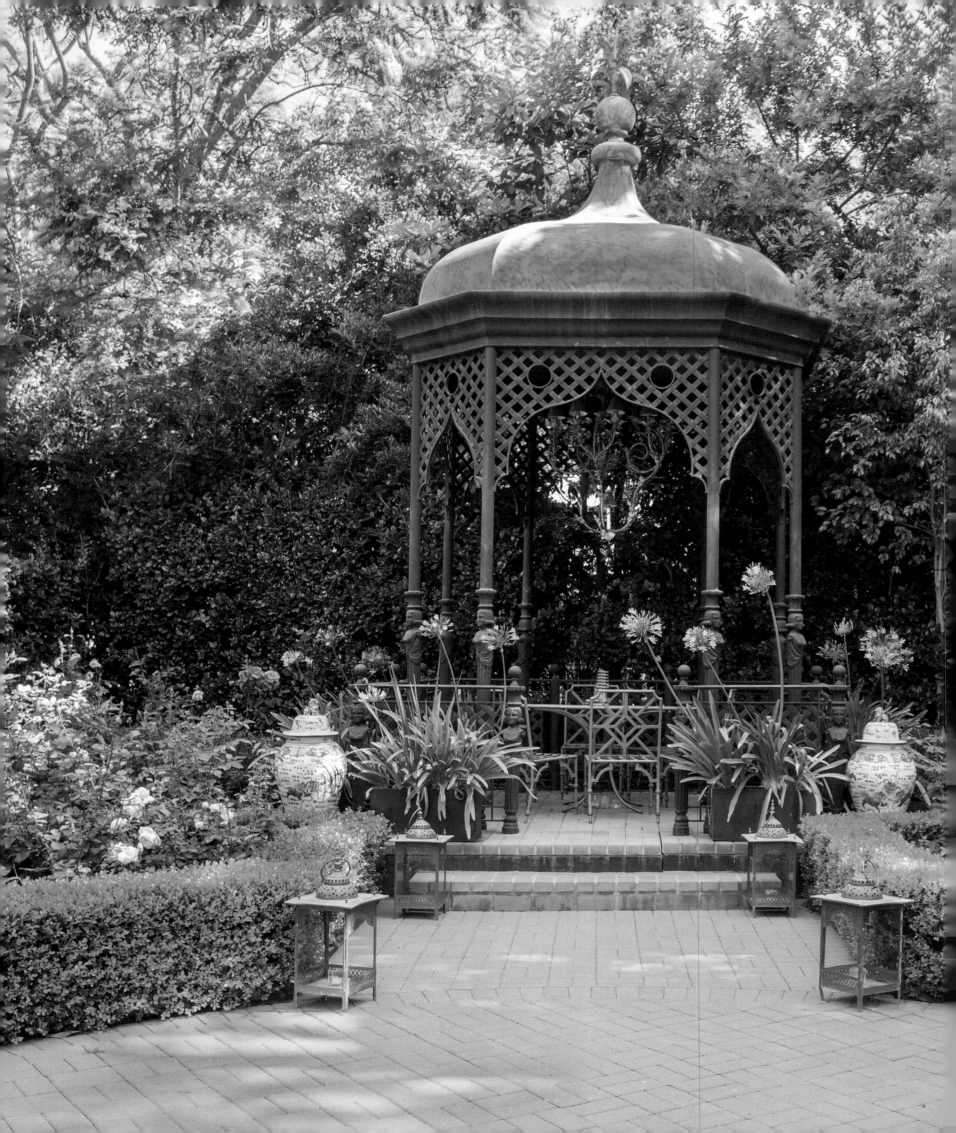

The pavilion, 2018. The structure was made to hold an onion dome from the 1959 MGM film *The Gazebo*, and was constructed entirely out of wrought iron, except for the dome. I found the iron caryatid columns in a pile at Tony's ranch and designed the pavilion around them.

Gardens and Terraces

While Casa La Condesa was under construction, we purchased the property next door, a double lot that gave us another garden to the north and a three-bedroom guest house. Connecting Casa La Condesa to the new garden proved to be a challenge. The elevation of the garden was higher than the house, and there was a gully between them. Our friend Juan Prieto, who was visiting from Boston, stepped in and suggested that we build a causeway between the garden and stair landing. This was a simple solution that conjured up visions of one of my favorite places in India: Akbar's Tomb. In that wonderfully exotic place, one can look down from causeways onto a Mughul garden where giant stars are bordered in marble. In the days of Shalimar, those marble-bordered stars would have held fragrant roses and other flowering plants. The experience at Casa La Condesa is similar, although the marble-framed stars seem to have eluded us.

The rose garden is now a second ceremonial entrance for events at the house. The pavilion was constructed using an onion dome from the 1959 MGM film *The Gazebo*, starring Glenn Ford and Debbie Reynolds. I created the columned metal frame using antique cast-iron caryatid columns, which I found in a pile of architectural fragments at Tony's Malibu ranch.

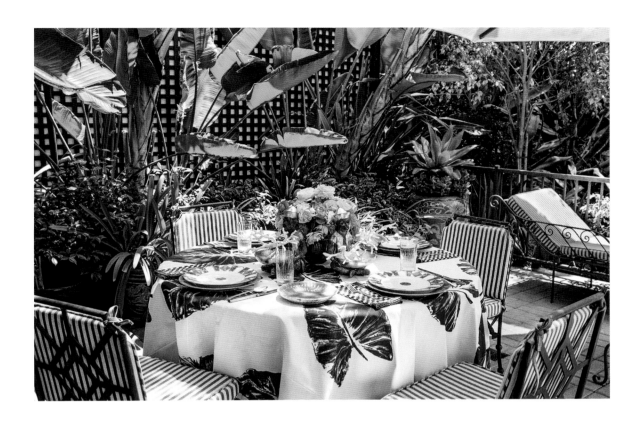

The pool terrace, 2018. The terrace features two jacaranda trees alongside coral-colored grotto chairs molded in cast resin from the eighteenth-century originals, which were part of the Hearst Collection. **Above:** Lunch on the terrace is set up using malachite and lapis lazuli-painted Limoges and Baccarat crystal.

Meanwhile, a narrow strip of land to the south of the house holds the swimming pool terrace, consisting of a paved deck with two planters holding jacaranda trees and jasmine. The coral-colored grotto chairs were molded in cast resin from the eighteenth-century originals Tony purchased from the Hearst Collection in the 1950s. There are also raised planters on both sides of the black granite landing near the Drawing Room doors, filled with giant bird-of-paradise, jasmine, and bronze-colored flax. Another raised planter running under the lattice-covered retaining wall contains more giant bird-of-paradise, blue agave, jade trees, and jasmine; the antique Chinese pots surrounding the infinity pool and lining the terrace hold agapanthus, geranium, flax, and ficus trees. On festive occasions, glowing Indian lanterns hang from the trees, while Moroccan lanterns line the pool and the red carpeted stairs leading down from the Drawing Room. We often invite friends over for cocktails at our house, and then lead them past the swimming pool and into the Dawnridge garden next door for dinner followed by dancing upstairs in the original Duquette house. But sometimes we reverse the process and have cocktails at Dawnridge, then proceed down to the garden for dinner and over to Casa La Condesa for dancing, just to break up the monotony.

I consider the courtyard entrance to the house as its own room. For me, this area—with its glamorous oval swimming pool and flickering gas light illumination—is for all intents and purposes the entrance hall.

CASA DEL CONDE

Forty years ago, Tony told me that there was a house up the street that had eighteenth-century French boiseries installed in the dining room; the owner turned out to be an Italian gentleman, Ambassador Conti. One day, I was driving to a decorating job in Santa Barbara when my cell phone rang. It was my real estate agent, Nandu Hinds, calling to tell me that the house had just been put on the market. My immediate response was, "Buy it." "What do you mean?" she asked me. I said, "Buy it. Offer them full price, all cash, no contingencies, and no exceptions." She did, and the offer was immediately accepted. I was leaving for Europe three days later, so told Nandu, "I'd really like to see what I bought before I leave town."

An appointment was made for the day before my departure, and Ruth and I saw for the first time what we were getting. It was a charming south-of-France style house in white stucco, which lent itself beautifully to antique French furniture and decoration. In fact, there was eighteenth-century French paneling in the dining room, so Tony's story from so many years ago was accurate. There were three bedrooms and bathrooms and an expansive garden, which we immediately decided to annex onto the still-under-construction Casa La Condesa next door. Dawnridge had become an interesting compound of three united properties, and Casa del Conde would serve as the guest house. After several years, I decided it was time to make the most of what we had at Casa del Conde, and we added a courtyard entrance and a garage.

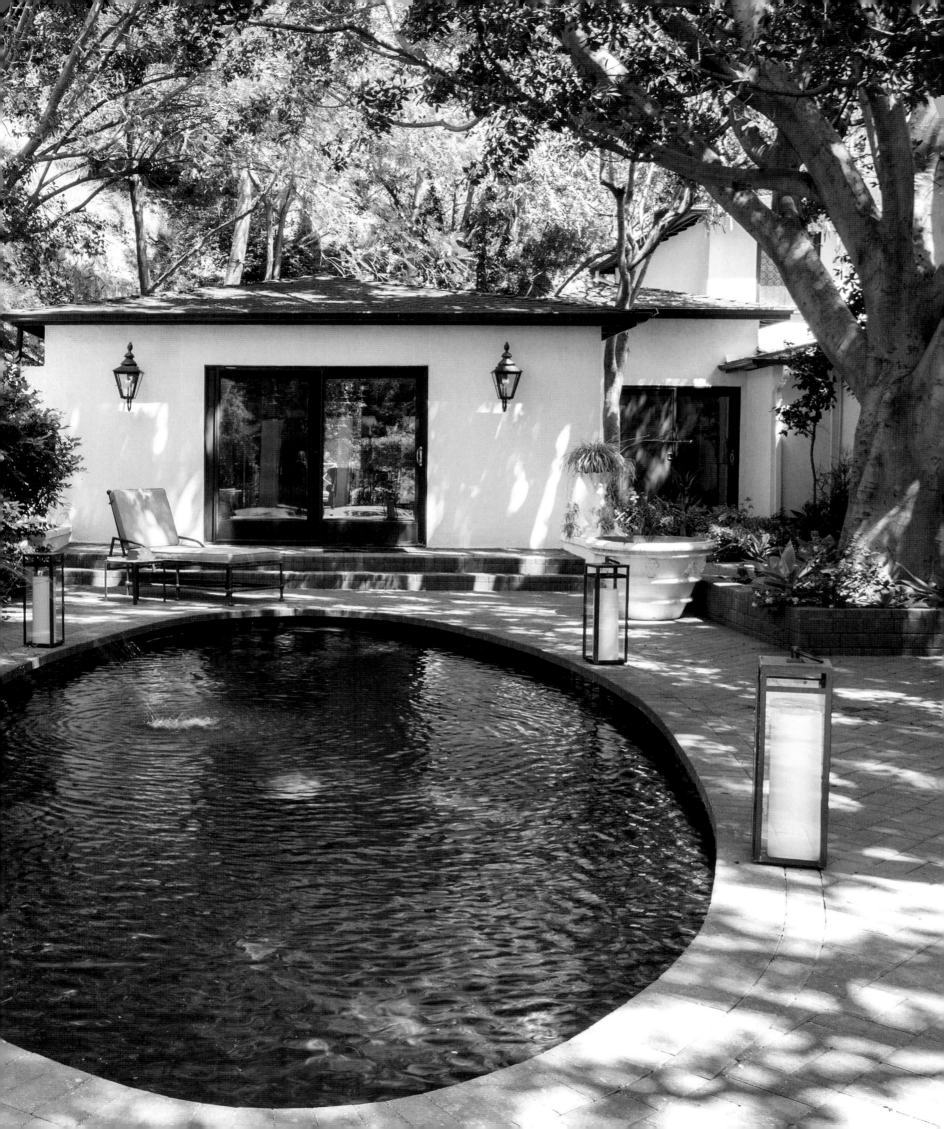

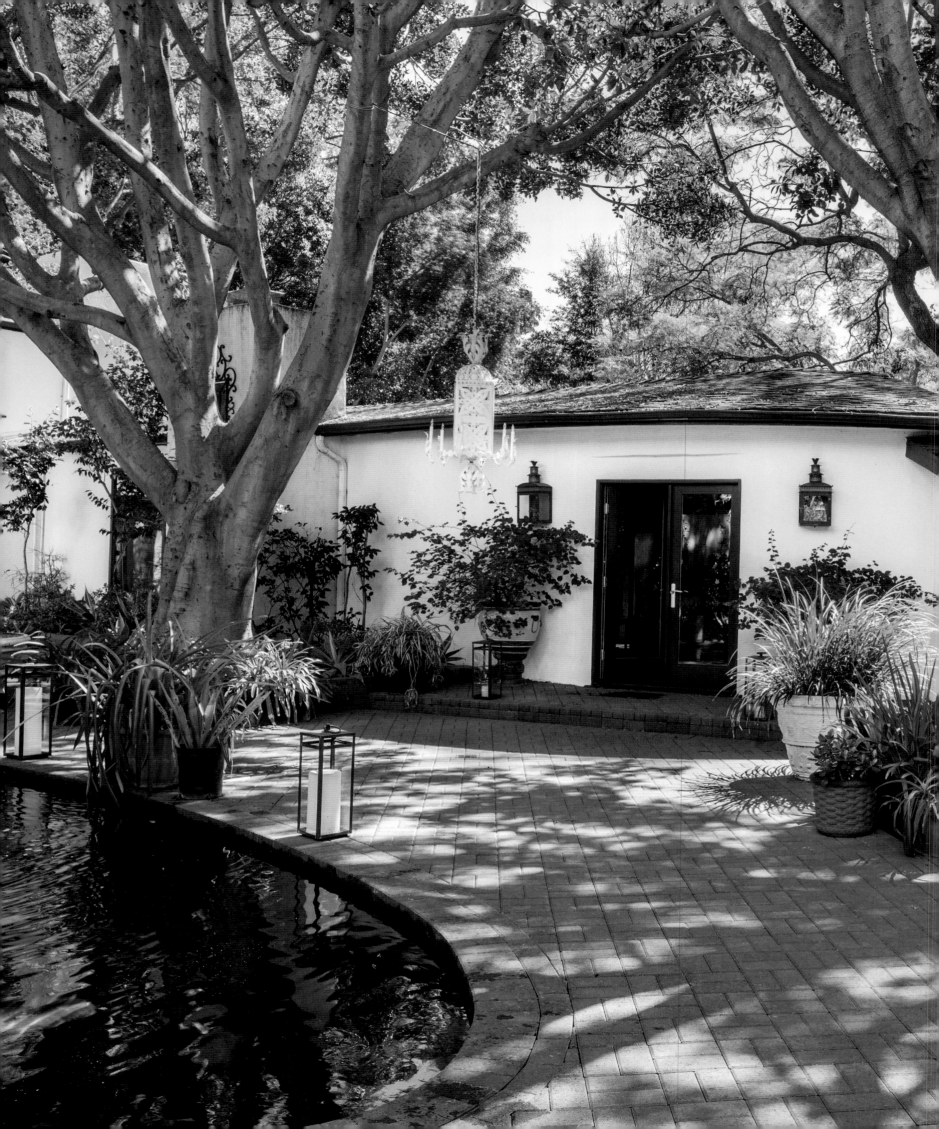

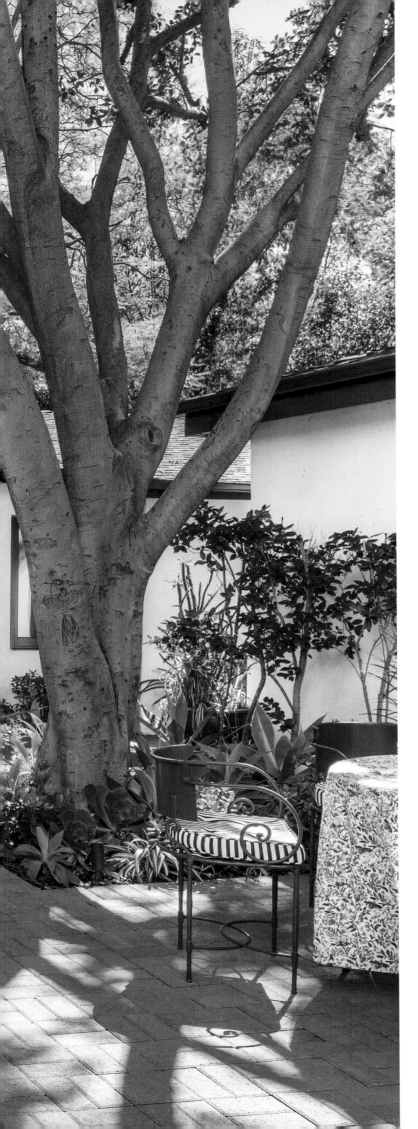

Entrance hall, 2018. The courtyard was created by constructing a new garage in front and building an oval Jack Wolfe-inspired pool in the center. It's a cool, shady place to relax. The north and south terraces, which are more private, are reserved for sunbathing. The area is decorated with iron furniture from Italy, framed mirrors, and Art Deco sculptures of sea horses in white plaster.

The Entrance Hall

I consider the new courtyard, with its oval-shaped pool and water-spouting dolphin, to be the entrance hall of the house. This elegant outdoor room is decorated with framed mirrors, panels of antique Portuguese *azulejos*, Art Deco seahorses, and an iron chandelier hanging from a tree near the front doors. There are tables and chairs, chaise longues and marble-topped side tables—enough furniture to comfortably entertain a large group of friends. The rooms that can be accessed off the courtyard include a large family room, a mud room leading to the kitchen, and the actual entrance hall. Glass front doors lead directly into the drawing room through a Coromandel-paneled vestibule.

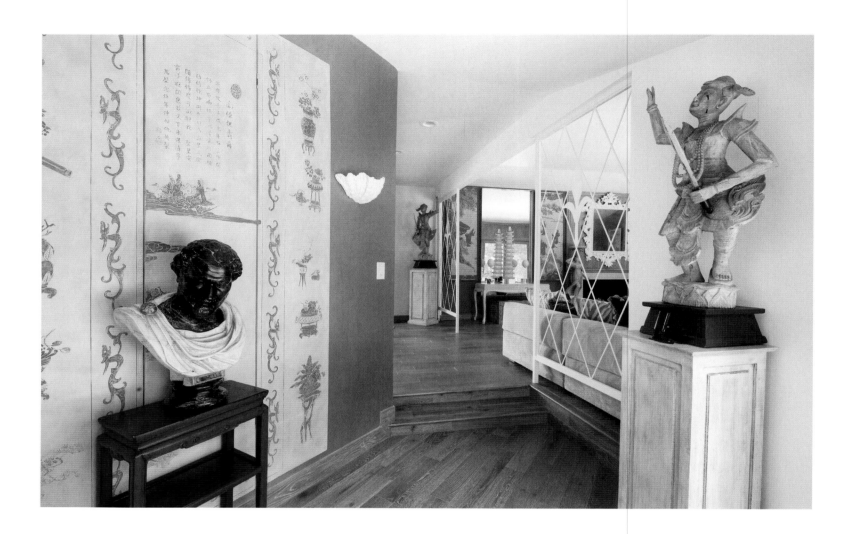

A pair of carved wood statues depicting
Thai dancers on stands preside
over the two corners of the hall.

The Drawing Room

The large drawing room is separated from the Coromandel vestibule by mid-century metal screens featuring fleur-de-lis decorations that I found in Tony's collection of architectural fragments at his Malibu ranch. The ivory-and-blue-colored Coromandel panels on either side of the fireplace are antiques purchased in Paris from C. T. Loo, the venerable Chinese dealer off the Boulevard Haussmann. Inspired by Elsie de Wolfe's famous ivory Coromandel screen, I commissioned Scarlett Abbott to paint an antique screen from my collection to match the ivory-and-blue panels in the living room. The fireplace is surmounted by an eighteenth-century Venetian mirror and is flanked by eighteenth-century figural stands holding Chinese foo dog–patterned ginger jars. The room is furnished with a pair of custom banquettes placed diagonally across from each other, French armchairs, woven zebra rugs, blue agate tables, and simple lighting. Paintings by Elizabeth Duquette have been placed throughout the house, with two strong examples at the end of the drawing room, flanking the doorway into the dining room.

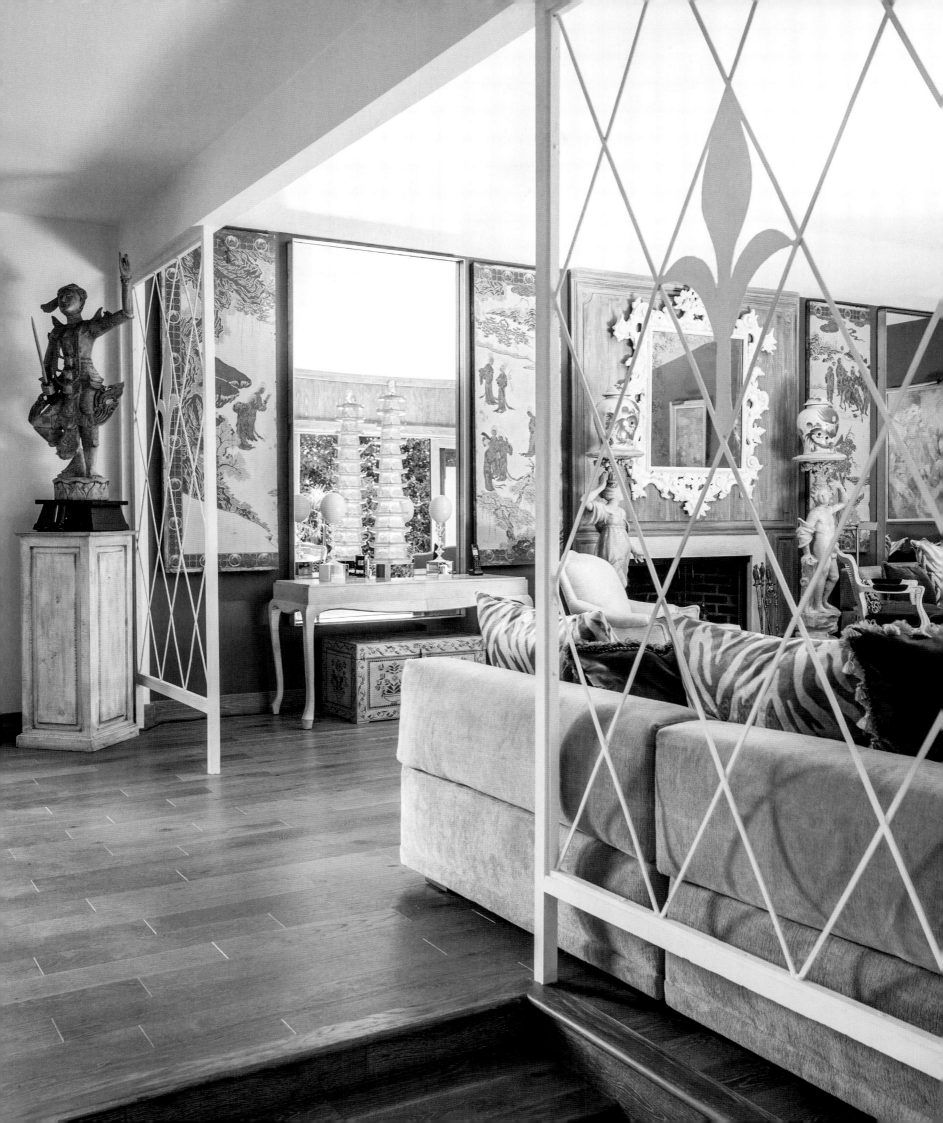

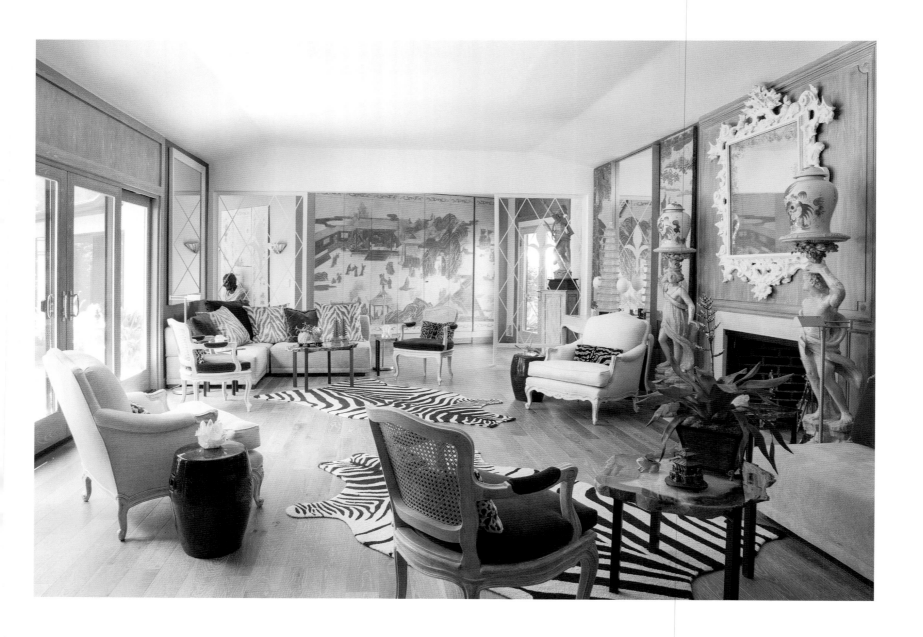

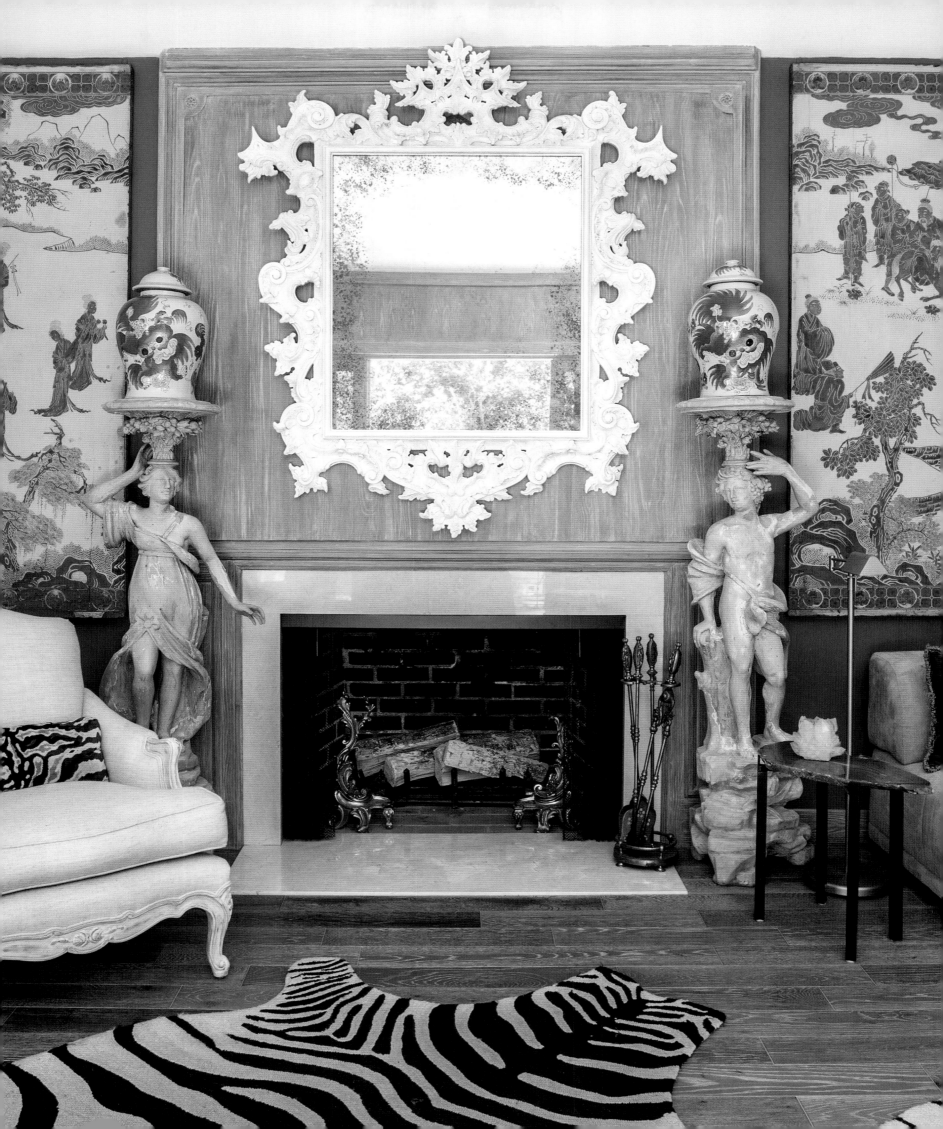

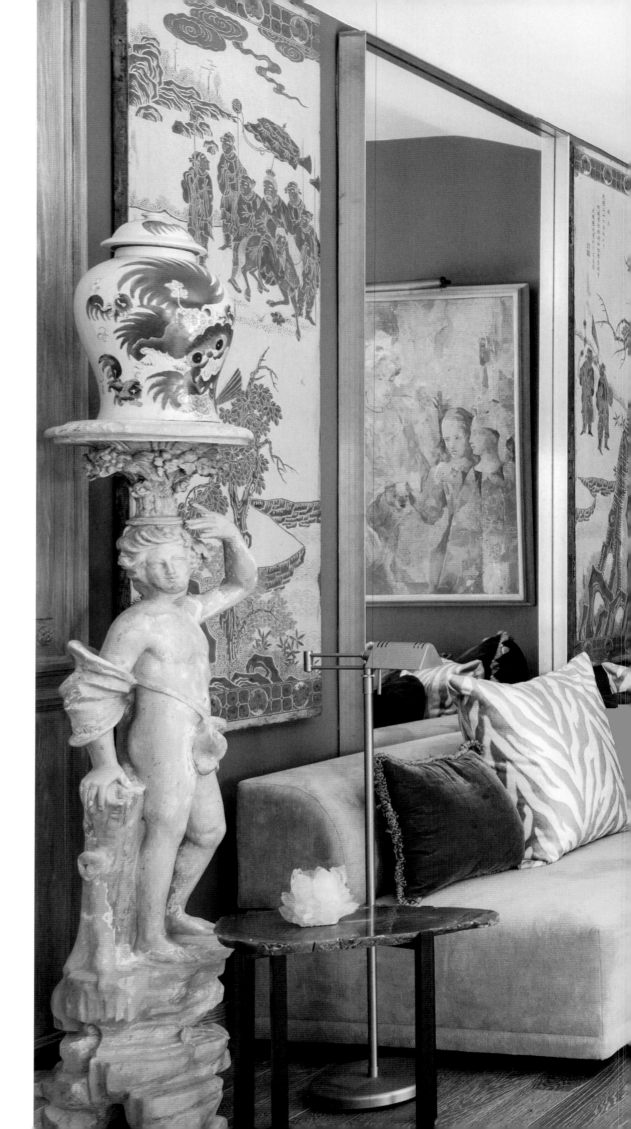

Hanging above one of the two custom-designed corner banquettes are antique ivory Coromandel panels from C.T. Loo and a painting by Elizabeth Duquette. The coffee tables were created from a large slab of blue agate set in an iron framework.

The dining room, 2018. A Venetian screen, painted by Elizabeth Duquette, was placed in the corner to mimic the curved wall opposite it and create the illusion of a circular dining area.

The Dining Room

The dining room is paneled with eighteenth-century French boiseries that were brought in by the original owner in the 1930s. I updated the paneling by painting it a mouse-gray color, but I left the door that leads into the kitchen the original wood finish. The ceiling is painted a Schiaparelli pink, and the corner banquette features a linen slipcover in the same color. There's a mirrored bar behind the double doors, and silver-leafed Chinese Chippendale cabinets hold a collection of ceramic dishes, tureens, and covered bowls. The paintings in the room are by Elizabeth Duquette, as is the painted Venetian screen, which I've placed in the corner, creating a similar curve to the window facing it. This illusion of a circular end to the room allowed me to put a round carpet under the Lucite and glass table, providing a sense of symmetry to a room that is not at all symmetrical.

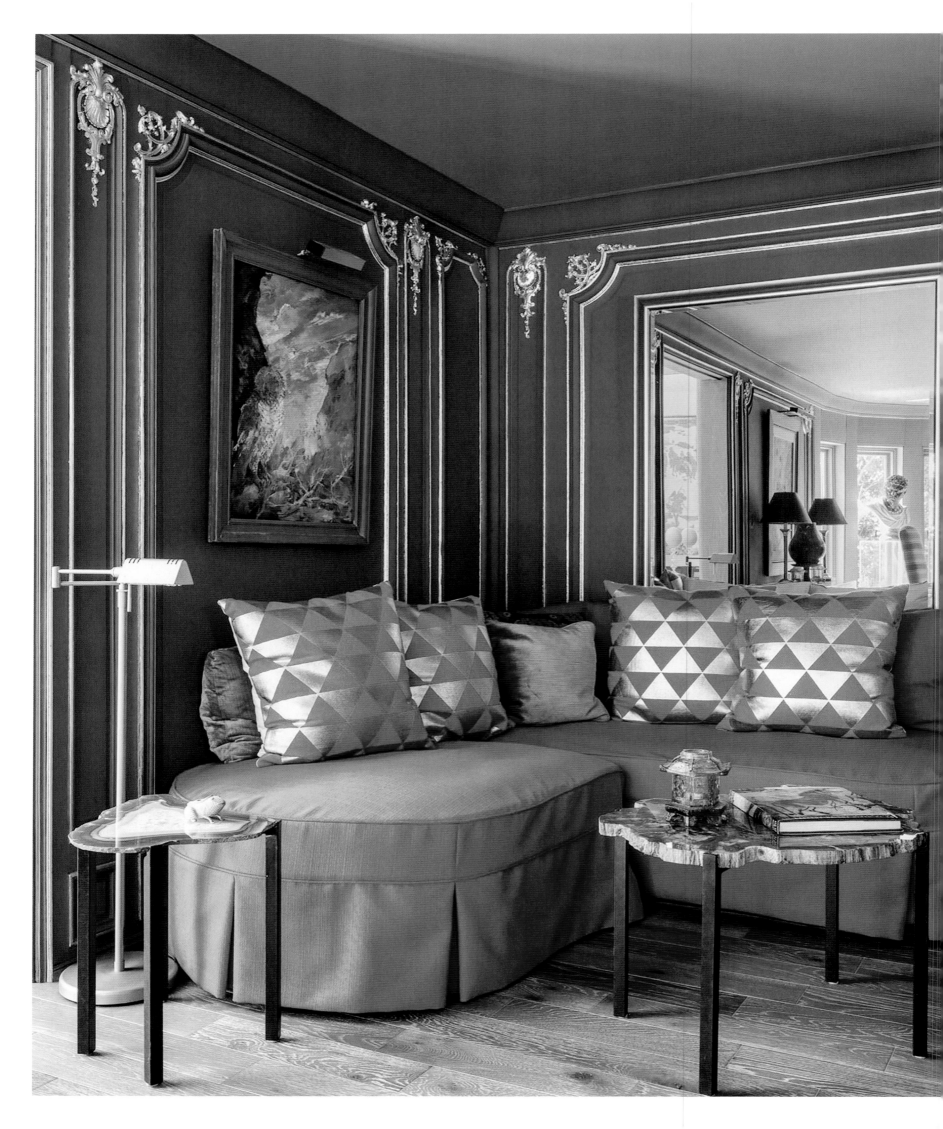

The dining room, 2018. The eighteenth-century French boiseries were installed in the 1930s by the original owner. In the corner (opposite), a banquette creates an area to enjoy cocktails near the bar. A pair of silver-leafed Chippendale display cabinets (below) surmounted by ebony mirror frames inlaid with bone flank the eighteenth-century carved French door leading to the kitchen.

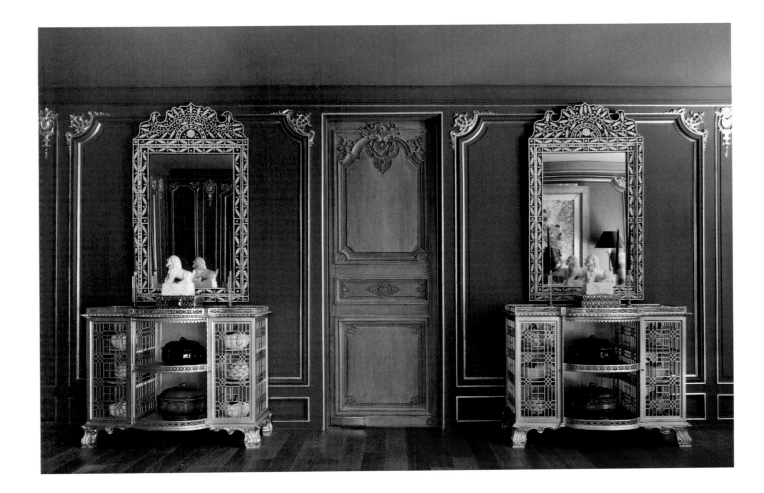

The kitchen, 2018. At Casa del Conde, the kitchen is the hub of the house. Located between the family room and the dining room, it is where guests congregate for breakfast to plan their days.

........................

Following spread:
The family room, 2018. The family room, which has its own bathroom, has come in handy as an additional bedroom, and because it's centered between the swimming pool terrace and a sunbathing terrace, is in use all day long as a media room when guests are present.

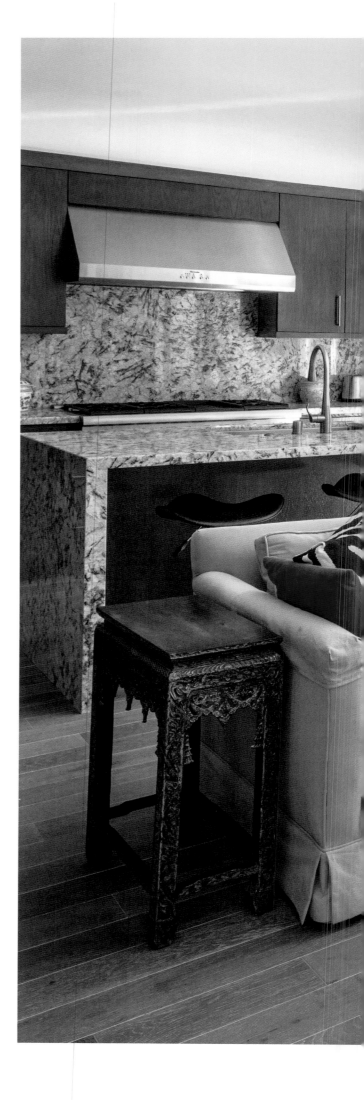

The Family Room and Kitchen

A large modern kitchen is accessed from the dining room through the eighteenth-century paneled door. Besides all the modern conveniences, including a hidden laundry room and a bar counter with stools, this space has room for a round table and eight chairs, as well as a sofa for watching television.

The wide hall leading from the kitchen passes through a slate-tiled mud room just off the family room. This comfortably decorated space doubles as a media room and can easily convert to a guest bedroom that has its own closet and bath. With sliding glass doors looking onto the swimming pool on one side, and its own private courtyard for sunbathing on the other, it is one of the most serene rooms in the house.

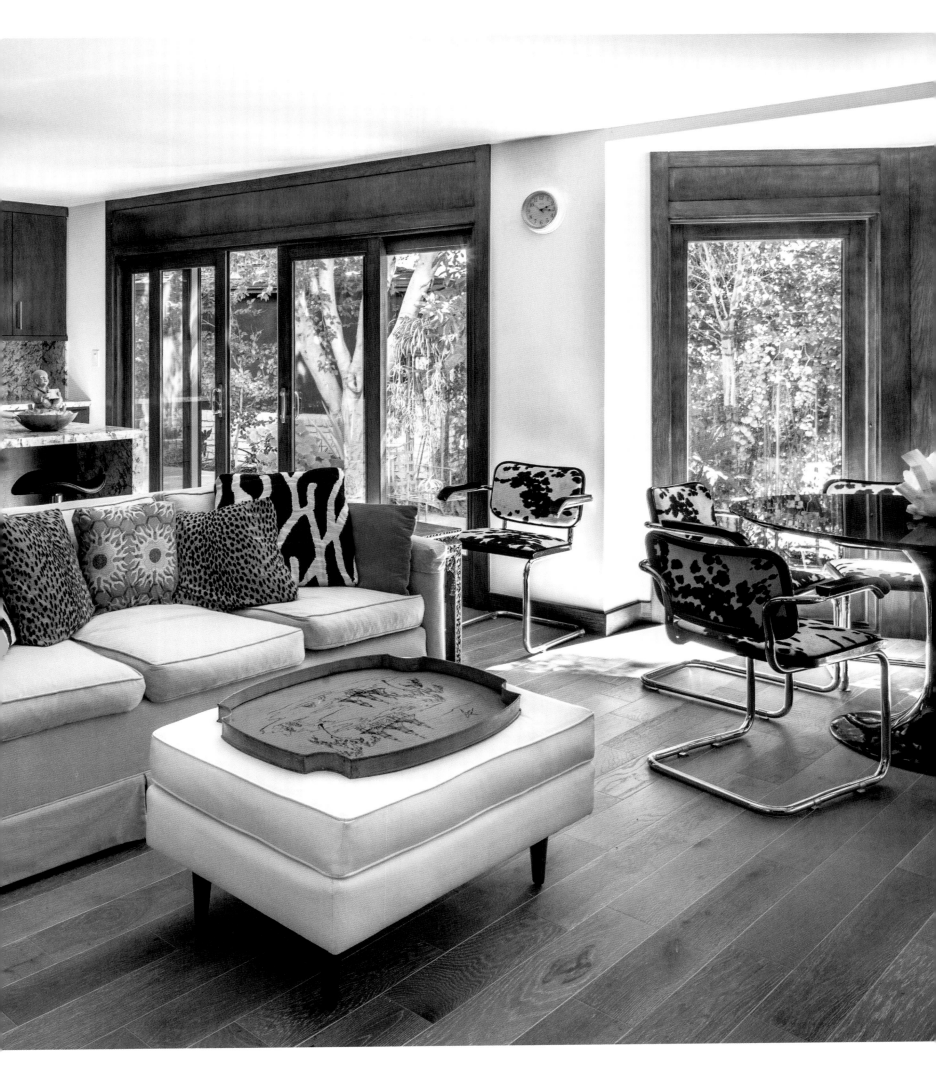

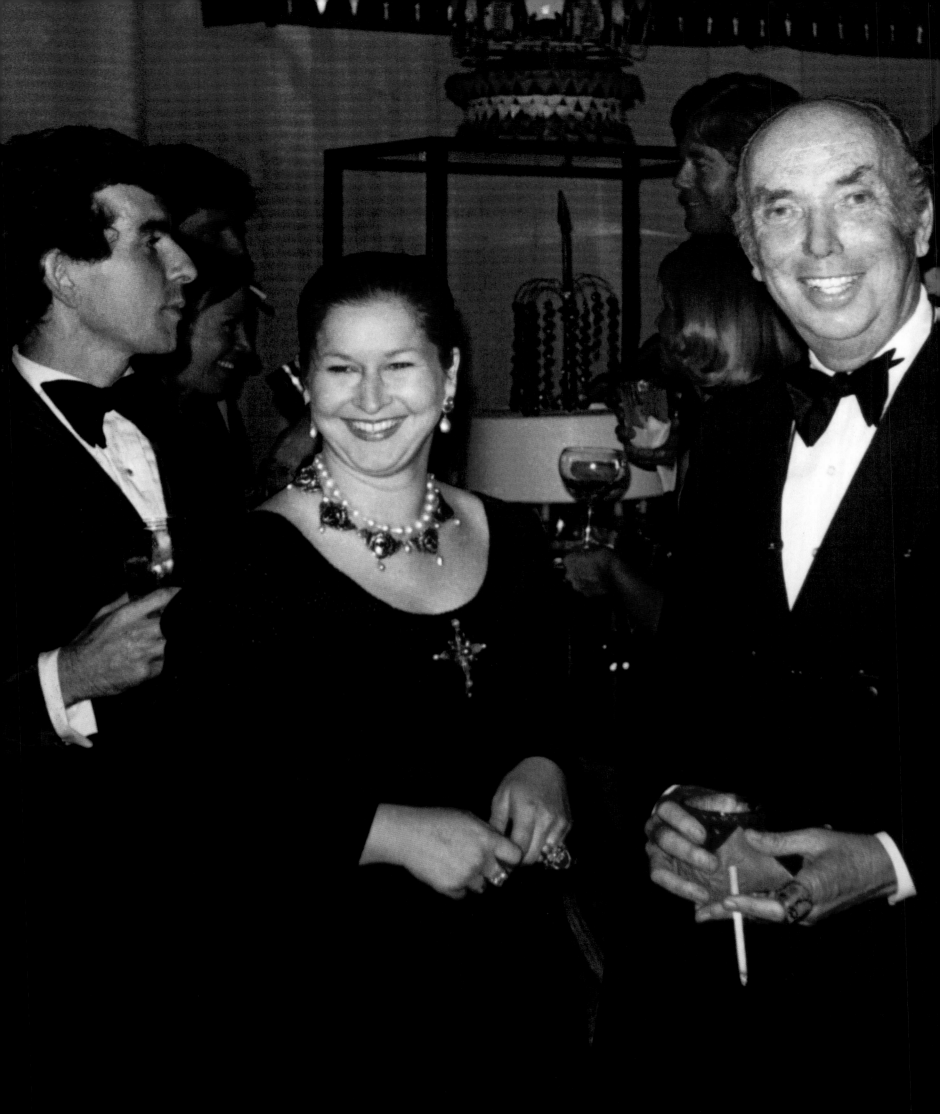

Afterword
THE PLEASURE OF YOUR COMPANY

F estivities in the garden at Dawnridge are always special. Today, our staff wears gold lamé coats with feathered turbans to set the mood. Parties with themes like "Return to the Raj," "Tropical Nights," "Walk like an Egyptian," and anything "Venetian"—not to mention dozens of black-tie affairs—are *de rigueur* at Dawnridge. There is always music in the garden, whether it's piped in or provided by musicians: jazz bands, balalaika players, flamenco guitarists, ten-piece dance orchestras, troupes of African drummers, or Balinese dancers with their accompanists. The entertainment is always diverse and the décor constantly changing.

Our friend Eleanor Phillips, the West Coast editor of *Vogue*, once described us as "professional party givers." We are not, although we love to entertain, and on occasion we have been hired to supply themed decorations for private balls and charity events around the country. We also host lunch for visiting friends daily at Dawnridge, which is served by our extraordinary housekeeper and cook, Flory Vargas. Just as she did for Tony and Beegle before us, she continues to make the best Mexican food in Los Angeles and has mastered all of our favorite Western, Indian, and Chinese dishes as well. My father's side of the family was from Alabama; my mother's side from South America; and Ruth and I were born in Southern California—I think our sense of Southern hospitality comes naturally. We like to entertain semi-formally, even if it's just a buffet for forty, but for groups above that we rely on outside caterers. Seated dinners from eight to one hundred and twenty are not unusual here, and often include dancing.

What Ruth and I hate most are people who are brought for the first time as someone else's guest and announce when introducing themselves, "You know, I've never been here before." To which I invariably answer, "Come to think of it, I've never been to your house before either." Strangers can't figure out that Dawnridge is a private residence. We rarely have parties here that are not our own. We have lent the house for charity events and have weakened on occasion when friends ask if they can have a wedding or other special occasion here, but it is never open to the public except by invitation.

Dinner was served on the middle terrace at Dawnridge for the Return to the Raj Ball, 2015. **Below:** The façade of Dawnridge was entirely covered with a painted backdrop, turning the house into the Amber Palace at Jaipur for our Return to the Raj Ball, 2015.

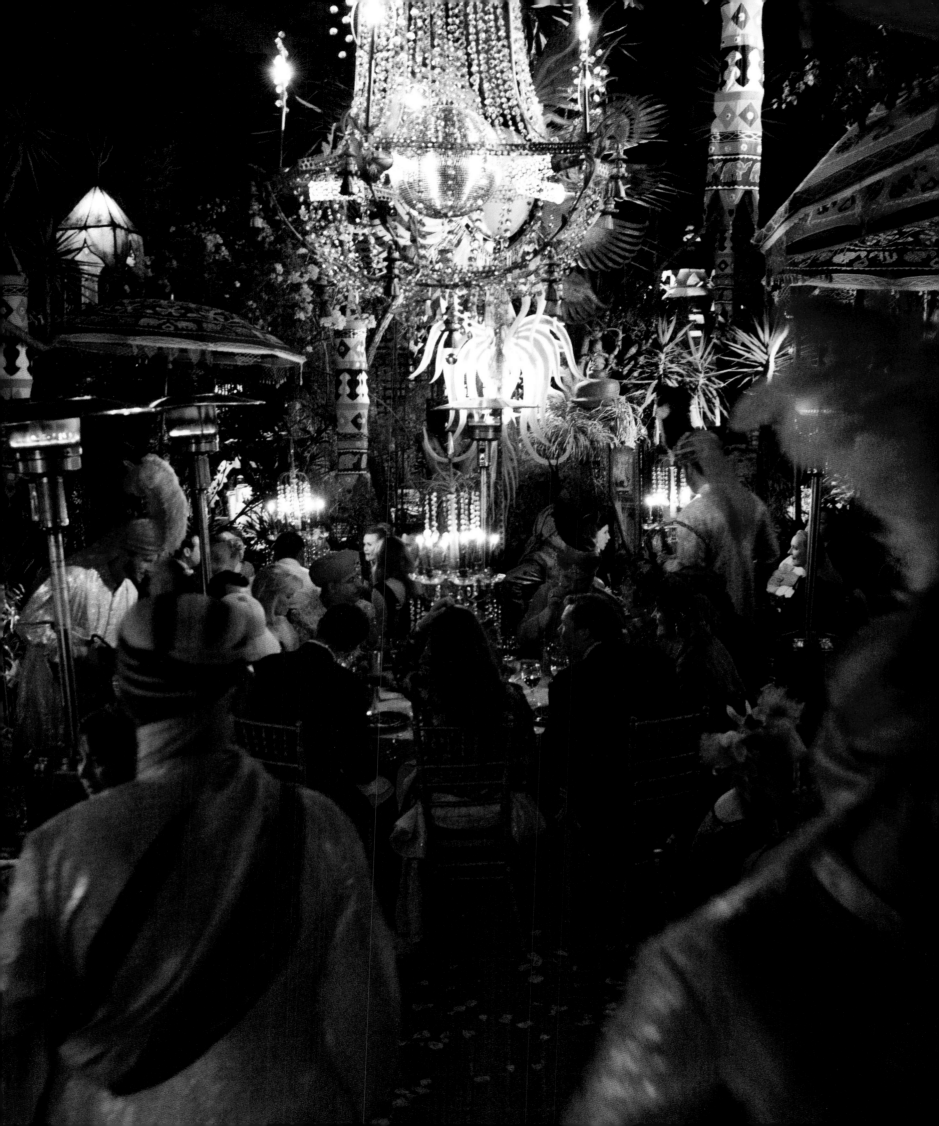

Nautch girls entertain during dinner to the delight of international guests Miranda Reise Williams, Manfred Flynn Kuhnert, and Rebecca de Ravenal at the Return to the Raj Ball, 2015.

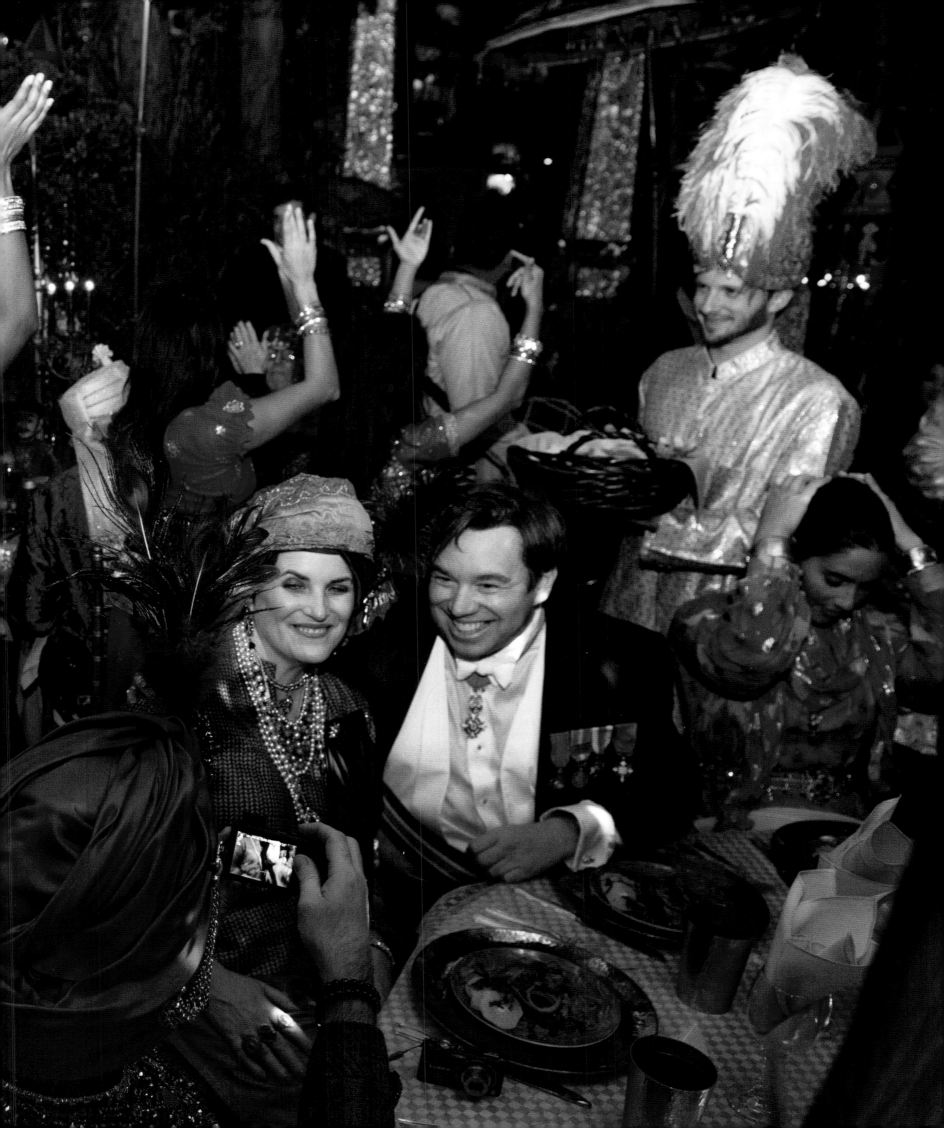

MENUS AND RECIPES OF THE TONY DUQUETTES'

From the pages of Vogue, *April 15, 1957*

..................

RECIPES

Dinner in the Kitchen

GUACAMOLE
Served with Fries
CHICKEN LIVERS
ALBÓNDIGA SOUP
BARBECUED CHICKEN
CHILES RELLENOS WITH SAUCE
FRIJOLES
FRIED RICE
GREEN SALAD
BEL PAESE CHEESE
MACÉDOINE OF FRUIT

Buffet in the Supper Room
CREAMED CHICKEN AMANDINE
STUFFED ZUCCHINI
GREEN SALAD WITH CHOPPED
ARTICHOKE HEARTS AND AVOCADO
CHERRY AND KIRSCH ICE
PETITS FOURS

GUACAMOLE

2 ripe avocados
1 ripe tomato
½ onion, minced fine
Jalapeño peppers, chopped
Lemon juice
Chiles
Salt and pepper

Mash the avocados with the ripe, peeled tomato. Add minced onion, a little lemon juice, chopped jalapeño peppers. Season with salt and pepper. Use chiles to taste, for desired spiciness. Serve with Fritos; for six to eight.

ALBÓNDIGA SOUP

4 tablespoons oil
1 onion, minced
¼ cup tomato sauce
3 quarts chicken stock
1 pound fresh peas
½ pound string beans, chopped
3 tablespoons cooked rice
½ pound ground pork
½ pound ground beef
6 mint leaves
¼ cup chopped parsley
1 egg, slightly beaten
Salt and pepper

Fry onion in oil 5 minutes, then add to tomato sauce and stock. When mixture is boiling, add peas and string beans. Prepare meat as follows: mix cooked rice into meat, adding chopped parsley and mint leaves, egg, salt and pepper, and form into balls. Drop into boiling stock, cover tightly, and let simmer half an hour. Serves six to eight.

CHILES RELLENOS

8 Ortega's green chiles
8 oblongs of cream cheese, 2 x ½ x ½ inches
4 eggs
4 tablespoons flour
Shortening

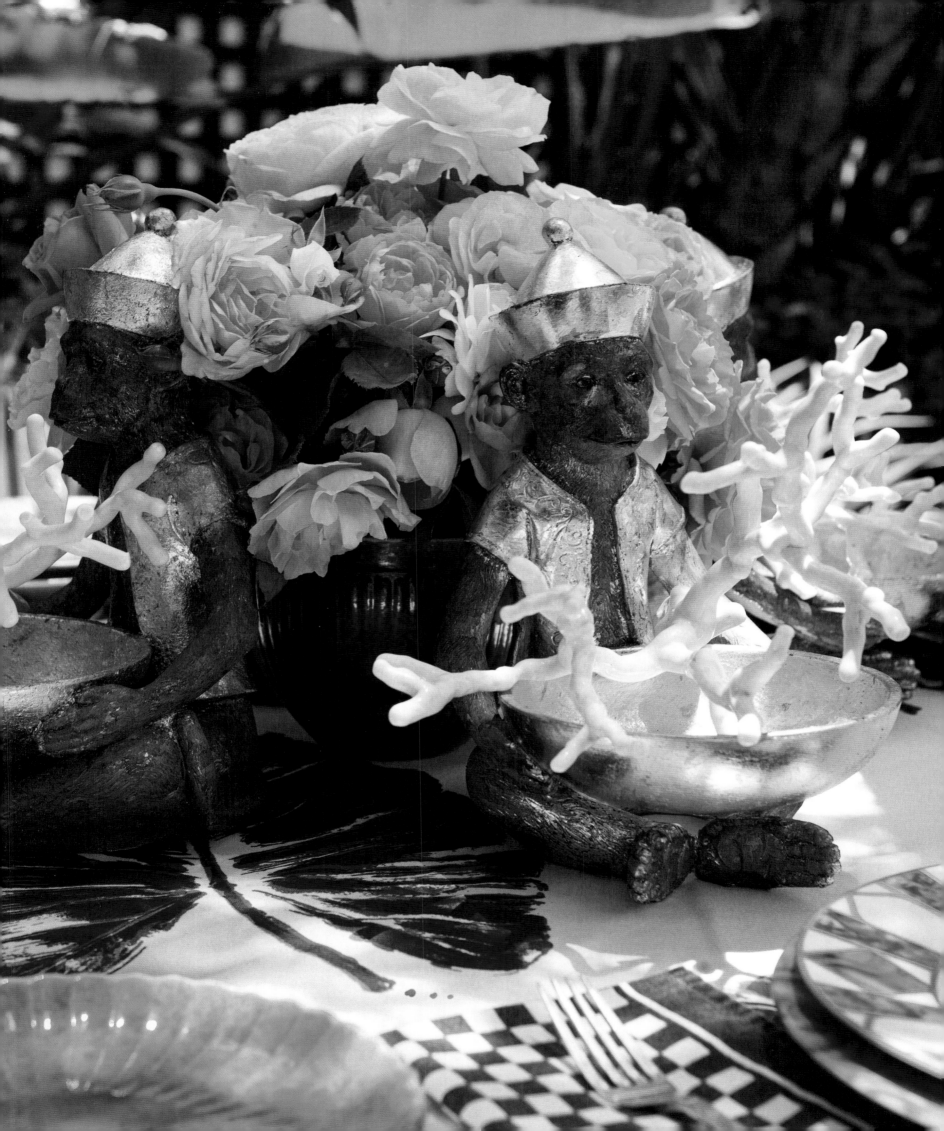

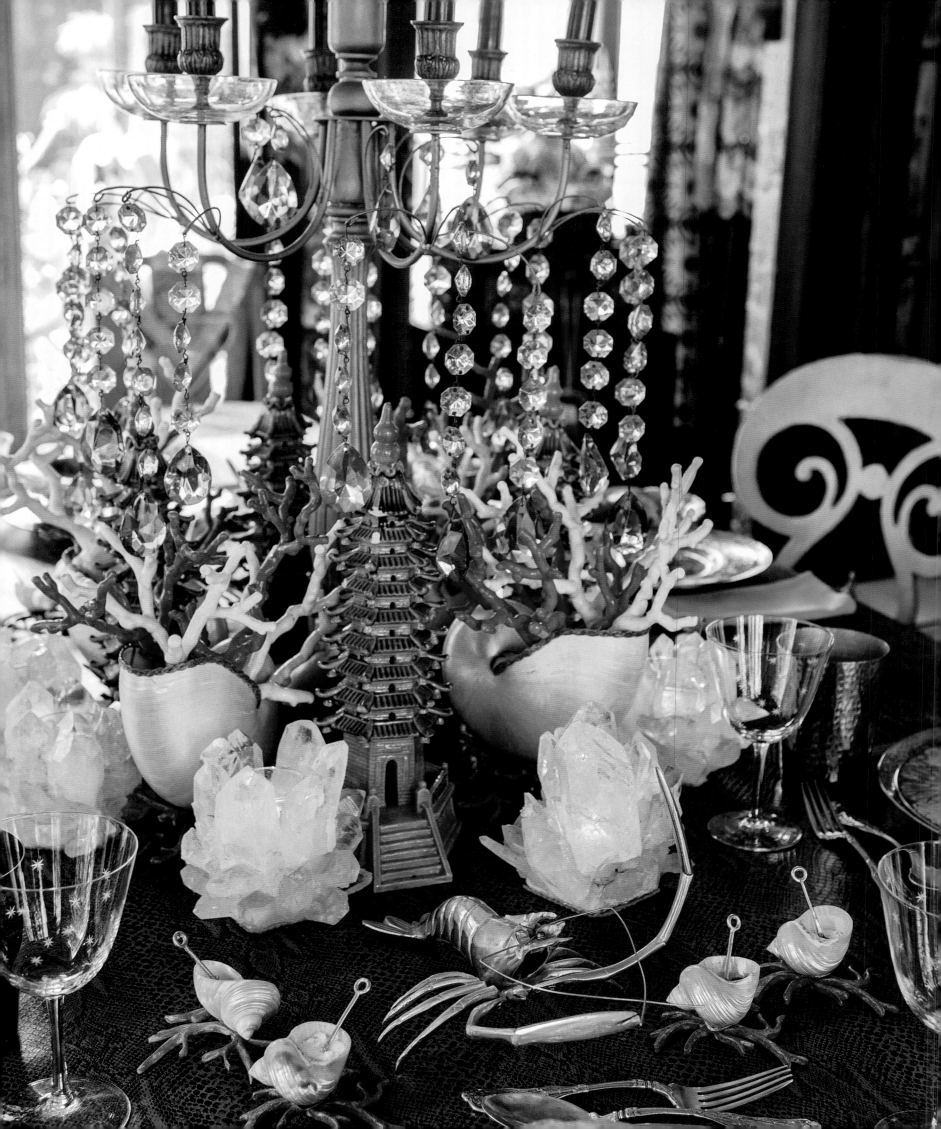

Stuff each whole, peeled green chile with an oblong of cheese. Separate eggs, beat whites until stiff, then add yolks. Add flour. Dip chiles into batter, one at a time, and fry in hot shortening. Brown on both sides; drain on absorbent paper. Serves eight.

SAUCE (one quart)

2 cups tomatoes, lightly stewed
2 cups chicken or beef stock
1 onion
1 clove garlic
1 1/2 teaspoons salt
1/2 teaspoon pepper
1/2 teaspoon oregano

Strain stewed tomatoes through a sieve. Fry onions in hot oil, 1 1/2 inches deep, but do not brown. Add onions and chopped garlic to tomatoes. Pour in chicken or beef stock and boil. Once bubbling, add oregano, salt, and pepper. Pour a little sauce on each chile.

CREAMED CHICKEN AMANDINE

1 six-pound chicken
Enough stock to cover chicken
1/2 cup chopped carrots
1/2 cup chopped white turnips
1/2 cup chopped green celery
2 leeks
6 sprigs parsley
Sprig of thyme
2 bay leaves
5 cloves

6 peppercorns
1/2 pound fresh mushrooms
2 large green peppers
1/2 cup canned pimiento, drained
2 tablespoons butter
Salt
8 patty shells or a vol-au-vent

Make a stock of carrots, turnips, celery, leeks, parsley, bay leaves, thyme, cloves, peppercorns, and salt to taste. Put the chicken in the stock mixture and simmer slowly for 2 1/2 to 3 hours. Then let the bird cool in the broth. Discard skin and bones; dice the meat.

Slice the mushrooms, green peppers, and pimientos, all thin. Sauté in butter; drain off the butter. Add the chicken meat. Keep the mixture hot while preparing sauce. Serves eight.

SAUCE

3 cups medium white sauce
3 egg yolks
Salt
White pepper
Nutmeg
1/4 cup dry sherry
1 cup almonds

Add beaten egg yolks to white sauce; combine with chicken and vegetables. Season with salt, pepper, and nutmeg. Reheat, without boiling, and stir in the sherry, and almonds, blanched, toasted, and shredded. Serve in patty shells or a vol-au-vent.

STUFFED ZUCCHINI

6 zucchini
1/2 cup chopped raw spinach
2 tablespoons minced onion
Parmesan cheese
2 tablespoons butter
1 cup bread crumbs
Salt and pepper

Cook zucchini in boiling salt water for 10 minutes. Cut zucchini in boat shapes and scoop out centres. Mix pulp with raw spinach, minced onion, Parmesan cheese, and remaining ingredients. Fill zucchini shells and bake in 350° oven for 15 minutes. Serve with bacon. Serves six.

CHERRY AND KIRSCH ICE

1/2 cup sugar
1/2 cup sauterne
1 cup pitted, ripe black cherries
1/4 cup light honey
2 tablespoons kirsch
1/8 teaspoon salt

Boil the sugar and sauterne together for 5 minutes, counting from the time the first bubbles appear. Set aside to cool. Press the cherries through a sieve, then strain through a double layer of cheesecloth. Beat together the cherry juice, the sugar syrup, and the honey with a rotary beater and add, during the beating, kirsch and salt. Freeze. Serves six.

Index

........................

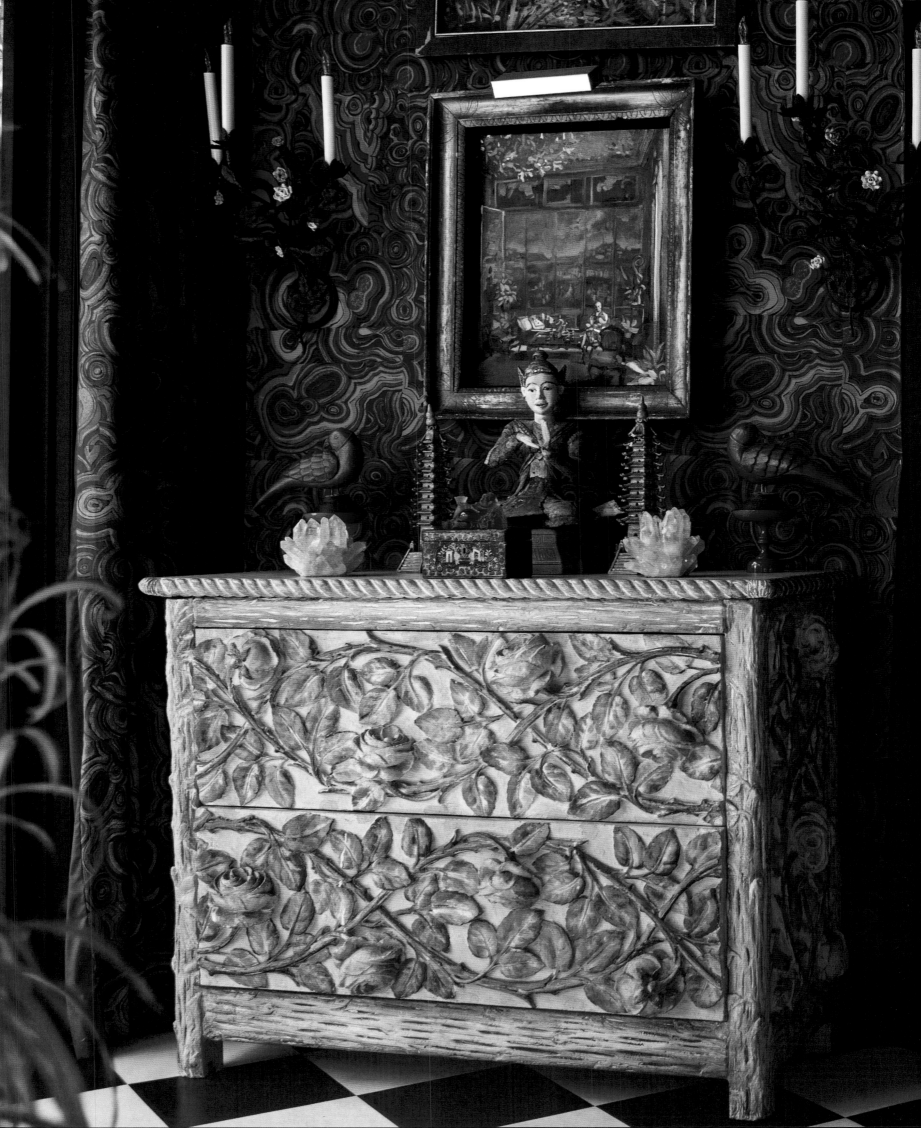

Ruth's sitting room at
Casa La Condesa, 2018.

Photo Credits

.................

Illustrations by Juan Bastos: Pages 2–3

Fernando Bengoechea: 72

Shirley Burden: 14, 40, 44 (top), 58, 65, 66, 90, 114, 116, 120 (top)

© Christie's Images/Bridgeman Images: 48, 49, 92

Duquette Archives: 5, 18, 19, 20, 21, 22, 23, 24, 25, 26, 27, 28, 29, 31, 32, 33, 53, 56, 60, 61, 62, 64, 68, 69, 101 (top and bottom right), 122, 123, 124–125, 129, 136, 139, 140, 142 (top), 151, 152, 153, 164, 165, 234

Oberto Gili: 5, 41, 84, 106, 110, 117, 118–119, 142 (bottom), 157

Fred Iberri: 236

Christin Markmann: 253

Courtesy Scott Mayoral and Remains Lighting: 156

Tim Street-Porter: 6, 8, 12, 16, 17, 34, 36, 38, 39, 42, 43, 44 (bottom), 45, 46–47, 50, 51, 52, 54, 55, 57, 63, 67, 70, 71, 74, 75, 76, 78, 79, 80, 81, 82, 83, 85, 86, 87, 88, 89, 93, 94, 95, 96, 97, 98–99, 100, 101 (left), 102, 103, 104, 105, 108–109, 111, 112, 113, 115, 120 (bottom), 121, 126, 127, 128, 130, 131, 132–133, 134, 135, 138, 143, 144, 145, 146, 147, 148, 149, 150, 155, 158, 159, 160, 162, 163, 166, 167, 168, 169, 170, 171, 172–233, 241, 242, 245, 247, 251, 252, 254–255

Courtesy Jim Thompson, Thai Silk: 77

Danforth Tidmarsh: 30

Dave Welch: 237–239

Every reasonable effort has been made to trace and contact copyright holders for individual images. In the event a copyright holder has been missed, the author and publisher would be glad to rectify the situation.

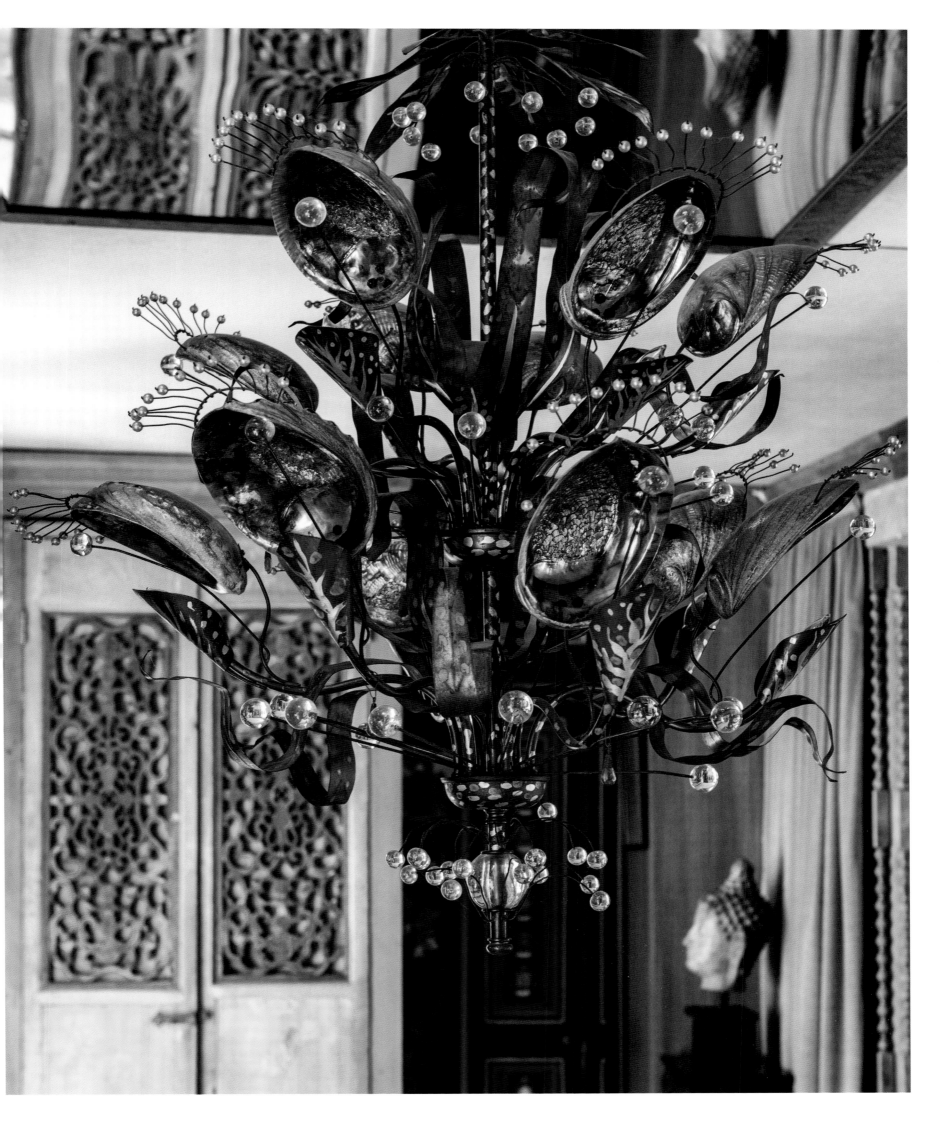

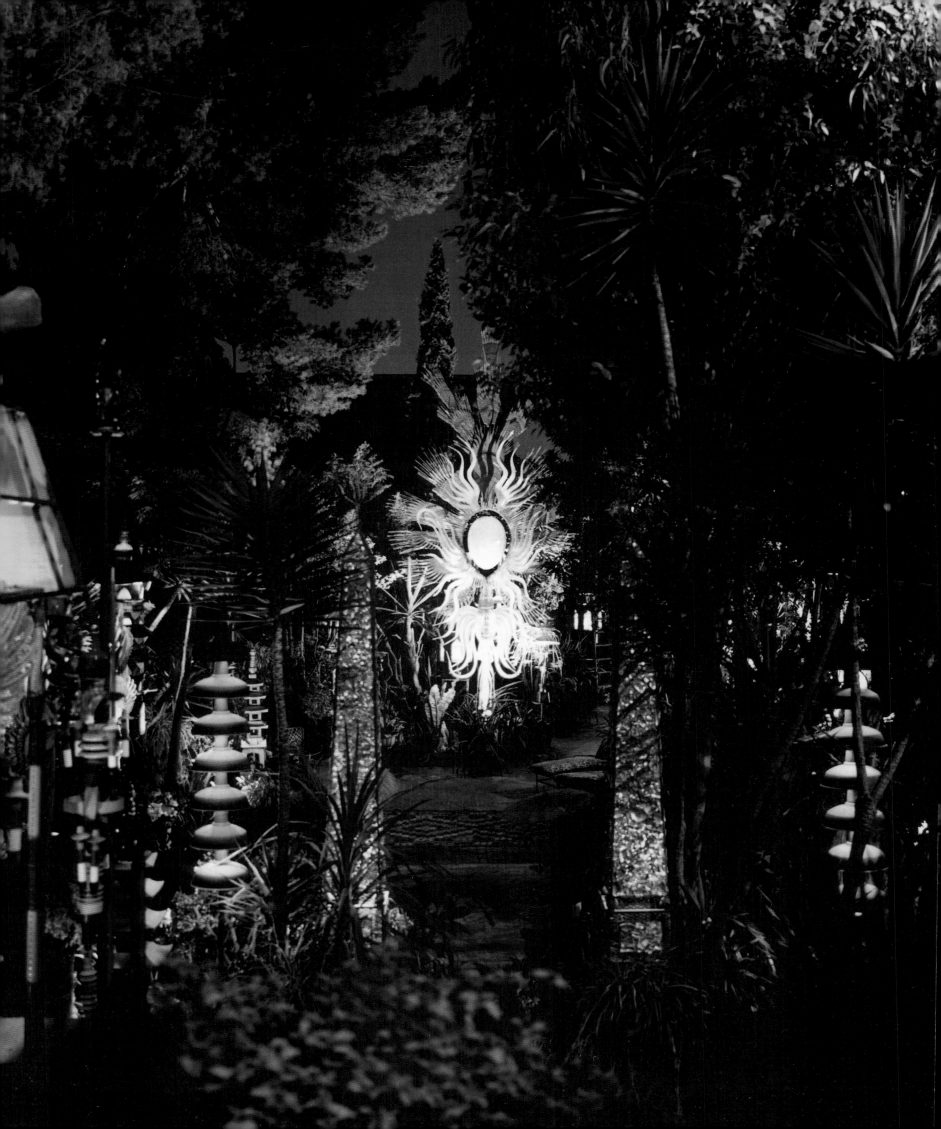

Tony Duquette's *Phoenix Rising From Its Flames* in the gardens at Dawnridge.

One morning, around ten, he called me and asked, "Are you free today?" Luckily, I was. The 1960s Ducommun house was about to be dismantled and sold, and strategically placed paintings by Modigliani, Braque, and Klee, as well as sculptures by Calder and Duquette, were being removed that same afternoon. Working quickly, I managed to photograph everything. This proved to be the only record of Tony's very best decorating, for clients who had given him complete creative freedom.

Encouraged by my interest in his creations, Tony found himself working again, beginning with his 55-acre ranch, Sortilegium, which rose Xanadu-like from a dry mountaintop high above Malibu. Soon, a pattern emerged: I would show him a set of freshly taken 4-by-5 transparencies, and he would follow up a few days later to say that he had made a few changes to the room, and could I possibly take a few more pictures? Happy to oblige, I repeated the process, and soon he was transforming the ranch—and looking noticeably happier. A sizeable crew of workers arrived, working seven days a week, trying to keep up as Tony threw himself into new landscaping projects and the construction of new pavilions, one of which he very kindly gave us to stay in whenever we wished. Reviewing progress with Tony over Sunday lunch with the latest batch of transparencies, I became aware that I had unintentionally kick-started his creative engine.

Tony proved to be an unstoppable shopper, constantly on the hunt for raw materials for future projects. Wherever he traveled, containers of newly found treasures would be shipped back to Beverly Hills. When we joined Hutton and Tony in Bali one year, we immediately identified his villa, its forecourt piled to the ceiling with brown paper–wrapped boxes tied with string. He had been shopping since the moment he arrived, with Hutton complaining that he was not even allowed to stop for lunch.

Meanwhile Dawnridge was also receiving its share of transformations, and it was wonderful to witness his mind at work, day by day, like an artist breathing fresh air into a familiar canvas. One of my last photos at Dawnridge during Tony's lifetime was of *Phoenix Rising From Its Flames*, a large sculpture he had just placed in his garden after his 1995 exhibition at the Hammer Museum. This was created after his Malibu ranch burned to the ground—a symbol of rebirth and continuance that showed Tony's extraordinary resilience and creative drive.

—TIM STREET-PORTER

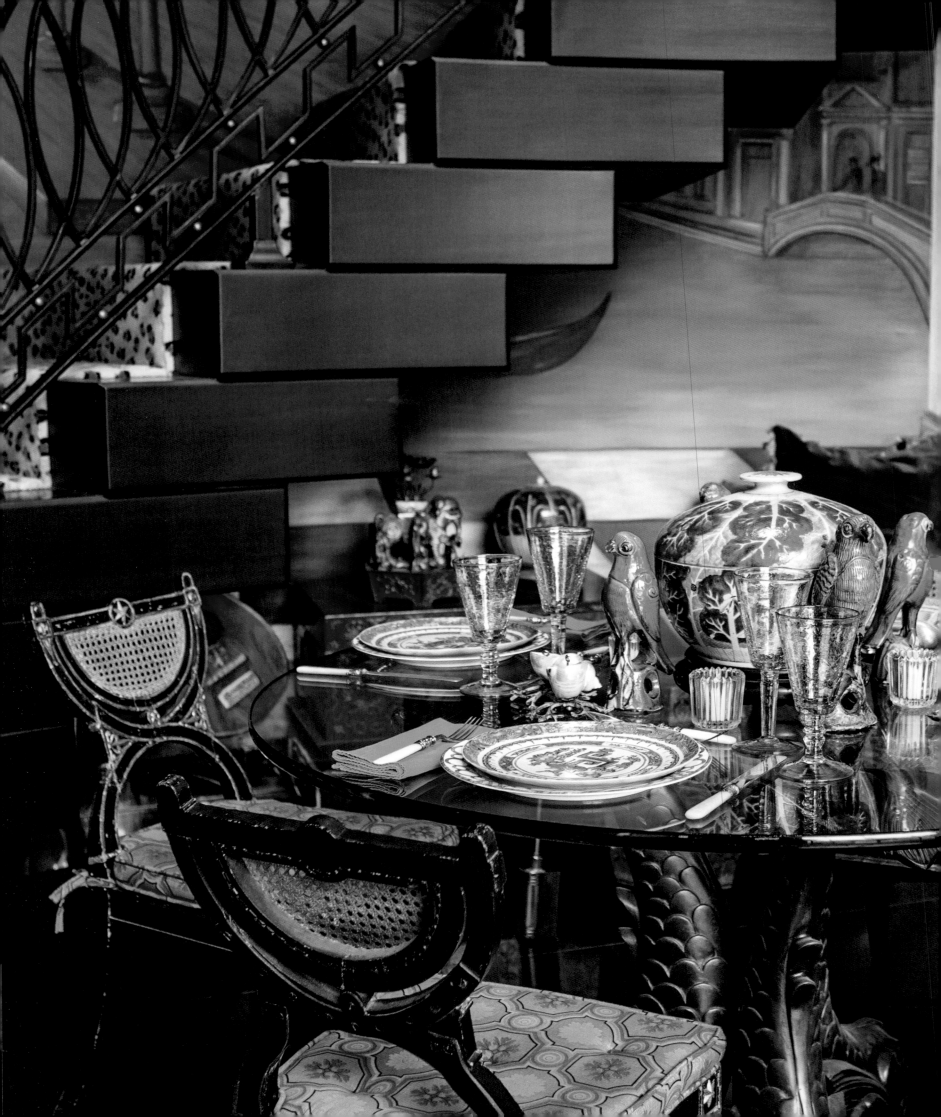

Editor: Sarah Massey
Designer: Emily Wardwell
Production Manager: Anet Sirna-Bruder

Library of Congress Control Number: 2017956932

ISBN: 978-1-4197-3262-1

Text copyright © 2018 Hutton Wilkinson
Principal photographs copyright © 2018 Tim
Street-Porter

Jacket and cover © 2018 Abrams

Printed and bound in China
10 9 8 7 6 5 4 3 2 1

Abrams books are available at special discounts
when purchased in quantity for premiums and
promotions as well as fundraising or educational
use. Special editions can also be created to
specification. For details, contact specialsales@
abramsbooks.com or the address below.

ABRAMS The Art of Books
195 Broadway, New York, NY 10007
abramsbooks.com